The
BFI Companion
to German Cinema

The
BFI Companion
to German Cinema

Edited by

Thomas Elsaesser

with Michael Wedel

Series Editor: Ginette Vincendeau

 Publishing

First published in 1999 by the
British Film Institute
21 Stephen St, London W1P 2LN

The British Film Institute is the UK national agency with responsibility for
encouraging the arts of film and television and conserving them in the national
interest.

Set in 9.5/11pt Times Ten by Fakenham Photosetting Limited, Fakenham, Norfolk
Printed in Great Britain by St Edmundsbury Press, Bury St Edmunds

Cover designed by Megan Smith
Cover images: (front) Solveig Dommartin in *Wings of Desire* (*Der Himmel
über Berlin*) – Wim Wenders, 1987; (back) Franka Potente in *Run Lola Run*
(*Lola Rennt*) – Tom Tykwer, 1998

British Library Cataloguing-in-Publication Data
A catalogue record for this book is available from the British Library
ISBN 0–85170–750–5 (hbk)
ISBN 0–85170–751–3 (pbk)

CONTENTS

ACKNOWLEDGMENTS

My thanks go first of all to the contributors to *The BFI Companion to German Cinema* whose expertise and knowledge of the field have been essential. A special mention is due to Joseph Garncarz. He was involved in drawing up the initial list of personality entries and critical key terms, many of which he subsequently researched and wrote up, now finally included for the first time.

Michael Wedel has accompanied the project from the start, and besides writing a substantial number of entries has also provided background research for others, invaluable for the filmographies and bibliographical references. Credits for additional translations are due to Berta Joncus, Karen Pehla and Michael Wedel.

A work of reference such as this is inevitably indebted to many sources and predecessors. Any scholar of German cinema owes an outstanding debt to *CineGraph*, the loose-leaf encyclopedia coordinated by Hans-Michael Bock. Most of the other sources, notably monographs and collections, are mentioned in the bibliography after each entry.

CONTRIBUTORS

Editor: Thomas Elsaesser, Professor in the Department of Art and Culture at the University of Amsterdam and Chair of Film and Television Studies, whose recent books include, as author *New German Cinema: A History* (1989), *Fassbinder's Germany* (1996) and *Weimar Cinema* (2000), and as editor, *Early Cinema: Space Frame Narrative* (1990), *A Second Life: German Cinema's First Decades* (1996) and *Cinema Futures: Cain, Abel or Cable* (1998).

Michael Wedel teaches film at the University of Amsterdam and is completing a book-length study on Early German Cinema and its Cultural Contexts. His previous publications as author and editor include *Max Mack: Showman im Glashaus* (1996) and *Kino der Kaiserzeit: Genres, Stars, formale Entwicklungen* (1999).

KEY TO CONTRIBUTORS

AL – Andrea Lang
BF – Bo Florin
FM – Franz Marksteiner
GV – Ginette Vincendeau
HB – Hans Beerekamp
IR – Isabella Reicher
JG – Joseph Garncarz
JM – Jonathan Munby
KD – Karel Dibbets
KP – Karen Pehla
KU – Katja Uhlenbrok
LGA – Lars-Gustaf Andersson
ME – Marguerite Engberg
MW – Michael Wedel
SG – Sabine Gottgetreu
SSc– Sonja Schachinger
TE – Thomas Elsaesser
US – Ulrike Sieglohr
WB – Warren Buckland

GENERAL INTRODUCTION

This book aims to bring together under one volume the breadth and variety of German cinema in a concise, accessible and informative form. Written entirely by specialists (see **Contributors**), it is meant equally for professionals – teachers, students – and for film enthusiasts. The desire to include a considerable amount of information in a manageable and affordable single volume dictated drastic choices. A general principle has been to privilege coverage, including of recent material, with a large number of short entries. The entries contain key factual points about a person, institution or critical concept, as well as areas of interest and debate, in other words not just what a person or institution did and when, but why they are interesting, famous or controversial.

The *Companion* does not claim to be exhaustive or 'impartial'; all entries express, to some extent, the opinion of their writers (who are identified by their initials – see under **Key to Contributors**). At the same time, it tries to be as inclusive and accurate as possible, given all the difficulties that such an enterprise presents. Extreme care has been taken to check all sources, in the hope of reducing errors to a minimum. All historical works have more or less hidden agendas and have to operate choices further to those dictated by constraints of space. Choices in *The BFI Companion to German Cinema* have been made according to the following principles:

– the necessity to acknowledge the important figures and landmarks of German cinema, as sanctioned by reputable historians and by the expertise of the writers;
– the desire, at the same time, to redress the balance of established film history:

a) towards the cinema of 'small' countries (Austria, Switzerland),
b) towards popular traditions (the entertainment cinema, the despised, supposedly mediocre, genres, and the stars and directors of popular cinema often unknown outside their own countries),
c) towards 'other voices': women, gays and lesbians, post-colonial communities;

– as far as possible, the desire to provide a perspective from *within* German cinema. Most writers are nationals; when they are not, their expertise has made them intimately familiar with the cinema they are writing about.

There are three major types of entries:

1. *Entries on personnel*: directors, actors, cinematographers, musicians, writers and others are classified under their surname or most common name. This is followed by their date and place of birth and, as the case may be, death, as well as their real name, if relevant. The first words of the entry briefly characterise the person. To save space, the country in which a person was born and/or died is indicated next to their birth/death place only if situated outside this person's country, e.g.:

BEYER, Frank
Nobitz, Thuringia 1932

German director...

but

THIELE, Wilhelm
Wilhelm Isersohn; Vienna 1890 – Los Angeles, California 1975

Austrian director and scriptwriter...

As a rule, biographical details such as marriage and children are indicated only if considered relevant to the work or achievements of the person.

2. *Critical entries*, ranging from well-established genres or movements such as **Expressionist Film** or **New German Cinema** to critical and pan-European concepts, like **Emigration** and **Film Europe** or **Autorenfilm**.

3. *Entries on institutions*, ranging from film schools and festivals to production companies (**DEFA**), archives and other institutions.

Cross-referencing
• Within entries: an asterisk at the end of a name denotes a separate entry – for instance, 'shaped in the films directed by Detlef Sierck* ...'.
• At the end of entries (or within the text) attention may be drawn to other related entries [> NEW GERMAN CINEMA].

Bibliography
• At the end of entries, a single short bibliographical reference may be indicated (under **Bib**) in an abbreviated form, to direct the reader to further reading.
• At the end of the *Companion*, a general bibliography contains full references to books on German-language cinema. Preference has been given to works in English, though authoritative works in other languages are included.

THE
BFI COMPANION
TO GERMAN CINEMA

INTRODUCTION: GERMAN CINEMA IN THE 1990s

Thomas Elsaesser

Art-versus-Commerce to Comedy-and-Commerce

'All's well that ends well. The German cinema is gone. Dead, finally.' Early in 1990, after one false dawn too many in the protracted agony of West Germany's post-60s 'authors' cinema', distributor Laurens Straub tried to lay the last remaining ghosts.[1] But if the names of Fassbinder*, Wenders*, Herzog*, Syberberg* appeared to him to belong to another aeon, not just another era, the burial of the German cinema proved premature. Only a few years later, in the wake of unification (though hardly as its consequence), the media landscape of the new Federal Republic, including its cinema production, had transformed itself so dramatically that one could be pardoned for trumpeting a revival, some even declaring all-out war 'of the present, on the rest of time'.[2] Whether the films thus spotlighted should be called 'German cinema' is another matter. So many different factors came into play – the deregulation of television, a handover between generations, the emergence of multiplex cinemas, revised export and investment strategies on the part of American majors – that neither the lines of force, nor the lines of battle run strictly along the national divide, not even the euphemistically named 'German-German' one.[3]

What stands out, however, is that the fresh breeze blowing through the ruins of former reputations does not fit the traditional idea of a 'new wave'. It is a cockily mainstream, brazenly commercial cinema that wants to have no truck with the former quality label 'art-cinema' (in German: *Autorenfilm**), dreaded as the kiss of death for any hard-won street-credibility in the market place: a stance which, of course, makes sense if one holds to the pendulum swing theory of generational change, for, like the New German Cinema* in the 1960s, the 1990s directors are rebelling against their cinematic fathers (and mothers), with perhaps one crucial difference: they do so mostly by ignoring them altogether, rather than baiting their elders with manifestos and polemics.[4]

The change of guard and mood consolidated itself between 1991 and 1994, with the surprise success of Detlev Buck's *Karniggels* (1991) and Söhnke Wortmann's *Allein unter Frauen/Alone among Women* (1991), *Kleine Haie/Small Sharks* (1992) and *Der bewegte Mann/Maybe ... Maybe Not* (1994) drawing in its wake a number of similar films, usually comedies, appealing to young audiences and rather broadly satirizing upwardly mobile or downwardly self-destructing lifestyles,

3

homo- and heterosexual romance and the chaotic domestic arrangements they entail. As this description suggests, such material is close to television sit-com fare, which hints at a possibly vanguard function for the 1990s films. Taking from American television an un-German sarcasm about yuppie ruthlessness, gender role reversals and social dysfunctionality, directors provided recognisably German prototypes for contemporary attitudes to money and sex, which domestic television took up and in turn popularised. Film-makers furthermore reverted to proven box-office prerequisites: most of the successful titles in recent years have been star-vehicles, featuring actors who have become bankable through television cop-shows and soaps (e.g. Götz George*). Conversely, once recognised as fresh faces in the movies, these new stars, famous for being famous, quickly made it big on the small screen too: Til Schweiger, Katja Riemann and Veronika Ferres adorn the talk-shows as well as being adored by film fans.

Behind the faces, the figures: the German cinema of the 1990s is sexy, it seems, because of 'three million spectators in less than ten weeks', 'a 32% market share in the first quarter', or because 'the film premiered with 1,000 prints this week' – the latter figure referring, it is true, to *Independence Day*, but what does it matter, as long as it is directed by a German, Roland Emmerich*? In 1997 incredulity turned to intoxication, before giving way to megalomania. Not only were the Germans back, re-taking their home ground, they were also supplying some of the top talents of Hollywood: besides Emmerich and *Independence Day* (1996, followed by *Godzilla*, 1998), the champion was Wolfgang Petersen*, who with *In the Line of Fire*, *Outbreak* and *Air Force One* notched up three major international hits between 1993 and 1997. It seemed as if the era of Lubitsch*, Murnau* and Lang* had returned, complete with a latter-day Eric Pommer*: Bernd Eichinger*, the producer-distributor who launched Petersen and Emmerich on their transatlantic careers, while Americanising Uli Edel (*Last Exit to Brooklyn*, *Body of Evidence*) and introducing cameraman Michael Ballhaus* to Martin Scorsese and Francis Ford Coppola (*The Colour of Money*, 1991; *Bram Stoker's Dracula*, 1992; *The Age of Innocence*, 1993). Eichinger also put together the finance for such international co-productions as *The Name of the Rose* (1986) and *House of the Spirits* (1993). As producer of *Das Boot*, *The Neverending Story* as well as *Der bewegte Mann* he, more than anyone else, takes credit for being the strategist and driving force of the Germans' apparently savvy, but in any event unapologetic commercial turn in moviemaking.[5]

Eichinger, who began his producing career in 1978, brackets as well as bridges the 1970s and the 1990s, furnishing elements for an alternative history of the 1980s. Standing apart from both the New German Cinema and the old film industry chiefs, like Atze Brauner, Horst Wendlandt and Luggi Waldleitner, he pursued his own kind of internationalism, relying on best-seller story material. Often picking casts with worldwide appeal (Sean Connery, Meryl Streep, Jeremy Irons),

4

he also entrusted his films to non-German directors (Jean-Jacques Annaux, Bille August). Yet he was not altogether the only one with a market-oriented outlook. In retrospect, one can trace slightly divergent developments all through the 1980s which make the 'authors' cinema' not the decade's sole focus, but more like one 'genre' among others. These others would include a spate of German road movies and trucker films (*Theo gegen den Rest der Welt/Theo Against the Rest of the World*, 1980), the television comedians Loriot (*Ödipussi*, 1987; *Pappa ante Portas*, 1990) and Otto Waalkes turning film stars (*Otto-der Film*, 1985ff – four parts in all), and the work of Doris Dörrie*, an *auteur*-director whose films (several produced by Eichinger) kept their distance from the sombre mood of much of the New German Cinema by being well-scripted comedies. Her highly successful *Männer/Men* of 1985 became the template for several post-68, post-feminist, neo-macho comedies of the late 1980s and early 1990s, such as Ecki Ziedrich's *Singles* (1988), Katja von Garnier's *Abgeschminkt/Makin' Up* (1991) and Dominik Graf's *Spieler/Gambler* (1990). Apart from *Männer*, most of these lifestyle or *Szene* comedies were impossible to sell abroad, confirming a long-standing conviction in the trade that comedy, especially European comedy, is the least exportable of genres, since what is funny tends to vary mysteriously from country to country. This proved sadly true also of the mid-1990s comedy successes, such as the cartoon film *Das kleine Arschloch/The Little Asshole* (1997) or the cult-film *Ballermann 6* (1997).[6] When screened at international festivals, foreign critics shook their heads in disbelief, as much about the tastes of the great German public as about the reckless naiveties of the films thus touted as national assets. As one German critic commented on the desolate export situation: 'The German cinema faces catastrophe. Not the hot one of the market, nor the cold one of penury, but the lukewarm disaster of becoming the world's laughing stock.'[7] And another critic asked in mock exasperation: 'is our comedy too bland, our melancholy too thorough, our thoroughness too melancholy, and our blandness not even unintentionally comic?'[8]

Turning out comedies that made no-one from London, Paris or New York laugh except derisively had another drawback. The New German Cinema may not have been as loved by German audiences as it was esteemed by festival critics, and the production subsidies may not have brought the federal and regional funding authorities a return on their money, but compared to the slight impact that postwar West German literature had made on the international image of Germany, the cultural capital invested by the films of Herzog, Wenders, Syberberg, Fassbinder, von Trotta* and others in 'representing' the new Germany had brought inestimable returns. It gave the Federal Republic credibility as the home of a committed and self-critical artistic community which far outweighed the films' lack of mainstream appeal.

Misgivings about the lukewarm international response to the 1990s

face of German cinema were accompanied by economic worries. With the trade in moving images having become ever more global, and even Hollywood films increasingly depending for profit on exports and secondary markets, a revival of film production could not be sustained on a national basis alone, unless it was intended for television all along, with cinema releases supplying merely the showcase and warm-up phase for TV and the video stores. The not altogether hidden hand of television was in fact one of the chief reasons behind the feature film boom. While in the 1970s and 1980s, Germany's state-owned broadcasting companies wholly funded or co-produced feature films as part of their cultural and public-service brief, the expansion of networks following deregulation forced broadcasters to look for material with strong or proven audience potential, and, in a newly competitive market, it was often cheaper to support young native talent than to bid for the ever more expensive Hollywood imports. However, rather than investing in home-grown 'author-directors', in filmed literary classics or heavy-duty national self-examinations, these new television co-productions tried to second-guess existing spectator expectations: they relied on formula plots and character stereotypes, whether pastiching old movies or drawing on American television. The films, so to speak, served as television pilots, testing out new story material that might appeal to audience segments attractive to advertisers, which goes some way towards explaining the Niagara rush towards teenage romance, yuppie angst and lifestyle situation comedy.

The Americans, meanwhile, had not been idle in what was traditionally Hollywood's most lucrative export territory ('the world's second largest movie market').[9] Apart from dominating, as they had done since the early 1970s, the exhibition outlets (where a Hollywood blockbuster can easily expect to draw 4–5 million spectators), they also made sure they benefited from the 300–400,000 spectators of the most 'successful' authors' films, by becoming the distributors of Herzog, Schlöndorff, Wenders, even in Germany. Spotting the commercial potential of the 1990s comedy wave, US majors like Fox, Disney and Warner Bros. sent their talent scouts to Munich and Berlin, offering development money and co-production deals. 'Americans realised early on that local audiences want to see local films with local stars again.'[10]

The test case was *Knockin' on Heaven's Door* (1997, dir. Thomas Jahn) which attracted Buena Vista (the European-based distribution company owned by Disney) for a number of reasons: it had an American (rock'n'roll) title, it fitted genre expectations, updating Wenders' *Kings of the Road*-movie male couple, and combining it with *Thelma and Louise* let's-go-with-a-bang violence. It was also the pet project of Til Schweiger*, Germany's no.1 heart-throb, who supposedly 'gave [Buena Vista] executives a three-hour presentation of the script in which he played every role.'[11] His act and their gamble paid off. With nearly 6 million German spectators (and, albeit modest, worldwide distribution), it handsomely recouped Disney's up-front investment.

Such activity by the US majors also confirmed what industry experts and author-directors had always maintained: the problem with European cinema was not the quality of its films, but inadequate promotion and distribution in the crowded first-run circuit. Here some new opportunities for creative marketing have arisen from the success of the multiplex formula, especially vigorously pursued by a young ex-art-house programmer, Hans Joachim Flebbe, with his chain of ultra-modern Cinemax theatres all over Germany. Particularly instructive is the case of a relatively low-budget independent production, Caroline Link's *Jenseits der Stille/Beyond Silence* (1997), the feel-good story of a young woman growing up with deaf parents. After a fitful start, it was picked up by Buena Vista which gave it the full Disney treatment, using leverage with cinema owners for good seasonal slots (like the Christmas holidays) and promoting it as a companion film to Jane Campion's *The Piano*, with its mute heroine, and *Shine*, the surprise hit from Australia about an autistic pianist. Again, the effort was worth it, since *Beyond Silence*, in every respect a typical art-house film, reached two million spectators in Germany, and had a sizable run in France and most other European countries. Ironically, it was as if German cinema of the 1990s needed to become 'antipodean' first, before finding its audiences, if not its (national) identity: Peter Sehr's *Kaspar Hauser – Verbrechen am Seelenleben/Kaspar Hauser – a Crime against the Inner Life* (1994) and Josef Vilsmaier's* *Brother of Sound* (1995) also have protagonists that are at once hyper-gifted and handicapped.

Deathgames and Funny Games

'The German cinema is dead. Those who collectively created it as individuals now have to continue in solitary effort. The new German film has had its day.' Since 1982/83, when critic Peter Buchka filed his retrospective report, such pronouncements have been legion, making Laurens Straub's verdict from 1990 a self-consciously cited cliché tossed in with relish and a sigh of relief. A silent detonation had occurred, an invisible Chernobyl had deposited a poisoned cloud over the cinephile landscape. Sometimes conflated with the death of Fassbinder in 1982, sometimes blamed on the newly-elected 1983 conservative Minister of the Interior (who vowed to cut state funding if film-makers violated decorum and Christian values), these arguments, at once overly symbolic and one-dimensionally economic, failed to explain the spectacular decline of the New German Cinema or unravel the reasons for the gloomy, almost suicidal mood of so many of the once leading directors. 'Death' became a self-fulfilling prophecy, aided and abetted by what seemed the *Autorenfilmers'* masochistic self-abandon to rash pessimism and collective self-pity. The renewed Hollywood offensive and changes in government funding policy clearly did create a tougher climate, but the international reputation of

7

the leading directors also generated new opportunities to make films with foreign companies or partners. In several cases these opportunities became the breaking point, exposing professional and ideological weaknesses in the original concept of 'authors' cinema'. Professional flaws, in so far as the ideal of concentrating in one person all major functions – surviving in the 'subsidy jungle', producing, writing, directing – could not be sustained as budgets rose; a film had to satisfy cinemas, TV and video stores, so foreign partners wanted a say in scripts and casting, and the New German Cinema had few stars and often weak scripts. Ideological blind spots, in that the New German Cinema, as argued above, served the function of cultural and diplomatic 'representative' of a liberal, cosmopolitan and above all model 'European' (i.e. Francophile) Germany, which in turn gave directors at home the possibly illusory status of wearing the triple crown of artist, sage and seer.

Thus, another reason why even the deservedly famous German films from the golden age of the New German Cinema have lapsed into (temporary?) oblivion is that, most cruelly since unification, this understanding of the directors' public role has become heavily contested. A similar devaluation of their representative status was suffered by prominent postwar writers, such as Günter Grass, Martin Walser, or the East German Heiner Müller and Christa Wolf. Open hostility, accusations of elitist arrogance, and eventually indifference was the fate of several of these prophets without honour in their own country: an ingratitude perhaps more practically debilitating in a business as volatile, reputation-driven and capital-intensive as film-making than for a writer, used to working in solitary silence, exile and for posterity.

Several directors did indeed emigrate, at least semi-permanently. Wenders, always the most peripatetic, made films in the United States, with French money, or set in Australia and Portugal (*Paris, Texas*, 1984; *To the End of the World*, 1993; *Lisbon Story*, 1994; *The End of Violence*, 1997), but celebrated his homecoming to Berlin with *Wings of Desire* (1987) and *Faraway So Close* (1993). In the 1990s, the time lags between Wenders' projects have become longer and longer, the finished films garnering polite applause, but then quickly disappearing from both the screens and the debates. Margarethe von Trotta relocated to Italy, and her sporadic output sometimes became as painful to watch as it must have been tough to set up financially (e.g. *Zeit des Zorns/Time of Anger*, 1994). Syberberg has chosen internal exile, devoting his talent and apocalyptic sensibility to filming plays (*Penthesilea*, 1987), one-woman recitals (*Edith Clever liest James Joyce*, 1985) and staging impressive video-installations (most recently his meditation on Prussia, ruins and German unification at the documenta X, 1998). Herzog divides his time between Munich and San Francisco, mainly making documentaries for television. When not gloomily predicting the end of the world, thanks to natural or human disasters (*Lessons in Darkness*, 1992, *Echoes from a Sombre Empire*,

1992, *Bells from the Deep: Faith and Superstition in Russia*, 1993), he is looking for real-life overreachers (the mountaineer Ronald Messner in *Schrei aus Stein/Scream of Stone*, 1991; and Dieter Dengler, the German ex-Vietnam fighter pilot of *Little Dieter Needs to Fly*, 1997) to replace the late Klaus Kinski* and his melancholy, grandly futile exploits. Herzog has also staged operas in Germany and Italy. Many names once associated with German film-making in the 1970s and 1980s have found a livelihood – and an occasional directorial assignment – as professors at film academies, art colleges and universities. Others work, occasionally, in television and, as in other European countries, far too many once highly promising first-time directors seem exhausted after their second or third feature film (Jan Schütte and Dominik Graf come to mind).

This leaves the survivors, a not inconsiderable band of directors who from the 1970s to the 1990s, have battled on, adding film after film to their body of work, sometimes conceived on a grand scale (such as Edgar Reitz's *Heimat*, predicted to reach completion with its third and final instalment coinciding with the last days of the present millennium), and sometimes more like pieces of a mosaic, the overall shape determined by circumstance as much as by design. The latter applies to Harun Farocki*, a political and avant-garde film-maker who has emerged as a veritable long-distance runner with unexpected staying power as a film-essayist, conceptualist and archeologist of moving images and their palpable, bodily reality. His *Bilder der Welt und Inschrift des Krieges/Images of the World and Inscription of War* (1988) is the underground classic of the age of ubiquitous surveillance, smart bombs and the visual memory of the Holocaust. His *Videogramm einer Revolution* (1992, with Andrei Ujica) gives a painstaking dissection of the role of television in a post-Communist 'revolution' (the fall of Ceaucescu in Romania). A barely disguised old-fashioned *coup d'état* remote-controlled from the TV editing consoles is seen as a muddying not only of the political divide between left and right, but also of the differences between a public medium of record and the camcorder's potential as *agent provocateur*.

An inveterate *agent provocateur* and the initial cause of the new minister's displeasure is Herbert Achternbusch, an anarchic one-man-band of a film-maker in the tradition of Bavarian baroque-surrealists like Karl Valentin, with an incorruptibly acute eye for the moral schizophrenia of his complacently guilty and unhappily self-righteous fellow Germans. In the 1990s his output has barely slowed from its manic pace during the 1980s, except that lack of funds has forced him into ever more amateur formats and media, like super-8 and home video, marginalising him even further in the national film culture. With scant hope of even an art-house release or a late-night television slot, he nonetheless remains the insiders' German film-maker of choice.

Among the core directors of the New German Cinema, Volker Schlöndorff* and Alexander Kluge* are also still active in the 1990s: the former with more literary adaptations and 'Europuddings' (*Homo*

Faber, 1990, after Max Frisch, *Der Unhold/The Ogre*, 1996, after Michel Tournier, *Palmetto*, 1998); the latter with a regular, and regularly idiosyncratic meta-media slot on (commercial) television (*10 vor 11/10 to 11*). Among the old avant-garde, Ulrike Ottinger* (*Countdown*, 1990; *Taiga*, 1991; *Exil Shanghai*, 1997), Werner Schroeter* (*Malina*, 1991; *Poussières d'amour*, 1996) and Rudolf Thome (*Liebe auf den ersten Blick/Love at First Sight*, 1991; *Tigerstreifenbaby wartet auf Tarzan/Tigerstripe baby waits for Tarzan*, 1998) have continued making films at irregular intervals, but none has had a screen success that could ensure major funding and guarantee them continuity. Percy Adlon, after his Proust study *Celeste* (1981) turned to comedies with heart, and had a notable trio of critical and commercial successes with *Zuckerbaby* (1984), *Out of Rosenheim/ Bagdad Café* (1987) and *Rosalie Goes Shopping* (1988), all starring Marianne Sägebrecht, whom Adlon's films launched on an international career (*The War of the Roses*, US, 1989, dir. Danny de Vito).

In this generation, however, only the Austrian (German-born) director Michael Haneke* has greatly increased his reputation during the 1990s. With his trilogy about voyeurism and violence (*Benny's Video*, 1992; *71 Fragments of a Chronology of Accidents*, 1994; and especially *Funny Games*, 1997) Haneke has emerged as a disturbingly post-modern director. His cold detachment and vertiginous narrational logic hover between critique and collusion, a stance that has given him an international audience, confidently comparing him with Atom Egoyan and David Lynch.

Three directors, also from the first postwar generation, have come to prominence via television: Hans Breloer, Dieter Wedel and Helmut Dietl. Although Breloer has not (yet) made a feature film with theatrical release, his fictionalisations of scandals and crises from the postwar history of the Federal Republic as 'real-life political thrillers' have made him 'the Costa-Gavras of Germany' (*Wehner – die unerzählte Geschichte/Wehner – the untold story*, 1993). Breloer's reconstruction of the Baader-Meinhof/Red Army Faction kidnap, hijack and suicide mission during the 'Hot Autumn' of 1977 (*Todesspiel/Deathgame*, 1997) was the most expensive German television production yet, and its two-part screening became the major media event of 1997. Dieter Wedel was responsible for one of the most-talked about television series, a soap centred on a senior citizen patriarch (Mario Adorf*) taking on the yuppie generation (*Der grosse Bellheim*, 1991/92) and a red light district saga set in Hamburg, *Der König von St. Pauli* (1997). Helmut Dietl, finally, put Munich on the map in a series of TV portraits of eccentric Bavarians, drawn from acquaintances, relatives and hangers-on of the Munich Bohemian fringe. His breakthrough, however, was the feature film *Schtonk* (1991), a comedy with Götz George that took a cynical look at the conmen, careerists and credulous experts responsible for the scandal around the forged Hitler diaries. Dietl's second feature film, *Rossini* (1997) also with Götz George, costarring with Mario Adorf and Veronika Ferres, is set in a posh

Munich restaurant frequented by film people. Satirising the vanities and neuroses of six mid-life males and their changing female partners, Dietl aimed at a style somewhere between Fellini and Woody Allen. With *Late Show* (1999), about the stormy career of a talk show producer, Dietl completed what looks like a trilogy about the press, the movie business and commercial television: each film probes the human cost of being caught in a make-believe media world.

The new generation that started out in the 1990s has also produced a number of 'names', some of whom may well be set to become *auteurs* with a distinctive style and signature. Among likely candidates are Detlev Buck* (*Männerpension/Jailbirds*, 1995, *Liebe Deine Nächste/ Love Thy Neighbour,* 1998), Josef Vilsmeier* (*Schlafes Bruder/ Brother of Sound,* 1995, *Comedian Harmonists,* 1997), Peter Sehr (*Kaspar Hauser – Verbrechen am Seelenleben,* 1993, *Obsession,* 1997), Dani Levy (*Stille Nacht/Silent Night,* 1995, *Meschugge/Don't,* 1998) and Tom Tykwer* (*Winterschläfer/Winter Sleepers,* 1997, *Lola rennt/ Run, Lola, run,* 1998), with Christoph Schlingensief* (*Das deutsche Kettensägenmassaker/The German Chainsaw Massacre,* 1990, *120 Tage von Bottrop/120 Days of Bottrop,* 1997) the odd one out: a low-budget, noisily media-active self-promoter, he may be trying too hard to be an *enfant terrible* in the Fassbinder mould.

Most of them are film school graduates, in stark contrast to the previous generation. They are determined to reach a German public, which is not necessarily the same as being 'commercial'. However, they also know that the German market is ultimately too small to support big budget film-making solely on a national basis and in the absence of export potential they cannot pass up television as the indispensable secondary market. Not surprisingly, film-makers test very different generic formulas. These range from noirish psychological drama (Tom Tykwer's *Winterschläfer*) and sexually charged chamber pieces (Dani Levy's *Stille Nacht*) emulating French films of the 1980s, to American-inspired buddy movies (Detlev Buck's *Männerpension*, Thomas Jahn's *Knockin' on Heaven's Door*) and recognisably German soul-searching (Vilsmaier's *Brother of Sound*, Sehr's *Kaspar Hauser*), which can strike a false note of arch simplicity or calculated sentiment (Caroline Link's *Jenseits der Stille* [1997], Peter Lichtefeld's *Zugvögel/Birds of Passage* [1998]). Sometimes a formula yields densely textured psycho-drama, as in Romuald Karmokar's *Der Totmacher/The Death Dealer* (1996), reminiscent of Fritz Lang's *M*. It can revitalise the old-fashioned thriller in the Melville mode (Christian Petzold's *Cuba Libre* [1996]), or strike a Chabrolesque note of black humour, as in Rainer Kaufmann's *Die Apothekerin/The Prescription* (1997).[12]

Standort/Tatort Germany

'It's like counting buttons: the German cinema is dead, is alive, is dead, is alive ...'.[13] After the 'high' of 1997, the hangover the following year

was almost inevitable. A wag has called it the clay-pigeon effect: praise them to the skies, before shooting them down. The cycles are pre-programmed, and perhaps the most sobering thought is that since crisis seems a way of life for German cinema, it may be better to take other indicators altogether, not counting the box-office grosses nor the genius factor of individual *auteurs*. A number of features strike the eye: first, like recent American blockbusters, German films of the 1990s gravitate towards female audiences, reflecting women's prominence as television spectators and their purchasing power as consumers, as well as their higher educational attainments and growing self-confidence in the professions.

Second, the film business in Europe, including Germany is driven only partly by the films (the 'software'). It is part of the wider media landscape, in which the technological infrastructure of telecommunications, the strategies of software and hardware manufacturers, and the real-estate infrastructure of entertainment centres and leisure complexes come together to determine the economic climate for films and their makers also. But it is government policy that provides the interface. Thus, the boom of the German cinema in the 1990s – like the 'golden age of the 1970s' – is incomprehensible without taking into account the German film subsidy system, and how it has developed since the 1980s, when the 'Reaganomics' of the Kohl era first replaced the left-liberal 'watering-can' model. But instead of subsidies being cut by bigoted ministers, as critics claimed when trying to explain the decline of the New German Cinema, the funds have in fact quadrupled. Except they are now 'tied' to (different) conditions. These are, however, rarely based on the box-office receipts. Instead, subsidies depend on film-makers using specific locations, facilities or services – in other words, helping create jobs, renewing technical know-how, or participating in the high-tech refurbishment of certain formerly industrial manufacturing areas, such as the Ruhr valley, Berlin and Hamburg. Alternatively, they are (indirectly) tied to bringing 'cultural tourism' to a city, as with the many film-festivals that have sprung up all over Europe, including Germany, to the greater glory of medium-sized cities with no particular scenic or historical sites to attract visitors or media coverage. This regional and local policy-making in the area of film funding is known as *Standort-politik* ('the politics of place'), and there are in fact in Germany a number of regions fiercely vying with each other for recognition as a *Medien-Standort* ('media centre'), i.e. a region or city known for its media and information industries, training facilities and audio-visual services (apart from Munich, Hamburg and Berlin, contenders are Cologne, Stuttgart, Karlsruhe and Jena). The most energetic region in recent years has probably been North Rhine-Westphalia, whose Film Office is directed by Dieter Kosslick, a driven organizer who previously ran the European distribution fund, the EU's Media Programme's most successful initiative in the 1980s.

Finally, this 'regionalisation' of film-making is based on political and often long-term macro-economic projections. As the European Union

12

is consolidating itself and the modern nation state is undergoing profound transformations, the old regions of Europe are reasserting both their distinct cultural identities and their particular strengths, whether judged on their human resources, geographical advantages or historical traditions. The *Medien-Standort* concept can thus be seen as a staking of claims in the gold-rush of the information age – we might call it the Silicon Valley factor in Western Europe – where the financial or fiscal support of film and television production forms an integral part of overall planning, with job-creation and high-tech industrial development gradually replacing the 'cultural politics' of representing Germany abroad that was so typical of the New German Cinema and its international reputation during the Cold War era.

Germany is particularly rich in such regions, indeed it is nothing but a federation of regions, its experiments with the unified nation state in modern times having been at best negative and at worst catastrophic. Its distinctiveness is not the result of a national identity but of regional diversity. East (the newly added federal states of the former GDR), West (the rich Rhine valley from the Ruhrgebiet to Frankfurt), North (around the sea-ports and agricultural regions) and South (spanning the medium-sized but high-productivity industries from Mannheim via Stuttgart to Munich and beyond) have very different historical characters, reflected in their names: Saxony and Schleswig Holstein, Swabia and Bavaria, Brandenburg and Westphalia. Not all of these regions are fully 'present' on the cinematic landscape, but most of them have a very distinctive cultural identity with characteristic types of humour, language, popular and musical culture – differences which also translate into filmic genres, and not just in Bavaria, with its *Heimat* and mountain films. Take, for instance, the German road movie: it seems almost a typical Rhine/Ruhr valley genre: the prototype is Wim Wenders (born in Düsseldorf), who in *Alice in the Cities*, *Wrong Movement* and *Kings of the Road* pays tribute to the region. Other films that come to mind are Peter F Bringmann's *Theo gegen den Rest der Welt* (1980), Adolf Winckelmann's *Nordkurve/North Bend* (1992) and Thomas Jahn's *Knockin' on Heaven's Door* (1997).

The German cinema of the 1990s is a national cinema only across the regional push and pull of *Standort* (in both its cultural and economic dimensions), so that the different topographies a film touches (in its representation) and engages with (in its financing) become as important as the box-office takes, even for the economic health of the nation's filmmaking. Yet the crucial mediator of such topographies is not primarily the cinema, just as the old manufacturing industries are not necessarily the only defining element of the region's success as a *Standort*. The new media topography is one which is driven by television demographics – and which in turn produces television programming. One might call it the *Tatort* Germany, in honour of the most famous cop show on German television: for West German audiences the 'ethnographic', generic (and for new film-makers: professional) importance of this long-running series starring Götz George as Detective Schimanski can hardly be overestimated.[14]

13

Television exerts its gravitational pull by being both regionally inflected, and by having developed a 'German' iconography, defining what Germans look like, how they walk and talk. Besides *Tatort*, there are sitcoms like *Lukas* or *Salto postale*, big city soaps like *Lindenstrasse* (Munich), *Praxis Bülowbogen* (Berlin), *Ein Bayer in Hamburg/A Bavarian in Hamburg* (Hamburg) which develop the stereotypes and the repertoire of situations, but also 'service' rural areas e.g. *Der Bergdoktor/The Mountain Doctor* (Bavaria), *Gegen den Wind/ Against the Wind* (North Sea), *Schwarzwaldklinik/Black Forest Clinic* (Swabia). Similarly, several of the prime time cop shows (*Krimis*) have distinct locations: Frankfurt (*Ein Fall für zwei/A Case for Two*), Munich (*Derrick* and *Der Alte/The Old Man*), Hamburg (*Faust* and *Der Fahnder/The Searcher*) while each *Tatort* has a different, but carefully identified location, deliberately reflecting the 'imput' of the regional broadcasting company in the nationwide ARD schedule.[15]

It is also to television that one has to turn if one wants to know what has happened to the ex-GDR and its cinema. At first glance it looks as if it has disappeared without much of a trace, since, so far, no formerly prominent East German director has made a name for him/herself in the West, with the exception of one or two actors, such as Manfred Krug, and perhaps a number of documentary film-makers, such as Helke Misselwitz. Other directors of the ex-DEFA stable have taken cover in television (e.g. Frank Beyer*, Egon Günther*). But in another sense it is perhaps precisely the black hole into which the representations and representatives of the GDR have disappeared that obliges one to take a somewhat different approach to the whole issue of German cinema/national cinema in the 1990s. If ex-DEFA directors have found a livelihood on television, they have also inherited a task: to provide a kind of 'shelter' for their audiences' own sense of difference (from the West Germans). Which is why it is possible to speak of a new cultural artefact in the making: the former GDR as a 'nostalgic' media construction. The regional TV channels set up in the so-called *Neue Bundesländer* to present the ex-GDR citizens to themselves, often via in-jokes and self-mockery, are helping to preserve the memory of certain gestures and familiar objects, habits and locations, brand-names and household goods from Communist times. As social and psychic dislocation continues after nearly a decade of unification, the need for these constructions appears to become greater rather than to diminish....

The function of television and the cinema for the former GDR-citizen is only perhaps the most prominent example of how the 'Germany of the regions' has become a 'Germany of immigrants' or at any rate, a (post-)modern, multicultural society. Within this extended, 'ethnic' definition of 'regionality', it is undoubtedly the 'Turkish' German films that are the most significant. In the wake of Tevfik Baser's *40 m² Deutschland* (1987) came the films of the younger generation: *Langer Gang/Passages* (1992, dir. Thomas Arslan); *Kalte Nächte/ Cold Nights* (1995, dir. Kadir Sözen), *Winterblume/ Winterflower* (1996,

dir. Kadir Sözen); the most recent, and, in accordance with the current formula, most commercially-minded, being *Kurz und schmerzlos/Short Sharp Shock* (1998, dir. Fatih Akin). Thomas Arslan (born 1962) has made three feature films about the situation of German-born Turks of his generation: *Mach die Musik leiser/Turn the Music down* (1994), *Geschwister/Brothers and Sisters* (1996), *Dealer* (1998).

German history, too, has become another country: there have been a remarkable number of documentaries about skinheads and neo-Nazis, plus Ray Müller's extended documentary about Leni Riefenstahl and other films about problematic 'historical' topics, though no longer in the spirit of *Vergangenheitsbewältigung* (coming to terms with the past): *Der schwarze Kasten/The Black Box* (1992, dirs. Johann Feindt, Tamara Trampe) filmed interviews with formerly imprisoned GDR dissidents; *Stau – Jetzt geht's los/Let's get started* (1992, dir. Thomas Heise) about neo-Nazis from the former GDR; *Beruf Neonazi/Occupation neo-Nazi* (1993, dir. Winfried Bonengel) a controversial interview/portrait film of an authentic case of a neo-Nazi renegade, with legal consequences for both the film-maker and the protagonist. One could also mention Andres Veiel's documentaries: *Balagan* (1993) about an Israeli group of actors and the debate surrounding their attempt to put the Holocaust experience of their parents on stage and *Die Überlebenen/The Survivors* (1996), about the identity of the 'lost' generation between the 68ers and 89ers.

Thus one could end by, as it were, doubling back. After the irony and sarcasm of the press coverage of the comedies and the commercial successes, one can return to some of these films and look at them from a different perspective: they, too, are part of *Standort* Germany perhaps still tentatively but by no means haphazardly contributing to the ethnography and topography of the newly 'united', but also once more manifoldly 'regionalised' Germany. Instead of the self-colonisation, typified by Fassbinder, Herzog and Wenders ('the Yanks have colonised our subconscious'), a cinema under the banner of '*Standort/Tatort* Germany' offers difference and detail of a kind quite distinct from that of the New German Cinema.

Once the pressure to be 'representative' of New German Cinema (and the obligation to deal with the Big Historical Themes) is off the agenda, this cinema in due course will 'represent' post-unification Germany, besides providing a record of the conditions under which it itself existed. Will it show a Germany turning into a slightly mythical, slightly clichéd country, a pastiche and parody of itself, recycling the media after-memories of its own previous incarnations?

That may not be a happy ending for all those who are 'counting buttons' about the 'life and death of German cinema', but it may not be such a bad start after all for the cinema of the 'Berlin Republic'.

Notes

1. Quoted by Eric Rentschler, 'Film der Achtziger Jahre' in Wolfgang Jacobsen, Anton Kaes, Hans Helmut Prinzler (eds), *Geschichte des Deutschen Films* (Stuttgart: Metzler) p. 285.
2. 'Wollt Ihr den Totalen Film?' ('Do you want total film?') ran the sarcastic headline (paraphrasing the notorious Goebbels mobilisation call) in *Die Zeit*, 6 June 1997, p. 43. 'The Attack of the Present on the Rest of Time' is the description coined by Alexander Kluge for the vanishing historical depth in the digital media.
3. 'Deutsch-deutsche Beziehungen' ('German-German relations') was the term initially used to refer to the mutual incomprehensions, accusations and hostilities between East Germans and West Germans in the early years after unification in 1990.
4. The Young German Cinema of the 1960s was identified with the 'Oberhausen Manifesto' (1962) and had as its slogan: 'Papa's Kino ist tot' ('daddy's cinema is dead').
5. What about Carl Schenkel, should he also be filed under Hollywood exports? See *Knight Moves* (US 1991), *Exquisite Tenderness* (US 1994).
6. Both films were said to score high on 'vomit humour' ('New German Films: No need to start snoring', *The Economist*, 14 June 1997, p. 105).
7. Andreas Kilb, 'Wollt Ihr den Totalen Film?', *Die Zeit*, 6 June 1997, p. 43.
8. Jan Schulz-Ojala, 'Neidlos bleiben, das ist die Kunst', *Der Tagesspiegel* (Berlin), 8 June 1997, p. 25.
9. 'Just the Ticket: Hollywood Changes Focus on Europe', *The Wall Street Journal Europe*, 31 Oct./1 Nov. 1997, p. 1.
10. Jacob Claussen, German producer, quoted in 'Just the Ticket', *The Wall Street Journal Europe*, 31 Oct./1 Nov. 1997, p. 6.
11. Jacob Claussen, German producer, quoted in 'Just the Ticket', *The Wall Street Journal Europe*, 31 Oct./1 Nov. 1997, p. 6.
12. What about a thriller like *14 Tage lebenslänglich/A Fortnight for Life* (dir. Roland Suso Richter)?
13. Margret Köhler, 'Ein unwirtlich Land', *Filmdienst* vol. 48, no. 2, August 1993, p. 14.
14. It has also netted a number of films: *Zahn um Zahn/A Tooth for a Tooth* (1985, dir. Hajo Gries, starr. Götz George). *Die Katze/The Cat* (1987, dir. Dominik Graf) made George a major star in the cinema also: *Der Totmacher/The Death Dealer* (1995, dir. Romuald Karmakar), *Solo für Klarinette/Solo for a Clarinet* (1998, dir. Nico Hofmann).
15. Unsurprisingly, interest in Berlin has risen since it was designated Germany's new capital. Among notable 1990s Berlin films are *Ostkreuz* (M. Klier, 1991), *Das Leben ist eine Baustelle/Life is a Building Site* (Wolfgang Becker, 1997), *Engelchen/Little Angel* (Helke Misselwitz, 1997), and *Lola Rennt/Run Lola Run* (Tom Tykwer, 1998).

PLATE 1: Hans Albers

PLATE 2: (above) DEFA production, *Berlin - Ecke Schönhauser* (1957)

PLATE 3: Rainer Werner Fassbinder

PLATE 4: Lilian Harvey

PLATE 5: *Heimat* (1938)

PLATE 6: *Heimat* (1984)

PLATE 7: Brigitte Horney

PLATE 8: Marlene Dietrich with Fritz Lang

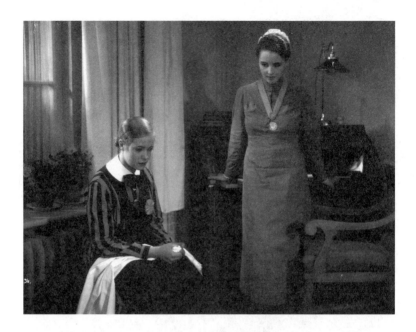

PLATE 9: (above)
Leontine Sagan's
Mädchen in Uniform
(1931)

PLATE 10: Doris Dörrie's *Männer...* (1985)

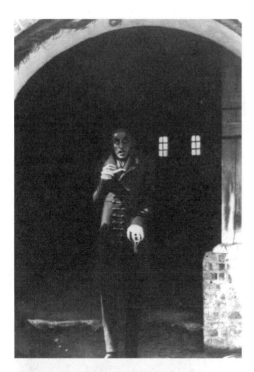

PLATE 11: F.W. Murnau's
*Nosferatu – Eine Symphonie
des Grauens* (1922)

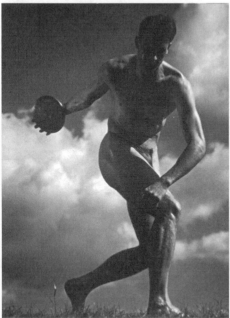

PLATE 12: *Olympia* (1938) –
directed by Leni Riefenstahl

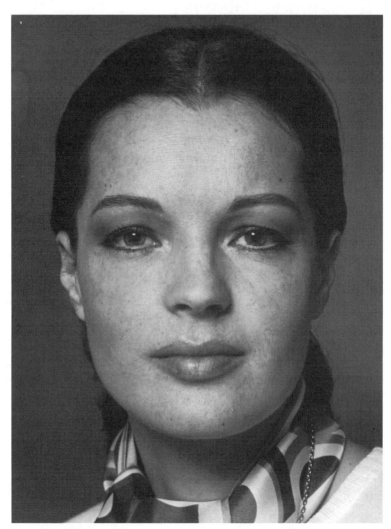

PLATE 13: Romy Schneider

A

ACHTERNBUSCH, Herbert

Herbert Schild;
Munich 1938

German director and actor. Author of a number of literary texts whose cunningly idosyncratic style and autobiographical subject matter has made him one of the most controversial avant-garde artists of the German cultural scene since the late 1960s. After studying visual art in Nuremberg and at the Academy of Fine Arts in Munich, Achternbusch made amateur short films. With *Das Andechser Gefühl/ The Andechs Feeling* 1974/75, his directing career took off, inspired by his friendship with Werner Herzog* (whose *Herz aus Glas/Heart of Glass* he co-scripted in 1976), Volker Schlöndorff* (in whose *Übernachtung in Tirol/Overnight Stay in Tyrol*, TV, 1973/74 he appeared as an actor) and, especially, Margarethe von Trotta* (who had a crucial part in his first feature film). In the 1970s and 1980s, quarrels with German public TV stations and film funding institutions have assured his often 'blasphemous' films broad media attention (*Servus Bayern*, 1977/78; *Das Gespenst/The Ghost*, 1982; *Wohin/Whither*, 1987). His work is marked by a radical, often cynical sense of humour, targeting typically Bavarian social institutions, from the Catholic church to Biergarten 'culture' (*I Know the Way to the Hofbrauhaus*, 1991), mocking the genre of the *Heimatfilm**, or obsessively exploring the satirical potential of Bavarian speech (*Mix Wix*, 1989). All his films feature himself as the lead and are based on his own literary texts. Together with work in the theatre and photography, his writing and filming are part of the same aesthetic life-project, making Achternbusch not only the 'Bavarian poète maudit and possibly the last true moralist of the German cinema' (Hans Günther Pflaum), but also something of a polemical parody of the German *Autorenfilmer*. Unafraid to take on the most controversial topics, such as the Nazi period or ethnic strife (*Heilt Hitler*, 1986; *Ich bin da, ich bin da/Here I am, Here I am*, 1992) he boldly goes where few others would venture (*Niemandsland/Nowhereland*, 1991; *Ab nach Tibet/Off to Tibet*, 1993). MW

Bib: Peter W. Jansen/Wolfram Schütte (eds), *Herbert Achternbusch* (1984); Thomas Elsaesser, 'Achternbusch and the German Avantgarde, *Discourse* 6 (1983).

ADORF, Mario

Zurich 1930

Swiss-born actor whose imposing stature and clear-cut features lent themselves to a wide range of (stereo)types in national (German and Italian) and international productions. After a brief debut appearance

in Joe May's* *08/15* (3 parts, 1955), Adorf's breakthrough came with his convincingly traumatised mass murderer in Robert Siodmak's* *Nachts, wenn der Teufel kam/The Devil Strikes at Night* (1957). Primarily typecast as a villain, he confirmed his talent for projecting inner conflict as the sensitive male in *Am Tag als der Regen kam/The Day the Rains Came* (1959). 'Rediscovered' in the 1970s, he became one of the New German Cinema's* most acclaimed actors in Volker Schlöndorff* and Margarethe von Trotta's* *Die verlorene Ehre der Katharina Blum/The Lost Honour of Katharina Blum* (1975), Schlöndorff's Oscar-winning *Die Blechtrommel/The Tin Drum* (1980) and R. W. Fassbinder's* *Lola* (1981). Adorf returned to one-dimensional villains in European co-productions, before settling for German television drama's favourite father figure. KU

Bib: Meinholf Zurhorst and Heiko R. Blum, *Mario Adorf: Seine Filme – Sein Leben* (1992).

Other Films Include: *Das Totenschiff* (1959); *Winnetou I* (1963); *Major Dundee* (1965, US); *Ganovenehre* (1966); *Fedora* (1978); *Rossini, oder die mörderische Frage, wer mit wem schlief/Rossini* (1997).

ALBERS, Hans
Hamburg 1891 – Tutzing, Munich 1960

German actor, the most popular and best-paid male star of his generation. Originally a vaudeville dancer, singer and comedian, he played minor film roles as shady seducer or charming rake, rising to stardom in *Die Nacht gehört uns/The Night Belongs to Us* (1929) and *Der blaue Engel/The Blue Angel* (1930). Despite Goebbels' disapproval of him, Albers maintained his pre-eminence in movies ranging from costume comedies (*Münchhausen*, 1943) to Westerns (*Wasser für Canitoga/Water for Canitoga*, 1939), and detective stories (*Der Mann, der Sherlock Holmes war/The Man Who Was Sherlock Holmes*, 1937), playing daredevils with a mission (*Flüchtlinge/Refugees*, 1933) and melancholy heroes with broken dreams (*Große Freiheit Nr.7/Port of Freedom*, 1944; banned in Nazi Germany). Even with advancing age, Albers' light-hearted version of (Hanseatic) machismo was unremittingly cast in romantic narratives (*Auf der Reeperbahn nachts um halb eins/On the Reeperbahn at Half Past Midnight*, 1954, *Das Herz von St. Pauli/The Heart of St Pauli*, 1957), while his acting increasingly focused on his characteristically hoarse voice. Albers' uniquely enduring appeal as the archetypal blue-eyed, blond male sex symbol continues to resonate in the nation's popular culture. KU/TE

Other Films Include: *Asphalt* (1929); *Bomben auf Monte Carlo/Monte Carlo Madness* (1931); *F.P.1 antwortet nicht* (1932).

18

ALEXANDER, Peter

Peter Alexander Neumayer;
Vienna 1926

Austrian actor with a solid career as a singer and stage comedian in radio shows from 1948 onwards. In the early 1950s Alexander played minor film roles before landing the lead part of a pop singer in *Verliebte Leute* (1954), a 'Viennese' comedy. After appearing in two German films with Caterina Valente – *Liebe, Tanz und 1000 Schlager* (1955) and *Bonjour Kathrin* (1955) – he became the undisputed star of the *Schlagerfilme* (pop musicals) with a 'boy-next-door' image to which he added, in the 1960s, cabaret-type parody (*Kriminaltango*, 1960). After operetta adaptations (such as the Austrian-French co-production *Die lustige Witwe/La Veuve joyeuse*, 1962), comedy classics (*Schwejk's Flegeljahre*, 1964) and the popular 'Pauker' and 'Lümmel' series (for instance *Hurra, die Schule brennt*, 1969), Alexander has weathered well as a television host and popular stage actor. KU

Bib: Peter Lanz, *Peter Alexander: Ein Leben für die Musik* (1986).

Other Films Include: *Verlorene Melodie* (1952); *Wehe, wenn sie losgelassen* (1958); *Die Abenteuer des Grafen Bobby* (1961); *Die Fledermaus* (1962).

ALLGEIER, Sepp

Freiburg 1895–1968

German cameraman, who cut his teeth on newsreels and expedition films for the Welt-Kinematograph company in 1918. A year later he became chief cameraman on Arnold Fanck's* mountain films [> HEIMATFILM]. His special skills included shooting atmospheric, static landscapes and photographing athletes, which won him not only a wide audience but high praise in the profession. Cameramen such as R. Angst, A. Benitz, K. Neubert and H. Schneeberger learned their trade from Allgeier, who also worked on British productions and was crucial to Leni Riefenstahl's* Nazi Party films. In the 1950s, the television network Südwestfunk employed Allgeier as chief director of photography. TE/SG

Other Films Include: *Der Berg des Schicksals* (1924), *Alpentragödie, Im Luxuszug* (1927); *Frau Sorge* (1928); *Das Tagebuch einer Verlorenen/Diary of a Lost Girl, Die weiße Hölle vom Piz Palü* (1929); *Baroud/Lost in Morocco* (1932, UK); *Der Sieg des Glaubens/Victory of Faith* (1933); *Triumph des Willens/Triumph of the Will, Escape Me Never* [UK], *Friesennot* (1935); *The Great Barrier* (1937, UK); *Der Feldzug in Polen* (1940); *Wetterleuchten um Barbara* (1941).

AMERICAN FILMS IN GERMANY

Received wisdom has it that the American film industry has enjoyed a dominant market position in Germany since the late 1910s, supposedly based on the fact that American films equalled or outnumbered German films released in Germany at any given time since the end of World War I. However, box-office statistics, rather than number of releases or censorship figures, give a different picture. Statistics from 1925 to 1932 and from 1950 to the present indicate that the fortunes of American films in Germany can be divided into just two phases: before and after 1971. Up to this time, German audiences preferred German-made films, with American films taking only a limited share of the market. By contrast, during the 1970s, demand for American films grew so rapidly that they all but wiped out German films from the domestic market.

Phase I: From 1925 to 1971, the German film industry established its national conventions, based on indigenous theatrical, musical and literary traditions, on German versions of European novels or biblical stories and relying on a well-established system of European stars. Outstanding commercial successes such as *Love* (1928/29), *The Last Command* (1928/29), *Conquest* (1950/51), *Ben Hur* (1926/27, 1927/28, 1960/61) shared these conventions, whereas other Hollywood genres (e.g. westerns and musicals) were not popular in Germany.

Given the public's preference for German films, American initiatives for gaining a foothold failed. Even the attempt by Paramount and Metro-Goldwyn to conquer the German market in 1925 through the Parufamet agreement was short-lived [> UFA]. Only by using their post-1945 leverage did the major American companies in the 1950s and 1960s succeed in making Germany their most lucrative export market, forming a cartel (the Motion Picture Export Association Inc. (MPEA)) which had the financial and diplomatic backing of the federal Informational Media Guaranty Program (IMG). By and large, however, as long as there was a family audience for the cinema, the German public's preference for German films remained unchanged.

Phase II: The period after 1971 witnessed a dramatic growth in the popularity of American films, dramatically reducing the box-office share of German-made films. The rise of television and the consequently lower age of film audiences (by 1965 more than 70% of film audiences were under 30) undoubtedly played a role. In West Germany as elsewhere, 'American values' such as adventure, individualism, anti-authoritarian emancipation began to win out over self-sacrifice, sense of duty, social responsibility. The cultural icons of pop music, convenience foods and clothing began to represent forms of self-fulfilment already popular in the USA and Britain.

Since the 1970s, the commercially most successful genre, especially with male teenagers, has been the 'adventure-spectacle film', in which a male super-hero, pursuing personal goals, performs spectacular physical feats. While Great Britain, France and Italy did supply such films (the James Bond series, Jean-Paul Belmondo films,

Bud Spencer and/or Terence Hill films), German cinema (perhaps for understandable historical reasons) featured no such *Übermenschen*, and it was the American film industry that proved particularly apt at filling the gap (e.g. the Rambo, Terminator and Indiana Jones series).

Various strategies were developed from the end of the 1950s to combat the rising popularity of American films and of television [> EXHIBITION]. They included international co-productions, production series aimed at teenagers [> GERMANY II: POPULAR GENRES: SERIES AND SERIALS] and films featuring taboo subjects [> GERMANY II: POPULAR GENRES: SEX FILMS]. When the two largest German distributors, Gloria* and Constantin*, began to founder economically in the 1970s, the victory of the Hollywood blockbuster seemed irreversible. In the 1980s, the German film industry settled for a market niche, either as a minority art-cinema [> NEW GERMAN CINEMA] or by producing mainstream star vehicles such as *Die Supernasen* (1983) and *Die Supernasen tanken Super* (1984) as well as a few films that adopted the new 'American' conventions, such as *Theo gegen den Rest der Welt* (1980) and *Die unendliche Geschichte* (1984). After the international success of *Das Boot* (1982), the most successful talents of German genre cinema (Wolfgang Petersen*, Roland Emmerich*, Michael Ballhaus*) found their way to Hollywood, aided by the strategic skills of producer Bernd Eichinger*. After unification in 1990, the supply of German genre films has once more expanded, even gaining back a respectable market share since 1996, without, however, seriously threatening the hold that major American releases have on the multiplex box-office. JG/TE

Bib: Thomas J. Saunders, *Hollyood in Berlin: American Cinema and Weimar Germany* (1994); Joseph Garncarz, 'Hollywood in Germany. The Role of American Films in Germany: 1925–1990', in D. Ellwood/ R. Kroes (eds), *Hollywood in Europe* (1994).

ANTEL, Franz François Legrand; Vienna 1913

Austrian director and producer. Antel started out in the 1930s as production supervisor at Wien-Film, working with directors such as E. W. Emo and Arthur Maria Rabenalt*. He directed his first feature, *Das singende Haus*, in 1948. From the 1950s onwards his films were hugely popular, among them classics such as *Hallo Dienstmann* (1952), starring Hans Moser* and Paul Hörbiger*, *Spionage* (1955), and the remake of Erik Charell's *Der Kongress tanzt/The Congress Dances* (1955). The decline of the Austrian film industry in the 1960s obliged Antel to work with German and Italian producers. He turned to recycling some of his own works, directing (very) light comedies and soft-porn movies, such as the

Wirtinnen series (1967–73). A craftsman who saw his task as entertaining a mass audience, Antel was criticised for making 'superficial' and overtly commercial films. But *Der Bockerer* (1981) revealed the other side of his populism: set in the period of the *Anschluss* (1938–45), the film is a telling portrait of the era, centred on a character who resists Nazism with a mixture of stubbornness, humour and sarcasm. IR

Bib: Franz Antel, *Großaufnahme. Mein verdrehtes, verliebtes Leben* (1988).

Other Films Include: *Der alte Sünder* (1951); *Lumpazivagabundus* (1956); *Liebesgrüße aus Tirol* (1964); *Außer Rand und Band am Wolfgangsee* (1971, Aust./Ger.); *Die lustigen Vier von der Tankstelle* (1972, Aust./Ger.); *Casanova u. Co./Treize femmes pour Casanova/ Casanova e C.ia* (1977, Aust./Ger./Fr./It.).

ARBEITERFILME

German film 'genre' (meaning 'Proletarian films'). In 1922 the distribution of Soviet proletarian films in Germany caused a demand among leftist intellectuals such as Béla Balázs* for an alternative to the dominant capitalist film ideology promoted by Ufa*. The successful German release of S. M. Eisenstein's *Bronenosets Potëmkin/The Battleship Potemkin* in 1926 provided further ammunition. Between 1926 and 1931, the Prometheus Film company produced powerful fiction films with a revolutionary perspective, attracting substantial critical and popular acclaim; titles include *Eins + Eins = Drei* (Béla Balázs*, 1927), and two classics, *Mutter Krausens Fahrt ins Glück/Mother Krause's Journey to Happiness* (Piel Jutzi, 1929 [> STRASSENFILME]) and *Kuhle Wampe oder Wem gehört die Welt?/Kuhle Wampe* (Bertolt Brecht/Slatan Dudow, 1932), which demonstrate the class aspect of social conflicts through a critical use of documentary material and distancing intertitles. The cultural heritage of the proletarian film was taken up in the mid-1950s in the GDR, beginning with Dudow's *Stärker als die Nacht/Stronger than the Night* (1954). In the Federal Republic, some films by, among others, Rainer Werner Fassbinder*, Christian Ziewer* and Helke Sander* represented a reworking of the realist aesthetics of the *Arbeiterfilm* tradition in the context of television genres such as soap opera or semi-documentary. MW

Bib: Bruce Murray, *Film and the German Left in the Weimar Republic: From Caligari to Kuhle Wampe* (1981).

ARCHIVES (AUSTRIA)

The *Österreichisches Filmarchiv* (Austrian Film Archive) in Vienna was inaugurated in 1954 as a parent organisation of several institutions and associations. It preserves and restores mostly Austrian films (e.g., early cinema, newsreels etc.) as well as other film-historical documents, and regularly publishes monographs and reports. The *Österreichisches Filmmuseum* (Austrian Film Museum) was founded in Vienna in 1964. It holds a collection of films and is the venue for 'Unsichtbares Kino' ('Invisible Cinema'), designed by Peter Kubelka*. The Film Museum and the Film Archive each have a small library, open to the public. IR

Bib: Michael Omasta, 'Zum Thema Forschen über den österreichischen Film', in Francesco Bono (ed.), *Austria (In)Felix* (1992).

ARCHIVES (GERMANY)

The first German film archive, the *Reichsfilmarchiv*, was opened on 14 Feburary, 1935. In July 1938 it was integrated into the film department of the 'Ministry of Popular Enlightenment and Propaganda'. Film producers were obliged to deposit a copy (not the negative) of all films passed by the censor [> CENSORSHIP]. The holdings of foreign films were enlarged by way of war booty. In 1942/43 the archive held 29,000 films, 3,500 of which were feature-length sound movies (mostly fiction films). After World War II, the *Reichsfilmarchiv* was dissolved and the diminished stock was distributed between the Allies and mostly shipped to the USA or the Soviet Union. In the 1950s and 1960s some of these films were returned to either West Germany's *Bundesarchiv/ Filmarchiv* and/or the *Staatliches Filmarchiv der DDR* (the state archive of the German Democratic Republic). But due to West Germany's decentralised federal structure, no single, central film archive has emerged, with a number of institutions competing with each other.

One of these, the *Bundesarchiv/Filmarchiv* was set up in Koblenz in 1954, originally with the aim of collecting documentary films for the historical record. From 1962 the archive received copies of films financed by national film foundations, and since 1974, copies of all federally-funded films have been deposited there. The archive began to collect and preserve source materials of older German feature films in 1969. In December 1978, the tasks of all German archives were reallocated under the auspices of the *Kinemathekenverbund* (Association of German Cinematheques). The *Bundesarchiv*, functioning as a central German film archive, now preserves all films produced in Germany since 1895 (as opposed to other archives specialising in 'culturally valuable' films). After unification in 1990, the *Staatliches Filmarchiv der DDR* (GDR) merged with the *Bundesarchiv*

(3 October, 1990). The *Staatliches Filmarchiv*, founded in 1955, had been the largest German film archive, since it required that a copy of all films made in the former East Germany be deposited there. Two thirds of its original collection now make up the *Bundesarchiv's* stock, which contains 141,500 titles (114,000 documentary films, 27,500 feature films).

One consequence of the division of labour agreements among the archives has been that tasks such as non-commercial film distribution, the preservation of foreign film stock, the collection of primary and secondary film-historical sources, the publication of film-historical work and the organisation of viewings and exhibitions, are now shared between the various archives.

The *Deutsches Institut für Filmkunde* in Frankfurt/M., founded in 1947 as the 'Archiv für Filmwissenschaft', mainly collects secondary sources, such as books, magazines, newspaper clippings, press and advertising materials, film scripts, dialogue listings, posters, photographs, programmes, registration of film companies, censorship decisions of the 'Freiwillige Selbstkontrolle der Filmwirtschaft' (FSK) [> CENSORSHIP]. Since 1962, the film archive department in Wiesbaden has collected important films (stock: roughly 5,000 titles) and since 1980 it has organised film viewings in the archive's cinema. Furthermore, it is the archive's non-commercial task to distribute the films in stock at the Friedrich-Wilhelm-Murnau-Stiftung (i.e. films of former nationally-owned film companies).

The *Stiftung Deutsche Kinemathek* (SDK) in Berlin was founded in 1971, taking over the 'Deutsche Kinemathek e.V.' (1963), formed to house Gerhard Lamprecht's and Albert Fidelius' private collections. The film archive holds about 8,000 important German and foreign films. Furthermore, the SDK collects secondary materials (scripts, photographs, posters, censorship cards, programmes, press and advertising materials, documents for film architecture [i.e. sketches, designs, models], technical machines, costumes and props). Furthermore, the SDK has acquired several estates (such as those of William Dieterle, Werner Krauß, Paul Kohner, Marlene Dietrich, Fritz Lang). The foundation's publishing activities are numerous: books on Asta Nielsen, Henny Porten, Guido Seeber, Ernst Lubitsch, Erich Pommer, as well as regular journals: 'Film und Fernsehen in Forschung und Lehre', 'FilmExil', 'SDK Newsletter/Filmgeschichte'). Since 1977 the SDK has also been in charge of the Berlin Film Festival's annual retrospective, producing lavish catalogues.

The *Munich Filmmuseum* was established in 1963 as part of the municipal museum. Its main aim is to collect historically important films and exhibit these in the archive's cinema (series on directors, actors, significant periods of national film production). The Munich Film Museum holds about 1,200 historically notable films: copies of new German films [> NEW GERMAN CINEMA] funded by the 'Kuratorium junger deutscher Film' were deposited here, together with a collection of classic Soviet silent films. Enno Patalas (director from 1973 to 1994)

supervised internationally acclaimed reconstructions of German classics from the 1920s and early 1930s, such as *Der müde Tod/Destiny* (1921), *Nosferatu* (1922), *Die Nibelungen* (1924), *Metropolis* (1926) and *M* (1931).

The *Deutsche Filmmuseum* in Frankfurt (M.), opened in 1984, is based on a private archive, the 'Archiv für Filmkunde Paul Sauerlaender'. It has a film museum, a film archive and a cinema, owns several company archives (e.g. Artur Brauner's CCC) and publishes monographs relating to in-house exhibitions (i.e. Artur Brauner and West German postwar film).

The *Filminstitut der Landeshauptstadt Düsseldorf* was founded in 1979 (its predecessor was the municipal cinema Filmforum, founded in 1970). The institute collects secondary materials (scripts, props, machines), holds parts of Helmut Käutner's and Harry Piel's collection of papers and has owned film copies since 1982. Since 1984 it has had its own cinema and since 1993 its own museum. JG

Bib: Hans Günther Pflaum and Hans Helmut Prinzler, *Film in der Bundesrepublik Deutschland* (1992, 2nd ed.)

ARNHEIM, Rudolf Berlin 1904

German film theorist. One of the most prominent exponents of the anti-realist tendency in film aesthetics, Arnheim saw film less as an optical-mechanical reproduction process than as an autonomous art form translating reality into significant forms (colour, shape, size, density, brightness), through which all human perception of natural phenomena takes place. While still a psychology student, he became a member of the editorial board of *Die Weltbühne* in the late 1920s, in which the seventy articles at the core of his 1932 *Film als Kunst* (in English: *Film*, 1933) first appeared, forming the basis of his theory of the cinema. In August 1933, after the book was banned by the Nazi authorities, Arnheim left Germany for Italy and eventually emigrated to the US. Though film was no longer at the centre of his interests, he frequently reaffirmed his belief in his earlier ideas. First at Harvard, then at Ann Arbor, he has remained a prolific writer on aesthetics (*Art and Visual Perception*, 1954; *Visual Thinking*, 1969; *The Power of the Center: A Study in Composition of the Visual Arts*, 1982). MW

Bib: Dudley Andrew, *The Major Film Theories: An Introduction* (1976).

AUSTRIA

Film historians usually like to point out that Austria is not a film-producing nation, and – its cinema being no exception – that Austria's

fate has been to be overshadowed by Germany, the powerful neighbour to the north. But there are at least three salient facts that complicate this apparently self-evident assessment. First, since the early 1960s Austria has developed a very distinctive cinematic voice – principally in the area of experimental and avant-garde cinema associated with Peter Kubelka*, Kurt Kren, Peter Weibel and Valie Export*, but since the mid-1970s also in the form of an *auteur* cinema of at least half a dozen internationally recognised directors, among them Franz Novotny*, Peter Patzak*, Niki List* and Michael Haneke*. Second, Austria has, almost since the beginnings of the cinema, nurtured an indigenous 'commercial' production sector. Associated with names like Luise Kolm, Count Sascha Kolowrat, Willi Forst*, Hans Moser* and Paula Wessely*, it may have been comparatively small (1,009 silent films between 1907 and 1930, with an average of 120 films a year during the peak years 1918–22; 197 sound films between 1930 and 1945, averaging twenty-four films a year during the peak years 1933–37). Nonetheless, this production amounted to a distinct cinematic tradition, boasting a special kind of continuity in its themes and genres over a lengthy period. Finally, there is the matter of 'colonisation'. In so far as Austria was perceived by distributors as a mere annexe to the German market, it may seem that much of Austrian cinema happened in Germany. But the inverse is equally true, for much of the most popular German cinema since the 1920s has come from directors and stars 'made in Austria' and the Austro-Hungarian empire. The Austrians may have been seeing 'German' films, but very many of them had Austrian personnel. The list is endless: Joe May*, Sándor (Alexander) Korda*, Mihály Kertész (Michael Curtiz), Fritz Lang*, G. W. Pabst*, Richard Oswald*, Karl Grune, Carl Mayer*, Ferenc Feher, Geza von Bolvary*, Geza von Cziffra*, Peter Lorre*, Marika Rökk*, Rudolf Forster*, Fritz Kortner*, Jenny Jugo*, Käthe von Nagy, to name a few. But the 'talent drain' from Budapest to Vienna, and from Vienna to Berlin, did not stop there. The impressively versatile German 'invasion' of Hollywood in the 1930s was made up of many who had originated from Austria: directors Otto Preminger, Billy Wilder, Fred Zinnemann, Walter Reisch; actors Oskar Homolka, Alexander von Granach, Bertold Viertel, Paul Henreid, Hedy Lamarr; musicians Max Steiner, Hugo Riesenfeld, Robert Stolz and many more. It is said that in the making of *Casablanca* no fewer than twenty Austro-Hungarians were involved.

Thus the distinctive voice of Austrian cinema until 1945 has to be sought along the creative axis Vienna-Berlin-Hollywood, with an additional twist, namely that both in Germany and in Hollywood these adventurers and émigrés significantly contributed to a mythical Vienna (of Austro-Hungarian decadence), made for export, and consisting of Vienna waltzes, Emperor Franz Josef court intrigues, the Prater amusement gardens, charming but penniless aristocrats, and the epitome of seductive naiveté, the '*Wiener Mädl*' (the 'Viennese girl'). This myth was serviced by Austrian stars and directors, but even more

so – indicating its imaginary pull – by barely native directors such as Erich von Stroheim (whose parents emigrated in 1909) and Joseph von Sternberg (who left in 1914), and altogether non-natives such as Ernst Lubitsch* (from his Prince Nukki in *Die Austernprinzessin/The Oyster Princess* in 1919, to *The Smiling Lieutenant* in 1931), Max Ophuls* (*Liebelei*, 1933, *Letter from an Unknown Woman*, 1948) and Ludwig Berger* (*Ein Walzertraum/The Waltz Dream*, 1925).

1896–1918: Austria had its own generation of pioneers who, characteristically, excelled not so much in the technical field as in understanding the nature of popular entertainment, spanning curio-cabinets and vaudeville shows at one end of the social scale, and operetta and boulevard theatre at the other. However, it was the French Cinematograph that brought moving pictures to Vienna (first showing: 27 March 1896), thanks to Eugène Dupont, the Austrian representative of Lumière. The close connection with France persisted for the first indigenous productions, by Louis Veltée, who in the summer of 1896 began showing films at his waxworks museum housed in the so-called 'City-panoptikum'. One of Veltée's daughters, Luise, married Anton Kolm, a photographer, and in 1908 the Kolms, together with an assistant, Jakob Fleck, and a relative, Claudius Veltée, inaugurated Austrian feature film production with *Von Stufe zu Stufe* (1908). The film, 600m long, was produced by Anton Kolm, scripted and edited by Heinz Hanus and Luise Kolm, with camerawork by Jakob Fleck and direction by Hanus, who also played the male lead, a raffish count who seduces and then abandons a young ingénue. Thus the first Austrian fiction film already set the pattern for one of the dominant genres, and the Wiener Kunstfilm-Industrie (a typical family firm, founded by the Kolms and Jakob Fleck) took the lead in Austrian documentary and feature film productions. It is notable that one of Austria's pioneers should be a woman, for Luise Kolm not only produced, scripted and edited, she also directed (*Der Unbekannte*, 1912).

Drawing on the ethnic diversity of its empire, and the mostly comic genres of popular performance arts, Austrian cinema in the 1910s derived its energy if not its identity from adaptations of fairground attractions, peasant farces and passion plays, while also pioneering *actualités*. Early Austrian cinema also produced an entrepreneur of genius, Count Alexander Kolowrat-Krakowsky, who in 1910 founded his first film company, which, in 1914, became Sascha-Film, Vienna. Until his death in 1927 the 'film count', as he was known, headed Austria's most important production company, not least by gambling on super-productions and attracting talent from the other arts. For just like France and Germany, Austria had its *film d'art* debate around the cinema's competition with the stage for middle-class audiences, which was won in 1913 when several noted Austrian authors began writing original screenplays: Arthur Schnitzler, Egon Friedell, Hugo von Hofmannsthal, Felix Dörmann. 1913 also saw the first example of another Austrian speciality, the operetta film as musical biography:

Johann Strauß an der schönen blauen Donau/Johann Strauss and the Blue Danube. By 1915 Vienna had 150 movie theatres, while Sascha-Film stabilised its economic basis with newsreels and patriotic films, trying, after the war, to expand into the world market by following the examples of Italian and American epics and spectaculars.

1918–1933: The Hungarians Sándor (Alexander) Korda and Mihély Kertész (Michael Curtiz) were the most active film-makers after 1918. Korda made six films for Sascha-Film between 1919 and 1924 (among them *Samson und Delila*, 1922). Kertész made fifteen films between 1919 and 1926 (including international box-office hits such as *Das sechste Gebot/The Sixth Commandment*, 1923, and *Die Sklavenkönigin/The Queen of the Slaves*, 1924). Two other Austro-Hungarians destined for a career elsewhere, the Czech Gustav Ucicky* and the Hungarian Ferenc Feher, also worked successfully in Vienna during the 1920s. By the end of the silent era, however, the film industry had become heavily dependent on German distribution, with some German directors preferring (the lower production costs of) Vienna. Robert Wiene, for instance, made *Orlacs Hände/The Hands of Orlac* there in 1924.

In the transition to sound, Sascha-Film was bought out by the German Tobis. Austrian film production peaked in the early 1930s, for with sound films 'Austria' could become a distinctive cinematic and aural signifier, not least because of the pleasingly lilting Viennese accent, cultivated by armies of highly trained stage actors from the Burgtheater and the Theater an der Josephstadt. The result was the so-called 'Viennese film', a genre of erotic melodrama in operetta night-life settings, told in a tone of resigned irony, and most supremely embodied in the films of Willy Forst*, whose decorative opulence as a director was perfectly matched by his world-weary elegance as an actor (*Maskerade/Masquerade in Vienna*, 1934; *Bel Ami*, 1938; *Operette*, 1940). Austria excelled in musical biopics (such as *Leise flehen meine Lieder*, 1933), and cornered the market in other sub-genres of musical entertainment films, such as ice-skating revue films and especially operetta. On the one hand, well-known operas by the likes of Franz Léhar, Nikolaus Dostal, Robert Stolz and Emerich Kalman were adapted; on the other hand, attempts were made to give operetta a new life through film, with music specially composed for the cinema. The popularity of singers such as Richard Tauber, Jan Kiepura and Martha Eggert enlivened the genre. Others, whose range was not sufficient for musical theatre (such as Joseph Schmidt), found a perfect medium in sound film. Austrian productions of the 1930s and early 1940s were often quality investments, with stars like Paula Wessely* earning huge salaries, and Ernst Marischka* (and his brother Hubert) breathing life into costume and *Heimat** films, which were to retain their popularity well into the 1950s. While the Viennese element was crucial for the Nazi entertainment cinema, there was no Austrian cinema strictly speaking between 1938 and 1945, since after

28

the 1938 *Anschluss* Austrian production companies were amalgamated into the Wien-Film company, at first majority-owned by Tobis, and in turn absorbed by the Ufa* holding company when Goebbels 'nationalised' the German film industry in 1941.

1945–1964: In its artistic personnel and generic identity, Austrian commercial cinema cannot be said to have experienced a 'zero hour', as did Germany, in 1945. Yet the country's administrative division into Allied zones, splitting Vienna's traditional film-making sites between them until 1955, may well have contributed to the decline of indigenous studios, increasingly hired out to foreign productions (from Carol Reed's *The Third Man*, 1949, to Robert Wise's *The Sound of Music*, 1965). At the same time Austria continued to provide the stars and stories that Germany wanted: Nadja Tiller*, Oskar Werner*, Maria Schell*, Helmut Berger were all headed for careers outside Austria, and after creating with Magda and Romy Schneider* the ideal on-screen, off-screen mother-daughter pair, Marischka made an international superstar out of Romy Schneider with the hugely successful *Sissi* trilogy (1955–57), skilfully presenting every conceivable Austrian national cliché and thus mightily reviving the country's much-needed tourist industry.

Alongside this cinema for Euro-export, the first shoots of a new independent cinema emerged. Kurt Steinwendner's *Der Rabe/The Raven* (1951), Herbert Vesely's *Nicht mehr fliehen/Flee No More* (1955) and Edwin Zbonek's *Erschießungsbefehl/Execution Order* (1962) announced a formally and thematically more individual cinema, but what shaped the image of Austrian cinema in the 1960s came from an iconoclastic, non-narrative film avant-garde.

1965–1995: The famous Austrian experimental school emerged in total opposition to the commercial film industry. Partly because the movement's intellectual and artistic core had affinities with modern painting ('tachism'), Austrian literary and art school avant-gardes (Wiener Aktionismus), as well as links with the American 'expanded cinema', its radicalism was quite different from that of other European 'young' cinemas and New Waves of the 1960s. Austrian experimental cinema divides into an abstract-formalist wing (most pronounced in the work of Peter Kubelka* and Ferry Radax) and a politically interventionist grouping around Kurt Kren, Günther Brus and Otto Muehl, who came out of the 'fluxus' movement and 'happening' aesthetics, scandalising the public with provocative, often pornographic and scatological body-centred action pieces. The common denominator was an angry antagonism to postwar Austrian society and the Austrian state apparatus, castigated as corrupt, hypocritical and mired in its fascist past. Altogether wittier and more playful, but no less bitingly satirical, were the films of Valie Export* (often made with her then partner Peter Weibel), whose features *Unsichtbare Gegner/Invisible Adversaries* (1978) and *Die Praxis der Liebe/The Practice of Love* (1984) have become classics of international women's cinema.

29

By the time some of the protagonists of Vienna actionism, rather than face prosecution and prison, had chosen to emigrate to Germany (where they called themselves 'the Austrian government in exile'), another generation of film-makers had come to the fore, whose films were characterised by a more latent violence. The 'New Austrian cinema' of Franz Novotny* and Peter Patzak* focused on their country's troubled relation to its fascist past as it reverberated in psychologically-damaged individuals. Films depicted an urban underclass at odds with the values but also deprived of the benefits of the prosperous Austrian 'Second Republic' (Novotny's *Die Ausgesperrten/ Locked Out*, 1982), or they went to the countryside, where the Alpine idylls of summer tourists and skiing instructors peel away to reveal still-lifes of brutalising everyday existence in the provinces, as traditional peasant structures make way for Mafia-like agri-business and political wheeler-dealing (Christian Berger's *Raffl*, 1984). Some combined the Nazi past with the provincial theme, such as Wolfram Paulus'* *Heidenlöcher* (1985). A key term of this cinema is '*abreagieren*' (giving vent to frustration), encompassing violence within the petit-bourgeois family, silent rages and sexual humiliations, a culture of resentment that leads to racism, xenophobia and anti-semitic aggression: phenomena which have marred official Austria's liberal self-image and are skilfully worked into the popular genre films of Patzak, such as *Kassbach* (1979). Where these concerns are more stylised and formally controlled, as in Michael Haneke's* work (*Der siebente Kontinent/The Seventh Continent*, 1989; *Benny's Video*, 1992), the films attain an intense, claustrophobic intimacy that has impressed festival juries and foreign audiences.

Austrian cinema in the 1990s exists, as in so many other European countries, thanks to a network of legal provisions and funding systems, including especially the Österreichisches Filmförderungsgesetz (ÖFG) (Austrian Film Funding Law), in force since 1981 and amended in 1987 and 1993, which regulates subsidies to Austrian films. While this funding authority is obliged to take into consideration a project's commercial potential as well as its artistic and cultural value, the Filmbeirat at the Ministry for Education and Arts promotes art and experimental films. In addition, the City Council of Vienna has had its own fund since 1976 to subsidise foreign productions using Vienna locations, personnel or service industries, and since 1981 the Film-Fernseh-Abkommen (Film and Television Agreement) defines the co-operation between Austria's national broadcasting company ORF and the Austrian Film Institute, thereby confirming ORF's role as the most important commissioner of Austrian films. While these measures relaunched national production in the 1980s and form the basis of the survival of an *auteur* cinema, commentators have voiced their doubts about this occasional oxygen boost. But television, the obvious alternative, is no less problematic to those believing in the cinema, so that the inevitable co-productions have had a mixed response, except for the so-called 'New *Heimatfilm*'* which has brought forth some re-

markable television series, especially Austria's anticipation of Edgar Reitz's* *Heimat*, the family chronicle *Alpensaga* (1976–80), with camerawork by Xaver Schwarzenberger*, one of R. W. Fassbinder's* preferred cinematographers and a leading Austrian director. Whatever the balance will be between *auteur* cinema and television, one fact seems certain: the Austrian cinema is unlikely in the near future to be overshadowed by the German cinema, in comparison to which it appears vibrant and full of promise. TE

AUTORENFILM

I – Generic term, denoting, in the period just before World War I [> WILHELMINE CINEMA], a film drama made with reference to well-known figures of the German literary and theatrical scene, either because of the direct participation of writers and stage actors, or indirectly, in the form of literary adaptations [> LITERATURVERFILMUNGEN]. In 1908, the director Heinrich Bolten-Baeckers founded the Society for the Utilisation of Literary Ideas for Cinematographic Purposes, inspired by Pathé's French *films d'art* which entered the German market the same year. However, it was not until 1912/13 that the first German *Autorenfilme* were released. The years in between saw a bitter campaign against the cinema, waged by theatrical institutions which made the new medium responsible for the economic crisis in German theatres, culminating in May 1912 with an agreement to boycott the cinema and to prevent theatre actors from working in the cinema. The agreement was signed by the professional organisations 'Verband Deutscher Bühnenschriftsteller' (authors), 'Deutscher Bühnenverein' (directors) and 'Genossenschaft Deutscher Bühnenangehöriger' (actors).

Despite this institutional boycott, negotiations between the major production companies [> PRODUCTION] and single artists continued, resulting in an unexpected reversal of the situation in November 1912, when the Danish company Nordisk, which had been producing authors' films (so-called 'forfatterfilm') for the Danish public since 1910, announced future collaboration with such prominent writers as Gerhart Hauptmann, Arthur Schnitzler, Hugo v. Hofmannsthal, Felix Salten and Jacob Wassermann, among others. In a parallel move, PAGU* signed an exclusive contract with the 'Verband Deutscher Bühnenschriftsteller' and founded a joint distribution company. It was Vitascope, however, that released the first German Autorenfilm of the season: *Der Andere*, directed by Max Mack* and premiered in January 1913, was based on a screenplay by Paul Lindau and starred the famous stage actor Albert Bassermann (Mannheim, 1867 – Atlantic Ocean, 1952). While Vitascope continued to work with Bassermann and Mack (who with *Wo ist Coletti?* [1913] also made the first comic detective film scripted by a well-known writer, Franz von Schönthan), several other film companies contributed to this genre in the following

two years: The Deutsche Bioscop contracted the hugely successful writer Hanns Heinz Ewers*, the stage actors Paul Wegener*, Grete Berger and Alexander Moissi, resulting in films like *Der Student von Prag* (1913), *Das schwarze Los* (1913), and *Die Augen des Ole Brandis* (1914). Paul Davidson's* PAGU* had assured itself of the collaboration with Germany's leading theatre director, Max Reinhardt*. Initially contracted to making four films each year up to 1916, Reinhardt was finally responsible for only two films made in 1913, *Die Insel der Seligen* and *Die venezianische Nacht*. Messter Film* made three films based on works by Richard Voss, and Continental* produced a series of screenplays by Heinrich Lautensack. In close collaboration with the authors, Nordisk achieved considerable success in the German market with adaptations of Hauptmann's *Atlantis* (August Blom, 1913) and Schnitzler's *Liebelei* (1914). Nordisk also signed the Austrian writer Hugo v. Hofmannsthal to script *Das fremde Mädchen/The Strange Girl* (1913, dir. Mauritz Stiller) for the Swedish Svenska Film, premiered in Berlin in July 1913.

Although the influence of the *Autorenfilm* might seem marginal compared to the total number of films released in Germany at that time, its impact becomes evident when considered in the context of the long narrative film, to which this genre made a considerable contribution. Set up in opposition to the popular *Kinodrama*, the *Autorenfilm* met some of the central demands of the Kino reform movement*, calling for a 'cultural upgrading' of the long feature film, after the commercial success of what were termed *Schundfilme* ('trash-films') in 1910/11. Apart from the literary input, the *Autorenfilm* could boast of unprecedentedly expensive advertising campaigns and other exhibition innovations, such as exclusive premieres [> EXHIBITION]. *Autorenfilme* also helped legitimate the building of larger, architecturally more ambitious movie theatres, thus signalling the industry's intention to widen the audience to include the upper-middle class, and preparing for the emergence of professional film criticism*. On the production side, the *Autorenfilm* conveniently coincided with the introduction of new studio* capacity, the most notable example being the remodelling of Bioscop's 'Glashaus' in Neubabelsberg in 1912/13.

Although it has often been argued that *Autorenfilme* brought about only minor innovations in terms of cinematic narration and visual style, relying more on the literary prestige of the subject matter or amounting to little more than 'filmed theatre', several of the films in fact pioneered a combination of literary themes and cinematic possibilities which was to become constitutive of German cinema as a self-consciously 'national' cinema. The *Autorenfilm* for instance, naturalised a whole array of fantastic themes and motives, and for the first time integrated scenic 'views' of exteriors ('Naturaufnahmen') with studio compositions ('internal montage') into integrated storytelling. If by April 1914 the *Autorenfilm* had already outlived its day, as was claimed by the Viennese trade journal *Filmwoche*, it had changed the German cinema irrevocably, both in its self-definition and

in the critical expectations the cultural establishment has applied to it ever since. MW

II – Critical term. In postwar art cinema, the Young and New German cinema's* rejection of commercial genre cinema conventions meant that film-makers such as Alexander Kluge*, Volker Schlöndorff*, Hans Jürgen Syberberg*, Werner Herzog*, Helma Sanders-Brahms* and Wim Wenders* once more consciously drew on literary rather than cinematic models, but also saw themselves in the tradition of the French *cinéma d'auteurs*. Film-makers generally publicised themselves as *Autorenfilmer*, meaning that they combined the roles of script-writer, director and producer and exercised complete control over the final product [> FILMVERLAG DER AUTOREN], so that despite the group label, the New German Cinema became identified with its directors [> STAR SYSTEM], whose names functioned as trade marks and advertising for the films. Largely the result of the funding system [> FILM FUNDING] and the promotion of New German Cinema at film festivals, the label *Autorenfilm* combined 'personality' cult with a 'national' generic recognition value. The image of the New German Cinema's author-directors was formed by film critics and scholars, habitually identifying films as expressions of individual artistic subjectivity and attaching value to them for cultural reasons, thus both compensating for and occasionally stimulating a measure of commercial success. JG/MW

Bib: Joachim Paech, *Literatur und Film* (1988), Leonardo Quaresima, 'Dichter Heraus', *Griffithiana*, 38–39 (1990).

B

BAKY, Josef von
Bacska, Hungary 1902 –
Munich 1966

Hungarian-born director working at Ufa* in the 1930s and 1940s, with a sure hand for navigating the propagandist ends to which his films could be put. In 1928 Baky became assistant director to Geza von Bolvary*. From 1936 he directed for Ufa, specialising in popular comedies (*Intermezzo*, 1936; *Menschen vom Variete/People from the Variety*, 1939) and women's pictures (*Die kleine und die große Liebe/Minor Love and the Real Thing*, 1938). The enormous success of *Annelie* (1941), a combination of both genres, prompted Goebbels to

assign him to *Münchhausen* (1943), the hugely successful twenty-fifth anniversary Ufa colour production. However, Baky's 1944 *Via Mala*, an alpine story of patricide, was banned and not shown until after the war. In 1947 Baky founded Objektiv-Film which, among other films, produced *Der Ruf/The Last Illusion* (1949), starring Fritz Kortner* as an émigré academic returning to a professorial chair in Germany. Today counted among the few '*Trümmerfilme*' ('ruin films') which have retained their unsettling potential beyond their historical moment, it was not a commercial success, and Baky's company folded. Other more profitable films, across a range of genres, followed in the 1950s, before he retired in 1961. MW

Other Films Include: *Ihr erstes Erlebnis/Her First Experience* (1939); *Der Kleinstadtpoet/Small Town Poet* (1940); *Und über uns der Himmel/And the Sky Above Us* (1947); *Der träumende Mund/ Dreaming Lips* (1953); *Tagebuch einer Verliebten/Diary of a Married Woman* (1953); *Hotel Adlon* (1955); *Robinson soll nicht sterben/The Girl and the Legend* (1957); *Die seltsame Gräfin/The Mysterious Countess* (1961).

BALÁZS, Béla
Herbert Bauer; Szeged 1884 – Budapest 1949

Hungarian-born film theorist, who worked in Germany and the Soviet Union, the most prominent and influential theorist of the period of formalist thinking when the intellectual avant-gardes first embraced the cinema's artistic potential in the 1920s and early 1930s.

A latter-day 'universal man', Balázs' intellectual identity was shaped by his early studies with Georg Simmel in Berlin and Henri Bergson in Paris. Author of novels, plays, poems, literary criticism and several librettos for composer Béla Bartók, Balázs was an outstanding representative of Hungarian cultural life, before his participation in Béla Kun's short-lived communist government forced him into exile to Austria and Germany in 1919. In Germany he became a sought-after scriptwriter, collaborating with G. W. Pabst* on *Die Dreigroschen-oper/The Threepenny Opera* (1931), and with Leni Riefenstahl* on *Das Blaue Licht/The Blue Light* (1932). From 1923 onwards, he developed his ideas about film as an autonomous art form in theoretical essays on the artistic potential of purely filmic phenomena such as montage, close-up, and camera movement. Setting out the medium's formal qualities, his 1924 book *Der sichtbare Mensch* (*Visible Man*) also detailed cinema's cultural significance as a visual medium communicating without the intermediary of language. Inspired by the coming of sound and a critical dialogue with theoretical positions held by Eisenstein, *Der Geist des Films* (*The Spirit of the Film*, 1930) already marked Balázs' shift of focus from a pure constructivist aesthetic of the 'productive camera' towards a more dialectic view of film as a

performing and multi-medial art, which in his *Iskusstvo Kino* (1945, transl. as *Theory of the Film: Character and Growth of a New Art*, 1952) led him to discuss the philosophical and psychological implications of all the technical components of film, to which Balázs pays tribute as a signifcant industrial and socio-political force in the context of modern societies.

In October 1931 Balázs moved to the Soviet Union, where he was made professor of film aesthetics at the Academy of Film Art (GIK/VGIK) in Moscow from 1933 to 1945. Returning to Hungary after the end of war, he continued writing scripts and remained a popular lecturer on film, especially in East European countries. MW

Bib: Joseph Zsuffa, *Béla Balázs: The Man and the Artist* (1987).

BALLHAUS, Michael — Berlin 1935

German cinematographer. After training as a photographer, Ballhaus began working for television in 1959, but his feature film debut was *Mehrmals täglich/Several Times Daily* (1969). A superb craftsman, renowned for his fluid tracking shots and sensual interiors (perhaps a tribute to his relative Max Ophuls*), Ballhaus' crucial phase began in 1970, when he became Rainer Werner Fassbinder's* preferred cameraman, responsible for the sinuous energy animating so many of the director's claustrophobic sets. After working on fourteen Fassbinder films in total (until Xaver Schwarzenberger took over on *Berlin Alexanderplatz*, 1980), Ballhaus was cameraman for Peter Lilienthal and on some television documentaries. Thanks to Lilienthal's *Dear Mr Wonderful* (1980), shot in New York, he made contact with Martin Scorsese, which heralded the start of his American career. Since being granted American film union membership, Ballhaus has been much in demand as cinematographer on films such as *Baby, It's You* (1982), *The Color of Money* (1986), *Bram Stoker's Dracula* (1992) and *The Age of Innocence* (1993). TE

Other Films Include: *Quiz Show* (1994), *I'll Do Anything* (1994), *Outbreak* (1995), *Sleepers* (1996), *Air Force One* (1997), *Primary Colors* (1998), *The Wild, Wild West* (1999).

BECCE, Giuseppe — Lonigo, Italy 1877 – Berlin 1973

Italian composer who worked in Germany, adapting existing musical compositions for Messter* Film and other companies in 1913 (for instance *Richard Wagner* in which he starred as the composer), while simultaneously writing original accompanying music which he called *Autorenillustrationen* (author's illustrations). Becce decisively shaped the musical dramaturgy of German silent cinema and his *Kinothek*, an

alternative to foreign music compilations, appeared in print from 1919. In the 1920s Becce became head of Ufa's* music division. His most notable compositions were incidental music for F. W. Murnau's* *Tartüff* (1926, use of leitmotif and quotations) and *Der letzte Mann/ The Last Laugh* (1924, rhythm). He remained one of Germany's most productive film composers of the sound era. Famous from the later period are his soundtracks for Luis Trenker's* *Berge in Flammen/The Doomed Battalion* (1931) and *Der Berg ruft/The Challenge* (1938), and Leni Riefenstahl's* *Das blaue Licht/The Blue Light* (1932). SG

BERGER, Ludwig Mainz 1892 – Schlangenbad 1969

German director, who began as an opera and theatre director. Berger's first films, all adaptations from the stage and examples of the *Kammerspielfilm**, were made with producer Erich Pommer*, first for Decla-Bioscop, then for Ufa*. Berger gained a considerable reputation in the fantasy genre with the Cinderella variation *Der verlorene Schuh/Cinderella* in 1923, marked by an ironic lightness which contrasted with the nightmarish world of other German fantasy films of the period. In 1928 he went to Hollywood, where, among other projects, he collaborated with Mauritz Stiller on *The Street of Sin* (1928) and completed the first musical in colour, *The Vagabond King* (1930). Back in Germany in 1932, he began shooting *Walzerkrieg/Court Waltzes*, which premiered in September 1933 without his name on the credits. In 1936 an offer from Rudi Meyer* took him to the Netherlands, where he made a film of Shaw's *Pygmalion* (1937). He then worked in France (*Trois valses/Three Waltzes*, 1938), in Britain (co-directing *The Thief of Bagdad*, 1940, with Tim Whelan and Michael Powell) and again in the Netherlands, where he survived the German occupation under a false identity and directed *Ergens in Nederland/Somewhere in Holland* (1940), a pivotal film for the Dutch cinema. After one more film in France (*Ballerina/Poor Little Ballerina*, 1950), Berger started another career in Germany as a prolific scriptwriter for the cinema, radio and television. MW

Bib: Hans-Michael Bock and Wolfgang Jacobsen (eds), *Ludwig Berger* (1992).

Other Films Include: *Die Meistersinger von Nürnberg/The Meistersingers, The Woman from Moscow* (US), *Sins of the Fathers* (1928, US); *Das brennende Herz/The Burning Heart* (1929); *Playboy of Paris* (1930, US; Fr. version *Le Petit café*); *Early to Bed* (1932, UK). **Television**: *Die Spieler* (1954); *Frau Mozart* (1954); *Undine* (1956); *Stresemann, Der Tod des Sokrates, Der Widerspenstigen Zähmung* (1957); *Was Ihr wollt, Viel Lärm um Nichts, Wie es Euch gefällt, Maß für Maß, Ein Sommernachtstraum* (1958); *Das Paradies und die Peri, Die Nacht in Zaandam* (1960); *Hermann und Dorothea* (1961);

Alpenkönig und Menschenfeind (1962); *Ottiliens Tollheiten* (1964); *Samen von Kraut und Unkraut* (1967); *Odysseus auf Ogygia* (1968); *Demetrius* (1969).

BERGNER, Elisabeth
Drohobycz, Galicia, Poland (now Russia) 1897 – London 1986

German actress, who worked in repertory under Max Reinhardt* between 1923 and 1933. Mostly directed by Paul Czinner* (her husband from 1933), she began her film career with a number of *Kammerspielfilme** for which her tomboyish femininity with its erotic understatement was perfectly suited, her androgynous persona stretching to cross-dressing (*Der Geiger von Florenz/Impetuous Youth/The Violinist of Florence*, 1926; *Dona Juana*, 1927). Just as she was to gain major star status with her performances in *Ariane* (1931) and *Der träumende Mund* (1932; she also starred in the English version, *Dreaming Lips*, 1932), she was forced to leave Nazi Germany for Britain (1933). There, she continued to play leads in films directed by Czinner, receiving an Academy Award for her performance in *Escape Me Never* (1935), before once more devoting herself to the theatre. MW

Bib: Helga Belach (ed.), *Elisabeth Bergner* (1983).

Other Films Include: *Catherine the Great* (1934, UK); *As You Like It* (1936, UK); *Paris Calling* (1941, US); *Die glücklichen Jahre der Thorwalds/The Happy Years of the Thorwald Family* (1962; dir. Wolfgang Staudte*); *Der Osterspaziergang* (1984).

BERLIN – see FESTIVALS

BERNA, Emil
Zurich 1907

Swiss cinematographer. After collaborating on Ufa's* famous 'Kulturfilm' documentary, *Wege zu Kraft und Schönheit/Ways to Health and Beauty* (1925, co-dir. W. Prager and N. Kaufmann), and heading the animation department of Corona Kunstfilm Zurich, Berna was hired by Lazar Wechsler* at Praesens-Film in 1927, where he became Switzerland's leading cinematographer from the late 1930s to the 1960s, thanks to his compellingly sober and unpretentious early camerawork on his own documentaries and films by Eduard Tisse, Walther Ruttmann* and Hans Richter, among others. As chief cameraman of the nation's most prosperous film company, Berna deployed his talents with exceptional continuity in over forty national and international productions by leading directors such as Fred

Zinnemann (*The Search/Die Gezeichneten* 1947), Leopold Lindtberg*, Franz Schnyder* and Kurt Früh*. In 1964 Berna moved to Central-Film. He retired shortly afterwards. MW

BERNHARDT, Kurt [US: Curtis] Worms 1899 – Pacific Palisades, California 1981

German director. Coming from the stage, Bernhardt entered film as the director of the anti-war picture *Namenlose Helden/Nameless Heroes* in 1924, helped Marlene Dietrich* to stardom (*Die Frau nach der man sich sehnt/Three Loves*, 1929) and by 1930 had sufficiently established himself with a number of socially aware dramas to direct Conrad Veidt* in *Die letzte Kompagnie/The Last Company* (1930), one of Ufa's* very first sound films. In 1934 he left Germany for France, where he specialised in atmospheric thriller-melodramas such as *Carrefour* (1938). In 1939 Bernhardt went to the US where, thanks to the American distribution of *Carrefour*, he received offers from Warner Bros and MGM, signing a seven-year contract with Warner. He shot his first American picture, *My Love Came Back*, in 1940, followed by a series of melodramas (such as *Possessed*, 1947) and *films noirs* (such as *High Wall*, 1947) for which he is justly famous. After numerous visits to Germany in the 1950s, he eventually directed *Stefanie in Rio* (1960) for Artur Brauner's CCC-Film, which also brought back Fritz Lang* and other émigrés. A film directed in Italy was followed by Bernhardt's last film (*Kisses for My President*, 1964), made back in the US. MW

Other Films Include: *Qualen der Nacht/Agonies of Night, Die Waise von Lowood* (1926); *Kinderseelen klagen euch an, Das Mädchen mit den 5 Nullen* (1927); *Schinderhannes/The Prince of Rogues, Das letzte Fort* (1928); *Der Mann, der den Mord beging* (1931); *Der Rebell/The Rebel* (1932, co-dir. Luis Trenker*); *Der Tunnel* (1933); *L'Or dans la rue* (1934, Fr.); *The Beloved Vagabond* (1936, UK); *The Lady With the Red Hair* (1940, US); *Juke Girl* (1942, US); *Conflict* (1944, US); *My Reputation, Devotion, A Stolen Life* (1946, US); *The Doctor and the Girl* (1950, US); *Payment on Demand, Sirocco, The Blue Veil* (1951, US); *The Merry Widow* (1952, US); *Miss Sadie Thompson* (1953, US); *Beau Brummell* (1954, US); *Interrupted Melody* (1955, US); *Il tiranno di Siracusa/Damon and Pythias* (1961, It./US).

BEROLINA-FILM

German production company founded by Kurt Ulrich (1905–67) and Kurt Schulz (1912–57) in 1948. Berolina was one of the most prolific and commercially successful postwar German production companies, completing about seventy films between 1948 and 1962. Like other

companies at the time it financed its films through guarantees from distributors such as Herzog, Gloria* and Constantin*. Berolina launched the successful genre of the *Heimatfilm** with *Schwarzwaldmädel* (1950) and *Grün ist die Heid* (1951), produced operettas like *Das Land des Lächelns* (1952) and *Der Vogelhändler* (1953), and put together star vehicles for Heinz Rühmann*, for instance *Wenn der Vater mit dem Sohne* (1955), *Charleys Tante* (1955) and *Der Pauker* (1958). Berolina had its own talent scout department and gave future stars Romy Schneider* and Götz George* their first chance. The first German production company after World War II to use colour, it often shot outdoors, using particularly scenic locations, partly to compensate for not owning a studio. The company was dismantled in 1967 after the death of Kurt Ulrich. JG

BESS, Jane 1894–?

German scriptwriter. The popular but critically ignored Bess had her first success as a writer when she invented Detective Morten (played by Harry Frank, and later by Olaf Storm), and the attractive woman detective Madge Henway (played by Edith Posca). By 1926 she was said to have written 126 scripts in almost every popular genre: apart from adventure and detective films she wrote treatments for *Straßenfilme** ('street' films) such as *Das Kind der Straße/Child of the Street* (1921, dir. Wolfgang Neff), *Der Aufstieg der kleinen Lilian/The Ascent of Little Lilian* (1924, dir. Fred Sauer) and *Die Moral der Gasse/Morals of the Streets* (1925, dir. Jaap Speyer), for comedies, costume dramas and operetta films. From the mid-1920s she (co-)wrote the scripts of more prestigious films by directors such as Mihály Kertesz [Michael Curtiz in the US] (*Der goldene Schmetterling/The Golden Butterfly*, 1926), Richard Oswald* (*Funkzauber*, 1928), Joe May* (*Dagfin*, 1926) and, most often, Victor Janson. The coming of sound brought her career to an abrupt end. In 1933 she appears to have left Berlin, possibly for the Netherlands, where a screenplay of hers (*De Kribbebijter*) was directed by Herman Kosterlitz (Henry Koster) in 1935. MW

BEYER, Frank Nobitz, Thuringia 1932

German director. Beyer studied direction at FAMU in Prague, assisting Kurt Maetzig* among others. In 1958, he joined DEFA* features studio in Potsdam-Babelsberg, and had his first success with *Fünf Patronenhülsen/Five Shell Casings/Five Bullets* (1960), the story of a difficult friendship between five members of the International Brigade during the Spanish Civil War. In *Königskinder/Invincible Love* (1962), he combined traditional realistic story-telling with a complex flashback structure. The same year, he adapted Bruno Apitz's autobiographical

Nackt unter Wölfen/Naked Among Wolves (1963), based on the author's experiences at the Buchenwald concentration camp. Beyer's career was halted by the reception of *Spur der Steine/Traces of the Stones* (1966), which, except for a single preview shortly after its completion, was never publicly shown in the GDR. It became, however, a respectable box-office success in East and West Germany when re-released in 1989, spearheading the exhibition of a whole group of previously undistributed 1960s films. It was eight years before Beyer was allowed to direct another film, *Jakob der Lügner/Jacob, the Liar* (1974), the only DEFA film ever to be nominated for an Oscar. From the early 1980s Beyer worked for West German production companies and television, but returned to DEFA to direct the thriller *Der Bruch/The Break* (1989). His first post-unification film was *Der Verdacht/The Suspicion* (1991). MW

Bib: Ralf Schenk (ed.), *Regie: Frank Beyer* (1995).

BIRGEL, Willy
Cologne 1891 – Dübendorf, Switzerland 1973

German actor, who started his screen career relatively late, in Paul Wegener's* *Ein Mann will nach Deutschland/A Man Wants to Go to Germany* (1934) and in his first years predominantly featured in shady roles. From 1937, after Birgel had become a *Staatsschauspieler* (state actor) in Nazi Germany, he turned to playing severe, cold masculine types. With ... *reitet für Deutschland/Riding for Germany* (1941), he perfected his style as the '*Herrenreiter des deutschen Films*' (gentleman rider of the German film). Despite facing tough questions from the Allies after the war, Birgel returned to the cinema thanks to Erich Pommer*. After a disappointing directorial debut with *Rosenmontag* in 1955, he increasingly worked for the theatre. From the 1960s to his death, he also played in countless television productions. MW

BLANC, Anne-Marie
Vevey 1921

Swiss actress. Already a national icon in the late 1930s and early 1940s through leading parts in some of the most successful Swiss films directed by Leopold Lindtberg* (*Wachtmeister Studer*, 1939; *Die missbrauchten Liebesbriefe*, 1940; *Landamman Stauffacher*, 1941; *Marie-Louise*, 1943), Blanc continued to be popular throughout the next three decades in over thirty films made in Switzerland and Austria, but also in Britain (*White Cradle Inn*, 1947), France (*On ne meurt pas comme ça*, 1946, co-starring Erich von Stroheim), and Germany (*Roman eines Frauenarztes*, 1954, *Via Mala*, 1961). A celebrated stage actress, she toured Europe with partners such as Albert Bassermann (1948), Oskar Werner* (1959), Axel von Ambesser (1972), Sonja

Ziemann and Charles Régnier (1975). Through her collaboration with a new generation of film-makers, Blanc served as an important recognition factor for audiences in the 1970s and 1980s, helping to integrate the 'new Swiss cinema' into the international mainstream and contributing a strong sense of continuity to Swiss national cinema. MW

Other Films Include: *Gilberte de Courgenay* (1941); *Maturareise* (1942); *Palace Hotel* (1951); *Hoheit lassen bitten* (1954); *S.O.S. Gletscherpilot* (1959); *La Blonde de Pékin* (1966); *Riedland* (1975); *Violanta* (1977); *Séverine* (1980); *L'Allégement* (1983); *Der Pendler* (1985).

BOESE, Carl Berlin, 1897 – 1958

German director, one of the country's most productive and popular cross-generic directors from the 1920s to the 1950s. Active in German film from 1912, he made his directorial debut in 1918/19 in a series of nearly 20 films, including *Der Fluch des Nori/The Curse of Nori* (starring Hans Albers*) and *Nocturno der Liebe/Nocturno of Love* (starring Conrad Veidt*). He maintained this rate of productivity throughout his career: during the 1920s he directed over 50 silent films, and more than 80 sound pictures between 1930 and 1957, working in almost every conceivable genre. The best-known amongst his early films are the fantastic *Der Golem, wie er in die Welt kam/The Golem* (co-dir. with Paul Wegener*, 1920), the historical Fridericus Rex-movie *Die Tänzerin Barberina/The Dancer Barberina* (1921, starring Otto Gebühr* for the first time in the role that made him famous), and the socio-critical street films* *Die letzte Droschke von Berlin/The Last Hackney-Carriage in Berlin* (1926) and *Kinder der Straße/Children of the Street* (1928). During the Third Reich, Boese directed sentimental and slapstick comedies, some on military subjects. In 1939 he made his sole, but notable contribution to the popular genre of the 'Revuefilm', *Hallo Janine/Hello Janine* (1939). In postwar Germany, he won acclaim for his psychologically acute Trümmerfilm* *Beate* (1947), as well as for directing some of the most popular films of Grete Weiser (1903–1970), such as *Wenn Männer schwindeln/When Men Start to Lie*, 1950; *Der keusche Lebemann/The Chaste Rake*, 1952), of Hans Moser* (*Der Onkel aus Amerika/The Uncle from America*, 1953) and of Theo Lingen* (*Meine Tante, deine Tante/My Aunt, Your Aunt*, 1956; *Vater macht Karriere/Father Makes Good*, 1956). MW

BÖHM, Karlheinz [Karl Heinz BOEHM]
Darmstadt 1928

German actor. The son of a famous conductor, Böhm started out as the elegant young lover of Arthur Maria Rabenalt's* *Alraune* (1952)

and in the film operetta *Der unsterbliche Lump* (1953). He featured in over thirty films during the following decade, still typecast as the stiff juvenile hero in Ernst Marischka's* hugely popular *Sissi* trilogy (1955–57), leaving him with a serious image problem. Böhm attempted a change in British, French and American films, and succeeded almost too well as the self-conscious serial killer in Michael Powell's* *Peeping Tom* (1960). He subsequently appeared in the striptease thriller *Too Hot to Handle* (1959, UK), the lynch-law drama *La Croix des vivants* (1960, Fr.), as a Nazi officer in Vincente Minnelli's *The Four Horsemen of the Apocalypse* (1962, US) and as a sadistic agent in *The Venetian Affair* (1966, US). A second German career began in 1972, when Rainer Werner Fassbinder* made full use of Böhm's by now many-layered star image, first as the worldly-wise Prussian councillor Wüllersdorf in *Fontane Effi Briest/Effi Briest* (1974), then as the sadistic husband in *Martha* (1974), the homosexual art dealer in *Faustrecht der Freiheit/Fox and His Friends* (1975), and finally the arrogant, middle-class communist Tillmann in *Mutter Küsters Fahrt zum Himmel/Mother Kuster's Trip to Heaven* (1976). Apart from occasional appearances on stage and television, Böhm has devoted much of the last fifteen years to promoting charities for starving children in Central Africa and Ethiopia. TE/MW

BOIS, Curt Berlin 1901–91

German actor. With a film debut in *Klebolin klebt alles* (1909) and a final appearance in Wim Wenders'* *Der Himmel über Berlin/Wings of Desire* in 1987, Bois has had the longest career in German film history. He starred in the comedy *Der Jüngling aus der Konfektion* (1926), followed by *Der Fürst von Pappenheim* (1927, dir. Richard Eichberg*), famous for his transvestite scenes, later maliciously used to travesty the film's meaning and to tar Jewish actors in the compilation propaganda film *Der ewige Jude* (1940). In his few German sound films before emigrating to the US in 1933, Bois recreated the Jewish *schlemihl* made famous by Ernst Lubitsch* in the 1910s. Appearing in many émigré films in Hollywood in the late 1930s and 1940s, Bois is best remembered for his nimble-fingered pickpocket in Michael Curtiz's *Casablanca* (1942). In 1950 he returned to East Germany, where he was associated with Bertolt Brecht's theatre and acted sporadically in DEFA* films, before moving to West Berlin in 1954 and concentrating on his stage career. Appropriately for someone so closely identified with Berlin, Bois rendered eloquent homage to its past in Wenders' romantic masterpiece, *Der Himmel über Berlin*. MW

BOLVARY, Geza von
Budapest 1897 – Rosenheim, Germany 1961

Hungarian-born director of musical comedies in the prosperous German and Austrian cinemas of the 1930s and 1940s. Already known for his silent melodramas and comedies, Bolvary became hot property after his first sound film, the Willy Forst* vehicle *Zwei Herzen im 3/4 Takt* (1930), which made him the specialist of a new musical sub-genre, the Viennese film operetta. The film's huge international success led to a number of follow-ups centred on popular German actors – Forst again (*Ein Tango für Dich*, 1930; *Die lustigen Weiber von Wien*, 1931), Zarah Leander* (*Premiere*, 1937), and Willy Fritsch* (*Die Fledermaus*, 1945). Most notable among his postwar films, apart from other musicals, were a number of entertaining but historically and politically intriguing portraits of musicians, including the classic *Ein Lied geht um die Welt* (1958). MW

Other Films Include: *Champagner/Champagne, The Vagabond Queen* [UK], *The Wrecker* (1929, UK); *Der Herr auf Bestellung* (1930); *Der Raub der Mona Lisa* (1931); *Wiener G'schichten* (1940); *Schicksal* (1942); *Schrammeln* (1944); *Fritz und Friederike* (1952); *Mein Leopold* (1955); *Schwarzwaldmelodie* (1956); *Was die Schwalbe sang* (1956), *Zwei Herzen im Mai* (1958).

BORSCHE, Dieter
Hanover, 1909 – Nuremberg, 1982

German actor. A former ballet dancer, Borsche began his career as a stage actor in Weimar (1939–42) and Breslau (1942–44) as the juvenile lead, before he was conscripted into the army, injured and later taken prisoner. Through Bernhard Minetti, Borsche returned to the stage as the artistic director of the Städtische Bühnen Kiel (1947–49). However, his stage career began in earnest only after he joined the Freie Volksbühne Berlin in the early 1960s, where he played major parts under the direction of Erwin Piscator. His first screen appearance dates from 1935 (*Alles weg'm dem Hund/All Because of the Dog*), and he starred in four more films before the war (amongst them, Paul Martin's 1938 *Preussische Liebesgeschichte/Prussian Love Story*, banned because of the Goebbels-Baarova-affair and not shown in public until 1950). Borsche gained star status in postwar German cinema, beginning with the role of the Catholic chaplain von Imhoff in Harald Braun's* *Die Nachtwache/The Nightwatch* (1949). Whether in a cassock (as in *Die Nachtwache*), a doctor's white coat (*Dr. Holl*, 1951), or in a soldier's uniform (*Es kommt ein Tag/A Day will Come*, 1950), Borsche personified the masculine and moral ideal of the period: quiet and upright, his trustworthy authority derived from a reticent melancholy that charmed his female leads, usually played by Maria Schell*

and Ruth Leuwerik*. So much of an institution was his screen image that it took Kurt Hoffmann* to cast him in *Fanfaren der Liebe/Fanfares of Love* (1953) in a daringly different, cross-dressing role, opposite comedian Georg Thomalla. One of the most iconic actors in postwar Germany, Borsche entered the international arena with Jacques Becker's* *Ali-Baba et les 40 Voleurs/Ali Baba and the 40 Thieves* (1954) and Douglas Sirk's (Detlef Sierck's*) *A Time to Love and a Time to Die* (1958). By that time Borsche had matured into the shady villain of innumerable films of the hugely popular Edgar Wallace series [> GERMANY: SERIES AND SERIALS], a type he carried over into television (*Das Halstuch/The Scarf*, 1961), where he regularly appeared until serious illness confined him to a wheelchair in the late 1970s. MW

BRANDAUER, Karin Alt Aussee 1946 – Vienna 1992

Austrian director, notable for documentaries and adaptations of Austrian literature, mainly for television. After *Der Weg ins Freie* (1982, a Schnitzler adaptation) and *Erdsegen* (1986, based on Peter Rosegger), Brandauer came to international festival attention with *Einstweilen wird es Mittag/Marienthal* (1988), a docu-drama about a mining village during a strike in 1930, based on a celebrated sociological study of unemployment. Observing the role of women in traditional communities confronted with industrialisation and social change (*Verkaufte Heimat*, 1989), Brandauer's films are strongly committed to rural values while showing an acute historical sense, as in a television series on the South Tyrol referendum in 1939, and *Sidonie* (1990, adapted from a novel by Erich Hackl). She was married to actor Klaus Maria Brandauer*. TE

BRANDAUER, Klaus Maria Klaus Maria Steg; Bad Aussee 1944

Austrian actor. After work in theatre and television, Brandauer's career took off when he starred in István Szabó's* *Mephisto* (1981), *Redl Ezredes/Colonel Redl* (1985) and *Hanussen* (1988), where he specialised in power-hungry, self-tormented and contradictory characters. Brandauer has won a variety of film awards, including a 1982 Academy Award for *Mephisto*, which led to major roles in British and American productions. He directed his first film in 1989, *Georg Elser – Einer aus Deutschland,* with himself in the title role of the lone would-be assassin of Hitler. MW

Other Films Include: *The Lightship* (1985, US); *Streets of Gold* (1986, US); *Burning Secret* (1988, UK); *Das Spinnennetz* (1989; dir. Bernhard

44

Wicki*); *Mario und der Zauberer/Mario and the Musician* (1994); *Rembrandt* (1999).

Bib: Heiko R. Blum/Sigrid Schmitt, *Klaus Maria Brandauer: Schauspieler und Regisseur* (1996).

BRAUN, Harald Berlin 1901 – Xanten 1960

German director, who began at Ufa* in 1937 thanks to Carl Froelich* and made his directorial debut in 1942 with *Die Zwischen Himmel und Erde/Between Heaven and Earth*. He was granted a producer's licence by Erich Pommer* in 1947. With *Die Nachtwache* (1949), one of the biggest box-office hits of the time, came Braun's first real postwar success. A kind of ecumenical *Heimatfilm*, *Die Nachtwache* tells the story of a doubting woman doctor brought back to the church by the determined efforts of a priest. In a similar vein, Braun's subsequent films often revel in symbolism, betraying his religious upbringing and highbrow education. His biopic of the Nobel prize-winning pacifist Bertha von Suttner, *Das Herz der Welt* (1951), earned him several awards. MW

BROOKS, Louise Cherryvale, Kansas 1906 – Rochester, New York 1985

American actress, who made brief but significant appearances in European cinema. In Germany she rose in G. W. Pabst's* films from a beggar in *Das Tagebuch einer Verlorenen/The Diary of a Lost Girl* to a siren in *Die Büchse der Pandora/Pandora's Box* (both 1929), while in France she was a celebrated beauty queen in *Prix de beauté/Miss Europa* (1930, dir. Augusto Genina, script by René Clair). Subsequently, she virtually disappeared from the screen after returning to Hollywood. Consigned to oblivion for some three decades, she became the object of French cinephilia in the 1960s and since then has enjoyed iconic status as one of Weimar cinema's* archetypal *femmes fatales*. But unlike the inner soulfulness of an Asta Nielsen*, she became the signifier of an unsettling sexual androgyny and impetuous naivety, which created exactly the 'modernist' impression Pabst was looking for to move beyond Expressionism*. MW

BRÜCKNER, Jutta Düsseldorf 1941

German director, with an academic background. Brückner was a scriptwriter before making her first film, about her mother: *Tue recht und scheue niemand!/Be Upright and Walk without Fear* (1975). The semi-autobiographical *Hungerjahre – in einem reichen Land/Hunger*

Years – In a Rich Country (1979) depicts growing up in the repressive Adenauer era. Women's experiences, hopes and desires are Brückner's themes, and her characters a means to engage with historical processes from a feminist perspective. Attention to realistic details, including stills and documentary footage, characterised her approach in the 1970s. However, she turned towards performance art for *Ein Blick – und die Liebe bricht aus/One Glance – and Love Breaks Out* (1986), a compulsive and stylised re-enactment of women's enslavement to passionate love. *Kolossale Liebe/Mighty Love* (1984–92), about the Romantic writer Rahel Varnhagen, employs video technology to create fantasy images. Brückner is also a prolific film theorist and an activist for greater women's representation in European cinema. Her video *Lieben Sie Brecht?/Do you Love Brecht?* (1993) is leading to a film project about the writer, *Es Hat Zähne/It Has Teeth*. US

BUCHHOLZ, Horst Berlin 1933

German actor. After a spell dubbing foreign films into German, Buchholz became a 1950s pop icon, the German James Dean, playing the young rebel with the soulful eyes in *Die Halbstarken* (1956) and *Endstation Liebe* (1957), both directed by Georg Tressler*. A number of romantic leads in international productions followed, most notably in *Tiger Bay* (1959, UK), *The Magnificent Seven* (1960, US) and Billy Wilder's Cold War satire *One, Two, Three* (1961, US). Unsuccessfully trying his hand at direction, he eventually found, from the mid-1970s, a more mature acting identity in television and theatre. He returned to the screen as a heavy with a past in Wim Wenders'* *In weiter Ferne, so nah!/Far Away, So Close* (1993). TE/MW

Other Films Include: *Himmel ohne Sterne, Regine* (1955); *Herrscher ohne Krone, Robinson soll nicht sterben* (1956); *Montpi* (1957); *Nasser Asphalt* (1958); *Das Totenschiff* (1959); *Fanny* (1960); *Nine Hours to Rama* (1962, US); *Johnny Banco* (1966); *... aber Jonny!* (1973); *Frauenstation* (1975); *La Vita è bella/Life Is Beautiful* (1998, It.), *Dunckel* (1998).

BUCK, Detlev Bad Segeberg 1962

German director and actor whose unique touch for stand-up comedy, seasoning his films with laconic dryness and down-to-earth wit, has made him synonymous with the turn to commercial film-making in Germany after unification. Buck grew up on his parent's farm in Schleswig-Holstein, and his first short film was the work of an autodidact. He then atttended Berlin's Film & Television Academy (DFFB) from 1985–89. After several more shorts, he co-founded

Boje-Buck Filmproduktion in 1991 to finance his first feature film *Karniggels*, the story of a young police officer in the Northern province tracking a serial killer of East Friesian cows. The combination of dead-pan action and coarse humour made *Karniggels* a runaway hit with German audiences, allowing Buck to expand his production base and turn his distinct talent to the (West)German-(East)German question in *Wir können auch anders/Just You Dare* (1992), according to one critic 'the slowest road-movie in film history'. *Männerpension/Jailbirds* (1995, with Til Schweiger* and Heike Makatsch) pairs an odd couple of ex-convicts, reluctantly in search of the prescribed heterosexual mate. Typically featuring two engagingly self-defeating losers (one played by Schweiger, the other by Buck himself), it became one of the most successful German films of the decade and confirmed Schweiger as *the* male star of the 1990s. Apart from directing genre films (with *Liebe deine Nächste/Love Thy Neighbour* (1998) he ventured into the ambitious thriller mode), Buck takes supporting or even leading roles in all his films, and lends his acting talent to other directors, as in Wolfgang Beckers' *Kinderspiele/Children's Games*, Reinhard Münster's *Alles auf Anfang* (1994) and Maris Pfeiffer's *Küß' mich!/ Kiss Me!* (1995). MW

Bib: Edgar Reitz, 'Detlev Buck' in *Bilder in Bewegung: Essays, Gespräche zum Kino* (1995).

C

CENSORSHIP

'All films are forbidden, unless certified as complying with approved norms.' This rule of preventive censorship has held true for all German governments, whose generally hostile attitude to the cinema, suspecting its adverse impact on the morality of the masses, finds its mirror image in varying attempts to harness such influence – as propaganda – in the interests of the state.

Before 1920, no centralised film censorship existed. Implemented on the principle of 'keeping public peace, security and order' ('Erhaltung der öffentlichen Ruhe, Sicherheit und Ordnung'), censorship was the domain of regional police authorities, who applied very divergent standards. In May 1906, the Berlin chief of police introduced preventive censorship, and in 1910, censorship was centralised in Prussia: films approved in Berlin were automatically passed for other provinces

of Prussia. During World War I, censorship was carried out by the Military High Command.

In 1920, censorship laws were finally ratified for all of Germany (Reichslichtspielgesetz, 12 May 1920), giving, despite different organisational structures and enforcement practices, a surprising degree of continuity to all film censorship methods throughout the very different political systems Germany was to know this century. Practices included outright banning, restrictions on exhibition (age limits, observation of public or religious holidays, restrictions to specific social groups) and editorial interference (demands for cuts, changes to dialogue and intertitles, additions, title changes).

During the years of the Weimar Republic, the allegedly harmful influence of films on public bodies (such as the army, navy, police, judges, civil servants, teachers, physicians and lawyers) and on public morality (attacking the principles of Christian marriage, undermining patriotism) was thought to be adequately curbed by preventive censorship. Two offices in Berlin and Munich rated films accordingly, with a head office in Berlin to review appeals. Censorship committees included representatives from the film industry, from the arts or the academic community, as well as two officers from the domain of public health, education or youth welfare. The chair of the committee, a civil servant, had no voting powers. Members of censorship committees were nominated by the ministry of internal affairs; a number of cinema reformers thus became censors.

The norms of censorship reflected the standards of the conservative establishment. Many decisions of Weimar censors show political bias: danger to the state was mainly anticipated from the left, with lenience being shown to threats from the right. Demonstrations to boycott the *Fridericus Rex* films in 1922/23 and *Das Flötenkonzert von Sanssouci* (1930) did not lead to a ban, but films such as *Bronenosets Potemkin/ Battleship Potemkin* (German release 1926), *Cyankali* (1930) and *All Quiet on the Western Front* (German release 1930) were partly banned or released only with significant editing changes (either at the request of the censorship office or by distributors exercising voluntary self-censorship).

In the Third Reich, Weimar's censorship practices remained largely intact. Censorship was, however, re-structured and broadened to include production and pre-production. The *Reichsfilmkammer* (National Department of Film) was set up, a film funding system was introduced, and the office of the *Reichsfilmdramaturg* was established [> NATIONAL SOCIALISM AND GERMAN CINEMA]. Censorship of completed films became less important, since membership of the *Reichsfilmkammer* became mandatory. In addition, film funding was possible only through government institutions, due to the economic weakness of the German film industry [> EXPORT (COMPANIES)]. From February to December 1934, copies of all scripts had to be submitted to the office of the *Reichsfilmdramaturg* and, most importantly, the film industry became state-owned. Thus, the number of banned films

during the Third Reich was small (about two dozen in all), since control of the finished product was already established at the production stage.

Preventive censorship, i.e. of completed films prior to release, was modified by the Nazis in two respects. First, more criteria justifying outright banning were introduced, including grounds of ideology and taste ('Gesinnungs- und Geschmackszensur'), to ensure that no film contradicted Nazi political and artistic values. Also, a censored and approved film could be banned from domestic exhibition, if an uncensored version was known to be shown abroad. Second, reorganisation at ministerial level tightened the censorship system: the Ministry of Internal Affairs handed over its traditional task of censorship to the Ministry of Popular Enlightenment and Propaganda under Joseph Goebbels. The *Führerprinzip* ('principle of leadership') meant that the Munich censorship office was closed down and that Goebbels could override the decisions of the Berlin office, banning films which had previously been approved, and granting chairmen the right to take decisions on behalf of the committees they presided over. The Weimar Republic's practice of making censorship decisions public was abolished.

After World War II, the Allied authorities controlled censorship in their respective occupation zones, handing over in time to the Government of the Federal Republic, which passed censorship on to the industry itself (in imitation of the American film industry's code of practice). The *Freiwillige Selbstkontrolle der Filmwirtschaft* (FSK, Film Industry's Voluntary Self-Censorship), established in July 1949, in the interest of its industry members, tried to make federal censorship unnecessary by anticipating objections from police, the state procecutor's office, the Churches. The FSK had a censorship monopoly, i.e. all films released in West Germany had to be given a rating. Were they to flout these recommendations, distributors and exhibitors faced legal and economic pressures from the FSK.

The principles and organization of the FSK were based on the Weimar Republic's preventive censorship system. Due to the new political situation (the Allied Forces' defeat of Nazi Germany, the Cold War), anti-democratic films (including films promoting national-socialism and bolshevism) were prohibited from distribution. As in the Weimar Republic, committees were composed of members from the public sector (federal and state politicians, representatives from the Churches, members of federal youth associations) and from the film industry. However, unlike the Weimar Republic, disagreements were decided by the committee chair, drawn from the film industry.

The FSK sees itself as representing 'the public interest' rather than acting on behalf of a government or establishment. In the 1950s, films were censored if they seemed to offend German audiences' taste (for example, when John Houston's *The African Queen* [1951] was to be shown in Germany, its anti-German bias was deemed offensive, and a re-edited version of the film went on release in 1958). As values began

to change radically in the 1960s so did public opinion [> AMERICAN FILMS IN GERMANY; GERMAN CINEMA: SEX FILMS], and FSK decisions adapted accordingly, making, among others, the 'ugly' German an acceptable figure. A major change occurred to the FSK's brief in January 1972, when it ceased to censor films for adults (viewers of 18 years and over), and approved films for children and minors only. For the first time since 1920, adults were able to watch films in Germany free from the strictures of a central censorship office. JG

Bib: Martin Loiperdinger, 'Filmzensur und Selbstkontrolle', in W. Jacobsen/A. Kaes/H. H. Prinzler (eds), *Geschichte des deutschen Films* (1993).

CHARELL, Erik Breslau, 1894 – Munich, 1974

German director who assisted Max Reinhardt* in the production of the mystery play 'Miracle' at the Central Theatre in New York in 1923. On his return to Germany, and on Reinhardt's recommendation, Charell became artistic manager of the *Großes Schauspielhaus* in Berlin. There he emerged as the city's foremost specialist in opulent productions of operetta revues. In 1931 Erich Pommer* offered him the direction of *Der Kongreß tanzt*, Ufa's* most expensive project since *Metropolis* (4 million marks). An operetta film set against the background of the Congress of Vienna in 1814/15 and starring Lilian Harvey* and Willy Fritsch*, it proved to be one of the highpoints of Ufa's early sound productions. New to film, Charell created a virtuoso synthesis of choreography, musical montage and a smooth narrative flow, which enchanted audiences in Germany and abroad (French and English versions were released the same year). Despite his overnight fame, Charell left Nazi Germany for England, making his second and last film of the genre in Hollywood (*Caravan*, 1934). MW

CINEMA AND STATE

Whereas the American government sought to ensure the American film industry's economic success, the German state has traditionally been concerned with making the domestic film industry subservient to the national interest as interpreted by the government. Other priorities included levying special taxes, influencing the audience ideologically and pedagogically, or raising cultural standards. Unlike Germany's democracies (the Weimar Republic (1918–1933) and the Federal Republic of Germany (1949–)), the centrally-organised states of the *Kaiserreich* (1871–1918), the Third Reich (1933–1945), and the German Democratic Republic (1949–1990) have attempted to control the film industry from the top. To achieve these goals, both the democratic and non-democratic governments of Germany institutionalised

numerous mechanisms for controlling film production, distribution* and exhibition*. These methods include entertainment tax, film funding, film-rating systems, quota systems and censorship*. Some of these mechanisms, such as the nationalisation of Germany's private film industry or the dictating of employment policy in the film industry, were only used by the non-democratic governments of Germany.

All German governments considered the film industry a convenient source of revenue. Entertainment taxes were introduced in 1910, making it difficult for German film companies to show a profit on the domestic market [> EXPORT COMPANIES]. The government began to use the entertainment tax in 1926 to punish or reward film companies for making the types of films it approved of. The tax worked in conjunction with a film-rating system. Films which the semi-private 'Central Institute for Education and Training' ('Zentralinstitut für Erziehung und Unterricht') approved of were given a certain rating. The rating entitled the films either to reduction of, or even exemption from entertainment tax. The tax was not abolished in most federal states until the 1970s, and entailed a dwindling of the influence exerted by the rating system generally.

The German government introduced a quota law in 1921, limiting the number of foreign films allowed to be shown in Germany, but the measure, intended to protect the German film market against foreign dominance, did not achieve its goal. Since the German public actually preferred German films to foreign films at this time [> AMERICAN FILMS IN GERMANY], quotas were not only regularly ignored or circumvented, they also proved politically motivated rather than economically necessary. After a period of hyperinflation in Germany, a new quota law was introduced in 1925 to attract foreign currency into the country. In order to receive permission to show their films in Germany, the American film industry was forced to help finance German film productions (an example of an American-funded 'quota quickie' destined to become a classic was *Berlin, die Sinfonie der Großstadt/Berlin, Symphony of a City* [1927]). Quota systems were dispensed with, following pressure from the US authorities after World War II.

The German government also tried to support the film industry in times of economic crisis. For instance, exports of German films fell dramatically during the Third Reich and the government responded by lowering the entertainment tax by 50%. The government also made funding available to the film industry in the form of credits or subsidies to offset production costs. Often used to impose political or aesthetic norms, film funding was introduced during the Third Reich and was reintroduced in West Germany during the early 1950s and expanded in the late 1960s. Ideological conformism was the precondition for film funding during the Third Reich whilst state-funded films in West Germany were expected to comply with the standards of the cultural elite in the 1970s [> FILM AWARDS].

All of Germany's non-democratic governments modified existing means of controlling film production, such as censorship* and film-

rating, to further their own political ends. In addition, they invented methods different from those used by Germany's democratic governments to ensure that government authorities would control the German film industry. Only non-democratic governments undertook the nationalisation of the film industry. This took place for the first time during World War I under the auspices of the 'Picture and Film Office' ('Bild- und Filmamt' – Bufa). The office, founded in 1917, was in charge of centralising the production of German propaganda films and promoting the use of propaganda films in the war effort. Through Bufa's efforts, German film production for a while was concentrated in the hands of the military, leading to the founding of Ufa* in 1917, often seen as an attempt to create a powerful instrument of state control for the postwar period. This aspiration was never realised and the German government sold its Ufa* shares to the Deutsche Bank after World War I. Apart from movie houses, which remained in private hands, the National Socialists nationalised the German film industry in stages beginning in 1937. The National Socialists managed to control the German film industry years before it became state-owned [> NATIONAL SOCIALISM AND GERMAN CINEMA]. Thus the Ministry of Propaganda as early as 1933 introduced measures and revised established practices to ensure that the government could exercise full control over the film industry, for example shifting control of the finished product to control over the pre-production and production phases of the film. Such measures included the expulsion of Jews from the film industry, the financing of film productions through the government-controlled *Filmkreditbank*, censorship of screenplays and modifications of the film-rating system. Both the National Socialists (NSDAP) and the GDR Communists (SED) used their respective nationalised film industries to promote party policies as well. JG

CINEMATOGRAPHERS

At the turn of the century, the different tasks involved in making films (equipment manufacture, camerawork, directing, film development and copying) were often in the hands of a single individual (e.g. Max Skladanowsky*, Guido Seeber*). As the German film industry established itself around 1910 [> WILHELMINE CINEMA, DISTRIBUTION, EXHIBITION], the division of labour permeated all aspects, including the creative functions, thus allowing one to identify a distinct role for the cinematographer.

Despite a hierarchy headed by the director, film production in Germany displayed close co-operation among members of a team until well into the 1920s. Directors and cinematographers usually worked together over a long period of time, as in the case of Friedrich Wilhelm Murnau* and Karl Freund*, or Fritz Lang* and Fritz Arno Wagner*. German cinematographers often had more than a technical background, and were in touch with artistic developments in the other

visual and dramatic arts. For instance, low-key lighting found its inspiration in painting ('Rembrandt lighting'), while the plays staged by Max Reinhardt* exerted a strong influence on the design of sets and how to light them. Another German 'innovation', the mobile camera, whether hand-held or mounted on wheels may well have been inspired by the Futurists' experiments with rendering motion. Technical innovations in camera equipment gave rise to new aesthetic goals, which in turn demanded new practical solutions: reduced weight of cameras and more light-sensitive film were the result of bringing films closer to the aesthetic standards of avant-garde still photography.

The era of experimentation began with Guido Seeber*, but blossomed during the time when Erich Pommer* ran production at Ufa*. Pommer allowed creative talent great freedom in planning and producing films; nonetheless, artistic freedom also existed at other studios. Thus a cinematographer such as Sepp Allgeier*, who later trained Richard Angst and Hans Schneeberger, had the chance to become a pioneer in the filming of sports events [> HEIMAT FILMS AND MOUNTAIN FILMS].

Cinematographers were well-served by a variety of specialist publications (*Die Kinotechnik, Kinotechnisches Jahrbuch,* published for the *Deutsche Kinotechnische Gesellschaft* in Berlin by G. Hackebeil 1922–23; *Theorie und Praxis der kinematographischen Aufnahmetechnik,* by Guido Seeber* and G. V. Mendel in 3 volumes, 1927). In addition, the *Verband der Kameraleute Deutschlands* (Association of German Cinematographers), established in 1925, created a trade forum for technical aspects of film-making and aimed to represent the profession's interests.

As the producer-unit system was introduced at Ufa* in 1927 and as sound film caused production costs to soar, room for creativity on the part of the cinematographer began to shrink. Opportunities to experiment on the set dwindled; films were more tightly shot according to the shooting script which often specified technical detail (camera movement, shot size).

As costs and technology curtailed room for creativity, the high status that cinematographers commanded during the 1920s was lost during the 1930s. Those eager to experiment both artistically and technically were marginalised (e.g. Willy Zielke), and competent craftsman (e.g. Willy Winterstein und Klaus von Rautenfeld) were sought out by the studios. With rationalisation of production, training of cameramen also changed. After Guido Seeber*, Karl Freund* and others (many of whom began as still photographers), the second generation apprenticed as assistants, while the third was trained professionally, e.g. at the *Deutsche Filmakademie* (German Film Academy), established in 1938 to relieve the burden of training on the set [> FILM SCHOOLS].

The introduction of sound did not lead to the specialisation of camerawork as it did in the USA [> FILM TECHNOLOGY]. With the rise of multi-camera set-ups in the early sound era, the number of camera

operators in Hollywood increased, with the director of photography becoming an executive who supervised a team of 'camera operators'. The multiple-camera system came into use because Hollywood used the sound-on-disc system; in Germany, the sound-on-film system became the industry standard and therefore the cameraman's job was never broken down into specialised functions. Production credits from 1940 list only three types of function: the chief cinematographer, the assistant cameraman and the trainee volunteer. As in Hollywood, there were, however, cameramen in Germany who were experts in special effects, such as Eugen Schüfftan* and Theodor Nischwitz.

Many German cinematographers left for Hollywood, such as Karl Freund*, Curt Courant*, Eugen Schüfftan*, Franz Planer, the latter because they were discriminated against by the regime after 1933 [> EMIGRATION]. During the Nazi period, documentary, propaganda and newsreel work became the ambiguously outstanding technical training ground for Germany's leading postwar cinematographers. Starting in the 1960s, no doubt partly because of the break-up of the old studio-system, cinematographers began regaining their high status as the most trusted partner of the director. Film-makers of the New German Cinema* in the 1970s and 1980s preferred to work on an ongoing basis with particular cinematographers (Wim Wenders* with Robby Müller*; Rainer Werner Fassbinder* with Michael Ballhaus* and Xaver Schwarzenberger*; Werner Herzog* with Thomas Mauch and Jörg Schmidt-Reitwein), reverting to the practices of the 1920s, and allowing these cinematographers to make a major contribution to a director's style and greatly enhancing the New German Cinema's reputation as a 'visionary' cinema.

Owing to this different film-making culture during the 1920s as well as the 1970s, German cinematographers have traditionally enjoyed high prestige abroad, and can be said to have been the backbone of the German cinema's 'influence' on other national cinemas, genres and styles, notably poetic realism in France and *film noir* in the United States. From the 1920s onwards, German cinematographers regularly received offers from American film companies which sought to appropriate their special talents for their own productions. In return, German cinematographers found better pay, improved technical standards and better marketing for their films under the American system of film production. The particular visual styles developed in collaboration with the *auteur*-directors in Germany proved supple enough to incorporate the conventions of American genres (e.g. Karl Freund's* horror films of the early 1930s for Universal). There have been similarly successful collaborations with New Hollywood *auteurs*, such as Michael Ballhaus* for Martin Scorsese or Robby Müller* for Jim Jarmusch, while Francis Ford Coppola particularly admired the camerawork on Werner Herzog*'s films. JG

Bib: Michael Esser (ed.), *Gleissende Schatten: Kameraleute der 20er Jahre* (1994).

COMEDY: AUSTRIA

The most common type of Austrian cinematic comedy is the cabaret film. In the 1930s a special form of protest against Austrian fascism developed on small stages. A brilliant game of coding and decoding between actors and audience, it was a common struggle against censorship. Dramatic and terpsichorean bravado, wordplay in the Jewish tradition, improvisation, political and sexual suggestion, and sharp-tongued criticism of current events characterised Viennese cabaret and were influential on comic actors who then crossed over to film: Fritz Grünbaum (*Mädchen zum Heiraten*, 1932), Karl Farkas (*In der Theateragentur*, 1930 [short]), Fritz Imhoff (*Episode*, 1935; *Opernring*, 1936; *Schrammeln*, 1944; *Der Feldherrnhügel*, 1953), Hans Moser* (*Ungeküßt soll man nicht schlafen gehen*, 1936), Hugo Gottschlich, Josef Meinrad, Helmut Qualtinger*, and others. They all learned the art of using a pointedly raised brow, deft wordplay and grotesque expressions, though the explosive power of the political humour from the stage was substantially toned down in the films; this genre was gradually abandoned in favour of more harmless and less topical subjects in the postwar period. The cabaret traditions were, however, revived in the so-called 'New Austrian Film' of the 1980s and 1990s, to great popular success, since the most successful productions either borrowed from cabaret or were cabaret numbers adapted for film: *Müllers Büro* (1986, dir. Niki List*), *Muttertag* (1993, dir. Harald Sicheritz) and *Indien* (1993, dir. Paul Harather). AL

COMEDY: GERMANY

The financial backbone of the German film industry throughout its history was the continuous national popularity and success of light entertainment comedies, or *Lustspielfilme*. Until the early 1910s, German film comedy derived from variety, cartoon and slapstick traditions. As the few surviving films prove, the comic one-, two- or three-reelers revealed strong elements of subversive, grotesque and surrealist humour, as in the films of Heinrich Bolten-Baeckers, Leo Peuckert, Karl Valentin*, or the early Ernst Lubitsch*. While both Lubitsch (*Die Austernprinzessin*, 1919) and Reinhold Schünzel* (*Hallo Caesar*, 1927) took up the episodic cinema of attractions and grotesquerie, they also incorporated strong elements from operetta (*Madame Dubarry*, 1919, *Der Juxbaron*, 1926), which were to become of considerable importance in musical comedies after the introduction of sound in 1929.

With the hitherto strong Jewish contribution (Max Mack*, Victor Janson, Lubitsch, Schünzel among the directors, Felix Bressart, Julius Falkenstein, Paul Biensfeldt and Curt Bois* among the actors) vanishing from the German screen by the mid-1930s, Nazi comedy lacked its previous surreal and self-ironic dimension. Instead it was domi-

nated by musical comedies and revue films, watered down versions of contemporary American screwball comedies along with characteristically apolitical – though ideologically by no means neutral – comedies centred on the everyday problems of the petit-bourgeois male, whose most successful screen incarnation became Heinz Rühmann* in films such as *Der Mustergatte* (1937) and *Hauptsache glücklich* (1941).

The first postwar years produced a few comedies notable for their satirical treatment of contemporary social issues (*Berliner Ballade*, 1948; *Herrliche Zeiten*, 1950), but by the 1950s, with Germany's economic recovery under way, the film industry returned to politically non-committal entertainment, in line with a public taste unchanged since sound was introduced in the 1930s. Heading the popularity stakes among directors was Kurt Hoffmann*, and among the actors (apart from Rühmann) was Heinz Erhardt*, who became notorious for his bad puns and nonsense repartee. Musical comedies starring contemporary pop idols Peter Kraus and Conny Froboess also enjoyed a brief but significant vogue. When the cinema first tried to compete with television in the late 1960s and 1970s, a number of hugely popular series emerged by directors such as Harald Reinl* and Werner Jacobs, following an ever more rigid formula which reinforced innocuous nostalgia for monstrously stupid teachers and classroom pranks (modelled initially on one of Rühmann's greatest hits, *Die Feuerzangenbowle*, 1944). Equally successful at that time were regionally differentiated, but more often than not Bavarian, sex comedies.

After a long period of stagnation, German comedy once more gained national and international attention with Doris Dörrie's* well-crafted romantic-farcical love triangle *Männer.../Men* (1985). Keeping up the momentum, if in a somewhat less sophisticated direction, are a number of contemporary star comedians ('Otto' Waalkes, 'Loriot'), crossing over from television into features which were among the most successful German film productions of the 1980s, usually thought of as the decade of the New German Cinema*. While the 1990s were a lean period for German art cinema, it is once more the comedies, such as *Schtonk* (1992), about the persistence of the Nazi past, lifestyle comedies or the East/West comedies by Detlev Buck* which have determined the filmic image of the period [> INTRODUCTION]. MW/TE

CONSTANTIN

German production and distribution company, founded in 1949. Constantin enjoyed a meteoric rise because of its dominant role as a small to medium production unit, its exclusive distribution contracts with producers Horst Wendlandt and Wolf C. Hartwig and, finally, its ability to create a market niche based on product differentiation. Constantin's owner, Waldfried Barthel, developed a double strategy for capturing dwindling audiences. He attracted the younger, more

mobile moviegoers with film series targeted at teenagers and he took sex films out of the porn shops, making them respectable to adult movie audiences. Barthel also enhanced his production values, strategically deploying technological advances unavailable on television, such as colour and wide-screen. Constantin commissioned the most successful commercial film series of the postwar period, especially the thirty-six-part Edgar Wallace series produced by Wendtland (1959–72) and the seventeen-part Karl May series, also produced by Wendtland (1962–68). Constantin's other strategy was to adapt series or make clones from rival distributors' one-off hits, cashing in, for instance, on the success of the sex education film *Helga* (1967).

When American films overtook German films at the box-office in the early 1970s, Constantin went bankrupt (1977). Neue Constantin, founded to retain the brand name, has been managed by Bernd Eichinger, who changed the company's production and distribution strategies, specialising in blockbuster genres for worldwide distribution: action films such as *Das Boot* (1981), or adaptations of literary best-sellers like *Der Name der Rose/Le Nom de la rose/The Name of the Rose* (1986, dir. Jean-Jacques Annaud). JG/TE

CORTI, Axel Paris 1933 – Vienna 1993

Austrian director. Corti worked for Austrian radio and theatre before directing feature films for Austrian television in the 1960s, mainly docu-dramas and ambitious literary adaptations. He was the last director to make a film with actor Hans Moser* (*Kaiser Joseph und die Bahnwärterstochter*, 1962). His trilogy *Wohin und zurück* (1982–85), about an emigrant who escapes the Nazi regime in 1938, makes it to America and returns as a US soldier to his home country in 1945, received critical acclaim and prizes abroad, including the (German) Adolf Grimme Prize in 1987, for its sensitive treatment of the experience of forced emigration. IR

Other Films Include: *Der Fall Jägerstätter* (1971); *Eine blaßblaue Frauenschrift* (1984); *The King's Whore/Die Hure des Königs* (1990).

COURANT, Curt Berlin 1899 – Los Angeles,
California 1968

German cinematographer, who began his career in Italy and entered German film as cameraman on Joe May's* *Hilde Warren und der Tod* (1917). At first a craftsman rather than a creative force in his own right, his name could be found on the credits of films by virtually all the major commercial directors of the Weimar years, such as Rudolf Biebrach and Reinhold Schünzel*, Georg Jacoby* and Ludwig

Berger*, Kurt Bernhardt* and Carl Froelich*. His most prestigious German assignment came in 1929, when he did principal cinematography on Fritz Lang's* *Die Frau im Mond/Woman on the Moon*. His stint with Lang stood him in good stead after he was forced into exile in 1933: in Britain, he worked with Alfred Hitchcock* (*The Man Who Knew Too Much*, 1934), and Berthold Viertel (*The Passing of the Third Floor Back*, 1935). In France, where his reputation was highest, he shot Jean Renoir's *La Bête humaine* (1938), Marcel Carné's *Le Jour se lève* (1939), a film by Abel Gance (*Louise*, 1939), and Max Ophuls'* *De Mayerling a Sarajévo* (1940). In the US he photographed Chaplin's *Monsieur Verdoux* (1947) and, at the height of his fame, seems virtually to have retired, for not much is known of him thereafter, though he did shoot another film in 1961. TE

CROSS-SECTION FILM (Querschnittsfilm)

Cross-section films, unlike classical narrative cinema, do not construct linear plots, but are associative collages of usually unstaged moments of filmed 'reality'. The creative principles are those of abstract, 'absolute' avant-garde film, freely deploying painted, textured surfaces, colours and lines, as in such manifesto-works as Walter Ruttmann's* *Lichtspiel Opus I–VI* (1919–25) and Oskar Fischinger's *Studien 1–13* (1921–32). Their aesthetic tenets form the structuring principles of the cross-section films, which ignore the 'real' time and space of filmed events and organise their 'documents of reality' primarily according to graphic and rhythmic principles. Ruttmann's *Berlin, die Sinfonie der Großstadt/ Berlin, Symphony of a City* (1927), the prototype of the genre, was widely imitated in France and the Soviet Union. Ruttmann organised an impressionistic collage of a Berlin working day according to musical principles to create five 'movements'. Cross-section films were cinematic experiments which, for a brief period, found market niches. *Berlin, Symphony of a City*, for instance, was financed by Fox Europa to fulfil quota requirements [> CINEMA AND STATE] while Ruttmann's *Melodie der Welt* (1929), an early experiment in sound film, was produced by the Hamburg-Amerika shipping line to advertise their company. Cross-section films' rhythmical and associative style influenced standard films of the industry, appealing even to feature filmmakers when creating montage sequences (e.g. Vorkapitsch's work in Hollywood). Typically, such montage sequences functioned as bridging devices to condense prolonged periods of time or to evoke a particular era (as in *Die Umwege des schönen Karl* (1938)). JG

CZIFFRA, Geza von Arad 1900 – Dießen, Bavaria 1989

Austrian director. After his debut with the puppet movie *Gullivers Reisen* (1922), Cziffra went to Berlin in 1923, where he published lit-

erary and political articles and worked as an assistant director. A major figure in the Hungarian cinema after 1933, he was contracted by Wien-Film in 1941, for which, two years later, he directed the box-office hit *Der Weisse Traum* (1943), a melodramatic musical-on-ice. Immediately after the war he returned to Vienna and established the first production company licensed by the American forces in liberated Austria. In 1952 he set up his second and more successful company, Arion-Film, and was able to re-establish his reputation as a director of popular revue films. His twelve Peter Alexander* movies (including *Das haut hin*, 1957; *Schlag auf Schlag*, 1959; *Charleys Tante*, 1963) decisively shaped the German musical and light entertainment cinema of the 1950s and 1960s. MW

CZINNER, Paul Budapest 1890 – London 1972

Hungarian-born director, who began his career with Expressionist* films (*Homo immanis*, 1919; *Inferno*, 1919). From 1924 he worked regularly with his future wife Elisabeth Bergner* and with Carl Mayer*, making popular variations of the *Kammerspielfilm** (*Nju*, 1924; *Fräulein Else*, 1929; *Der träumende Mund/Dreaming Lips*, 1932), as well as the occasional historical costume drama (*Liebe*, 1926), cross-dressing comedy (*Der Geiger von Florenz/Impetuous Youth/The Violinist of Florence*, 1926), or a mixture of both (*Dona Juana*, 1927). All his German films contained exceptional star casts, including Bergner, Emil Jannings*, Conrad Veidt*, Rudolf Forster, Max Schreck and Alfred Bassermann, around each of whom Czinner knew how to create an appropriate cinematic frame, notable for its exceptional mobility.

In 1933, Czinner and Bergner emigrated to Britain, where they tried to adapt their brand of bitter-sweet melodrama to English tastes, with limited success. In 1939 they went to Hollywood, but were unable to work on further co-productions. In 1949 Czinner returned to Europe, directing ballet and opera films (*Don Giovanni*, 1955) and documentaries on European music and dance theatres. MW

Other Films Include: *The Woman He Scorned* (1929, UK); *Ariane* (1931); *As You Like It* (1936, UK).

D

DAGOVER, Lil
Java 1897 – Munich 1980

German actress, one of the international stars to emerge from the German cinema in the 1920s and 1930s. She had her screen debut in Fritz Lang's* exotic costume drama *Harakiri* (1919), in which she first practised her unfocused offscreen look. An abstract element in Lang's *mise-en-scène*, but also capable of connoting emotional turmoil and nameless dread, this look was Dagover's most memorable acting contribution to her best-known part as Jane in Robert Wiene's* *Das Cabinet des Dr Caligari/The Cabinet of Dr Caligari* (1920), adding greatly to the film's ambiguous tone, somewhere between horror and fascinated desire.

Dagover's skill with ocular excess gave depth to the mostly melodramatic roles she played in other Lang films, such as *Der müde Tod/Destiny* (1921) and *Dr Mabuse, der Spieler/Dr Mabuse, the Gambler* (1922), and F. W. Murnau's* *Phantom* (1922), making her an actress at once typically 'expressionist' and at the threshold of the transition from Henny Porten* to the *femmes fatales* of Weimar* cinema, such as Louise Brooks* and Marlene Dietrich*. In the 1970s, on talk shows and in interviews, she credibly represented Weimar cinema, giving its blessing to the neo-romantics of the New German Cinema*. TE/MW

Other Films Include: *Die Spinnen* (1919); *Tartüff* (1926); *Orient Express* (1927); *Der Kongress tanzt* (1931); *Schlußakkord* (1936); *Buddenbrooks* (1959); *Der Richter und sein Henker/End of the Game* (1976).

DAVIDSON, Paul
Loetzen, East Prussia 1867 – Berlin 1927

German producer, who could scarcely know, when he founded the Allgemeine Kinematographen in Frankfurt in 1906, that it would make him one of the fathers of the German film industry. From equipment to theatres, from theatres to film exchanges, and from exchanges to studios, Davidson's rapid progress shows how thoroughly he had grasped the logic of the film business, which rests on the interlocking cogs of exhibition, distribution and production.

Davidson's early objective was to build up a chain of cinemas. Profits from his Union-Theater (UT), the largest in Germany at the time, and sited in prime locations in many regional industrial centres as well as Berlin and Brussels, gave him the capital to reorganise, by

1909, his different activities into the Projektions AG 'Union' (PAGU*), Germany's first vertically integrated film company. Moving operations to Berlin in 1913, he remodelled his UT at Berlin's Alexanderplatz into the country's biggest *Filmpalast*, with a capacity of 1,200 seats, and also converted his 1911 distribution contract with Asta Nielsen* (and her director-husband Urban Gad) into a production agreement for eight films per year, building for her the necessary studio space. Aware of the debates around the *Autorenfilm** and the need for cultural legitimacy, Davidson offered Max Reinhardt* a three-year contract in 1913 worth an astounding 200,000 Marks.

In 1914, Davidson 'discovered' Ernst Lubitsch*, starting a collaboration which lasted for nearly ten years and over thirty-five films. In 1917, Davidson sold PAGU to the newly founded Ufa*, retaining producer's rights and a seat on the board. Lubitsch's epic spectaculars such as *Madame Dubarry* (1919) and *Anna Boleyn* (1920) were all produced by Davidson, who was instrumental in the director getting his offer from Hollywood. Lubitsch's departure proved fatal: the Ufa subsidiary Paul Davidson-Film, set up in 1924, never found its stride and had ceased trading by spring 1927. A few months later, Davidson committed suicide. TE/MW

DEFA

East German production company licensed by the Soviet Allies on 17 May, 1946. Originally based on the Berlin 'Filmaktiv', a filmmakers' collective comprising such key figures as director Kurt Maetzig*, set-designer Carl Haacker, Willy Schiller, and Hans Klering, DEFA (Deutsche Film AG) started as a limited company (GmbH), concerned only with production. In November 1947, with the participation of the Moscow distribution company Sovexport, DEFA was relaunched as a German-Soviet joint-stock company (AG), to be handed over to the East German authorities and become a nationally-owned company (Volkseigener Betrieb, VEB) in 1953. By the mid-1960s DEFA also handled distribution, at home through the 'Progress-Filmverleih', and abroad through 'DEFA-Außenhandel', leading to internal restructuring and diversification: feature film production, popular science films (until 1969), short and documentary films* (some 100 cinema and TV productions annually, plus the newsreel* *Der Augenzeuge*), animation (from 1955; c. 55 films per year), dubbing, printing laboratory, and the 'DEFA-Filmübernahme und Außenhandelsbetrieb'. The feature films division, with an annual average of 15 features from the mid-1950s onwards, produced between 1946 and 1990 approximately 12% of all feature films released in East German cinemas.

From 1947 DEFA used the full Ufa* studio capacities in Babelsberg and became not only the first, but also the largest German postwar production company, earning for itself considerable international

prestige. This position entailed a fundamental paradox in that the new company's avowed ideological orientation was socialist, reflected in its choice of film genres ('ruin films', 'reconstruction-films', 'proletarian films', 'anti-fascist films'), while at the same time, it had to fall back not only on the technical facilities and personnel, but also on some of the stylistic traditions of Babelsberg's politically compromised Ufa-past. In the first years after the war, for instance, the list of DEFA employees included established directors such as Werner Hochbaum, Erich Engel*, Günther Rittau (director of *U-Boote Westwärts*, 1941), Erich Waschneck* (director of *Die Rothschilds*, 1940), Hans Deppe*, Gerhard Lamprecht*, and Arthur Maria Rabenalt* (director of ... *reitet für Deutschland*, 1941). Although the presence of ex-Nazi personnel was by no means as conspicious as in the West, with DEFA making determined efforts to open the studio to returning exiles (e.g. Wilhelm Dieterle*, Slatan Dudow) and international directors (e.g. Roberto Rossellini), some historical continuities might appear symptomatic: Hans Heinrich, for instance, as the studio's chief editor was responsible for *Die Drei Coronas* (1940) and *Ohm Krüger* (1941) as well as for the first DEFA production *Die Mörder sind unter uns* (Wolfgang Staudte*, 1946) and *Rotation* (Staudte, 1949). The same composer, Wolfgang Zeller, wrote the music score to Veit Harlan's* *Jud Süß* (1940) as well as to Kurt Maetzig's* *Ehe im Schatten* (1947), the story of a Jewish actor driven to suicide by the Nazis. Continuity of personnel, however, need not be identical with perpetuating either style or ideology, as in the case of the semi-documentary *Freies Land* (1946) by Milo Harbich, who had been an editor on *Hitlerjunge Quex* (1933).

After Sepp Schwab was put in charge of DEFA in 1949, the early 1950s saw a determined effort to eliminate the 'disruptive effects' of both DEFA's Expressionist (*Wozzeck*, 1947) and satirical (Staudte's *Der Untertan/The Kaiser's Lackey*, 1951) heritage, signalling that ideological correctness was to be more important than the expertise of veterans such as Engel, Rabenalt, Lamprecht, Staudte, and Paul Verhoeven, all of whom were shed or left in the course of the decade. Those who stayed, headed by the director of *Kuhle Wampe* (1931), the Bulgarian Slatan Dudow (*Unser täglich Brot/Our Daily Bread*, 1949; *Familie Benthin/The Benthin Family*, 1950; *Frauenschicksale*, 1952; *Der Hauptmann von Köln*, 1956; *Stärker als die Nacht*, 1954), and including Martin Hellberg (*Das verurteilte Dorf/The Condemned Village*, 1951; *Geheimakten Solvay/The Solvay Dossier*, 1952), Kurt Maetzig (*Rat der Götter/Divine Councils*, 1950, the *Ernst Thälmann* films, 1954/55) and the documentary film-maker Andrew Thorndike (*Sieben vom Rhein/Seven from the Rhine*, 1954), subscribed more or less readily to the aesthetic doctrine of 'socialist realism', and put their often considerable artistic potentials at the service of the young GDR state, looking for ideological and historical self-definition.

The political 'thaw' of the late 1950s and early 1960s saw DEFA venture into popular genre films (musicals, comedies, *Indianerfilme*,

directed by Richard Groschopp, Roland Oehme, Joachim Hassler, Günther Reisch and others). Negotiating the shifting sands of political conformity, social relevance and stylistic self-expression, a new generation of DEFA directors began to claim for themselves a share of the radicalism they could observe in Italian neo-realism and the young East European cinemas: Konrad Wolf*, Frank Beyer*, Jürgen Böttcher, Gerhard Klein, Günther Rücker, Egon Günther*, Ralf Kirsten, Joachim Kunert, Heiner Carow, Frank Vogel began to make so-called '*Gegenwartsfilme*' ('films of the present'), probing alternative ways of showing everyday reality in the cinema. Films such as Klein's *Berlin – Ecke Schönhauser* (1957), Maetzig's *Septemberliebe* (1961), Kirsten's *Beschreibung eines Sommers* (1963), Wolf's *Der geteilte Himmel* (1964) and *Ich war neunzehn* (1968), or Carow's *Die Legende von Paul und Paula* (1973) laid the foundation for a distinctively new DEFA tradition, which was taken up in the 1970s and early 1980s by other directors such as Hermann Zschoche (e.g. *Sieben Sommersprossen*, 1978), Helmut Dziuba (*Erscheinen Pflicht*, 1984), Lothar Warneke (e.g. *Leben mit Uwe*, 1974), Rainer Simon (*Jadup und Boel*, 1980/1988), Horst Seemann (*Zeit zu leben*, 1969), Iris Gusner (*Alle meine Mädchen*, 1980), Roland Gräf (*Märkische Forschungen*, 1982), Siegfried Kühn (*Zeit der Störche*, 1971), or Evelyn Schmidt (*Das Fahrrad*, 1982). With Jutta Hoffmann, Manfred Krug*, Erwin Geschonneck, Armin Müller-Stahl*, Angelica Domröse, Katharina Thalbach, Renate Krößner, Katrin Saß, Ulrich Thein and Gisela Trowe they also introduced a new generation of actors and actresses to the screen, some of whom eventually found stardom in the West. Supported by top screenwriters such as Wolfgang Kohlhaase*, Ulrich Plenzdorf, Helga Schütz, cinematographers like Werner Bergmann, Günther Ost, Roland Dressel, Klaus Neumann, and Thomas Plenert, the set designer Alfred Hirschmann, and film editors such as Evelyn Carow, Erika Lehmpfuhl, and Monika Schindler, the DEFA films from the 1960s onwards will stand as enduring testimony of a film-making practice that attempted to reflect socialist realities while trying to keep faith in a political ideal. The reverse side of these realities – the standing in line for production money, the jockeying for positions, promotions and permissions, the practices of censorship*, the power of political functionaries right down to the film reviews – are in the end just as visible, and form part of these films' moral and political legacy.

Naturally, the more critical view, often glimpsed from behind the veil of comedy*, of literary adaptations, or even children's and youth films (a genre especially nurtured by the DEFA, forming over 5% of all feature films released between 1953 and 1989), demanded its price. As the State's official, centralised film company, occupying a monopoly position and trading under the name of the Ministry of Culture, DEFA was tethered to the party line. The 11th Plenum of the Central Committee of the *Sozialistische Einheitspartei Deutschlands* (SED), held in December 1965, stands as the most restrictive official course

correction in the life of DEFA, resulting in a ban of nearly the entire annual feature film output. Maetzig's *Das Kaninchen bin Ich*, Vogel's *Denk bloß nicht, ich heule*, Beyer's *Spur der Steine*, Egon Günther's* *Wenn du groß bist, lieber Adam*, Jürgen Böttcher's *Jahrgang 45*, Kurt Barthel's *Fräulein Schmetterling*, and Hermann Zschoche's *Karla*), found themselves variously branded as 'modernistic, nihilistic, anarchistic and pornographic' films.

After the fall of the GDR regime in 1990, DEFA facilities and personnel were put under the administration of trustees who, in December 1992, sold the Babelsberg studio complex to the French business conglomerate 'Compagnie Générale des Eaux' (CGE). In order to fulfil its undertaking to maintain feature production at the site, and with the participation of Ufa television, owned by media giant Bertelsmann, the CGE subsidiary 'Compagnie Immobilière Phénix S.A.' (CIP) hired German director Volker Schlöndorff* to oversee the remodelling of Babelsberg into a European media centre. By stressing the studio's long Ufa tradition, the new management seems intent on playing down any memories still lingering from the days of DEFA. MW

Bib: Ralf Schenk (ed.), *Das zweite Leben der Filmstadt Babelsberg: DEFA-Spielfilme 1946–1992* (1994).

DEPPE, Hans Berlin 1897–1969

German director, whose first film, *Der Schimmelreiter* (1934), has become a film adaptation classic (based on Theodor Storm). In a diverse pre-World War II output, including a masterpiece of observational cinema (*Straßenmusik*, 1936), it was Deppe's two Ludwig Ganghofer adaptations – *Schloß Hubertus* (1934) and *Der Jäger von Fall* (1936) – that announced the genre on which the director's fame would eventually rest: the *Heimatfilm**. Skilfully modulating between the rural pantheism favoured by Nazi blood-and-soil epics and nostalgic, picture-postcard sentiment, Deppe became, with the phenomenal success of his 'panorama picture' *Schwarzwaldmädel* (1950) and *Grün ist die Heide* (1951), postwar Germany's foremost director of the *Heimatfilm*, inaugurating the genre's vigorous and long-lasting renaissance. The Deppe era, synonymous with the ideological mix that made the genre so popular, coincided with the Adenauer era in politics. TE/MW

DIETERLE, Wilhelm Ludwigshafen 1893 –
 Ottobrunn 1972

German director and actor. Managing a parallel career on stage (with Max Reinhardt's* Deutsches Theater) and in the cinema from 1913 onwards, Dieterle starred in numerous films, including E. A.

Dupont's* *Die Geier-Wally* (1921), Paul Leni's* *Das Wachsfiguren-kabinett/Waxworks* (1923), and F. W. Murnau's* *Faust* (1926). From 1923, he directed a string of hits, leading him to set up his own production company in 1927.

A bad debt on one of his theatre ventures obliged Dieterle to accept a contract with Warner Bros in 1930, directing their German-language versions of American pictures and doing remakes of European successes (*Madame Dubarry*, 1934). Classed as a reliable B-picture director, Dieterle made a Hollywood living with such films as *The Last Flight* (1931) and *Satan Met a Lady* (1936). When Max Reinhardt* went to Hollywood, Dieterle co-directed with him *A Midsummer Night's Dream* (1935), a prestige venture that upgraded him to A-director status and teamed him with Paul Muni on a highly successful series of biopics.

In 1939 he became the co-founder of the anti-fascist magazine *The Hollywood Tribune* (edited by Dupont) and of the English-speaking exile theatre group 'The Continental Players' (with Leopold Jessner as director), while together with his wife, the actress Charlotte Hagenbruch, he played a major part in securing work permits for German and Jewish refugees. Until 1956 Dieterle was employed by RKO, MGM, Selznick, Paramount and Columbia, and among many other films, made a classic gothic costume melodrama, *The Hunchback of Notre Dame* (1939), starring Charles Laughton. He returned to Europe in 1958 where he retired from film after directing some Italian and German co-productions in 1960. MW

Bib: Marta Mierendorff, *William Dieterle: Der Plutarch von Hollywood* (1993).

DIETRICH, Marlene
Maria Magdalene von Losch; Berlin 1902 – Paris 1992

German actress, for some synonymous with movie glamour, for others epitomising Weimar culture. She began in film in Wilhelm Dieterle's* *Der Mensch am Wege* and Joe May's* *Tragödie der Liebe* (both 1923), but still regarded herself as a theatre actress and cabaret singer. Seeing her in Georg Kaiser's comedy *Zwei Krawatten*, Josef von Sternberg offered her the role of Lola Lola in *Der blaue Engel/The Blue Angel* (1930): '*von Kopf bis Fuß auf Liebe eingestellt*'. The rest, as they say, is history. Dietrich left for Hollywood in 1930 and worked on six films by Sternberg which turned her into a legend she was careful to nurture for the next half-century. After films for Ernst Lubitsch* (*Desire*, 1936, *Angel*, 1937), Rouben Mamoulian (*Song of Songs*, 1933), Tay Garnett (*Seven Sinners*, 1940) and, reputedly, a string of lovers from Maurice Chevalier and Jean Gabin to Ernest Hemingway, she was officially 'box-office poison', but not short of roles, including a Western parody (*Destry Rides Again*, 1939), before playing tongue-in-cheek comments

on her own star image in Fritz Lang's* *Rancho Notorious* (1952), Orson Welles' *A Touch of Evil* (1958) and Billy Wilder's *A Foreign Affair* (1948) and *Witness for the Prosecution* (1958). An American citizen, she worked for the US Entertainment Organization during World War II, touring the front in Europe and earning her stripes as a staunch anti-Nazi. Back in Berlin in 1945, for her mother's funeral, she 'also buried the Germany she once knew and loved'. In later years, living in Paris, she worked for radio and, until an accident on stage in 1975, as a successful *diseuse*. She is buried in Berlin, where the Stiftung Deutsche Kinemathek has acquired her estate. TE/MW

Bib: Maria Riva, *Marlene Dietrich* (1992).

DINDO, Richard Zurich 1944

Swiss director. A former office worker from a working-class background, Dindo spent three formative years in Paris where he witnessed the May 1968 events and saw hundreds of films at the Cinémathèque Française. Self-taught, he started film-making at the age of 26, with a documentary about two juveniles which also traces the history of the Swiss labour movement (*Die Wiederholung*, 1970). He next shifted his attention to another blind spot in his country's political history, the Swiss legal system, in *Die Erschiessung des Landesverräters Ernst S.* (1976). After two documentaries about the Spanish Civil War (*Schweizer im spanischen Bürgerkrieg*, 1973, and *Raimon – Lieder gegen die Angst*, 1977), he made his first feature, *El Suizo – Un amour en Espagne* (1985), which investigates the same topic from the point of view of the younger generation. After taking a critical look at the Zurich youth movement in *Dani, Michi, Renato & Max* (1987), Dindo – in a reprise of his earlier films about Swiss writer Max Frisch in *Max Frisch, Journal I–III* (1978–80) and actor Max Haufler in *Max Haufler, der Stumme* (1981) – made documentary essays about the French poet Arthur Rimbaud (*Arthur Rimbaud, une biographie*, 1991) and the Jewish painter Charlotte Salomon (*Charlotte – c'est toute ma vie*, 1992). Despite their attention to facts, these documentaries radically test the limits of the documentary genre in their exploration of subjectivity. MW

Other Films Include: *Ernesto Che Chuevara, das bolivianische Tagebuch/Ernesto Che Guevara, the Bolivian Diary* (1994), *Une saison au paradis/Season in Paradise* (1997), *Grüningers Fall/The Grüninger Case* (1997).

DISTRIBUTION

As in other countries, film distribution developed in Germany with the advent of longer narrative films (around 1910), superseding previous practices of film sales and film exchanges. Instead of films changing owners, they were distributed by companies who merely owned the rights to rent films to exhibitors in specified geographical areas. From 1916 this system was in place nationwide and still exists today.

Except for the period between 1921–22, when the European film alliance (EFA), representing American interests, was a rival in the production sector, and a brief period thereafter, when a few cinemas owned by Universal directly competed in exhibition (not unlike the few American-owned multiplex cinemas in the 1990s), it was the German distribution sector which, for most of this century, has borne the brunt of the intense competition with American companies.

Film distribution throughout Germany is dominated by a handful of companies. In the late 1920s the five largest distribution companies held the rights to 40% of all films shown in German cinemas. Between 1942 and 1945 film distribution was monopolised by the Deutsche Filmvertriebs GmbH (DFV)), and in the 1950s five of Germany's most successful distributors were in charge of about 35% of the market share. By the mid-sixties they controlled over 50%, while in the 1980s this figure rose to over 70%. Most of these distributors are now American-owned.

The economic weakness of smaller production companies and the financial strength of distribution companies led to the latter becoming themselves producers. The process started in the 1930s, and by the 1950s and 1960s, after the demise of Ufa* and the absence of large production companies, distributors had become the main financiers of the film industry. In the 70s, with the advent of American distributors on the German market, German distributors withdrew from financing films.

Large distribution companies compete for market share. In the 1920s Ufa* had a market share of 20%, which made it one of the top distributors. In the 1950s the distributors Herzog and Gloria* headed the list of larger companies. In 1956/57 Constantin* led the way with 8.7%. In the 1960s Constantin controlled 15%, nearly as much as Ufa* had previously achieved.

The contest between distributors involves German as well as American companies. Due to contingency laws, which did not make foreign offices a profitable enterprise for American companies, German distributors monopolised the import trade of American films in the 1920s. From 1924 Famous Players, for example, distributed its films with the help of National-Film GmbH.

Initiatives such as the Parufamet agreement, which aimed to establish the American film industry on the German market, failed to alter German audiences' preference for German films. After the contingency law was changed in 1928, most American film companies such as

Universal, United Artists, Fox and Warner Brothers established foreign offices in Germany. From July 1940 American companies were no longer permitted to distribute in Germany if their distribution packages included any films which the Nazis rejected on political grounds. Companies producing anti-Nazi films had to close their offices in Germany (Paramount and MGM closed their offices in 1940).

After World War II American film distributors extended their market share by saturating the German market (first by creating a trust with MPEA and then, from the mid-fifties, opening their own offices once again). Despite the massive presence of American distributors, German audiences still preferred indigenous productions – particularly musicals, war films and *Heimatfilme**, at least until the early 1970s. In 1955, for example, distribution sales of German films were at 47.3%, American films at 32.4%.

In the early 1970s, American distributors finally achieved a breakthrough, and have dominated the German market ever since. In 1990, for example, turnover from American films was 83.8%, whereas German films only achieved 9.7%. The increase of American films on the German market was partly caused by the American distributors forming a trust in 1982: Cinema International Corporation, MGM and United Artists formed UIP, which in the 1980s achieved 25% of the market share.

As a consequence the two largest German distributors went to the wall: Gloria* was sold in 1973 to the American film industry, while Constantin filed for bankruptcy in 1977 [> CONSTANTIN]. In 1971, with the emergence of the New German Cinema*, directors such as Hark Bohm, Rainer Werner Fassbinder*, Hans W. Geissendörfer and Wim Wenders* founded a company, the Filmverlag der Autoren*, which began by producing films but which, from 1974, has specialised in distributing them. After the economic failure of this art cinema, Rudolf Augstein, publisher of the news magazine *Der Spiegel* took over in 1977, and almost all of the film-makers involved in the company left. Today most films made in Germany need an 'international' (i.e. American-owned) distributor, if they are to be shown in German cinemas. JG

DOCUMENTARY

Kulturfilme. As in other European countries and in the US, the earliest years of the German film industry were dominated by documentaries or *actualités*. The transition to narrative fiction film around 1910 motivated opponents of the young industry to organise the Kino Reform Movement*, which was partly responsible for an oppositional, distinctively German documentary practice, the *Kulturfilm* ('cultural film'), which included films for training and educational uses that, like newsreels (see below), mostly accompanied feature films. The war

68

saw the almost total appropriation of documentary for military, industrial and nationalist propaganda purposes. Documentaries were produced in large numbers during the Weimar years at Ufa* and other major companies. Often feature-length and making up a complete programme, *Kulturfilme* in the 1920s ranged in scope from the 'naturist' manifesto *Wege zu Kraft und Schönheit* (1925, dir. Wilhelm Prager and Nicholas Kaufmann) and industry-sponsored science and technology films, to the two-part, heavily nationalist compilation film *Der Weltkrieg* (1927, dir. Leo Lasko).

Socialist documentaries tried to oppose the conservative *Kulturfilm*, emphasising political mass education; they reached their peak in the late 1920s with *Blutmai* (1929) and Piel Jutzi's *Unser täglich Brot/Our Daily Bread/Hunger in Waldenburg* (1929). While this documentary tradition played an important role in the development of the *Arbeiterfilme** of the late Weimar period, it was able neither to establish an alternative form nor engage a wider public. These goals were better served by a genre of experimental documentary known as the 'cross-section' films*, such as Walter Ruttmann's* *Berlin, die Sinfonie der Großstadt/Berlin, Symphony of a City* (1927) and *Melodie der Welt* (1929), which, together with Hans Richter's *Alles dreht sich, alles bewegt sich* (1929), combined an awareness of the technical and artistic implications of film with the social-political commitment of the 'Neue Sachlichkeit'. Ruttmann's films, along with Ufa's feature-length *Kulturfilme*, make up the tradition that Leni Riefenstahl* drew on for her ultimate symbiosis between newsreels, avant-garde experiment and political appropriation. *Sieg des Glaubens* (1933), *Triumph des Willens/Triumph of the Will* (1935), and *Olympia* (1938) represent a peculiar continuity in personnel and style between the documentary avant-garde of the late 1920s and the Nazi propaganda-compilation films.

Although personnel active before 1945 still dominated *Kulturfilm* production in the first decade after World War II, the documentaries made in the 1950s soon dissociated themselves from the *Kulturfilm* tradition by making use of new technical developments such as the 16mm hand-held camera and synchronous sound. Preparing the ground for a new generation of documentary film-makers, television directors such as Klaus Wildenhahn and Peter Nestler also used the financial opportunities of the new medium to expand its aesthetic and ideological boundaries. Wildenhahn adopted a *cinéma-vérité* approach of long-term observation (*In der Fremde*, 1968; *Heiligabend auf St. Pauli*, 1968; *Emden geht nach USA*, 1976). This model soon became the norm, both because of Wildenhahn's teaching at the Berlin film school, and because other politically committed documentary film-makers (Rolf Schübel, Theo Gallehr, Eberhard Fechner, Jutta Brückner*, Helke Sander*) were in sympathy with this practice. A comparable mode of 'participatory observation', carried out over often very extended periods of time, was used in the GDR to counter the ideological manipulation of official television (directors: Jürgen Böttcher, Volker

Koepp, Winfried Junge). A distinct documentary approach also helped articulate the style and ideological orientation of much of the New German Cinema*. Film essays, montage films and observational documentaries mounted a critique of commercial fiction film and explored social reality, landscape and human interaction in what came to be known as the 'new sensibility'. Elsewhere, documentary as an autonomous genre gained a new self-confidence, with the films of Klaus Wyborny, Vlado Kristl, Helmut Herbst and Werner Nekes, as well as more overtly political films such as Hartmut Bitomsky's reworking of Germany's audiovisual past and present in *Deutschlandbilder* (1983) and *Reichsautobahn* (1985), and Harun Farocki's* television-financed critiques of television's power of incorporation, *Bilder der Welt und Inschrift des Krieges* (1988) and *Videogramm einer Revolution* (1993). German documentary has recently diversified, without a distinctive strategy yet emerging out of the new realities of unification. The very diverse and competitive media 'landscape' puts pressure on but also preserves niches for film-makers continuing to investigate their countries' history, constituting, at their best, a counter-memory to the dominant industrialised image machinery they are nevertheless part of. MW

Newsreels (*Wochenschau*). A product of the pioneering efforts of cinematic innovator Oskar Messter*, who put out the first *Wochenschau* (Messter Woche) in 1910, the German newsreel rose to be the one effective competitor to the French companies Pathé and Gaumont which dominated the European market, and it became the most effective arm of National Socialist ideological manipulation in the 1930s and 1940s [> NATIONAL SOCIALISM AND GERMAN CINEMA]. During World War I, the state seized upon the propaganda potential of the newsreel, Messter Woche providing the first footage of the front in October 1914. In 1917 Messter Film was integrated into the new state-controlled Ufa*, designed explicitly to raise the standards of German film-making and improve the national image abroad. Messter's film personnel formed the core of Ufa's news propaganda office, Bufa (*Bild und Filmamt*). In 1920, Messter Woche was absorbed by Deulig Wochenschau, which produced the first German sound newsreel in January 1932, as Deulig Tonwoche. In 1927, Alfred Hugenberg, a right-wing nationalist media mogul, saved Ufa from bankruptcy. He brought his political persuasion to bear most markedly on the production of newsreels, Ufa owning 80% of the market. Capitalising on the situation, Nazi Propaganda Minister Goebbels assumed administrative control of both Ufa and Deulig in 1933 (the Party finally buying out Hugenberg in 1937). A product of all existing *Wochenschau* resources (Tobis, Deulig, Deutsche and Ufa), the Nazi newsreel – Deutsche Wochenschau – not only reported on Party activity, but represented the German *Volk* as a unified mass spectacle, simultaneously valorising the technical superiority of German film-making and finding its greatest refinement in the documentaries of Leni Riefenstahl*.

The postwar/Cold War newsreel in both West and East Germany was almost totally dependent on state subsidy and subject to censorship by the occupation forces. The few privatised services of the 1950s and 1960s, like the American-sponsored Fox Tönende Wochenschau, remained allied to Western and capitalist state interests in underwriting the *Wirtschaftswunder*. Across the border, the transformation of Ufa into DEFA* (Deutsche Film Aktiengesellschaft, 1946), granted the Soviets 80% control of East German film-making, guaranteeing that the GDR newsreel, *Der Augenzeuge*, toed the Party line. Although the newsreel's function was eventually undermined by television, the *Wochenschau* was (and still is) a significant archival source for compilation film-makers. In the GDR, for example, Andrew and Annelie Thorndike's *Wilhelm Pieck: das Leben unseres Präsident* (1951), *Du und mancher Kamerad* (1956), and the *Archive sagen aus* series effectively exploited the newsreel's claim to authenticity to valorise the political hegemony of the time. JM

DÖRRIE, Doris Hanover 1955

German director, who studied drama and film at the University of the Pacific, Stockton, California, and at the New School of Social Research, New York. In 1975 she returned to Germany, where with Wolfgang Berndt she co-directed the documentary *Ob's stürmt oder schneit* (1976). She worked for television (ZDF), wrote and directed *Paula aus Portugal* (1979) and other film portraits of women, which combined humour and sensitivity (*Katharina Eiselt*, 1980; *Von Romantik keine Spur*, 1981; *Mitten ins Herz*, 1983). Dörrie achieved national and international acclaim in 1985 with *Männer.../Men*, a tragi-comic love triangle which, according to *Der Spiegel*, 'exactly captures the *Zeitgeist*' – post-feminist disenchantment making way for a new acceptance of the foibles and fallibilities of the human heart. While *Männer* might be accused of indulging its (male) protagonists, and ultimately lacking satirical bite, *Paradies* (1986), another *ménage à trois* story, this time with an *amour fou* ending, is more agonisingly bleak and failed to find an audience. With *Happy Birthday, Türke* (1992) Dörrie returned to the semi-documentary style of her earlier work. KP

Other Films Include: *Keiner liebt mich/Nobody Loves Me* (1994), *Bin ich schön?/Am I Beautiful?* (1998), *Erleuchtung garantiert/Illumination guaranteed* (1999).

71

DUPONT, Ewald André
Zeitz 1891 – Los Angeles, California 1956

German director. One of Germany's first regular film critics (from 1911), he began scriptwriting numerous detective film series in 1916, making the switch to directing in 1918 with twelve episodes of the *Max Landa* detective series. Two Henny Porten* pictures – *Die Geier-Wally* (1921) and *Das alte Gesetz* (1923) – as well as *Der Demütige und die Tänzerin* (1925) made Dupont the most commercially promising director of his generation. But it was *Varieté/Variety* (1925), produced by Erich Pommer*, which brought him world fame. Featuring Emil Jannings* and Lya de Putti, the film has remained a stylistic and dramatic *tour de force*, combining innovative camerawork (Karl Freund*) and lighting with a feel for eroticism and violence. Like so many who tried to repeat a German success in Hollywood, Dupont came unstuck. *Love Me and the World is Mine* (1927), his first US picture, was a commercial flop, and the studio unforgiving. His ventures in Britain were more promising: for British International Pictures, Dupont directed *Moulin Rouge* (1928) and *Piccadilly* (1929) two night-club films worthy of the director of *Varieté* and minor masterpieces of the British silent cinema. Still in Britain, but as a radical departure, Dupont made *Atlantic/Atlantik* (1929), Europe's first sound film, shot in three languages, as a highly profitable novelty, even if it is stylistically cramped and marred by stilted dialogue. Dupont made several more multi-language films starring Conrad Veidt* and Fritz Kortner*, before returning to BIP's German partner firm, Emelka, for which he made a circus film, *Salto Mortale/Trapeze* (1931). Sent to Los Angeles in 1932 for a film about the Olympics, Dupont decided to stay, accepting B-picture assignments, working as a press agent, editor of an émigré journal, and finally eking out a meagre existence on television series. TE/MW

Bib: Jürgen Brettschneider (ed.), *Ewald André Dupont: Autor und Regisseur* (1992).

E

EICHBERG, Richard
Berlin 1888 – Munich 1952

German director, who was extremely popular for two decades. Eichberg's success as a director prompted him to start a production company in 1916 (Eichberg Film). Featuring turbulent and sensational

action and employing a number of optical effects, his films were recognised by what the trade, in a half-derogatory, half-admiring tone, referred to as the 'Eichberg style'. From the early 1920s he was equally adept at comedy (*Der Fürst von Pappenheim*, 1927), and offered Lilian Harvey* (*Leidenschaft*, 1925) as well as Hans Albers* (*Der Greifer*, 1930) their first major roles. In the mid-1920s, he made big international production films for British companies, such as the astonishing melodrama *Song* (1928) with Anna May Wong and Heinrich George*. In the years following the Nazi takeover, Eichberg preferred working in Paris, and in India where he made versions of *Der Tiger von Eschnapur* and *Das indische Grabmal* (both 1938; silent versions by Joe May*). An émigré to the US between 1938 and 1949, Eichberg, ironically one of the most 'American' of all German directors, was unable to find employment in Hollywood. MW

Other Films Include: *Strohfeuer* (1915); *Das Skelett* (1916); *Im Zeichen der Schuld* (1918); *Kinder der Landstraße* (1919); *Der Fluch der Menschheit* (1920); *Die schönste Frau der Welt* (1924); *Die keusche Susanne* (1926); *Das Girl von der Revue* (1928); *Die unsichtbare Front* (1932); *Die Reise nach Marrakesch* (1949).

EICHINGER, Bernd Neuburg, 1949

German producer who, after studying film direction and production management at Munich's Academy for Television and Film 1970–73, founded Solaris Film-Produktion in 1974 and, having just produced the successful and controversial *Wir Kinder vom Bahnhof Zoo* (1978, dir. Ulrich Edel), rose to prominence when in 1979 he became president and main shareholder of the Constantin Group, renaming it *Neue Constantin Film* [> CONSTANTIN]. After the international hit *Das Boot/The Boat* (1981, dir. Wolfgang Petersen*), Eichinger co-produced (with Bavaria and Warner Brothers) the 60 million marks adaptation of Michael Ende's children's bestseller *Die unendliche Geschichte/The Neverending Story* (1984, dir. Petersen), in its time the most expensive film ever produced in postwar Germany. Originally shot in English and aimed at the international market [> EXPORT (COMPANIES)], it was Eichinger's first move to counter the American dominance of Germany's first-run cinemas. Driven by the motto 'If you can't beat them, co-produce with them', Eichinger took the international bestseller by Umberto Eco, assured himself of the collaboration of one of the leading Hollywood stars, Sean Connery, and of the proven craftsmanship of French director Jean-Jacques Annaud for the international co-production *The Name of the Rose* (1987) which was seen by over 5.5 million people, and topped the 1980–87 first hundred box-office hits in Germany, just ahead of *The Neverending Story* (4.6 million viewers). Encouraged by such figures, Eichinger started to produce in the US, following the tried and true

formula of adapting well-known bestsellers in collaboration with renowned international casts. The result was *Last Exit to Brooklyn* (1989, dir. Edel) and *The House of the Spirits* (1993, dir. Bille August). The commercial revival of popular German cinema in the 1990s, among whose main initiators he can count himself, has vindicated his twin-track strategy, developing high-profile, big-budget projects for the international market (e.g. *Ms Smilla's Sense of Snow,* 1995 and *Prince Valiant,* 1996) as well as films for the German domestic market (*Der bewegte Mann/Maybe ... Maybe Not,* 1994, dir. Sönke Wortmann*, *Drei Mädels von der Tankstelle/Three Girls from the Filling-Station,* 1997, *Bin ich schön? /Am I Beautiful?,* 1998, dir. Doris Dörrie*). With *Das Mädchen Rosemarie/A Girl Called Rosemarie* (1996) – part of his series of remakes of German Classics, test-driven on prime time television prior to theatrical release – and *Der große Baragozy* (1999) Eichinger has returned to working as a director as well. MW

EISNER, Lotte Berlin 1896 – Paris 1983

German historian, who in 1927 became a film critic for the daily *Film-Kurier.* She left Berlin for Paris in 1933, working as a correspondent for *World Film News* and other publications. Temporarily interned in the concentration camp of Gurs, she began working at the Cinémathèque Française in 1945, where she was curator until 1975, programming festivals and lectures, and scouring the globe for films and documents that decisively shaped the inspiring Cinémathèque approach. Besides studies of F. W. Murnau* (1965) and Fritz Lang* (1976), Eisner is the author of *L'Ecran démoniaque* (1952; in English: *The Haunted Screen: Expressionism in the German Cinema and the Influence of Max Reinhardt,* 1973). With its attention to pertinent art-historical connections between film, theatre, literature and the visual arts, the book remains the seminal aesthetic study of Expressionist film*. In 1975 she concluded the German edition of her book (*Die dämonische Leinwand*) with a salute to the young directors of the New German Cinema*, who idolised her as an incarnation of the history of their national cinema. MW

EMIGRATION (Film migration, exile)

Ever since the 1920s, emigration forms part of the tradition amongst German film-makers. While a terrfyingly long list of directors, actors, scriptwriters, art directors and cameramen were forced to leave Germany when the National Socialists came to power in 1933, others had left in the years before, when the American film industry, hoping to neutralise a potential rival, had been headhunting in Germany in order to lure talented and successful film-makers to Hollywood. The

74

number of émigrés include Ernst Lubitsch*, F. W. Murnau*, William Dieterle*, E. A. Dupont*, Paul Leni*, Ludwig Berger*, Emil Jannings*, Marlene Dietrich*, Conrad Veidt*, Pola Negri*, Lya de Putti, Erich Pommer*, Carl Mayer*, and Karl Freund*. Few of them were political refugees in the strictest sense; instead, many harboured expectations of economic and professional advantage in Hollywood, not all of which materialised. In return, the European contingent assumed the role of specialists in all matters European and were asked to deliver films with a European flair, European stars and with a European setting, in the hope that these would not only attract European audiences but could also be sold to the American public.

From 1 April 1933, Jews were systematically excluded from public life in Germany and, consequently, Jewish film-makers could no longer work. 20–30% of Germany's film industry fled to neighbouring countries and the US. Refugees were not welcomed with open arms upon arrival, since the majority of countries were primarily concerned with controlling the increasing number of asylum-seekers. European countries became a mere stopover for most exiled film-makers, partly because respective national film industries were quite small, and partly because the Nazis' influence soon reached beyond Germany's borders (e.g. from 1935, Austrian films were boycotted and in 1938 Austria was integrated into the German Reich). Alternatively, some countries adopted Nazi policies (Hungary ratified anti-semitic film laws in 1936; France collaborated).

France and Britain were important for émigré film-makers, because their film industries were experiencing a period of dramatic growth at that time. Consequently, German producers in France were able to establish new production companies which provided work for fellow émigrés. Between 1933 and 1940, producers such as Max Glaß, Hermann Millakowsky, Seymour Nebenzahl*, Arnold Pressburger, Gregor Rabinowitsch and Eugène Tuscherer produced about 46 films, some of which became box-office hits in France (*Mayerling,* 1937, *Quai des brûmes,* 1938 and *Carrefour,* 1938). In England, Alexander Korda and Max Schach produced costume films for the international market. While these projects also provided work for émigrés, they rarely proved profitable.

For professional as well as personal reasons, most émigrés intended to resettle in the US. Hollywood was, after all, the largest Western film industry with a vast national and international market to satisfy. It was always on the lookout for foreign, creative talent. Furthermore, most émigrés already had close contacts with Hollywood, either because they had worked there in the 20s or because they knew colleagues who had emigrated before the advent of the Third Reich. Since 1927, production methods in Hollywood resembled Ufa's* style, and obtaining working permits did not present as grave a problem as it did in other European countries. Finally, in the US, refugees were safe from the Nazis. Among those not reaching the US, many perished in concentration camps (Kurt Gerron, Otto Wallburg*, Hans Behrendt).

Few of the lucky arrivals in Hollywood between 1933 and 1938 had a studio contract in their pockets. Only 15% of German immigrants had steady work, others, such as Joe May*, Erich Pommer*, Erik Charell*, Werner Richard Heymann* and Theodor Sparkuhl found themselves in greatly reduced circumstances. After 1938/39, the number of refugees to the US increased dramatically. Consequently, the US government introduced measures to curb the influx. With the help of the European Film Fund and other American film companies, about 500 German film-makers were able to live in Hollywood. Emigrés to the US as well as to France and England usually worked in their own area of competence, with some finding employment in the new genre of anti-Nazi films. Unlike exiled writers, the film exiles did not address a German public but the native US audience.

The émigrés' influence was not restricted to one genre alone. In the 1920s and 1930s they worked on films with a 'European flavour' such as *The Last Command* (1928) and *Ninotchka* (1939). From the early 1940s film-makers such as Billy Wilder, Robert Siodmak* and Fritz Lang* made *Double Indemnity* (1944), *Phantom Lady* (1944), *Scarlet Street* (1945), later known as *film noir*. This genre, dealing with male sexual dependency, madness and murder and using, among other techniques, low-key lighting, is often seen as a descendant of the German film of the 1920s. Most of all, however, German émigrés are known for the anti-Nazi film which forms a distinct genre different from both the films with 'European flavour' and *film noir*.

About 180 anti-Nazi films were produced between 1939 and 1945 in the US. German émigrés worked as producers, directors and scriptwriters on about 60 of these films (German actors participated in about 90% of these films). The anti-Nazi films transmitted an anti-fascist message in traditional genre films such as spy thrillers (*Confessions of a Nazi Spy,* 1939, *Manhunt,* 1941), melodramas (*The Mortal Storm,* 1940) and comedies (*To Be Or Not To Be,* 1942). German producers were usually able to establish themselves professionally via these films (for example, Seymour Nebenzahl* and *Hitler's Madman,* 1942, Arnold Pressburger and *Hangmen Also Die,* 1943).

The majority of German émigrés managed to integrate themselves into the American film industry. Success depended to a large extent on linguistic abilities, on flexibility, age, professional skills and interested American firms and trade unions. Younger directors such as Billy Wilder, Douglas Sirk [i.e. Detlef Sierck*], Robert Siodmak* and Frank Wisbar [i.e. Wysbar*] were able to integrate, but older colleagues such as Joe May*, Richard Oswald* and Reinhold Schünzel* did not adapt. Late arrivals (1940/41) such as cameramen Curt Courant* and Eugen Schüfftan* failed to establish themselves due to restrictive trade union policies, where cameraman Franz Planer had had fewer problems in 1937. German actors and their Germanic accents, were sought after in the 1930s (for films with European flair) and the 1940s (playing Nazis and their victims in anti-Nazi films; for example, Ludwig Donath, Otto Reichow and Sig Rumann). Only a

few, however, achieved star status (Marlene Dietrich* and Peter Lorre*). Only a handful of film-makers returned to Germany after the end of World War II (Frank Wysbar*, Robert Siodmak*, Curt Bois*, Seymour Nebenzahl* and Robert Thoeren). Most had become settled in the US, and the German film industry, still run by those who had been active in the Third Reich, was not particularly welcoming.

An increasing number of German film-makers have been working in Hollywood since the late-1980s. Mainstream films no longer being produced in Germany, film-makers migrated to the US where, unlike their colleagues in the 1920s and 1930s who were responsible for 'European' films, they are content to make films according to the 'American' model (Bodo Scriba, Dieter Geissler [producers], Carl Schenkel*, Wolfgang Petersen* and Michael Ballhaus*).

It is difficult to ascertain to what degree (economic and political) emigration damaged the German film industry. There is little doubt, however, that German film production suffered from the drain of talented film people who found an outlet for their creativity elsewhere. From the 1930s the German cinema remained a national cinema which produced very few stars and even fewer internationally successful films. JG

Bib: Jan-Christopher Horak, 'Exilfilm, 1933–1945', in W. Jacobsen/ A. Kaes/H. H. Prinzler (eds), *Geschichte des deutschen Films* (1993). T. Elsaesser, 'Ethnicity, Authenticity, Exile: A Counterfeit Trade?', in H. Naficy (ed.), *Home, Exile, Homeland* (1998).

EMMERICH, Roland Stuttgart 1955

German-born director and scriptwriter who early on specialised in the sci-fi genre and today stands as one of Hollywood's A-category directors with special effect-packed blockbusters such as *Stargate* (1994), *Independence Day* (1996) and *Godzilla* (1998). He acquired his typically polished visual style when working in advertising before he began studying film in Munich in 1977, where his first collaboration on a film was the set design for Doris Dörrie's* *Der erste Walzer/The First Waltz* (1978). While still a film student, Emmerich undertook a sci-fi production *Das Prinzip Arche Noah/The Noah's Ark Principle* (1983, US release 1985), which became the most expensive student film ever made in Germany. To finance this project, Emmerich founded Centropolis in 1982, which, under the overall control of his sister Ute, has been the co-producer of all his films to date. Despite their comparatively modest budgets, Emmerich's German sci-fi films, often criticised for the utter banality of their narratives, already carry the marks of his Hollywood successes, revelling as they do in grandiose set design and exalted special effect work. Indeed, they have always been geared to the international market: the fantasy film *Joey* (1985) about a boy who uses his telekinetic abilities to contact his dead father and

the interplanetary economic warfare drama *Mond 44/Moon 44* (1989) were pre-sold to global distributors, shot in English and starred international actors such as Malcolm MacDowell and Michael Pare. But only when he teamed up with American producer Dean Devlin, who acted in a number of his German films, the 'Swabian Spielberg', as Emmerich was half-derogatorily nicknamed by his German critics, was able to turn pastiche into reality. After landing a smash-hit with *Universal Soldier* (1992), which made over $100 million at the box-office, Devlin and Emmerich were able to independently produce *Stargate*, which has become a cult-classic (and a strong influence on a number of subsequent films of this genre, including Luc Besson's *The Fifth Element*, 1996), not least because of its compatibility with TV series and computer games as spin-offs. With the megalomaniac *Independence Day* and *Godzilla* Emmerich seems to have finally caught up with Spielberg, at least in terms of the audience-pleasing effectivity and high-concept bankability of his work – a reputation which is the realisation of a life-long ambition, but which has also benefited from the talents of his fellow-German collaborators Volker Engel (special effects supervisor) and Karl Walter Lindenlaub (cinematographer). MW

Bib: Jo Müller, *Roland Emmerich: Eine Werkbiografie* (1998).

Other Films Include: *Franzmann* (1979), *ASA 400* (1981), *Hollywood Monster* (1987), *Ghost Chase* (1988).

ENGEL, Erich Hamburg 1891 – Berlin 1966

German director. A close friend of Brecht and one of his preferred theatre directors, Engel (with Brecht) directed the Karl Valentin* film *Mysterien eines Friseursalons* (1923). With the coming of sound, he began producing his own films (such as *Wer nimmt die Liebe ernst?*, 1931). During the 1930s Engel was a sought-after comedy director who, without falling foul of the regime, kept alive some of the genre's subversive potential, always upholding the right of the individual against society and the state (*... nur ein Komödiant*, 1935; *Der Maulkorb*, 1938; *Nanette*, 1940). His favourite actress was Jenny Jugo, who benefited most from his skill with actors, appearing in eleven of his films before 1945, which included, apart from comedies, the psychological *Kammerspiel**, *Pechmarie* (1934), and costume dramas. Among his ten postwar films, the best-remembered is *Die Affäre Blum* (1948), a historically acute DEFA* production about anti-semitism, a topic rarely treated by German film-makers. MW

Bib: Herbert Holba, Günter Knorr, Helmut Dan, *Erich Engel: Filme 1923–40* (1977).

78

Other Films Include: *Fünf von der Jazzband* (1932); *Ein Hochzeitstraum, Mädchenjahre einer Königin, Die Nacht mit dem Kaiser* (1936); *Hotel Sacher* (1939); *Altes Herz wird wieder jung, Man rede mir nicht von Liebe* (1943); *Es lebe die Liebe* (1944); *Der Biberpelz* (1949); *Die Stimme des Anderen* (1952); *Konsul Strotthoff* (1954); *Liebe ohne Illusion, Vor Gott und den Menschen* (1955); *Geschwader Fledermaus* (1958).

ERHARDT, Heinz Riga, Latvia 1909 – Hamburg 1979

German actor. A gifted cabaret comedian in the 1940s, Erhardt showed off his film talent in *Der müde Theodor* (1957). He perfected a typical, often ironically archaic use of language in a prodigious number of comedies [> COMEDY (GERMANY)] such as *Witwer mit fünf Töchtern* (1957), *Der Haus-Tyrann* and *Natürlich die Autofahrer* (both 1959), creating a unique screen persona, a bulky patriarch without authority but also without resentment. His wit was sometimes infantile but always innocent and anti-establishment, and his most characteristic part was that of the eponymous hero of *Willi Winzig/Bill Tiny* (1962). Later, Erhardt specialised in comic cameos in the Karl May series – cantor Hampel in *Der Ölprinz* (1965), Professor Morgenstern in *Das Vermächtnis des Inka* (1966) – as well as in filmed operettas like *Frau Luna* (1964). Towards the end of his career, Erhardt returned to his first screen alter ego Willi Winzig (four films), taking advantage of the vogue for series. By the 1970s he served as an apt reminder of some of the continuities that run through German popular cinema, despite all the breaks and ruptures. TE/MW

Bib: Rolf Thissen, *Heinz Erhardt und seine Filme* (1986).

Other Films Include: *Kauf dir einen bunten Luftballon* (1961); *Appartment-Zauber* (1963); *Die große Kür, Die Herren mit der weißen Weste* (1969); *Was ist denn bloß mit Willi los?, Das kann doch unseren Willi nicht erschüttern* (1970); *Der Opernball, Unser Willi ist der Beste* (1971); *Willi wird das Kind schon schaukeln* (1972).

EWERS, Hanns Heinz Düsseldorf 1871 – Berlin 1943

German scriptwriter. A popular author of bestselling fantastic novels and stories with a strong predilection for sensational and erotic effects. One of the first literary figures in Germany to recognise cinema as a cultural force of utmost importance, Ewers became involved in film as early as 1907. An instigator of the *Autorenfilm** in 1913, Ewers worked as scriptwriter on a string of ambitious films for the Deutsche Bioscop in co-operation with Stellan Rye*, Guido Seeber*, and Paul Wegener*. The best-known efforts of this collaboration are the first

Der Student von Prag and *Die Augen des Ole Brandis*. Ewers, who pictured himself as a ceaseless globetrotter and eccentric dandy in numerous travel reports, happened to be on a visit to Cuba at the outbreak of World War I, thus spending the next six years in the US, where he was interned in 1917 for spreading pro-German propaganda. On his return to Germany the former cosmopolitan had turned convinced nationalist who very early confirmed his Nazi sympathies in novels such as *Reiter in deutscher Nacht* and *Horst Wessel*, the latter adapted by Ewers himself for one of the most explicitly propagandistic feature films ever produced by the Nazis (*Hans Westmar – Einer von vielen*, 1933). His early and most successful novel *Alraune* (originally published in 1911) was first made into a film in 1919 by Eugen Illés, then in 1928 by Henrik Galeen, in 1930 by Richard Oswald* and, finally, in 1952 by Arthur Maria Rabenalt*. MW

Bib: Reinhold Keiner, *Hanns Heinz Ewers und der phantastische Film* (1988).

EXHIBITION

Films were exhibited in a variety of ways in Germany. Until 1905 they formed an integral part of popular entertainment venues (variety, fairground, itinerant cinema) and other public spaces (bars, cafés, railway station arcades). From 1905, fixed cinemas took over as the exclusive exhibition site. This remained the case until the 1960s, when television became the primary audiovisual medium (in 1956 4% of all households had television, in 1970 77%), eventually replacing the cinema as the most important exhibition site for films.

In 1905 Germany experienced a cinema boom which peaked in 1912 (3,200 cinemas). Despite changes due to World War I (cinema statistics fail to mention losses and gains of geographical areas) and despite destruction, the number of cinemas rose continuously: in 1926 over 4,200 cinemas existed, in 1938 about 5,400. After World War II, another cinema boom occurred, peaking at 7,000 cinemas in 1959. With the rise of television, the number of cinemas decreased (by the 1970s, a mere 3,000 cinemas were still in operation, bringing the figures back to what they had been around 1912). In rural areas, this decrease was disproportionally high and once again, as in the early part of the century, cinemas are now almost exclusively situated in the inner cities. The size and style of cinemas exhibiting popular films have changed continuously throughout the decades. In the early nineteen hundreds, shop cinemas were replaced by purpose-built theatres (so-called Lichtspieltheater) which showed films, live acts, variety numbers, theatrical sketches, dance numbers, with orchestras to accompany films musically.

From the time of World War I, an increasing number of cinemas had more than 1,000 seats (in 1918 there were 38, in 1925 85, and in 1929

171 large cinemas). The drastic fall in cinema attendance in the 1960s entailed a correspondingly steep decrease in the number of movie palaces (from 98 in 1959, 44 in 1969, 9 in 1979 to 4 in 1989). In a parallel development, cinecentres began, in the 1970s, to replace traditional cinemas, exhibiting films on several small screens, and driving down the average number of seats per cinema from 400 (1973), to 300 (1979) and 200 (1986). In the early 1990s multiplexes were built along American lines (e.g. the Cinedom in Cologne) in an effort to make film viewing more attractive, thanks to better screen and sound technology, larger foyers and lobbies, and adding space for other leisure activities (i.e. bars, fast-food and billiards).

Mass entertainment cinemas have always had to update their equipment with the latest technology in order to secure audiences. This particularly affected sound and image quality: in rapid succession optical sound, magnetic tape, stereo, Dolby and digital sound have followed each other, as did the different wide-screen formats. Since the cinema's technological advances usually occurred very quickly, they necessitated major investments. Within the course of one year (1930), for instance, the number of sound cinemas in Germany rose from 10% to 90%. Similarly, in 1955 52% of all cinemas in West German cities of more than 20,000 inhabitants had installed Cinemascope technology, at a time when few domestic wide-screen films were yet being produced. Innovations were usually initiated by the American competition, with the larger German studios following suit (Warner Brothers' success with sound film in 1926 also spurred the German film and electronics industry into action).

Apart from mainstream cinemas, other types of cinemas were created for specialised audiences: the *Autorenfilm** of 1913 was shown in cinema palaces (the Berlin Marmorhaus), premiere cinemas were often inaugurated with a specially targeted big-production film, with the cinema helping to promote the film and vice versa (e.g. Ufa's* Gloria Theater opened with *Tartüff*, 1926). Other special venues included the newsreel cinemas often sited in or near railway stations (e.g. the Dammtor-Filmtheater in Hamburg in the 1950s). When the laws against pornography were relaxed in the 1960s, special peep-show cinemas ('*Beate Uhse*') were being built. Art cinema houses have a tradition in Germany which dates from the film club movement just after World War II, paralleling the popularity of European cinema after World War I. Later developments are repertory cinemas (e.g. the Lupe cinemas in Munich and Cologne), so-called programme cinemas (e.g. the Broadway in Cologne) and 'communal' (i.e. municipally subsidised) cinemas, such as the 'filmforum' in Düsseldorf, or the oldest, the Frankfurt 'communal cinema' at the Deutschen Filmmuseum.

Cinemas in Germany are traditionally run as small family businesses. Neither the studio-owned cinema chains nor national-socialist film policies fundamentally altered this practice. The first cinema chain was created by Paul Davidson* in 1906 (Union-Theater, in short:

U.T.), later taken over by Ufa*. Ufa owned the largest chain in the 1920s and 1930s, but managed only a small percentage of all cinemas (in 1931 Ufa controlled 9% of all seats in daily operated cinemas). Similarly, the Nazis did not create a cinema monopoly. In the 1980s, concentration of cinema ownership changed dramatically: compared to 1931, when Ufa* owned just 40 cinemas out of several thousands, by 1989 five firms controlled more than 50% of cinemas. The trend towards concentration has accelerated in the 1990s, with more and more cinemas being owned by American companies (United Cinema International founded by Paramount and Universal, Warner Multiplex), virtually eliminating from the map the single, family-run cinema which used to be the standard film venue in the suburbs, working class areas and small provincial towns.

A specific cinema culture existed during the time when feature length movies were exclusively shown in cinemas (from the 1910s to the 1950s) which modelled the cinematic experience according to the theatre's standards (architecture, curtain, lighting, seating, programme notes, usherettes). Advertising and publicity, i.e. large, colourful posters, magazine articles (*Illustrierter Film-Kurier* [1919–44], *Illustrierte Film-Bühne* [1948–69]), star photographs (on postcards, cigarette pictures, posters) and fan magazines with up to 500,000 copies per edition (*Die Filmwoche* [1923–43], *Filmwelt* [1929–43], *Film-Revue* [1947–63], *Star/Star-Revue* [1948–61]) all contributed to create a film culture which determined the cinema's image for a long time.

From the 1960s, when cinema changed from a mass medium to a youth culture medium (less than 30% of viewers are older than 30, more than 70% are younger), cinema culture fundamentally changed. Cinemas became more functional (gongs, curtains and ushers disappeared), painted posters were replaced by small photo posters, magazine articles grew rare, and special fan magazines transformed into general magazines (in 1963 *Film-Revue* became *Die Freundin*; *Film und Frau* became *Petra* in 1969). JG

Bib: Rolf-Peter Baacke, *Lichtspielarchitektur in Deutschland: Von der Schaubude bis zum Kinopalast* (1982).

EXPORT (COMPANIES)

The German film industry, in order to have a return on investment, has always had to rely on exports (30 to 40%). Only the period between 1938 and 1943, when territorial conquests had artificially enlarged the domestic market, proved an exception. However, financial dependence on exports was neither due to the limited size of the home market nor to the films' lack of popularity, but a consequence of successive governments' fiscal policy, levying entertainment tax on every cinema seat sold [> CINEMA AND STATE], thus weakening the industry's economic position vis à vis its competitors.

The German film industry experienced both success and failure in exporting films. While between 1920 and 1924, enormous profits were made by exploiting the gap between domestic hyper-inflation and hard currency earnings, in the years between 1926 and 1929, when about 71% of the German film industry's annual output was exported (while only 41% of European countries' annual output was imported) the earning ratio nonetheless deteriorated, picking up slightly after the industry had converted to sound. With the Nazis in power from 1933, the German film industry was no longer able to export, given the increasingly hostile international climate. In 1928/29 exports still brought in about 30 million Reichsmark, with Ufa* alone showing an export profit of 11.1 million RM in 1931/32; by 1937/38, this had shrunk to 2.6 million Reichsmark.

After World War II, the West German film industry's profits from export remained smaller than the profits made from foreign films shown in Germany. For example, 15.2 million deutsche marks were earned from exporting German films in 1955, whilst foreign films in Germany earned 138.4 million DM. Whereas the US had been a major foreign competitor since the 1920s, German films imported to the US remained few and far between. After Lubitsch's* *Passion* (1919) and a few other titles in the 1920s, one has to wait until the 1960s to see a German film receive nation-wide distribution in the US: *Helga* (1967), followed in the 1980s by *Das Boot* (1981). For the rest, German-made films are confined to art houses (where *The Marriage of Maria Braun*, 1979 and *The Tin Drum*, 1980 proved quite popular) and minority cinemas catering for ethnic Germans.

Export profitability depended not only on films being popular in countries where German is understood, such as Czechoslovakia, Hungary, Austria, the Netherlands or the Scandinavian countries, but also on economic factors (inflation), political changes (a totalitarian regime), geo-political events (the World War), the division of the home market (German partition) or the loss of East European audiences during the Cold War. The failure of Germany's export strategies was also due to the institutions in charge of organising them. From 1920 onwards, German export companies operated on a national level (under names such as 'Deutsche Vereinigung für Filmimport und Export', from 1924, 'Export-Union der deutschen Filmwirtschaft e.V.', from 1954), yet despite having an umbrella organisation like SPIO*, they did not hold monopoly rights, and therefore had only very limited negotiating powers. Unlike the Motion Picture Producers and Distributors of America (MPPDA) and its subsidiary (after 1945), the Motion Picture Export Association (MPEA), German export firms (possibly with the exception of the 'Deutsche Filmexport-Gesellschaft', created by the Nazis) were neither supported by the state, nor free from internal rivalry. In effect, each company conducted its own export policy (Ufa's* foreign interests were handled by the Auslands-GmbH), negotiating contracts bilaterally with foreign partners.

The dramatic drop in numbers of moviegoers in France, Italy and West Germany from 1956 to 1958 forced film companies to radically revise their export strategies. Until then it had been standard practice for a film company to produce a film prior to securing export sales to other countries. Now the aim was to conclude inter-European co-production agreements, increasing a company's chances of guaranteeing distribution in the co-producing countries, and also of pooling investment funds for more costly productions, in the hope of appealing with star names and big budgets to European-wide cinema audiences [> FILM EUROPE, EICHINGER]. JG

EXPORT, Valie Waltraut Lehner; Linz 1940

Austrian director. Also a photographer, video and performance artist, Export successfully moved from experimental shorts to features. She called her *Tapp und Tastfilm/Grope-and-Feel Film* (1968) 'the first real woman's film'. It involved a 'cinema' strapped to her chest 'with the performance taking place in the dark as usual, but in a somewhat smaller hall. There is room only for two hands. In contrast to the dominant cinema where the viewer is a mere voyeur, here the spectator can finally grasp reality with both hands.' Like her other 'film happenings', such as *Cutting* (1967–68) and *Der Kuss* (1968), *Tapp und Tastfilm* is an attempt to redefine the audience-performer relationship and to extend cinematic conventions. Export's first feature, *Unsichtbare Gegner/Invisible Adversaries* (1978), about female identity, representation and the environment, was a 'feminist science-fiction' film which managed to be theoretically and visually challenging as well as entertaining and humorous. Together with her *Die Praxis der Liebe/The Practice of Love* (1984), *Unsichtbare Gegner* has become a classic of international women's cinema, and shows that Export has been able to address a wider audience without compromising her political and aesthetic positions. US/TE

EXPRESSIONIST FILM

German genre. Expressionist films such as *Das Cabinet des Dr Caligari/The Cabinet of Dr Caligari* (1920) and *Das Wachsfigurenkabinett/Waxworks* (1924) were produced in Germany between 1919 and 1923 by important companies such as Decla Bioscop, Ilag-Film and Neumann Produktion, complete with generous budgets and premiered after extensive advertising campaigns. Two goals were to be achieved with Expressionist films: to regain export territory closed to German films because of World War I, and to attract new, socially and artistically more sophisticated audiences to the cinema without scaring away traditional viewers. For this reason, the films mix popular, romantic and thriller fantasies based on novels by Hanns Heinz Ewers,

E. T. A. Hoffmann and Dostoevsky with elements derived from the vogue (which had already peaked) for Expressionist motifs in the established arts such as painting and the theatre. Examples of these motifs were stylisation of the decor, extreme artificiality, effective lighting design (lights and shadows), stereotypical characters and exaggerated acting. Unlike Expressionist drama, the films did not feature idealistic-rebellious protagonists protesting against inhuman demands – with the exception of *Von morgens bis mitternachts* (1920), not widely shown at the time – but instead seemed driven by strange urges and violent passions, and haunted by nameless phantoms and fears. Expressionist films used the contemporary German theatre's sophisticated stagecraft selectively, often turning it into mere signals of pathological states, but also, in the process, developing a fascinating poetic film language of mood, gesture and atmosphere.

Hollywood craftsmen and directors were much taken by German Expressionist cinema, developing its different elements and integrating them into more specific generic contexts (low-key lighting for mystery, distorted perspectives for horror). While not all the German films from the 1920s thus labelled should be regarded as Expressionist, there can be no doubt that their peculiar amalgam of primitive emotion and sophisticated film technique tapped deeply into the roots of cinematic pleasure, ensuring that the term has retained its currency ever since. JG/TE

Bib: John D. Barlow, *German Expressionist Film* (1982).

Other Films Include: *Genuine, Das Haus zum Mond* (1920); *Torgus* (1921); *Raskolnikov* (1923); *Der Golem, wie er in die Welt Kam/The Golem* (1920); *Nosferatu – Eine Symphonie des Grauens/Nosferatu the Vampire* (1922).

EYCK, Peter van Steinwehr 1913 – Maennedorf, Switzerland 1969

German actor, one of the few German-speaking film stars of the immediate postwar era with a durable international career. The tall blond Nordic type, he received his first film role in Hollywood in the early 1940s. Van Eyck (who had acquired American citizenship and served in the US Army from 1943 to 1945) initially played German officers of the Prussian type (in Billy Wilder's *Five Graves to Cairo*, 1943, and Douglas Sirk's [Sierck*] *Hitler's Madman*, 1943). Starring in more than eighty American, German, French, Italian and British productions after the war, he personified positive heroes as well as arrogant cynics and powerful villains. MW

Other Films Include: *The Wife Takes a Flyer, Once Upon a Honeymoon* (1942, US); *Hallo Fräulein!, Königskinder* (1949); *Die*

Dritte von rechts (1950); *The Desert Fox* (1951, US); *Le Grand jeu/Il grande giuoco* (1954, Fr./It.); *Attack* (1956, US); *Der gläserne Turm/The Glass Tower* (1957); *Der Rest ist Schweigen/The Rest is Silence* (1959); *Liebling der Götter* (1960); *Le Salaire de la peur/The Wages of Fear* (1953, Fr.); *Mr. Arkadin* (1955, Sp./Swi.); *Die tausend Augen des Dr Mabuse/The Thousand Eyes of Dr Mabuse* (1960); *The Longest Day* (1962, US); *The Spy Who Came in from the Cold* (1965, UK); *The Bridge at Remagen* (1969, US).

F

FANCK, Arnold
Frankenthal, Rheinpfalz 1889 –
Freiburg 1974

German director. Fanck entered film in the early 1920s with spectacular documentaries about skiing, mountaineering and glacier hikes, almost single-handedly inventing the genre of the mountain film [> HEIMATFILM] at a time when German film was dominated by studio-made productions. With *Der Berg des Schicksals* (1924) Fanck began casting professional actors, among them Luis Trenker* and Leni Riefenstahl* (*Der Heilige Berg*, 1926), who sometimes shared directorial credits. In *Die weisse Hölle vom Piz Palü/The White Hell of Piz Palu* (1929), G. W. Pabst* was in charge of the interior scenes. Refusing to become a Party member, Fanck was unable to make feature films in Germany after *Der ewige Traum* (1934). In Japan, he directed *Die Tochter des Samurai* (1937) and several documentaries; *Ein Robinson* (1940) was shot in Chile. Back in Germany during the war, he made a living by directing documentaries about public works projects, while his film portraits of the monumentalist sculptors Breker and Thorak remained uncompleted. TE/MW

Bib: Herbert Linder (ed.), *Arnold Fanck* (1976).

FAROCKI, Harun
Sudentenland
(now Czech Republic) 1944

German director and writer who began as a critic for the film journal *Filmkritik* before turning into an agitprop director with didactic shorts for teach-ins and political group work in the late 1960s. In his first full-length film, *Zwischen Zwei Kriegen/Between the Wars* (1978), about the support German industrialists gave to Hitler by devising the so-called

'Verbund'-system, a cartel-like recycling agreement between the coal and steel industries. Farocki manifests his abiding interest in different forms of production, also drawing the necessary analogies with the audiovisual and print media's own 'Verbund'-systems, especially as they affect a freelance director. Another formulation of the impossible options facing the politically committed avant-garde artist, *Etwas wird sichtbar/Before Your Eyes: Vietnam* (1981), deals with the impact of images from Vietnam on the West German left. Again, passages which seem aphoristic in relation to the Vietnam War become graphically descriptive when seen in the light of independent film-making. A third meditation on the media and modern warfare, *Bilder der Welt und Inschrift des Krieges/Images of the World and Inscription of War* (1988) has become Farocki's best-known film internationally, a reference film and meditation on film technology, Auschwitz, surveillance, smart bombs and invisible death. *Videogramme einer Revolution/ Videogrammes of a Revolution* (1991/92, with Andrej Ujica) examines the use of television as a strategic weapon in the Romanian (counter-) revolution and the overthrow of Ceaucescu. Combining a Brechtian dialectical intelligence with a modernist's acute visual sensiblity, Farocki's central insight in all his work for film and television is the pivotal role of cinematic ways of seeing and thinking in almost all spheres of modern life, having penetrated the world of work and production, politics and our conception of democracy and community, warfare and strategic planning, abstract thinking and philosophy, as well as interpersonal contact and gendered subjectivity. In this sense, Farocki's essayistic cinema is a meta-cinema, or as one commentator once put it, a cinema which 'superimposes on the rapid consumption of images a tranquillity needed for their examination'. Never a member of the New German Cinema*, Farocki is possibly the most consistently challenging director of the 1990s. TE/MW

Bib: Rolf Aurich, Ulrich Kriest (eds), *Der Ärger mit den Bildern: Die Filme von Harun Farocki* (1998).

Other Films Include: *Der Geschmack des Lebens/The Taste of Life* (1979), *Peter Lorre – Das doppelte Gesicht/Peter Lorre: The Double Face* (1984); *Wie man sieht/As You See* (1986); *Leben BRD/Life in the Federal Republic* (1989/90); *Was ist los?/What's Up* (1991); *Arbeiter verlassen die Fabrik/Workers Leaving the Factory* (1995); *Die Bewerbung/The Application* (1997); *Stilleben – Natur morte/Still Life* (1997); *Der Ausdruck der Hände/The Expression of Hands* (1997).

FASSBINDER, Rainer Werner Bad Wörishofen 1945 – Munich 1982

German director and probably the most important film-maker of postwar Germany. Born into a bourgeois family and raised by his mother

as an only child, he claimed that ('five times a week, often three films a day') from a very early age 'the cinema was the family life I never had at home'. After amateur directing-scripting-acting efforts – *Der Stadtstreicher/The City Tramp* (1965) and *Das kleine Chaos/The Little Chaos* (1966) – Fassbinder joined the Munich 'action-theatre'. There he worked with Peer Raben* and Kurt Raab, Hanna Schygulla* and Irm Hermann, who subsequently became the most important members of his cinematic stock company.

The years 1969–76 were Fassbinder's most prodigious and prolific period. An outstanding career in the theatre (productions in Munich, Bremen, Bochum, Nuremberg, Berlin, Hamburg, and Frankfurt, where for two years he ran the 'Theater am Turm' with Kurt Raab and Roland Petri) was a mere backdrop to a relentless outpouring of films (up to six a year, totalling sixteen feature films, and, for television, eleven feature films, a five-part series, two two-part adaptations, and a variety show). During the same period he also did four radio plays and took on ten roles in other directors' films, among them the title part in Volker Schlöndorff's* Brecht adaptation *Baal* (1970). His major international successes began with *Der Händler der vier Jahreszeiten/ The Merchant of Four Seasons* (1972) and *Angst essen Seele auf/Fear Eats the Soul* (1974), and by the time of *Faustrecht der Freiheit/Fox and His Friends* (1975) and *Despair/Eine Reise ins Licht* (1978) he had become an international figure. Meanwhile his work often received mixed notices from national critics, many of whom only began to take Fassbinder seriously after the foreign press had hailed him as a genius. Much of Fassbinder's work was financed by television. Thanks to the producer Peter Märthesheimer at WDR, Fassbinder in the late 1970s turned to recognisably German subject matter. Together they made *Die Ehe der Maria Braun/The Marriage of Maria Braun* (1979), Fassbinder's commercially most successful film and the first in his 'postwar German trilogy', followed by *Lola* (1981) and *Die Sehnsucht der Veronika Voss/Veronika Voss* (1982). His testament film was the controversial fourteen-part television adaptation *Berlin Alexanderplatz* (1980), which is still one of the unrecognised masterpieces of world cinema. His sudden death from a drug overdose in June 1982 symbolically marked the end of the most exciting and experimental period the German cinema had known since the 1920s [> NEW GERMAN CINEMA]. TE

Bib: Thomas Elsaesser, *Fassbinder's Germany* (1996).

Other Films Include: *Liebe ist kälter als der Tod/Love Is Colder than Death, Katzelmacher* (1969); *Götter der Pest/Gods of the Plague, Warum läuft Herr R. Amok?/Why Does Herr R. Run Amok?* [co-dir. Michael Fengler], *Das Kaffeehaus/The Coffee House* [TV version of stage production], *Die Niklashauser Fahrt/The Nicklehausen Journey* [TV], *Der Amerikanische Soldat/The American Soldier* (1970); *Rio das Mortes, Whity, Warnung vor einer heiligen Nutte/Beware of a Holy*

Whore, Pioniere in Ingolstadt/Pioneers in Ingolstadt [TV] (1971); *Bremer Freiheit/Bremen Coffee* [TV version of stage production], *Die bitteren Tränen der Petra von Kant/The Bitter Tears of Petra von Kant, Wildwechsel/Jailbait* (1972); *Acht Stunden sind kein Tag/Eight Hours Are Not a Day* [five-part TV series], *Welt am Draht/World on a Wire* [two-part TV series] (1973); *Nora Helmer* [TV version of stage production], *Martha* [TV], *Fontane Effi Briest/Effi Briest* (1974); *Wie ein Vogel auf dem Draht/Like a Bird on a Wire* [TV show with Brigitte Mira] (1975); *Mutter Küsters Fahrt zum Himmel/Mother Kuster's Trip to Heaven, Angst vor der Angst/Fear of Fear* [TV] (1975); *Satansbraten/Satan's Brew, Ich will doch nur dass ihr mich liebt/I Only Want You to Love Me* [TV], *Chinesisches Roulette/Chinese Roulette* (1976); *Bolwieser/The Station Master's Wife* [two-part TV film], *Frauen in New York/Women in New York* [TV version of stage production] (1977); *Deutschland im Herbst/Germany in Autumn, In einem Jahr mit dreizehn Monden/In a Year of Thirteen Moons* (1978); *Die dritte Generation/The Third Generation* (1979); *Lili Marleen, Lola, Theater in Transe/Theater in a Trance* [video production of international theatre festival] (1981); *Querelle*, 1982.

FESTIVALS

Founded in 1951 by Alfred Bauer (its director until 1976), the Berlin International Film Festival (*Berliner Filmfestspiele*, or *Berlinale*) is Germany's most important festival, and also one of the three major festivals in Europe (along with Cannes and Venice). In the *Wettbewerb* (international competition) for the Golden Bear award, films are asessed by a jury of international celebrities. Apart from the competition, the festival includes the *Panorama* (showing new films from all over the world), the *European Film Market* (only open to producers, distributors and cinema owners), a series of *New German Films*, a *Festival of Children's Films*, and a historical retrospective, organised by the Stiftung Deutsche Kinemathek [> ARCHIVES]. Affiliated to the Berlinale since 1971 but independently organised and administered by Ulrich Gregor (co-director of the Berlinale since 1980) and the Freunde der deutschen Kinemathek ('Friends of the German Cinematheque'), the Internationales Forum des jungen Films ('International Forum of Young Cinema') puts an emphasis on independent and innovative film-making (features, documentaries, experimental films) from all over the world.

The *Internationale Kurzfilmtage Oberhausen* (Oberhausen international short film festival), held annually since 1955 (in April), exhibits a wide variety of short films. The *Internationales Film-Festival Mannheim* (November), established in 1952, emphasises debut features and documentaries. The *Internationale Hofer Filmtage* (Hof International Film Days) has been a meeting place for younger German film-makers, especially film school graduate since 1967. The

Leipzig festival (November–December), launched in 1957, is a forum for politically committed documentary film-making. Although its political focus has shifted since the end of the GDR to Third World film, it still functions as a window for Central and Eastern Europe. Germany has two major women's film festivals, *Feminale* (Cologne, May, since 1984) and *Femme totale* (Dortmund, since 1987). The Stuttgart animation film festival has been running since 1982.

Austria has three main annual film festivals. *The Viennale – Internationale Filmwochen Wien* (Vienna international film festival, every autumn) is subsidised by the Vienna City Council and a private sponsor, and includes thematic retrospectives, symposia and publications. The other two festivals are dedicated to Austrian cinema: the *Österreichische Film Tage Wels* (Austrian Film Days, Wels) since 1984, and the *Diagonale – Festival des Österreichischen Films* (festival of Austrian cinema) held in Salzburg since 1993 and organised by the Austrian Film Commission. MW

FILM AWARDS

Film awards in Germany are given by a variety of public bodies, government, film industry associations, festival juries and newspapers to promote particular films, individuals or trends (such as propaganda films or art films). The awards help to publicise a film and often provide financial incentives. The German system of film awards, however, differs from the American in that the awards given out by the film industry do not promote the commercial success of films. In contrast to the Academy Awards (Oscars), which have aided the commercial success of films since 1927, the German government and the filmmakers' lobby groups each tries through their awards to profile and support the films best corresponding to their own standards of success. Consequently, German prizes such as the 'Award of the Nation' (1941–45), the 'German Film Award' (since 1951) 'The Golden Bear' and 'The Silver Bear' (since 1956) [> FILM FESTIVALS] have never had the effect on the industry which the Academy Awards have had.

The Nazis created the *Nationalpreis* (Award of the Nation) as an instrument for boosting propaganda films (such as *Ohm Krüger* [1941], *Heimkehr* [1941], *Der große König* [1941] and *Die Entlassung* [1942]). State prizes were also awared to individuals as an incentive to political conformity. Directors, actors, heads of film companies were made professors (e.g. Karl Ritter* [1939], Carl Froelich* [1939], Veit Harlan* [1943], Wolfgang Liebeneiner* [1943]), national actors (e.g. Heinrich George* [1937], Hans Albers* [1939], Heinz Rühmann* [1940]) or *Reichskultursenatoren* (Senators of Culture, e.g. Gustav Gründgens*, Emil Jannings*, Ludwig Klitzsch).

A new system of awards developed in West Germany after the national film industry had been split up [> PRODUCTION]. Awards became a means of providing financial support for films. The Minister of

the Interior has been handing out the 'German Film Award' since 1951 to films whose form and content distinguish them from the average. Feature films with some kind of social criticism or message won most of the awards during the 1950s and early 1960s (e.g. *Canaris* [1955], *Der Hauptmann von Köpenick* [1957]), *Die Brücke* [1960]). The German Film Award provides the winner with money to partly offset production costs. Unlike the Golden Bear and Silver Bear of the International Film Festival Berlin, the German Film Award not only helps promote the film, but is intended to draw attention to the artistic achievement of particular individuals in a variety of areas (directing, screenplay, camerawork, set design etc.). The distinguished achievement awards do not carry any financial rewards.

The increasingly complex subsidy system from the 1960s onwards meant that films could be made irrespective of their box-office potential. Thus, fewer and fewer of the winners of the German Film Award were commercially successful (for instance, *Abschied von gestern* [1967], *Katzelmacher* [1970], *Die Sachverständigen* [1973] and *Heinrich* [1977] did not find an audience, despite receiving prizes). A whole series of new awards were created within the framework of German art film production. These awards promoted the films of the New German Cinema* either by bestowing money on the winner (for example, the Bavarian Film Award of the Bavarian State Government, or the Max Ophüls Award of the City of Saarbrücken, both established in 1980) or by granting special recognition to talented individuals. Awards based on talent helped to establish a film-maker's reputation and make it easier for him/her to get funding for future productions (e.g. the 'German Film Critics Award', established in 1968, or the 'Gilde Award', established in 1977).

There are two awards given out in the Federal Republic of Germany in recognition of a film's commercial success. Unlike the Academy Awards, both prizes are awarded after the film has made the major part of its profit. Thus these awards exercise little influence on how the public responds to the film. The 'Bambi' Award for the most commercially successful film existed from 1949 to 1968; winners were decided on the basis of a survey carried out amongst movie theatre owners. The *'Goldene Leinwand'* (Golden Screen award) was created in 1964 by the Association of German Movie Theatres and the trade journal *Film-Echo* [> FILM CRITICISM]. It is given for films which attract more than 3 million viewers within 18 months.

Finally, foreign film awards given to German film-makers have proved crucial for launching their international careers. Volker Schlöndorff provides the best example: after winning both the Palme d'Or and an Oscar for his film *Blechtrommel* (1979 and 1980), Schlöndorff was hired by CBS to direct *Death of a Salesman* (1985) and *A Gathering of Old Men* (1987). JG

FILM CRITICISM

I – Critics. German film criticism never had a key figure who single-handedly made the 'film critic' into a serious and autonomous profession as André Bazin did in postwar France. With the possible exception of the Munich-based journal *Filmkritik* in the 1960s, nor has there been any professional film magazine comparable to the French *Cahiers du Cinéma* or the British *Sight & Sound*, which would have given film critics the opportunity to build up an independent critical discourse and secure their professional identity. Thus, being a film critic in Germany has traditionally been more a stop-over than a life-long occupation; some turned to film-making (E. A. Dupont*, Wim Wenders*, Hartmut Bitomsky, Harun Farocki*, Hans C. Blumenberg), others went into festival organisation (Wolf Donner, Ulrich Gregor) or into archival work (Helmut Regel, Enno Patalas). For most of its history German film criticism has had to find its place and voice in trade journals, daily and weekly newspapers, *Feuilleton* and local listings magazines (*Stadtmagazine*). To a large extent, the quality of the critical discourse about film within these journalistic and commercial constraints was thus strongly dependent on the taste and talent of each individual critic.

In the first decade after 1895 articles on film were either of a technical, commercial or industrial nature, and regular film criticism emerged only in the years just before World War I, parallel to the advent of the long narrative film and the *Autorenfilm**. Although Paul Lenz-Levy attempted to establish regular film reviews, taking an aesthetic point of view in the trade journal *Lichtbildbühne* as early as 1909, film criticism in the proper sense of the word primarily developed along two lines in the years 1912–14: on the one hand in the pages of the Kinoreform*-magazine *Bild und Film*, most notably by Hans Häfker, and on the other in newspapers and cultural magazines through literary figures such as Kurt Pinthus, Kurt Tucholsky, Karl Bleibtreu or Adolf Behne.

At the end of the war, cinema had achieved full recognition if not as an autonomous art form then at least as a strong branch of the entertainment industry. Film criticism became an established category in almost every newspaper and intellectual magazine of the Weimar Republic. Among the theatre critics, Herbert Jhering (in the *Berliner Börsenkurier*) was primarily interested in acting techniques on screen, Alfred Kerr (*Berliner Tageblatt*) extended his associative-descriptive criticism to film, and Roland Schacht (*Freie Deutsche Bühne*, *Weltbühne*) defended the qualitative entertainment film against highbrow scepticism. Among the intellectuals, Hans Feld (from 1926) and Lotte Eisner* (from 1927) regularly wrote film reviews for the *Film-Kurier*, Hans Sahl for the weekly *Montag-Morgen*, Alfred Polgar and Axel Eggebrecht in the *Weltbühne*.

In the Weimar period two interdependent debates about the role of the film critic evolved around the question of the critic's relation to the

film industry and whether to judge cinema from an aesthetic or socio-logical point of view. Whereas Willy Haas* argued for a closer collab-oration between the film critic and practical film-making, Hans Siemsen made a passionate plea for the unconditional industrial inde-pendence of the film critic. Béla Balázs* and Rudolf Arnheim* saw film as an entirely new art form, the expression of a visual culture arising from below, demanding a specialised critic (*Fachkritiker*) able to ascribe to every single work its aesthetic value and artistic position within the world of film production.

The counter-programme of a distinctively socio-ideological film crit-icism was formulated by Siegfried Kracauer* in 1932, when he stated that the real film critic is only conceivable as a social critic, whose task it is to discover collective desires and ideological strategies in any film, independent of the film's artistic quality. Seeing any artistic potential vanishing with the advent of sound film, Arnheim, too, turned to a pos-ition which favoured the critique of film primarily as a cultural and in-dustrial product. While industrial film production continued to flourish after the Nazis' rise to power in 1933, serious film criticism was si-lenced or forced into exile. Those who stayed, among them Karl Korn, Werner Fiedler, Elisabeth Noelle and Carl Linfert, temporarily adapted themselves to the political realities before any non-commer-cial discourse about film was entirely banned through the so-called *Kunstbetrachter Erlaß* in 1936 [> CINEMA AND STATE].

Film criticism in the 1950s was strongly marked by a lack of political and aesthetic methodology, which also applied to the three most prominent critics of that period, Günther Groll (who favoured an im-pressionistic style à la Kerr), Karena Niehoff and Friedrich Luft, whose work showed some skills in putting cinematic experience into words. This kind of 'feuilletonistic' criticism came under attack by a young generation of film critics associated with the magazine *Filmkritik*, founded and edited since 1957 by, amongst others, Enno Patalas, Frieda Grafe, Wilfried Berghahn, Ulrich Gregor and Theodor Kotulla. With programmatic reference to Walter Benjamin and Kracauer, these critics undertook an ideological critique of domestic film production as well as an aesthetic critique of the international avant-garde. Under the influence of films of the nouvelle vague, the double ambition of *Filmkritik* led to insurmountable polarisation amongst the authors, leading to a split between an 'aesthetic' and a 'political' faction, the latter leaving the magazine in 1969. *Filmkritik* was subsequently relaunched, no longer reviewing films but putting together special issues by single authors. It ceased publication in 1984, after 333 issues.

Despite a variety of German language film magazines, since the 1970s film criticism to a large part was once more localised in the daily and weekly newspapers. The prevailing critical method thus depended very much on the editors in charge of film reviews in the single news-paper: while Wolfram Schütte, Gertrud Koch and Karsten Witte have, since the 1960s, stood for a socially committed and aesthetically open-

minded film criticism in the pages of the *Frankfurter Rundschau*, the weekly *Die Zeit*, with Wolf Donner in the 1960s, Blumenberg in the 1970s, and Andreas Kilb since the late 1980s illustrates a more general return to subjective, journalistic criticism, with literary pretensions. MW

II – Film magazines. Until the late 1950s secondary discourse about film took place almost entirely in trade journals (see below), fan magazines and single articles in daily newspapers and intellectual journals. Since then, there has been a greater variety of publications, and they have been more diverse in their scope and critical approach, but weakened by irregular publication, financial insecurity or their short-lived existence.

Despite the considerable number of current German language film magazines, none enjoys the critical status that *Filmkritik* had in the late 1950s and 1960s (see above).

The second important magazine in the 1960s was *Film*, founded in 1963 by Hans-Dieter Roos, which ceased publication in 1971 after changes in the editorial board and title (*Fernsehen und Film, tv heute*). The 1970s and early 1980s saw three stimulating, though unfortunately short-lived attempts to establish critical film magazines in the Federal Republic: *Kino* (edited by Kraft Wetzel in 1973/74), *F Filmjournal* (edited by Günter Knorr 1978–80), and *Filme* (edited by Jochen Brunow, Antje Goldau and Norbert Grob 1980–82).

Among the film magazines originating in the 1970s and still in existence, *Frauen und Film* deserves special recognition since it represents the only European feminist film journal edited exclusively by women [> FRAUEN UND FILM].

Emerging from the 1984 fusion of *Kirche und Film* and *Film-beobachter*, the monthly, relatively independent 'Zeitschrift des Evangelischen Pressedienstes', *epd Film* (currently edited by Wilhelm Roth) contains reviews, festival reports, film-political articles and longer essays with serious journalistic standards.

Dealing with a broad spectrum of issues in the print and audiovisual media, the liberal voice has traditionally been *medium* (published by the 'Gemeinschaftswerk für Evangelische Publizistik'). During the 1970s it also fought some of the most important film-political debates around film subsidy, filmed literature, the concept of the authors' film*. Since it was given a new format and layout in 1990, the two-weekly film guide of the Catholic Institute for Media Information, *film-dienst* (founded in 1948 as *Filmdienst der Jugend*), has entered into serious competition with its Protestant counterparts.

While the two-monthly *filmfaust* (since 1976; edited by Bion Steinborn) devotes particular attention to the discussion of international up-and-coming young film-makers, the special issues of the quarterly *filmwärts*, founded in 1986 and edited until 1995 by historians Rolf Aurich, Heiner Behring, Theo Matthies and Rainer Rother, were notable for their special interest in German film as well as for the

94

space devoted to reviews of recent film literature. *Kino/German film* (since 1970; edited by Dorothea and Ron Holloway) appears three to four times a year and offers English-language interviews, scripts, articles, reviews and filmographies, entirely devoted to current developments in German film. Founded in 1973 as the official publication of the 'Verband der Film- und Fernsehschaffenden der DDR', *Film und Fernsehen* (after the death of Rolf Richter in 1992, edited by Erika Richter alone) continues to provide information about political and aesthetical changes taking place in the eastern part of Germany and East Europe in the form of articles, interviews, festival reports and reviews.

For a long time the East German magazines *Deutsche Filmkunst* (from 1953) and *Filmwissenschaftliche Beiträge* (from 1967) were the only academic film journals. Since then, *Frauen und Film* and *Augen-Blick*, published by the German faculty of the University of Marburg (1986 onwards) have given space to scholarly debate, and they have been joined in the 1990s by a number of journals with explicitly high theoretical standards: the half-yearly *montage/av* (edited by Wolfgang Beilenhoff, Frank Kessler, Eggo Müller, Hans J. Wulff and Peter Wuss) devoted its first three issues to the theoretical and historical implications of intertextuality, filmic suspense and popular culture; the yearbook, *KINtop* (edited by Frank Kessler, Sabine Lenk, and Martin Loiperdinger) took up the long neglected task of investigating the field of early cinema, starting off with special issues on early German cinema and George Méliès, while *FilmExil* (since 1992), published by the Stiftung Deutsche Kinemathek, provides an ongoing forum for the discussion of German film emigration. MW

III – Austrian film journals. It is characteristic of film criticism and related research activities in Austria that it is mostly initiated and carried out by a variety of private associations that are dependent on government funding and private sponsorship. None of the universities has a department for film studies, so that writing on film is almost exclusively a matter of day-to-day reviewing. Measures taken in the 1980s to take film more seriously as part of cultural life are slowly becoming effective, mostly thanks to a number of individuals and institutions who have managed to sustain a continuous level of publishing activity. Associated with the *Österreichisches Filmarchiv* (Austrian Film Archive) [> ARCHIVES] in Vienna, the *Österreichische Gesellschaft für Filmwissenschaft, Kommunikations- und Medien-forschung* (Austrian Society of Film Sciences, Communication and Media Research, since 1952) is concerned with research and documentation and is the editor of the magazine *Filmkunst*. *Synema – Gesellschaft für Film und Medien* (formerly *Gesellschaft für Film-theorie*, founded in 1984), regularly organises conferences and special film programmes, supports various research projects and seminars, publishes anthologies and conference-papers, as well as the yearbook *Kinoschriften* (since 1988). Currently there are only two magazines

dedicated to film and film theory: *blimp. Zeitschrift für Film* has been published in Graz since 1984 and regularly features articles on and interviews with Austrian experimental film-makers; *Meteor. Texte zum Laufbild* (from 1995 on) which features critical essays on newly released films (with a strong bias towards Austrian and American film-making, both commercial and experimental) and in-depth analyses of film-historical and film-theoretical issues. IR/MW

IV – Trade journals communicate information within the film industry, relaying news between different branches of the industry (production, distribution*, exhibition*). The most important trade journals before 1945 were *Der Kinematograph* (1907–35), *Licht-Bild-Bühne* (1908–40) and *Film-Kurier* (1919–45). Other journals from this period include *Der Film* (1916–43) and *Reichsfilmblatt* (1922–35). The most important journals after World War II were *Film-Echo* (1947–) and *Filmblätter* (1949–69); *Der Neue Film* (1947–60), *Die Filmwoche* (1950–62) and *Blickpunkt: Film* (1976–) are also of historical significance.

Apart from reporting on current news within the film industry and providing a vehicle for advertising, trade journals also announce projects or comment on any changes in legislation affecting film. Trade journals may also lobby governments on behalf of members of the film industry for policy changes. In addition, they report on technical innovations and film festivals, as well as featuring obituaries, reviews, statistics on film ratings and on film censorship, while compiling box office charts on films and popularity polls.

Trade journals are one of the most important sources for verifying the historical context within which a film was produced, distributed, released and viewed. This is especially true for Germany, since fewer films are still extant than, for example, in the US. Important sources for the history of German film which have survived include the records from the company of Oskar Messter*, many files from Ufa*, records of the Junge Film Union and the Filmaufbau GmbH Göttingen (Rolf Thiele*). Despite the fact that a large number of film production companies existed (particularly during the Weimar Republic, historical information is scant, many of the records having been lost or destroyed.

In Austria, the Austrian Film Commission (AFC) (since 1986) promotes and represents Austrian films at festivals. Its annual catalogue *Austrian Films* includes bio-/filmographical informations and texts in English and French translation; additionally, a bi-monthly trade brochure *Austrian Film News* has appeared since 1992.

Trade journals have been influenced in the past both by national politics and by the goals of the commercial film industry and therefore are not always a source of objective historical information. For example, *Film-Kurier* represented diverse interests within the film trade during the Weimar Republic, while serving as the official publication of the lobby for Germany's film industry, the SPIO*. JG

Bib: Helmut H. Diederichs, *Anfänge deutscher Filmkritik* (1986); Norbert Grob/Karl Prümm, *Die Macht der Filmkritik: Positionen und Kontroversen* (1990).

FILM EUROPE

German-led European film initiative. Erich Pommer* seems to have been the first to develop the idea of making 'continental' and 'pan-European' films to expand film markets beyond national borders, leading to two European-wide film congresses, one held in Paris in 1926 and the other in Berlin in 1928. Cultural topics were the most discussed, while economic questions stayed largely off the agenda, possibly so as not to offend American guests but also ensuring that the events had few practical results. Beginning in 1924, film companies from various European countries entered into reciprocal distribution agreements. They also promoted exchanges of creative talent, hoping to develop products aimed at an international market. E. A. Dupont* and Olga Tschechowa* were under contract to the British film industry, resulting in films such as *Moulin Rouge* (1928) and *Piccadilly* (1929), while Alfred Hitchcock also worked briefly in German studios. The German-Dutch company Tobis-Klangfilm succeeded in creating a European cartel from 1929 to 1930 by monopolising the patent for sound film in Europe, and for a short time the pan-European market was protected against the American film industry more strongly than had ever been the case. French film personnel especially felt the pull of Ufa, but a great number of Italians also worked in Berlin during the 1930s.

A much more effective co-operation between European countries began at the end of the 1950s. Of all films produced in Germany in the 1960s around 40% were co-productions with European partners, without, however, bringing about an integration of European film markets. This to some extent happened in the 1970s, though predominantly as a consequence of American movies' box-office strength and Hollywood distribution strategies. The frequently launched initiatives to defend Europe's markets against American domination seem doomed, since such attempts, however worthy, concentrate on promoting low-budget art films with limited popular appeal and few infrastructural benefits. JG/TE

FILM SCHOOLS

One consequence of the Oberhausen manifesto of 1962 [> NEW GERMAN CINEMA] was to draw attention to the problem of training and education in film. In 1962 Alexander Kluge*, Edgar Reitz*, and Detten Schleiermacher set up West Germany's first film school, the *Institut für Filmgestaltung Ulm*. However, it closed in 1966. The same

year, the *Deutsche Film- und Fernsehakademie Berlin* (DFFB) admitted its first students, and the *Hochschule für Film und Fernsehen* (HFF) opened in Munich in 1967.

Among the internationally known directors only Wim Wenders* (HFF) and Wolfgang Petersen* (DFFB) graduated from a film school. Fassbinder* was turned down when he applied to Berlin. Each institution developed its own distinct approach to subject matter, style and politics. Both the 'Berlin School' (among its students: Hartmut Bitomski, Harun Farocki*, Helke Sander, Christian Ziewer) and the 'Munich School'(Doris Dörrie*, Uli Edel, Bernd Eichinger*, Dominik Graf), as they came to be known, were to have a normative influence on the way German television and cinema evolved. While the study of film-making practice during the 1970s and 1980s was restricted to Berlin and Munich, the beginning of the 1990s saw the establishment of alternative film schools, with a shift of emphasis towards media art, commercials, animation and TV in Cologne (*Kunsthochschule für Medien*, since 1990), Berlin (*Hochschule der Künste*) and Ludwigsburg (*Filmakademie Baden-Württemberg*, since 1991).

In the former GDR, graduation from the film school in Potsdam-Babelsberg (or an equivalent institution in other socialist countries) was the basic requirement for employment at the DEFA*-studios. Founded as *Deutsche Hochschule für Filmkunst* in 1954, it was renamed *Hochschule für Film und Fernsehen der DDR* in 1969, and since 1985 has been associated with the name of Konrad Wolf*. After 1990, it went through a lengthy process of redefinition of goals and policy, refocusing its personnel and study methods. With 260 student places it is the largest film school in Germany.

In Austria, practical film-making has been taught since 1952 at the Department for Film & Television at the *Hochschule für Musik und darstellende Kunst*. MW

FILM TECHNOLOGY (Sound, Colour, Wide-screen)

Innovations in film technology can make film production more efficient, as did the replacement of the dolly shot by the zoom. Innovations can also raise the quality of the film (such as improvements in film stock), or increase the market value of the product (as did synchronised sound, colour film and wide-screen). Such innovations may result from chance discoveries or they may be the product of long-term investment and planning by individuals or large companies. Only a fraction of the break-through innovations in film technology are taken up by film companies and become the industry standard. Which are adopted and how quickly they are accepted depends on a number of factors. Among the most important of these are audience reaction, economic efficiency and patent ownership.

How the German film industry organised research in film tech-

nology and the speed with which innovations became standard practice changed dramatically between the time film was invented and the 1920s. At the turn of the century in Germany, as elsewhere, film technology developed partly by accidental discovery. Scientists or craftsmen were often working simultaneously on the same problems. For example, both Ottmar Anschütz and Edward Muybridge conducted research in order to better understand how humans and animals move. They did so for scientific purposes; neither was interested in film entertainment. Anschütz constructed a device to record a series of photographs of moving subjects on glass slides in 1880 as well as a device to reproduce them in motion in 1890. The latter was called an 'Elektrotachyskop'. Anschütz developed a projector in 1894 which created the impression of moving images by projecting a series of photographs on glass slides. He held the first performance of moving images for a paying audience in Berlin on 25 November, 1894.

Recognising the economic potential of the new medium, inventors such Oskar Messter* and Karl A. Geyer* founded companies to market the equipment they invented. Oskar Messter* secured nearly 70 patents (including a special Maltese Cross and an optical printer) and manufactured various items of film equipment which he had invented (including film projectors, cameras, machines for developing and copying). Messter distributed his equipment through his company 'Messters Projections GmbH', founded in 1900, in which he owned a majority of the shares.

Karl A. Geyer* repeatedly set new technical standards for film equipment as of 1906. He was responsible for automating the process of film developing and printing. Geyer sold his post-production equipment across Europe through 'Karl Geyer Maschinen- und Apparatebau GmbH', founded in 1918.

As the film business in Germany increasingly industrialised, privately owned chemical, electric and film companies stepped up research on film technology, exploiting or developing earlier inventions. From the 1920s onwards, scientists became employees of large firms, no longer able to claim the rights to their own inventions. One notable exception was the invention of an optical sound-on-film system, developed by Hans Vogt, Jo Engl and Joseph Massolle, who gave themselves the name 'Triergon' in 1922. Their research was conducted independently, since the film industry in the early 1920s did not believe that sound film would be lucrative. Eventually, different film companies acquired the rights to the development of Triergon, and by 1925 Ufa* had already created a special department of roughly 30 employees to further develop the Triergon system. Due to the financial difficulties Ufa* was experiencing at this time, funding was cut and the project was shelved in 1927, at about the same time as Warner Brothers launched the sound film world wide.

A multi-coated colour film (*Agfacolor-Verfahren*) was developed by the chemists Wilhelm Schneider and Gustav Wilmanns of the I.G. Farbenindustrie AG during the first years of the Third Reich

(1934–38). Their research, too, was carried out independently of any research taking place outside Germany.

Technical innovations such as the Maltese cross, which increased the quality of the film, or automated film developing, which made film production more efficient, were adopted relatively quickly by the film industry. As well as being useful, the new equipment had to be cheap to produce in order to be acceptable as the industry standard. Technical innovations which improved the marketability of the film such as sound, colour and wide-screen films took longer to become accepted by the industry. This was due to the expense of introducing such technology – often requiring movie houses to be re-equipped and refurbished, making introduction dependent on demand from movie-goers and instant profitability – besides licensing and investment costs.

Following the success of sound film in the US, two large patent groups emerged in Germany in 1927–28: the Tonbildsyndikat AG (Tobis) made up of patent holders and banks, and the Klangfilm GmbH, owned by the electrical companies AEG and Siemens & Halske. After a short rivalry, both firms merged to form the 'Tobis–Klangfilm' in March 1929. Specific areas of interest were divided between the two companies: Klangfilm took over manufacturing the equipment and projector sales, while Tobis was responsible for film production and camera sales. Almost immediately, a fight for control of the market in sound film began between Germany (Tobis-Klangfilm) and the US (Western Electric/ERPI). Measures were introduced in both countries to establish a monopoly, including a ban against showing a competitor's film on equipment of a rival company, but the dispute ended with an agreement signed on 22 July, 1930. It created an international cartel in sound film, with Germany having the monopoly in large parts of Europe, and the US taking over North America, Australia, Russia and some other markets. Those parts of the world not covered by the agreement had to pay a licence fee to use the sound film equipment.

The resolution of the German/American dispute made it possible for the German film industry to convert swiftly to sound. The percentage of movie theatres capable of exhibiting sound films in Germany rose from 10% to 90% in a single year (1930). Similarly, the percentage of sound films produced in Germany grew from 4.4% in 1929 to 69.2% in 1930, to 98.6% in 1931. Sound proved particularly attractive to German cinema audiences, leading to a rapid increase in their supply. Even though sound films only added an insignificant percentage to the total box-office revenues in 1929, they had replaced silent films by 1930.

The development of colour film was affected by political factors. The Nazis' rise to power meant that Germany became ostracised from the international community, with the result that the 'Agfacolor' process was the first colour process adopted in Germany, only in the mid-1950s giving way to the technically superior American Eastman Colour process, also adopted by Agfa-Gevaert itself in 1969.

100

The first German colour feature film, *Frauen sind doch bessere Diplomaten*, premiered in 1941. During the war roughly 3% of German feature films were in colour. These include films featuring spectacular scenes, such as the adventure film *Münchhausen* (1943), the revue film *Die Frau meiner Träume* (1944) and the war film *Kolberg* (1945). The number of colour films increased in the 1950s and reached a short-lived high point in 1956, when 63.4% of all films produced in Germany were colour. Following this, a drop in cinema attendance forced film companies to reduce production costs (black-and-white representing a saving of 20–30%), and the percentage of colour films sank to 22.3% by 1960. As with sound, the public found colour to be an attractive production value, but unlike sound, it remained something of an optional extra, compared to the importance of stars. This is evidenced by the continuing popularity among others of such films as *Der Pauker* (1958), *Das Mädchen Rosemarie* (1958), *Freddy, die Gitarre und das Meer* (1959), all of which were shot in black-and-white, whilst most American films in distribution were in colour. By the end of the 1960s, however, over 90% of all German films were also in colour, the exception being films of the New German Cinema*, notably Wim Wenders'* *Im Lauf der Zeit/Kings of the Road* (1975), by which time black-and-white had acquired special artistic status.

Wide-screen films (defined as a picture wider than 1:1.66) did not gain acceptance in German film production the way sound and colour had. Although such films were popular between 1962 and 1965 [> AMERICAN FILMS IN GERMANY], they could not stem the fall-off in cinema attendances for long, and again, cost factors were a further disincentive. Wide-screen films became even less a factor during the 1970s and 1980s, since films co-produced with public television had in any case to be made with the small screen in mind. JG

Bib: Gert Koshofer, *Color: Die Farben des Films* (1988); Harald Jossé, *Die Entstehung des Tonfilms* (1984).

FILM THEORY

A theory is used to explain observed phenomena and to produce generalisable knowledge about a field of inquiry as a whole. Individual observations are integrated into a mental construct, arrived at by processes of deduction or induction, formed on the premise that the pertinent observations are not determined by subjective opinion, and that the field can be sufficiently defined to become a discipline. A discipline is clearly defined when: a) it is a relatively independent area of study b) theories exist particular to this field of study c) it is institutionalised in an academic community. In this sense, cinema cannot yet claim to be a discipline in Germany, which in turn affects the nature of German film theory.

Likewise, such theories as exist about German cinema and are academically accepted have been formulated by film critics and not by German film scholars. Film critics such as Siegfried Kracauer*, who began writing film reviews for the *Frankfurter Zeitung* in 1921, and Rudolf Arnheim*, who wrote film reviews for *Stachelschwein* and *Weltbühne* beginning in 1925 and 1928 respectively, had backgrounds in other academic fields. Kracauer was trained in the social sciences and Arnheim had studied art history; both expressed their ideas as part of a philosophy of art. They created theories in order to show why the cinema should be considered an art form, responding also to the need to redefine aesthetics in modern, industrialised societies. Their approach was shaped to some degree by phenomenological systems of thought and included ideological opinions and evaluative judgements. In his book *Theory of Film. The Redemption of Physical Reality* (1960), Kracauer* maintains that in the modern age, reality is itself mediated and lacks authenticity, which is why, paradoxically, films can restore or 'redeem' our sense of physical reality and perceptual presence. Arnheim, too, maintained that the artistic essence of the cinema lay in the excessive artificiality of the cinematic medium. Because silent film is the type of cinema furthest removed from one's experience of the world (colour and sound being absent), Arnheim argues in *Film als Kunst/Film as Art* (1932) that only silent films are capable of being art. Such views aimed to explain the 'nature' of the medium and understood themselves as normative. Films inconsistent with their categories were considered 'uncinematic' (in Arnheim's case, sound films and in Kracauer's case, animation or graphic cinema). A more social-science-based study of film began at German universities in the 1910s (for example, the dissertations of Emilie Altenloh* [1914] and Rahel Lipschütz [1932]). Although their research did not receive the public attention given to the work of Arnheim and Kracauer, empirical studies of film and cinema have slowly gained ground, next to onto-logical-philosophical theories in the German tradition, or deconstructive and neo-phenomenological approaches imported from abroad. The subjects of empirical studies comprise diverse types of film, from different periods and genres, with an emphasis on film stars*, audiences, technical innovations*, modes of production, distribution*, exhibition* and the mutual impact of politics and the film industry on each other [> CENSORSHIP, CINEMA AND STATE].

Research in film history amongst academics has mainly been in the context of doctoral dissertations (besides Altenloh and Lipschütz, the work of Peter Bächlin [1945], Gerd Albrecht [1969] and Corinna Müller [1994] come to mind). Researchers at film archives* (Deutsches Institut für Filmkunde, Deutsches Filmmuseum, Stiftung Deutsche Kinemathek and CineGraph Hamburg) have also made substantial contributions to German film history, with archival institutions increasingly responsible for quality publications on German film. As a consequence, new light has been shed in the 1980s and 1990s on central areas of German film history, such as Ufa*, regional audience

reception and local cinema history, and there have also been monographs on film-makers, studios and production companies. Unlike Anglo-American academics, German film scholars lack an overview of the field and their knowledge remains patchy and selective. Individual studies tend not to be integrated into a more comprehensive view of German cinema, which, for instance, does not possess a history of its audiences. Similarly, although several individual production companies have been studied (Ufa*, Terra*, Junge Film Union, CCC), no book yet exists on the history of film production in Germany, even though film research has been carried out by academics from a variety of fields (including theatre, history, literature, sociology, economics and law) continuously since the 1910s. Since the 1970s, the number of courses on cinema offered at Germany universities has increased, mainly, however, under the umbrella of other disciplines, as documented in the annual reports *Film in Forschung und Lehre* (Cinema in Research and Teaching), published since 1978. Since 1985 the *Gesellschaft für Film- und Fernsehwissenschaft* (GFF, Society for Cinema and Television Studies) has been organising the scholarly community in Germany around annual conferences and a news bulletin, reflecting the growth of the field as it tries to consolidate theory and research into an autonomous discipline. JG/TE

Bib: Sabine Hake, *The Cinema's Third Machine: Writing on Film in Germany 1907–1933* (1993).

FILMVERLAG DER AUTOREN

German distribution co-operative. Modelled on the literary *Verlag der Autoren* (and Hollywood's 'United Artists'), the *Filmverlag der Autoren* ('Publishing House of Authors') was founded in 1971 by a group of directors wishing to enter the market. Initially a co-operative between Wim Wenders*, R. W. Fassbinder*, Hans W. Geissendörfer, Uwe Brandner and Laurens Straub, the Filmverlag's guiding idea was for 'name' directors to act as a distribution company and take maximum advantage of the German subsidy system. The Filmverlag's shares were acquired in 1985 by former manager Theo Hinz and, despite chronic financial problems, the company continues to distribute innovative German films [> NEW GERMAN CINEMA]. MW

FISCHER, Otto Wilhelm Klosterneuburg 1915

Austrian actor. After training at Max Reinhardt's* school, Fischer played both light and serious parts on Viennese stages and at the Munich Kammerspiele. From 1936 to 1945 he appeared on screen as harmless young artist or aristocrat in a number of films, but his fame rose with his increasing specialisation in melodrama, which turned him

into the most popular male star of postwar Germany. In contrast to the Nazi ideal of male decisiveness, Fischer represented a new type of man, suffering from inner conflicts: like female melodramatic characters, his heroes yearned, sacrificed and cried. Their struggle to act morally can be seen as symbolic of the dilemma faced by Germany and the Germans during the immediate postwar period of reconstruction and *Wirtschaftswunder* (economic miracle). Fischer imbued these unconventional melodramatic characters with the elegance, discreet charm and even geniality of his earlier roles, but he added excess and unpredictability: elegance became artificial (especially in his way of talking), and charm, eccentricity and geniality turned to cynicism. Outside German cinema, Fischer gained some popularity through 1960s international co-productions such as *Axel Munthe, der Arzt von San Michele/La Storia di San Michele/Le Livre de San Michele* (1962, Ger./It./Fr.). KU

Bib: Dorin Popa, *O. W. Fischer: Seine Filme, sein Leben* (1989).

Other Films Include: *Sieben Briefe* (1944); *Bis wir uns wiedersehen* (1952); *Tagebuch einer Verliebten* (1953); *Bildnis einer Unbekannten, Ludwig II. Glanz und Elend eines Königs* (1954); *Skandal in Ischl* (1957); *Es muß nicht immer Kaviar sein/Pourquoi toujours du caviar* (1961); *Teerosen* (1976, TV).

FORST, Willi Wilhelm Frohs; Vienna 1903–80

Austrian actor and director. A specialist in stage comedy and operetta from 1919, Forst appeared in various Austrian silent films, starting with *Der Wegweiser* (1920). He rose to international recognition in two sound films by E. A. Dupont* (*Atlantic/Atlantik*, 1929; *Peter Voss, der Millionendieb*, 1932) and worked for directors such as Robert Siodmak*, Geza von Bolvary* and Karl Hartl*. Forst was already a popular star of the sound cinema when he directed his first film, *Leise flehen meine Lieder* (1933). He was subsequently often scriptwriter, producer and star as well as director of his films, his exceptional vocal qualities making him one of the most popular stars of Austrian and German musical comedies and film operettas of the 1930s and 1940s (together with Lilian Harvey* and Willy Fritsch*) in such films as *Zwei Herzen im 3/4 Takt* (1930), *Der Prinz von Arkadien* (1932), *Ein blonder Traum* (1932), *Königswalzer* (1935), *Mazurka* (1935), *Serenade* (1937), *Operette* (1940) and *Wiener Blut* (1942). *Maskerade/Masquerade in Vienna*, which he directed in 1934, made Paula Wessely* into a major film star. Enjoying his greatest successes between 1938 and 1945, Forst proved an expert craftsman and master of the 'Viennese film', establishing a stylistic quality which other directors and other films in the genre failed to attain, as he depicted a carefree Viennese dream world set to waltzes. This led to later accusations

104

that he had turned a blind eye to the atrocities of the Nazi regime and the war. Forst himself described his work as a 'silent protest', arguing that he made 'Austrian films' at a time 'when Austria had ceased to exist'; he also refused to act in Veit Harlan's* *Jud Süss* (1940) and incurred Nazi disapproval.

Forst's postwar films did not match his pre-1945 successes, either artistically or commercially. The sole exception, *Die Sünderin/The Sinner* (1951), is the story of a young woman (Hildegard Knef*) who becomes a prostitute to make a living and support her artist lover and who later commits suicide with him. The Catholic Church's protests turned the film into a *succès de scandale*. Forst's last film as director was *Wien, Du Stadt meiner Träume* (1957). FM

Bib: Robert Dachs, *Willi Forst: Eine Biographie* (1986).

FORSTER, Rudolf Gröbming 1884 – Bad Aussee 1968

Austrian actor, who developed a range of expressive performances in his characteristic role as the urbane and charming aristocrat. His talent for pantomime, which was noted for its precision, helped him give his characters often diabolically ambivalent features. He surprised his audience in his first sound film, G. W. Pabst's* version of Bertolt Brecht's *Die Dreigroschenoper/The Threepenny Opera* (1931), playing Mackie Messer as an unexpected 'gentleman gangster'. In 1937 Forster emigrated to the US, but he returned to Germany in 1940 to play the former Viennese mayor Lueger in *Wien 1910* (1942), an openly anti-fascist film. In the course of his career Forster worked with directors such as Paul Czinner*, Willi Forst*, Otto Preminger and Helmut Käutner*. His film persona lost almost all its former popularity after 1945, however, having by then flattened into a cliché. FM

FRAUEN UND FILM

Founded by film-maker Helke Sander* in 1974, *Frauen und Film* is the first and only feminist film journal in Europe. The primary concerns of *Frauen und Film* are a continuing analysis of the workings of patriarchal culture in cinema and the concomitant demand for radically improved opportunities for women in film and television. In January 1984, the Berlin editors decided to cease publication, arguing that the recognition *Frauen und Film* had attained among fellow film journalists would run counter to the journal's radical ethos. However, the Frankfurt editors – Karola Gramann, Gertrud Koch and Heide Schlüpmann – took over, and *Frauen und Film* continues to publish two issues a year, emphasis having shifted from political engagement with contemporary issues of film production to historical and theoretical concerns, with special issues devoted to women's experience of film

in the 1950s, psychoanalysis and film, avant-garde and experimental film-making, masochism, female desire and early film history. In its present form *Frauen und Film* is the only film journal of such high theoretical standards in Germany, having in this respect taken on the task once briefly fulfilled by *Filmkritik*. MW

FRAUENFILM

German women's film movement (the term means 'Women's cinema'). Until the mid-1970s there were very few women directors in West Germany. Ula Stöckl and Erika Runge, whose careers started in the mid-1960s, were notable exceptions. The state- and television-subsidised New German Cinema* of the 1970s, though dominated by male *auteurs* such as R. W. Fassbinder* and Wim Wenders*, provided an institutional framework and an – albeit limited – space for women. Television, in particular, offered many first-time film-makers, and therefore women, a chance. Recognising the need for an infrastructure, in 1973 Claudia von Alemann and Helke Sander* organised the first International Women's Film Seminar; in 1974 the feminist film journal *Frauen und Film** was founded. The journal became an important forum for discussing ideas and organising distribution, exhibition and film festivals (such as the *Feminale* in Cologne, from 1984); the Association of Women Film Workers was founded in 1979. Most women film-makers involved being politically committed, both to the Left and to the Women's Movement, their prime concern was initially with didactic socialist/feminist agitation and information, dealing with such issues as domestic violence – Christina Perincioli's drama-documentary *Die Macht der Männer ist die Geduld der Frauen/The Power of Men is the Patience of Women* (1978) – and motherhood – Helga Reidemeister's prize-winning documentary *Von wegen 'Schicksal'/This is 'Destiny'* (1979). The early films of Sander, Jutta Brückner*, Helma Sanders-Brahms* and Margarethe von Trotta* also dealt with such political issues. From the 1980s the concern shifted from realism and 'positive' images of women towards theoretical and aesthetic interests. This led to a preoccupation with formal elements, such as sound; Alemann's *Die Reise nach Lyon/Blind Spot* (1980) literally traces the footsteps of Flora Tristan in the city of Lyons. Film-makers also became increasingly concerned with fantasy and psychic reality, for example Ulrike Ottinger* and Brückner in her 1980s films. Elfi Mikesch, a prize-winning cinematographer, directed a variety of films, from documentaries to stylised sexual fantasies.

Although most women worked in low-budget features – and thus remained marginal – von Trotta's and Sanders-Brahms' move towards international art cinema paid off in terms of public recognition, and paved the way for other successes: Marianne Rosenbaum's *Peppermint Frieden/Peppermint Peace* (1982), a light-hearted autobiographical account of growing up in the 1950s, and Alexandra von

106

Grote's *Novembermond/November Moon* (1985), a romantic love story between two women caught up in the turmoil of World War II. Doris Dörrie's* 1980s comedies showed a new tendency towards popular cinema, and similarly, in the 1990s, Monika Treut's* cheerful engagement with sexual politics is a far cry from the didactic films of the 1970s. US

Bib: Julia Knight, *Women and the New German Cinema* (1992).

FREUND, Karl
Königsdorf 1890 – Santa Monica, California 1969

German cinematographer, who began in 1906 as a projectionist in Berlin before graduating to newsreel cameraman for Pathé and technical operator for Oskar Messter* in 1908 [> DOCUMENTARY (GERMANY)]. In the 1920s, he worked at Ufa* and gained an international reputation as a master of extreme camera angles, camera movements and bold lighting effects. Freund worked with directors such as Fritz Lang* (*Metropolis*, 1927), F. W. Murnau* (*Der brennende Acker/The Burning Soil*, 1922; *Der letzte Mann/The Last Laugh*, 1924), Paul Wegener* (*Der Golem, wie er in die Welt kam/The Golem*, 1920) and E. A. Dupont* (*Varieté/Variety*, 1925), helping to create some of the most influential and highly regarded films of Weimar* cinema. In 1927 he co-produced and co-scripted Walter Ruttmann's* landmark documentary, *Berlin, die Sinfonie der Großstadt/Berlin, Symphony of a City*. Three years later Freund went to the US to work on an experimental colour programme for Technicolor. He filmed classical fantasy and horror pictures for Universal Studios, including *Dracula* (1931) and *The Mummy* (1933, which he also directed), and won an Academy Award for cinematography on *The Good Earth* in 1937. In 1944 he founded the Photo Research Corporation in Burbank, California. Among other Hollywood films he shot *Undercurrent* (1946, Vincente Minnelli) and *Key Largo* (1948, John Huston). In 1954 he was given a technical award by the American Academy for designing and developing the direct-reading light meter. MW

FRITSCH, Willy
Wilhelm Egon Fritz; Kattowitz 1901 – Hamburg 1973

German actor. After minor roles at the Deutsches Theater Berlin, his film debut, *Seine Frau, die Unbekannte* (1923), established Fritsch as a juvenile lead. He is best remembered, however, for his screen partnership with female star Lilian Harvey*. Dating back to the 1920s (*Die keusche Susanne*, 1926; *Ihr dunkler Punkt*, 1928), their on-screen romances made them the dream couple of the 1930s. The immensely

popular Fritsch came to incarnate the optimistic hero of Ufa's* depression era comedies (*Die Drei von der Tankstelle*, 1930) and operetta films (*Der Kongress tanzt*, 1931). Also partnered with Käthe von Nagy (*Ihre Hoheit befiehlt*, 1931), Fritsch later played more serious roles in melodramas (*Die Geliebte*, 1939), eventually maturing into fatherly parts (*Wenn der weiße Flieder wieder blüht*, 1953). KU/TE

Other Films Include: *Spione* (1928); *Amphitryon* (1935); *Glückskinder* (1936); *Fanny Elßler* (1937); *Capriccio* (1938); *Frau am Steuer* (1939); *Film ohne Titel* (1947); *Was macht Papa denn in Italien?* (1961).

FRÖBE, Gert
Planitz 1913 – Munich 1988

German actor whose first role was in a 1944 film (*Die Kreuzlschreiber*) not released until 1950, when he was known mainly as a circus, variety and cabaret performer. Despite a successful leading role in *Berliner Ballade* (1948, dir. R. A. Stemmle), Fröbe's film career only took off in the mid-1950s with (co-)productions that allowed him to develop a screen persona as a 'heavy' ranging from criminal psychopaths (*Es geschah am hellichten Tag*, 1958) to police inspectors (as in Fritz Lang's* *Die 1000 Augen des Dr Mabuse*, 1960). International acclaim came to Fröbe as the eponymous villain in the James Bond movie *Goldfinger* (1964), and he subsequently starred in a number of American and European films, before turning to German television in the 1970s, as a lead in several detective series. Fröbe received several German film awards*, including the Preis der deutschen Filmkritik (1959), Bambi (1966, 1967) and the Deutsche Filmpreis (1978). KU

Bib: Gregor Ball, *Gert Fröbe: Seine Filme, sein Leben* (1982).

Other Films Include: *Der Tag vor der Hochzeit* (1952); *Man on a Tightrope* (1953); *Mr. Arkadin/Confidential Report* (1955); *Robinson soll nicht sterben* (1957); *Peau de banane* (1963); *Ludwig* (1972); *Das Schlangenei/The Serpent's Egg* (1977); *Der Falke* (1981).

FROELICH, Carl
Berlin 1875–1953

German director, cameraman and film pioneer, who as early as 1903 joined Oskar Messter's* technical department, before becoming cameraman for Henny Porten's* 1906 debut film *Meissner Porzellan*. As co-director, he created the special effects in *Richard Wagner* (1913), which was distributed successfully in the US. During the war he was one of only eight licensed film correspondents at the front, shooting material for the 'Messter Woche', making him one of the fathers of the German newsreel [> DOCUMENTARY (GERMANY)].

In the first years after the war Froelich directed, among other films,

Arme Thea (1919), starring Lotte Neumann, *Der Tänzer* (1919) with Lil Dagover*, and *Die Brüder Karamasoff* (1920) with Emil Jannings* and Fritz Kortner*. Shortly after the huge success of *Mutter und Kind* (1924, again starring Porten), Froelich, Porten and her husband Wilhelm von Kaufmann set up Porten-Froelich Produktion, Berlin, which produced fifteen films before 1929, most of them enormously popular and professional star vehicles for Porten. Froelich directed one of the first German talkies, *Die Nacht gehört uns* (1929, starring Hans Albers*), which, because of its enormous budget, was shot in London as a German-French co-production. Two years later, Froelich supervised Leontine Sagan's* *Mädchen in Uniform/Maidens in Uniform* (1931). In 1933 he became a member of the National Socialist Party, and directed *Ich für Dich – Du für mich* (1934) for the Reichspropaganda Ministry. He directed two major Zarah Leander* films (*Heimat*, 1938; *Das Herz der Königin*, 1940), and, once more, Porten in the nostalgic two-part romance, *Familie Buchholz/ Neigungsehe* (1944). Imprisoned immediately after the war, he was 're-habilitated' in 1953, on the occasion of his fiftieth anniversary in the movie business and the year of his death. MW

FRÜH, Kurt St. Gallen 1915 – Boswil 1979

Swiss director. A left-wing writer, actor, cabaret artist, stage director as well as industrial and advertising film-maker, Früh worked at the *Ciné-journal suisse* newsreels during World War II and between 1949 and 1953 was assistant director to Leopold Lindtberg* at Lazar Wechsler's* Praesens-Film. He started his own career as a feature film director at Gloria-Film with two urban dialect comedies – *Polizischt Wäckerli* (1955) and *Oberstadtgasse* (1956). His next film, *Bäckerei Zürrer* (1957), drew a very personal and accurate picture of a petit-bourgeois milieu but also managed to introduce some ambiguity into its straightforward narrative. For a long time, *Bäckerei Zürrer's* slightly ironic dimension remained the only deviation from popular genre forms in Früh's work, as neither the Heinz Rühmann* vehicle *Der Mann, der nicht nein sagen konnte* (1958), nor the Max Haufler pictures *Hinter den sieben Gleisen* (1959) and *Der Teufel hat gut lachen* (1960), nor the musical *Der 42. Himmel* (1962) revealed a particular talent for subverting comic and melodramatic stereotypes.

When Früh turned to television, radio and film teaching in the 1960s, it seemed as if his career in cinema had come to an end. In the early 1970s, however, he made an astonishing comeback with two films said to have inspired the younger generation of Swiss film-makers. *Dällebach Karl* (1971) is the portrait of an authentic regional character living in complete social isolation, while *Der Fall* (1972) traces the financial and mental decline of a down-at-heel private detective. Despite considerable critical acclaim, both films were financial failures, and, funds having dried up, they remained Früh's last. MW

Other Films Include: *Café Odéon* (1959); *Es Dach überem Chopf* (1961); *Im Parterre links* (1963).

G

GANZ, Bruno Zurich 1941

Swiss-born German actor. Working with Peter Stein's prestigious Berlin Schaubühne from 1970, Ganz became one of the most acclaimed young actors of German theatre. He left the ensemble to star in Eric Rohmer's* *Die Marquise von O/La Marquise d'O* (1976) and achieved international recognition in the role of Jonathan in Wim Wenders'* *Der amerikanische Freund/The American Friend* (1977). A key actor of the 1970s and 1980s, he became, along with Hanna Schygulla* and Klaus Kinski*, the international face of the New German Cinema*. After co-directing a documentary on his actor colleagues Bernhard Minetti and Curt Bois*, *Gedächtnis* (1982, with Otto Sander), he worked mainly for television in the mid-1980s. He appeared as one of the angels in Wim Wenders' *Der Himmel über Berlin/Wings of Desire* (1987) and in the same director's *In weiter Ferne, so nah!/Far Away, So Close* (1993). MW

Other Films Include: *Der Herr mit der schwarzen Melone* (1960); *Chikita* (1961); *Die Wildente* (1976); *Die linkshändige Frau* (1977); *The Boys from Brazil* (1978, US), *Nosferatu – Phantom der Nacht/ Nosferatu the Vampyre* (1979); *Die Fälschung* (1981); *Ręce do góry/ Hands Up* (1967, Pol., rel. 1981; dir. Jerzy Skolimowski*); *System ohne Schatten* (1983).

GEBÜHR, Otto Kettwig 1877 – Wiesbaden 1954

German actor, famous for his incarnation of King Frederick II of Prussia. His film debut in 1917 was in an Oskar Messter* production (*Der Richter*), where his striking physical resemblance to portraits of Frederick II was first noticed, leading to *Fridericus Rex* (1920–23). Although Gebühr portrayed other historical figures – Blücher in *Waterloo* (1928), the king of Saxony in *Bismarck* (1940) – his Frederick made him a legendary figure of the German cinema of the 1920s and 1930s. Putting in personal appearances, especially in small towns, dressed as the king and receiving standing ovations from a near-hysterical audience, he gratified the national craving for the 'spirit of Potsdam' and served the Right's propaganda machine. KP

GEORGE, Götz Berlin 1938

German actor. Son of the actors Heinrich George* and Berta Drews, George made his screen debut in *Wenn der weisse Flieder blüht* (1953) and through the 1960s specialised in juvenile daredevils and young heroes in moral conflict, as in Wolfgang Staudte's* *Herrenpartie* (1964). His huge popularity, however, is chiefly due to his long-running performance as the unconventional Inspector Schimanski in the television crime series *Tatort* (1981–91). He continued to work in film, transferring Schimanski to the screen in *Zahn um Zahn* (1985). In Helmut Dietl's satirical look at the public scandal around the faked Hitler diaries, *Schtonk* (1992), George demonstrated a previously un-revealed comedic talent which made him one of the most prominent actors of the 1990s. MW

Other Films Include: *Der Totmacher/The Death Dealer* (1995), *Rossini, oder die mörderische Frage, wer mit wem schlief/Rossini* (1997), *Das Trio/The Trio* (1998), *Solo für eine Klarinette/Solo for a Clarinet* (1998).

GEORGE, Heinrich Heinz Georg Schulz; Stettin 1893 – Sachsenhausen 1946

German actor, epitome of bull-necked and bullying German mascu-linity. An extremely able man of the theatre, George acted on and pro-duced for stage and screen from 1921. Also directing at Erwin Piscator's Volksbühne (1925–28), and at the Heidelberg Festspiele (1926–38), he was a member of the Communist Party until 1933, when he joined the National Socialists. In his films, George's characters hide sensitivity behind brutal behaviour (*Das Meer*, 1927, *Manolescu*, 1929, *Berlin-Alexanderplatz*, 1931), but they can also be ruthless (*Jud Süss*, 1940). Playing the Communist father in *Hitlerjunge Quex* (1933), he might have been dramatising his own political confusion, but there-after George became one of the Nazi cinema's key dramatic actors (*Der Biberpelz*, 1937, *Heimat*, 1938), in charge of his own production unit at Tobis from 1942. Arrested by Soviet troops in 1945, he died in the Sachsenhausen camp of appendicitis. He was honoured with a commemorative stamp for the centenary of his birth. KP/MW

Bib: Erich M. Berger, *Heinrich George im Film seiner Zeit* (1975).

GERMAN EXPRESSIONISM – see EXPRESSIONIST FILM

GERMAN MOUNTAIN FILMS – see HEIMATFILM

GERMAN STREET FILMS – see STRASSENFILME

GERMAN WOMEN's CINEMA – see FRAUENFILM

GERMANY

I – THE GERMAN CINEMA AS IMAGE AND IDEA

Germany can look back on as long a film history as any other country, and yet, more often than not, its cinema has seemed ambivalent even in its achievements. The disasters of German history this century have left their mark on the cinema, and even more so on the image and idea we have of it. With political unification, the moment may have come also to stress the continuities: of personnel, genres and film policy, as well as of the industry's and the state's role in creating a 'national' cinema, across the divides of popular cinema and art cinema, but also bridging the post-World War II developments in East and West Germany. Thus, looking back at a hundred years of cinema today requires rather more radical a shift of accent and perspective than would have seemed either possible or necessary even twenty years ago, when the phenomenon of the 'New German Cinema'* briefly focused international attention on a film tradition which seemed to have taken leave of its – and our – senses a long time ago. We now can look with fresh eyes at the beginnings of the cinema, and adopt an outlook that spans the whole of German cinema, reintroducing its technicians and crafts(wo)men as well as its directors. We can give due weight to the institutions and their often remarkable continuity across the historical breaks, and one needs to find the right balance between the stars-and-genre cinema and the art-and-*auteur* cinema. Now that more material has become available on the early period, we can afford to pay a little less attention to the best-known periods: the 1920s and the 1970s.

The beginnings up to 1917

Although it seems perverse to argue that the cinema was not inaugurated in France, it is nonetheless true that the brothers Max and Emil Skladanowsky* showed projected moving images on their 'Bioskop' to a paying public at the Berlin Wintergarten on 1 November 1895, almost two months earlier than the Lumière brothers. But the Wilhelmine cinema's first pioneer was Oskar Messter*, the first universal movie man: inventor-director-producer-distributor-exhibitor all in one. Messter's production companies were eventually absorbed by Ufa* in 1917, but by then he had covered the entire range of popular film subjects and genres: scenic views and *actualités*, detective films and social dramas, domestic melodrama and historical epic, romantic

112

comedies, operas and operettas. Actors who started with Messter were among the leading names of the German silent era: Henny Porten*, Lil Dagover*, Ossi Oswalda, Emil Jannings*, Harry Liedke, Harry Piel*, Reinhold Schünzel*, Conrad Veidt*. Messter shaped much that would remain the bedrock of the German commercial cinema. Its other pioneer was Paul Davidson*, starting from the opposite end. On his way up from distribution to production, he acquired the first chain of picture palaces, the first international star (Asta Nielsen*), the first purpose-built glasshouse studio, and he also gave Germany's first world-class director, Ernst Lubitsch*, his start in pictures. His outlook was international, trading with Pathé and Gaumont and closing deals with Nordisk and Cines.

An art cinema (the *Autorenfilm*) has existed since 1913, thanks to Nordisk and other Danish imports, and in the films of Paul Wegener*, a first (neo-romantic, literary) notion of national cinema made its appearance, already fixing the topics, moods and styles which to this day are most persistently associated with the German cinema, under the somewhat misleading name of 'Expressionism' [> EXPRESSIONIST FILM]. With Wegener's massive bulk and scowling face, the brooding male entered the German cinema, setting the example for many other actors: Jannings, as well as Werner Krauß*, Fritz Kortner* and Heinrich George*.

Expressionism, Weimar cinema and Ufa

The expressionist cinema of the early 1920s is regarded as the isolated pinnacle of German screen art, yet the films are often judged severely, by historians such as Siegfried Kracauer* and Lotte Eisner*, for the political message they are said to convey. Paul Wegener's* *Der Golem/The Golem* (1915), Robert Wiene's* *Das Cabinet des Dr Caligari/The Cabinet of Dr Caligari* (1920), Fritz Lang's* *Der müde Tod/Destiny* (1921), Paul Leni's* *Das Wachsfigurenkabinett/ Waxworks* (1924), F. W. Murnau's* *Nosferatu – Eine Symphonie des Grauens/Nosferatu the Vampire* (1922) and *Der letzte Mann/The Last Laugh* (1924), Henrik Galeen's *Der Student von Prag/The Student of Prague* (1926) and Lang's *Metropolis* (1927) have all been variously interpreted as products of frustrated impulses and social unrest, foreshadowing future monsters or reflecting a troubled body politic. Clearly, German national cinema is more than a history of successive styles or directors' masterpieces: it belongs to the complex and intriguing phenomenon known as Weimar*, lasting from 1919 to 1933. Its defining style could also have been 'New Objectivity', and not merely for the latter half of the decade. The sexually and socially explicit films of Richard Oswald*, Reinhold Schünzel's* naturalist *Das Mädchen aus der Ackerstrasse* (1920), Fritz Lang's 'reflection of the times' *Dr Mabuse, der Spieler/Dr Mabuse, the Gambler* (1922), Joe May's *Tragödie der Liebe* (1923), E. A. Dupont's* *Varieté/Variety* (1925), whose atmospheric and romantically sordid realism was equalled in America only by Stroheim, and the sardonic, gritty films of

113

G. W. Pabst* (*Die freudlose Gasse/Joyless Street*, 1925, *Die Liebe der Jeanne Ney/The Loves of Jeanne Ney*, 1927, and *Die Büchse der Pandora/Pandora's Box*, 1929) are as convincing a German national tradition, leading to proletarian films, such as Piel Jutzi's *Mutter Krausens Fahrt ins Glück/Mother Krause's Journey to Happiness* (1929), the *Straßenfilme**, and 'cross-section' films* like Walter Ruttmann's* *Berlin, die Sinfonie der Großstadt/Berlin, Symphony of a City* (1927) and *Melodie der Welt* (1929).

At the time, national cinema was defined by neither of these styles. The question was, rather, how to create a viable film industry which could break the boycott against German film exports after the war in Europe, and perhaps break into the US market. Setting up Ufa* was a national(ist) attempt at a massive concentration of capital and resources, in order to pursue a strategy of product differentiation between the domestic market, the international commercial market and the international art cinema (also a market). Its champion was Erich Pommer*, who helped create a production and distribution network which, however briefly, seemed to pose the only challenge to Hollywood hegemony in Europe. While Ufa's overall strategy might not have been achieved, despite a mixture of legislative, film-diplomatic (Film Europe*) and financial measures, the German film industry in the 1920s built up an impressive technical infrastructure, with geniuses like Guido Seeber* and other crafts(wo)men (cinematographers, art directors, composers) forming a professional and creative avant-garde much envied and emulated elsewhere, and leading to emigration*. The competitively weakest aspect of German films was felt by American critics to be story construction, despite scriptwriters as notable as Carl Mayer* and Thea von Harbou*: an absence of linear narrative causality, obliquely motivated characters, complicated flashback structures made German films seem slow, murky, confused – the reverse side of its virtues: psychologically subtle, introspective, atmospheric, moody and uncanny.

The conversion to sound
The coming of sound seemed set to dispel the peculiarities of the German style. Initially developed by German engineers (Triergon) but not exploited until the Americans had shown the way, optical sound was introduced relatively quickly, thanks to the new management at Ufa under Ludwig Klitzsch having injected capital into the ailing giant in 1927–28, and astute deals with rivals both at home (Tobis-Klangfilm) and abroad preventing costly patent wars. While critical successes like *Der blaue Engel/The Blue Angel* (1930), *Die Dreigroschenoper/The Threepenny Opera* (1931) and *M – Eine Stadt sucht ihren Mörder/M* (1931) may be remembered as the best examples of early German sound cinema, Ufa's international hits were musicals and comedies, usually shot in multi-language versions (German, French and English), such as *Der Kongreß tanzt* (1931), *Die Drei von der Tankstelle* (1930), *Bomben auf Monte Carlo* (1931), *Ich*

bei Tag und du bei Nacht (1932). Fast-paced and witty, they carried across the world an image of Germany as youthful, sporty and vital. The sound cinema also profiled new faces, with female stars such as Renate Müller*, Lilian Harvey*, Marika Rökk* beginning to draw level with their male colleagues (Willy Fritsch*, Heinz Rühmann*, Hans Albers*) and not only ensuring that the German film industry was by far the strongest in Europe (with over 500 films produced between 1930 and 1933), but also drawing talents away from Rome and Paris to Berlin throughout the 1930s.

The Nazi years
The major break in German film history is unquestionably 1933. Yet despite the political changes brought about by Hitler's seizure of power, and the exodus it imposed on Jewish film personnel [> EMIGRATION AND EUROPEAN CINEMA], Nazi film policy only gradually transformed the business into an instrument of direct state propaganda. The German film industry's reputation as sophisticated, technically innovative and perfectionist did not cease in 1933, but continued right until 1945. The best propaganda, according to Joseph Goebbels, was popular entertainment which could express the regime's populist ideology as an attainable ideal, while making no mention of the totalitarian reality. A new generation of often gifted directors embraced (or, as they would later claim, braced themselves for) the task, such as Veit Harlan*, Wolfgang Liebeneiner*, Gustav Ucicky*, Hans Steinhoff*, Karl Hartl* and Geza von Bolvary*, while their erstwhile colleagues Billy Wilder, Robert Siodmak*, Max Ophuls*, Kurt Bernhardt*, Edgar Ulmer and many others had to try their luck in France, Britain or, towards the latter half of the 1930s, in Hollywood, helped by the deft survivor's skills of German-Jewish producers like Pommer and Seymour Nebenzal*, or Austro-Hungarians like Alexander Korda and Arnold Pressburger.

The films made in Germany during the Nazi years are still the object of critical controversy. For the most part, they continued popular genres already established at the time of the Weimar cinema: costume dramas, comedies, films of national history, social problem films, literary adaptations, biopics, melodramas. While often considered artistically worthless, many of them were not only box-office successes at the time, but have become secret classics of the subsequent fifty years for Sunday matinee spectators and television viewers in both Germanies and across the generations. Zarah Leander*, Adele Sandrock*, Kristina Söderbaum*, Sybille Schmitz, Willy Birgel*, Willy Forst*, Rudolf Forster, Carl Raddatz*, Theo Lingen have remained household names to this day, a fact that raises issues which have never been adequately answered, about the continuity of forms and their political uses, about popular culture as mass deception or as reservoirs of resisting energy. Parallel to the entertainment feature films, the Nazi cinema dubiously distinguished itself in the genre of the formally often experimental but ideologically coloured documentary* (*Kulturfilm*),

115

whose most famous practitioner was Leni Riefenstahl*. Her films had also helped train scores of cameramen and editors, who played a crucial function in the demagogic but, especially during the last war years, also shockingly realistic newsreels.

Postwar divisions and continuities
The German cinema as a film industry ceased to exist in 1945, with the collapse of the Third Reich and the Allied Forces' decision not only to dismantle Ufa and its vertically integrated structure, but also to prevent a different kind of studio system from emerging. Given the fact that large parts of the industrial infrastructure and most of the actual studios came under Communist control, the West German commercial cinema continued a kind of ghostly afterlife of the Nazi genre cinema, while for the East German, state-controlled company DEFA* directors such as Erich Engel, Kurt Maetzig* and Wolfgang Staudte* tried to give a somewhat less shadowy afterlife to the realist traditions of the *Straßenfilme**, by reinventing the proletarian film (*Arbeiterfilm**). Both Germanies contributed to the brief life of the *Trümmerfilme* 'ruin films', halfway between Weimar's sordid realism and Hollywood's *film noir*. Since the vast majority of film directors, actors and technicians active in the cinema of the 1950s had either been successful professionals or had learnt their craft during the Ufa years, this ghost image of the cinema was no return of the repressed, but merely the outward signs of the continuity and conservatism typical of popular culture almost everywhere.

German film criticism had always had difficulties in coming to terms with the 'escapist' tendencies of the mass media, demanding from cinema a commitment either to art and innovation or to (critical) realism. The disappointment was particularly vivid when films in the 1950s and early 1960s failed to pass these tests, preferring, like their audiences, Romy Schneider* in *Sissi* (1955) or Hans Deppe's* *Heimatfilme**, which were often remakes of titles from the 1920s, 1930s and 1940s. More recently, a younger generation of critics, writing also in feminist film journals like *Frauen und Film**, have rediscovered many of the melodramas, pop musicals (*Schlagerfilme*) and social problem films of the 1950s, once more alert to the kinds of contradictions worked out in the films, or fascinated by their own love-hate relationship to these spectacles of damaged masculinity, where hysterical wives are obliged to prop up self-tormented husbands and stagger with them towards the happy end. A cinema based on stars, it made a whole generation of men and women cling to the tight-lipped faces of Dieter Borsche, O. W. Fischer, Curd Jürgens* and O. E. Hasse*, or dissolve in the tear-stained eyes of Maria Schell*, Ruth Leuwerick* and Hildegard Knef*.

From the 1960s to the 1980s
For the generation of short-film directors, however, who were trying to break into the closed shop of the German film business, such a cinema of stars and genres was anathema. They distrusted the commercial in-

116

stincts of producers like Artur Brauner, or distributors turned producers like Ilse Kubaschewski of Gloria*, seeing their hugely successful series (Karl May films, Edgar Wallace films) merely as a symptom of the bankruptcy of commercial movie-making. The Oberhausen Manifesto insisted on a complete break with the German cinema's past, but also wanted a European outlook, following the lead that the French New Wave and the 'new' cinemas in Britain, Czechoslovakia or Poland had given. Thanks to the tactical skills and publicity efforts of Alexander Kluge*, the New German Cinema* came also to stand for a conception of film-making where the government acted as patron, providing film-makers with the kind of funds given to the other arts like theatre, opera and music, with the film-maker, as writer-director-producer, enjoying the same recognition as other artists and authors (*Autorenkino*).

The cinematic benefits of the film funding system were more easily detectable in the second generation, when directors like Rainer Werner Fassbinder*, Werner Herzog*, Wim Wenders*, Margarethe von Trotta* and Helma Sanders-Brahms* made films that came to be noticed abroad. They also helped actors, mainly from the theatre, such as Klaus Kinski*, Bruno Ganz*, Hanna Schygulla* and Barbara Sukowa*, to become, if not stars, then at least the recognised faces of this cinema. The increased film-making activity, especially around Fassbinder, also professionalised traditional crafts such as cinematography, with cameramen (Michael Ballhaus*, Xaver Schwarzenberger, Thomas Mauch, Jörg Schmidt-Reitwein, Robby Müller*) winning international recognition. Next to the *auteurs*, another New German Cinema emerged which turned towards the exploration of social issues and political dilemmas. It was largely funded via co-productions with television, which wanted topical and even controversial material, but presented with a personal signature or autobiographical slant, in order to bypass the requirement of 'balanced' reporting applied to politically sensitive issues. This 'niche' between current affairs television and committed or experimental film-making gave many women film-makers a first opportunity, making the German cinema of the 1970s and 1980s a centre for European women's film.

Decline and new beginning: unification and beyond
With the death of Fassbinder in 1982, and a change of funding policy under the conservative government of Chancellor Kohl, the German cinema seemed to have entered into a period of rapid decline, following a classic pattern, where a much-trumpeted national 'new wave' leaves, as it ebbs away, a few *auteurs* who have to succeed on the international art cinema and festival circuits. Such is the uncertain fate of Wenders, Herzog and von Trotta. On the other side, a transfer of power from cinema to television occurred, which at first absorbed a considerable number of as yet unaffiliated directors, cameramen and related personnel, before this labour market achieved saturation, as it did in the mid-1980s. With it, the New German Cinema vanished like

117

a mirage, having never been popular with domestic audiences, and having produced too many one-off films and film-makers.

With unification in 1990, a whole new pool of potential talent emerged from the other part of Germany, as did new subjects, not least unification itself, and its many tragic, brutally absurd and tragi-comic consequences for the lives of people both east and west (Dani Levy, Detlef Buck*). So far, however, it is difficult to see new genres or new personalities, either among directors or actors. Rather, it seems as if the long association of the German cinema with television has finally shifted the balance, and made the comedians familiar from tele-vision the only film stars the German cinema audience still recognises: Otto Waalke, Loriot, Gerhard Pohl. By chance and coincidence, in 1992 the old Ufa studio in Babelsberg celebrated its 75th anniversary just in time to see its site and premises sold to a French conglomerate, who nominated former 'New German Cinema' director turned international independent (and only postwar German Oscar-winner) Volker Schlöndorff* as (caretaker) director. Whether this was the sig-nal for the German cinema to become its own museum, or the start of a whole new cycle, making Berlin once more the heart of a film-making nation, remains to be seen. TE

II – THE GERMAN CINEMA: POPULAR GENRES
The German cinema's international image (like that of other European cinemas) has been based on great *auteurs* and privileged 'movements' (such as the 'New German Cinema'*). Yet a wealth of popular genres sustained its industry and audience interest at least until the 1970s. Some, such as the *Heimatfilm**, *Straßen-filme**, *Kammerspielfilme** and *Arbeiterfilme** attained some celebrity. Others, equally important, are listed below (in alphabetical order).

Arztfilme (Doctors' films), loved by audiences from the late 1930s to the 1960s, and especially popular in the early 1950s. The biggest suc-cesses were melodramas such as *Robert Koch, der Bekämpfer des Todes* (1939), *Die Nachtwache* (1949), *Dr Holl* (1951) and *Sauerbruch – Das war mein Leben* (1954), where physicians (especially surgeons) represented selfless, heroic fighters striving to save lives or battle with bureaucracies. Doctors' films clearly played on the audience's need for strong, helpful father figures, inevitably suggesting parallels to the Führer cult, and idealised via the profession's high ethical standards. Stories went all out for tears, while nostalgically affirming a value sys-tem that had never existed: a caring community, undivided by class, held together by a belief in the nation and an all-powerful deity. While the genre's popularity during the Nazi period is easily explained, its even greater resonance in the immediate postwar period hints at a compensation mechanism, a desire to make up for collective disap-pointment and replace the disgraced idols with more trustworthy ones. Apart from the comedy *Frauenarzt Dr Prätorius* (1949) and a sex film such as *Mädchen beim Frauenarzt* (1971), few doctors' films went for

118

laughs, or traded on the audience's voyeurism, in contrast to films of this genre elsewhere, for instance, Britain's *Carry On Nurse*, or the American *MASH*. TE/JG

Ausstattungsfilme (**Costume films**). Inspired by successful Italian and US spectaculars, costume films became popular under the label of *Großfilm* at the end of the 1910s. During the period of hyper-inflation (1918–23) the young Ufa* could afford to invest in Joe May's* gigantic *tour de force*, *Veritas Vincit*, and his costly eight-part series *Die Herrin der Welt/The Mistress of the World* (both 1919). However, it was the historical films directed by Ernst Lubitsch*, beginning with *Madame Dubarry/Passion* (1919) and culminating in *Das Weib des Pharao/The Loves of Pharaoh* (1921), that finally assured international profitability and brought further forays into the genre. German costume films were exercises in international grandiloquence (the French Revolution, the Italian and Spanish Renaissance, oriental adventures), but from the mid-1920s some of the most expensive and most popular of these *Austattungsfilme* ('films with production values') showed a penchant for national history and nationalist mythology (e.g. Fritz Lang's* *Die Nibelungen*, 1924). Using typically melodramatic devices, they were preferably set in the days of Prussia's glory (a subgenre known as *Preußenfilme*), from the reign of Frederick the Great to the Vienna Congress of 1814 (*Fridericus Rex*, four parts, 1922–23; *Der Kongress tanzt*, 1931), but also included musicals and comedies set in turn-of-the-century Vienna. With World War II, the historical costume film proved to be most suitable for promoting nationalism, allowing the Nazi film industry to turn already well-established patterns to overtly propagandist purposes (e.g. *Jud Süss*, 1940). Throughout the 1950s costume films continued to make money, fostering a new generation of stars, such as Karlheinz Böhm* and Romy Schneider*. The latter's *Sissi* trilogy (1955–57) kept European audiences in thrall. Well into the 1960s remakes like Lang's *Das indische Grabmal/The Indian Tomb* (1959) proved attractive, before the appeal of costumes and period decor moved to television and in the cinema was largely replaced by technical special effects. MW/TE

Musicals have always been among the most successful genres in Germany, producing different sub-genres to follow changing fashions in popular music. Operetta films, common from the mid-1910s to the early 1950s, were based on stage versions and presented romantic love stories often played out in an aristocratic milieu. The most popular operettas adapted the works of turn-of-the-century Viennese composers such as Franz Lehár and Ralph Benatzky. A new type of operetta film, the *Filmoperette*, emerged in the 1930s, with original libretti and scores, combining traditions drawn from operetta, comedy, cabaret and music-hall revue. It generally featured ordinary people, and its songs often became popular recording hits. Many composers being Jewish, Ufa* changed the formula after 1933, switching to *Revuefilme*

119

(modelled on Hollywood 'backstage musicals'): *Hallo Janine!* (1939), *Der weiße Traum* (1943). The *Revuefilme* songs also often became hits. Films featuring Ufa* star Marika Rökk* were the most popular, while among the successful composers were Franz Grothe, Peter Kreuder and Michael Jary*. When the average age of German cinemagoers fell during the 1960s, *Schlagerfilme* (pop-music films) were introduced. As a rule, leading parts were played by pop stars using the film as promotion for their latest record. Among the best remembered *Schlagerfilme* are those with Peter Alexander*, Peter Kraus, Conny Froboess (*Wenn die Conny mit dem Peter*, 1958) and Freddy Quinn (*Freddy, die Gitarre und das Meer*, 1959). As German popular music made way for American pop at the beginning of the 1970s, so did the *Schlagerfilme*, bringing to an end one of the most typical and long-lasting German film genres. JG

***Problemfilme* (social problem films)**, where the individual confronts social contradictions (class difference, moral conventions, poverty) beyond his/her control and/or comprehension. The social problem film covered several types of narrative, and can be distinguished by setting: the *Gesellschaftsfilm* (bourgeois melodrama) and the *Problemfilm* (petit bourgeois/working-class milieu), itself subdivided into *Straßenfilme**, *Kammerspielfilme** and *Arbeiterfilme**, which all emerged in the 1920s. The Nazis banned films too openly alluding to social realities as 'defeatist', and demanded uncompromising optimism. However, there were exceptions, such as Werner Hochbaum's* *Morgen beginnt das Leben* (1933). The aftershocks of Nazism and the war once more marked a return to the *Problemfilm*, under the stylistic traits of *film noir*, as in the *Trümmerfilme* (see below). In the late 1950s and early 1960s it was the bourgeois *Gesellschaftsfilm* that came to prominence, now emphasising emotional misery and moral isolation in the increasingly materialist world of opportunism during the 'economic miracle' (*Das letzte Rezept*, 1951; *Teufel in Seide*, 1956). The early 1960s also saw a return to working-class themes, although now focused on the disorientation of male adolescents, as in Wolfgang Staudte's* *Kirmes* (1960) and in a string of films by Will Tremper (*Flucht nach Berlin*, 1960), Georg Tressler (*Die Halbstarken*, 1956; *Endstation Liebe*, 1958) or Frank Wysbar (*Nasser Asphalt*, 1958). This last cycle converged with another trend, where under the East German label of *Gegenwartsfilme* (at DEFA*: Frank Beyer*, Konrad Wolf, Egon Günther*, and others), and under the West German label of *Junger deutscher Film* (Young German Cinema), directors like Alexander Kluge*, Edgar Reitz*, and others such as Jean-Marie Straub* and Danièle Huillet* (*Machorka Muff*, 1963) and Peter Schamoni (*Schonzeit für Füchse*, 1966), began to investigate the rigidities and dogmas of a social landscape whose official ideology seemed seriously out of step with what they perceived as the realities of people's lives. The *Problemfilm* can also be recognised in what came to be a distinctive feature of the 'New German Cinema'*, namely its

120

emphasis on issue-oriented film-making, covering every conceivable topic from abortion (*Es/It*, 1965) to vagrancy (*Abschied von gestern/ Yesterday Girl*, 1966), from social prejudice against homosexuality (*Jagdszenen aus Niederbayern/Hunting Scenes from Lower Bavaria*, 1969) to unemployment and ethnic minorities (*Angst essen Seele auf/ Fear Eats the Soul*, 1973). The genre eventually became so broad in range as to all but disappear into the many forms of docu-drama cultivated by public service television. TE/MW

Series and serials. A prototype of German series (copied from French and Danish models) was Joe May's* thirty-part 'Stuart Webb' detective series, featuring the star actor Ernst Reicher (from 1914 to 1923). Once originality and cultural prestige came to be prized in film-making, film genres took over their function from the 1930s into the 1950s. It was not until the German film industry experienced an economic crisis in the late 1950s that German studios hit once more on the idea of producing films in series, such as the Edgar Wallace series (1959–72), the Karl May series (1962–68) and several sex film series. Successful for a while, they signalled the final demise of a popular national cinema as it was replaced by television, which has of course always thrived on series. JG/TE

Sex films. While pornographic film goes back to the beginnings of the cinema, the first wave of sex films in Germany appeared just after World War I, in the period between the abolition of military censorship and the reintroduction of the centralised censorship of the Weimar Republic in May 1920. In the last years of the war sex-education films were often made in collaboration with medical experts; sex researchers such as Magnus Hirschfeld worked on films about syphilis (*Es werde Licht!*, four parts: 1916/17–1918) and homosexuality (*Anders als die anderen/Different from the Others*, 1919). So-called *Sittenfilme* ('sexual mores' films) by contrast were more openly pornographic, as in *Opium* (1919), where the viewer was 'warned' of the consequences of taking drugs by being shown the trancelike dreams of an abuser, with bare-breasted women suggestively beckoning. Sex films did not appear (at least overtly) during the Nazi regime, which did not tolerate 'smut'. It was German film distributors, especially Constantin*, who initiated the second wave of sex films between 1967 and 1973 in order to lure back diminishing audiences. The strategy worked: domestically produced sex films managed, for the last time (1968–70), to yield larger profit margins for German distributors than American films. This wave of sex films went through three cycles. Firstly, sex-education films were made from 1967 onwards, the statements of experts legitimising erotic scenes showing undressing and simulated intercourse. *Helga* (1967) enjoyed national and international success and was the prototype for this cycle, of which Oswald Kolle was the undisputed champion. Secondly, 'report films' appeared in 1970. Alluding to the Kinsey Reports, they showed sexual episodes

121

based on data allegedly collected in sociological studies. The thirteen-part series* *Schulmädchenreport* (1970–80) set the conventions. Thirdly, sex comedies emerged around 1972, abandoning the educational pretence. Legitimising voyeurism by making sex a subject of laughter, they harked back to the folk and carnivalesque forms of bawdy entertainment. Sex comedies often feature local settings, as in the six-part series *Liebesgrüße aus der Lederhos'n* (1973–82), parasitic on *Heimatfilms** and travelogues. More ethnographically intriguing was the popularity of a series set in the mining region of the Ruhr (*Laß jucken, Kumpel*, 1972–81). Production of mainstream sex films fell during the late 1970s as hard-core porn films and videos became socially acceptable. At first shown in special cinemas, they were absorbed into the general video market during the 1980s. JG/TE

***Trümmerfilme* (Ruin films)**. Ruin films are German *films noirs* produced during the immediate postwar years (1946–49). The nickname derived from the films' setting in the ruined cityscapes of postwar Germany, and their appeal was based on presenting German viewers with protagonists who shared their recent experience. *Film ohne Titel* and *Zwischen gestern und morgen* were the most popular films of 1948. Though they are set in the present, the outcome of the stories featured in *Trümmerfilme* is usually decided by past events which, although unnamed, would at the time have been readily identified as referring to the Nazi period. Moral dilemmas became psychological states, depicted by complex flashbacks or low-key lighting. In contrast to American *films noirs*, the plots of *Trümmerfilme* distinguished clearly between good and evil. In DEFA*-produced ruin films, made under Soviet control, didactic anti-fascist messages were obligatory (*Die Mörder sind unter uns/The Murderers are Amongst Us*, 1946). JG

***Kriegsfilme* (war films)**. As nationalist propaganda, the war film in Germany goes back to the Navy League's travelling cinemas of 1901–7, showing off the military might of modern warships while organising the German cinema's first distribution circuit. In the early 1910s, the Franco-Prussian War of 1870–71 served as background for melodramas of separated families, or moral conflicts. *Die Verräterin* (1911) and *Madeleine* (1912) were only two examples that represented war unheroically, challenging conventional norms. War-weariness and the demand for escapist films generally excluded the war film from the move to full-length feature films (an exception was Paul Leni's* *Der Feldarzt/Das Tagebuch des Dr Hart/The Doctor/Diary of Dr Hart*, 1916). Such was the shock of defeat that the first anti-war films, G. W. Pabst's* *Westfront 1918* and Victor Trivas' *Niemandsland*, were not made until 1930 and 1931, respectively. With the Nazis in power, it fell to Karl Ritter to polish the image of the military with his *Soldatenfilme* (soldier films): their message was that patriotism rather than victory makes a soldier's life and death important. In the 1950s, the Cold War and West Germany's anti-Nato debate found its parallel in the dis-

cussions around the 'revisionism' of popular anti-war films such as *08/15* (1955), *Haie und kleine Fische* (1957), and *Unruhige Nacht* (1955). Closest in spirit to Pabst and Trivas was Bernhard Wicki's* *Die Brücke/The Bridge* (1959), while the U-boat films of the 1930s and 1950s inspired a recent foray into a psychologically complex war film, Wolfgang Petersen's* technical *tour de force*, *Das Boot/The Boat* (1981). TE/KU

GERRON, Kurt
Kurt Gerso; Berlin 1897 – Auschwitz 1944

German actor and director, associated with one of the most tragic and shameful incidents of German film history. Gerron was trained as an actor by Max Reinhardt*, but had his first stage recognition under director Erich Engel*, playing in Brecht plays. A big man, he became typecast in the cinema, often in bit parts (as in E. A. Dupont's* *Varieté/Variety*, 1925), and in scores of films directed by Richard Oswald*, Reinhold Schünzel*, G. W. Pabst* and Hans Steinhoff*, and perhaps most memorably in *Der blaue Engel/The Blue Angel* (1930) as the magician, coldly observing Emil Jannings'* slide into self-humiliation. Essentially a comic actor, Gerron in 1928 teamed up with the famous Jewish comedian Sigi Arno, in an (unsuccessful) attempt to create a German Laurel and Hardy (as 'Beef and Steak').

Gerron directed his first film in 1926, but came into his own as a director in the sound period. An expert at comedies, Gerron directed two of the genre's stars, Heinz Rühmann* (*Meine Frau die Hochstaplerin*, 1931) and Willi Fritsch* (*Ein toller Einfall*, 1932); he also made a thriller with Hans Albers* (*Der weiße Dämon*, 1932). Politically as well as racially persecuted, Gerron left for France, then settled in Amsterdam in 1933, making several films there but concentrating on theatre and radio. Arrested by the SS in 1943 and interned at Westerbork, Gerron was sent to Theresienstadt in 1944, in order to direct a staged documentary intended to persuade world public opinion that the Jews were well-treated in concentration camps (*Der Führer schenkt den Juden eine Stadt/The Führer Donates a City to the Jews*). His job done, Gerron, along with his crew, was put on a train to Auschwitz and murdered there. TE

Bib: Barbara Felsmann, *Kurt Gerron gefeiert und gejagt* (1992).

GEYER, Karl A.
Ilmenau 1880 – Hamburg 1964

German technician and industrialist, who turned laboratory technology into an independent branch of the German film industry. In 1908 he constructed a perforator whose principles are still in use today, and in 1921–22 he automated film developing (as did the Americans at

123

the same time), as well as print production. His film laboratory equipment was sold throughout Europe via his own company, founded in January 1918. The introduction of sound created economic hardship in the German film industry as Tobis-Klangfilm tried to maintain a stranglehold over the patent for sound reproduction, but Geyer overcame this problem by founding his own company, the Deutsche Filmgemeinschaft, which produced Leontine Sagan's* *Mädchen in Uniform/Maidens in Uniform* (1931). After the war, Geyer-Werke went on to become West Germany's leading firm in laboratory technology, broadening its area of operations to include sound dubbing, video and photography. The majority of the company's shares are still owned by the Geyer family. JG

GLIESE, Rochus Berlin 1891–1978

German director and set designer. After training as a costume and stage designer at the Museum of Arts and Crafts in Berlin, Gliese was hired by Paul Wegener* in 1914. By the start of the war, he had begun to produce his own features, as well as advertising and silhouette films. In 1927 he accompanied Murnau* to America, was put in charge of the set design for *Sunrise*, the masterpiece that opened doors in Hollywood, where DeMille offered him a contract as director, writer and designer. Gliese returned to Germany two years later, having completed only one film (*The Main Event*, 1927). Turning to the theatre, he was offered, after a short stint in Essen, a position as art director at Gustaf Gründgens'* Staatlichen Schauspielhaus Berlin, followed by other theatre work as set designer (Schillertheater 1937–38, Wiener Burgtheater 1939–44). After the war, Gliese settled in the GDR, becoming artistic manager of the Nationaltheater Weimar (1945–46) and the Theater am Schiffbauerdamm (1947–48) before moving to the Landestheater Potsdam as its managing director (1948–49). From 1950 to 1970 he continued his career in the theatre as set designer and director in Berlin and the Federal Republic. JG

Bib: Erika and Ulrich Gregor (eds), *Rochus Gliese* (1968).

Other Films Include: *Der Golem* (1914), *Rübezahls Hochzeit* (1916), *Der Yoghi* (1916), *Der papierene Peter* (1917), *Der Golem und die Tänzerin* (1917), *Hans Trutz im Schlaraffenland* (1917), *Die schöne Prinzessin von China* (1917), *Der fremde Fürst* (1918), *Apokalypse* (1918), *Rausch* (1919), *Malaria. Urlaub vom Tode* (1918), *Der Galeerensträfling. 2 Teile* (1919), *Katharina die Große* (1920), *Der verlorene Schatten. Der Student von Prag* (1920), *Der brennende Acker* (1922), *Die Austreibung* (1923), *Komödie des Herzens* (1924), *Menschen am Sonntag* (1930), *Amphitryon* (1935), *Fidelio* (1956).

GLORIA ← √ on theatre career

German distribution company of the post-World War II period. Founded in 1949 by Ilse Kubaschewski, Gloria also opened first-run cinemas in 1955. Following the trend in the 1950s German cinema, Gloria subsequently extended its activities to include production, through its own company Divina, founded in April 1953, which produced three of the most successful films of the 1950s: *08/15* (released in three parts from 1954 to 1955), *Die Trapp-Familie* (1956) and *Der Arzt von Stalingrad* (1958). The company also made money on their *Heimatfilme** such as *Grün ist die Heide* (1951), *Weißer Holunder* (1957) and *Adieu, Lebewohl, Goodbye* (1961). In 1957, when German film attendance dropped, Gloria failed to develop a new market strategy. Despite an early investment in youth movies in the 1960s, Kubaschewski had to sell to an American company in 1973. JG

GLÜCK, Wolfgang Vienna 1929

Austrian director. Glück has directed film and television series since the 1950s, as well as *Heimatfilme** such as *Der Pfarrer von St. Michael* (1957, Ger.) and movies with moral lessons, including *Gefährdete Mädchen* (1957, Ger.) and *Denn das Weib ist schwach* (1961, Ger.). Many of his works are adaptations of contemporary Austrian literature, such as *Wunschloses Unglück* (1974, based on Peter Handke) and *Die kleine Figur meines Vaters* (1979, based on Peter Henisch). Glück laid a cornerstone of the 'New Austrian Cinema' with *Der Schüler Gerber* (1981, based on a novel by Friedrich Torberg), which won several prizes. *38 – Auch das war Wien* (1986) was, however, his greatest success. This sentimental treatment of another Torberg novel was strongly criticised as 'anti-fascist kitsch' but was nominated for a best foreign film Oscar in 1986; it received the Austrian Film Prize in 1987. Glück also works as a stage director. IR/AL

Other Films Include: *Die Gigerln von Wien* (1965); *Das Gebell* (1976); *Anleitung zum Unglücklichsein* (1986).

GOETZ, Curt Kurt Walter Götz; Mayence 1888 – Grabs, Switzerland 1960

German actor, playwright and director, who began as scriptwriter on, among other films, Ernst Lubitsch's* *Ich möchte kein Mann sein* (1918). His directorial debut was the ambitious *Friedrich Schiller* (1923), but he subsequently worked in the theatre. Returning to film in the mid-1930s, Goetz wrote *Glückskinder* (1936), *Land der Liebe* (1937) and *Sieben Ohrfeigen* (1937). In 1938 he emigrated to Hollywood, later settling in Switzerland (1946), where he wrote, di-

rected and acted in *Frauenarzt Dr Prätorius* (1950) and co-directed *Das Haus in Montevideo* (1951). After scripting and acting in Kurt Hoffmann's* *Hokuspokus* (1953), adapted from his play of the same name and co-written with his wife Valérie von Maertens, Goetz adapted another of his plays for Wolfgang Liebeneiner* *Ingeborg* (1960). His (and Maertens') brand of witty dialogue and understated but lethal critique of petit-bourgeois double standards makes them rare masters of German film comedy, whose importance exceeds their comparatively modest screen credits. TE/KU

GRETLER, Heinrich Zurich 1897–1977

Swiss actor, who started his career on the Zurich stage in 1919 and five years later made his screen debut in the Swiss-American co-production *Die Enstehung der Eidgenossenschaft/William Tell*. After a seven-year interlude on the Berlin stage during which he also appeared in several German films, he returned to Switzerland in 1933. His exceptionally deep voice and aged looks while still in his thirties destined him to portray fatherly characters, notably in numerous dialect comedies (including *Wie d'Warret würkt/The Effects of Truth*, 1933, and *Jä-soo!*, 1935), political apologias for national independence (*Füsilier Wipf*, 1938; *Landammann Stauffacher*, 1941, dir. Leopold Lindtberg*), and in Max Haufler's *L'Or dans la montagne* (1939) and Lindtberg's adaptions of Friedrich Glauser's popular novels *Wachtmeister Studer* (1939) and *Matto regiert* (1947). After the war he once more worked in Germany and Austria, his popular screen image inextricably bound up with weather-beaten, good-natured Swiss mountain folk, whose ultimate expression Gretler probably gave as Alp-Oehi in Johanna Spyri's *Heidi* (1952) and *Heidi and Peter* (1955). MW

Bib: Werner Wollenberger, *Heinrich Gretler: Der grosse Schweizer Schauspieler* (1981).

Other Films Include: *Die mißbrauchten Liebesbriefe* (1940); *Steinbruch* (1942); *Herz der Welt* (1952); *Die Sonne von St. Moritz, Rosen-Resli, Uli, der Knecht* (1954); *Der 42. Himmel* (1962); *Kohlhiesels Töchter* (1962).

GRÜNDGENS, Gustaf Düsseldorf 1899 – Manila 1963

German actor and director, whose life was immortalised as the 'Mephisto' of Klaus Mann's book and Istvan Szabó's* film (1981). In 1920 Gründgens worked in the theatre, acting and directing in the classic repertoire (Shakespeare, Büchner, Wilde, Shaw) while also doing cabaret and opera. His film career began in 1929, when he

126

played gentleman thieves and criminals (*Der Brand in der Oper*, 1930, *Die Gräfin von Monte Christo*, 1932, *M – Eine Stadt sucht ihren Mörder/M*, 1931). After acting in musical comedies (*Die Finanzen des Großherzogs*, 1934, *Tanz auf dem Vulkan*, 1938), historical epics (*So endete eine Liebe*, 1934, *Das Mädchen Johanna*, 1935), and propaganda films (*Ohm Krüger*, 1941), he was put in charge of a production unit at Terra-Filmkunst in 1938, where he directed a string of highly successful melodramas (such as *Der Schritt vom Wege*, 1939). Heavily compromised by his prominent role during the Nazi period, he nonetheless worked as director of several theatres after the war (Städtische Bühnen Düsseldorf, Deutsches Schauspielhaus Hamburg, 1947–63). KP

Bib: Heinrich Goertz, *Gustaf Gründgens* (1982).

GRUNE, Karl
Vienna 1890 – Bournemouth, England 1962

German director who began as an actor under Max Reinhardt* in Berlin. Grune's fame is based on *Die Strasse* (1923) a film which, by omitting intertitles, depicts big-city night-life as a psychic nightmare, thereby founding the genre of the Strassenfilm* (street film). After making a melodrama told from the point of view of a horse (*Arabella*, 1924), and a version of the popular *doppelgänger* theme (*Die Brüder Schellenberg*, 1926), Grune turned to opulent historical spectacles with the two-part *Königin Luise* (1927/28) and *Waterloo* (1928), the latter visibly influenced by Abel Gance's use of superimposition in *Napoleon* (1927). With the coming of sound, Grune founded his own production company in 1929, was chief of production at Emelka in Munich for two years and vice-president of Dacho, the umbrella organisation of the German film industry, until 1930. In 1933 he emigrated to London and worked for Capitol Film Production as its artistic director, directing the anti-Nazi costume drama *Abdul the Damned* (1935). He eventually obtained British citizenship and spent his final years in obscurity in a South Coast boarding house. MW

Other Films Include: *Manon. Das hohe Lied der Liebe* (1919), *Schlagende Wetter* (1923), *Arabella* (1924), *Komödianten* (1924), *Am Rande der Welt* (1927), *Das gelbe Haus des King-Fu/La maison jaune de Rio* (1931), *The Silver Darlings* (1947).

GÜNTHER, Egon
Schneeberg 1927

German director, who is, together with Konrad Wolf, Frank Beyer* and Heiner Carow, the best-known representative of the 'second' generation of GDR directors. Günther began in 1958 as a script editor at

127

DEFA*, directing his first film in 1965 (*Lots Weib*). His second feature, *Wenn du groß bist, lieber Adam*, made in 1965, was banned, following the clampdown ordered by the eleventh SED Party Congress on all stirrings of a cultural 'thaw' (it was premiered in 1990). Undaunted, Günther turned to literary adaptations, choosing a founding father of the GDR (Johannes Becher) but filming his most youthfully revolutionary work; *Abschied* (1968) was a major national and international success. A second adaptation, *Junge Frau von 1914* (1970), also based on a canonical GDR author, Arnold Zweig, showed Günther's acute eye for period, free of nostalgia. KP

Other Films Include: *Der Dritte* (1972); *Erziehung von Verdun* (1973); *Die Schlüssel* (1974); *Stein* (1990), *Rosamunde* (1990), *Die Braut/The Bride* (1999).

H

HAAS, Willy Prague 1891 – Hamburg 1973

Czech-born critic and screenwriter, chief polemicist on the *Film-Kurier** during the Weimar Republic. His 1921 article 'Why Are We Writing Film Criticism?' prompted a broad discussion in the specialist journals about the function of the film critic. His other talent was as a screenwriter for some of the most important directors of Weimar cinema*, including Murnau* (*Der brennende Acker*, 1922), and Pabst* (*Die Freudlose Gasse*, 1925). In 1925 he retired from the *Film-Kurier* and founded, together with the publisher Ernst Rowohlt Die literarische Welt, a literary review which played a crucial role in Weimar culture. After the Nazis seized power in 1933, the journal was sold, and Haas returned to his home town Prague, reviewing films for Prague newspapers. When the Nazis invaded Czechoslovakia in 1939, Haas once again emigrated, to France, Trieste and then to Bombay, where he wrote a number of treatments as employee of Bhavnani Productions. He returned to Germany in 1948. MW

Bib: W. Jacobsen/K. Prümm/B. Wenz (eds), *Willy Haas. Der Kritiker als Mitproduzent* (1991).

HANEKE, Michael Munich, Germany 1942

Austrian director and scriptwriter. A stage director, scriptwriter and director of television films since 1970, Haneke emerged in the 1990s as Austrian cinema's most significant talent internationally, with his bleak but compelling vision of the end of civilisation. He made his mark early on with a number of television films which portrayed isolated individuals and understated relationships in a style reminiscent of Robert Bresson – such as *Sperrmüll* (1976), *Lemminge* (1979, two parts) and *Wer war Edgar Allen?* (1984). In 1989, he introduced a new aesthetic paradigm in Austrian cinema with his first feature *Der Siebte Kontinent/The Seventh Continent* (1989), which depicts with relentless logic the journey to collective suicide of a middle-class Viennese family. It was followed by *Benny's Video* (1992) and *71 Fragmente einer Chronologie des Zufalls* (1994), forming a trilogy around the theme of narcissism, abjection and the coldness of personal contacts in the age of video, and portraying – through a disciplined, sparse style – what he has called 'my country's emotional glaciation'. AL

Bib: Alexander Horwath (ed.), *Der Siebente Kontinent* (1991).

HARBOU, Thea von Tauperlitz 1888 – Berlin 1954

German scriptwriter. A best-selling author of romance novels (*Die nach uns kommen*, 1910) and popular pamphlets (*Der Krieg und die Frauen*, 1913), she was hired by Joe May* Film in 1919. During pre-production on *Das indische Grabmal* (filmed by Joe May in 1921 and remade in 1959 by Fritz Lang), based on one of her novels, she met Fritz Lang*. Between 1920 (*Das wandernde Bild*) and 1933 (*Das Testament des Dr Mabuse*) Harbou wrote the scripts for all Lang's films, and for other directors; she was Weimar cinema's top writer, second only to Carl Mayer*. Intelligent and inquisitive, she had a unique gift for melodramatic confrontations, for pace and pitch, and a good understanding of what moved the new mass audience.

While Lang emigrated in 1933, Harbou stayed in Germany, continuing her thriving career. In 1933 she was elected chair of the Association of German sound film authors, becoming a member of the Nazi Party and acting as script doctor on overt propaganda films. She also tried her hand at directing, with less success. In the late 1940s she wrote dubbing scripts for Deutsche London Film, before rounding off her unusually long career with such commercial pot-boilers as *Es kommt ein Tag* (1950) and *Dr Holl* (1951). TE

Bib: Reinhold Keiner, *Thea von Harbou und der deutsche Film bis 1933* (1991, 2nd ed.); Karin Bruns, *Nationale Mythen: Thea von Harbou und der deutsche Film vor 1940* (1995).

Other Films Include: *Die heilige Simplicia* (1920); *Der müde Tod/ Destiny* (1921); *Der brennende Acker/The Burning Soil, Phantom* (1922); *Die Austreibung* (1923); *Die Nibelungen. 2 Teile, Die Finanzen des Großherzogs, Michael* (1924); *Zur Chronik von Grieshuus* (1925); *Metropolis* (1927); *Frau im Mond/Woman on the Moon* (1929); *Elisabeth und der Narr, Hanneles Himmelfahrt* (1934); *Der alte und der junge König, Ein idealer Gatte* (1935); *Eine Frau ohne Bedeutung* (1936); *Der Herrscher* (1937); *Jugend, Verwehte Spuren* (1938); *Hurra! Ich bin Papa!* (1939); *Via Mala, Fahrt ins Glück* (1948); *Dein Herz ist meine Heimat* (1953); *Das indische Grabmal/The Indian Tomb* (1959).

HARLAN, Veit Berlin 1899 – Capri, Italy 1964

German director of melodramas and historical spectaculars, notorious for some of the most overtly propagandist (*Der große König*, 1942; *Kolberg*, 1945), anti-semitic (*Jud Süss/Jew Süss*, 1940; not to be confused with the British version directed by Lothar Mendes in 1934) and tear-jerking (*Die goldene Stadt*, 1942; *Opfergang*, 1944) films of the Nazi regime. Harlan's film career started in 1926 when he acted in some twenty films for directors such as Ludwig Berger* (*Der Meister von Nürnberg*, 1927), Kurt Bernhardt* (*Das Mädchen mit den fünf Nullen*, 1927), Gustav Ucicky* (*Yorck*, 1931; *Flüchtlinge*, 1933; *Das Mädchen Johanna*, 1935), Richard Eichberg* (*Die unsichtbare Front*, 1932), Robert Wiene* (*Taifun/Polizeiakte 909*, 1933) and Geza von Bolvary* (*Stradivari*, 1935). From 1935 to 1958 Harlan produced his own films, except for a five-year break between 1945 and 1950. He was charged with war crimes but later cleared, and returned to film-making despite protests from the German left. His ideologically less blatant literary adaptations (*Die Kreutzersonate*, 1937; *Der Herrscher*, 1937; *Die Reise nach Tilsit*, 1939; *Immensee*, 1943), comedies (*Krach im Hinterhaus*, 1935; *Kater Lampe*, 1936; *Der müde Theodor*, 1936), and melodramas (*Maria, die Magd*, 1936; *Jugend*, 1938; *Verwehte Spuren*, 1938; *Das unsterbliche Herz*, 1939) nonetheless show a predilection for myth and heavy symbolism which associate Harlan with the ideals of Nazism. MW

Bib: Siegfried Zielinski, *Veit Harlan: Analysen und Materialien zur Auseinandersetzung mit einem Film-Regisseur des deutschen Faschismus* (1981).

HARTL, Karl Karl Anton Hartl; Vienna 1899–1978

Austrian director and producer. Hartl's first two films, *Ein Burschenlied aus Heidelberg* (1930) and *Berge in Flammen/The Doomed Battalion* (1931, co-dir. Luis Trenker*), led to Ufa* entrusting him with more substantial (multilingual) productions. His pre-

ferred genres were science fiction: *F.P.1 antwortet nicht/I.F.1 ne répond plus/Secrets of F.P.1* (1932, Ger./UK/Fr.), *Gold/L'or* (1933–34. Ger./Fr.); and comedy: *Die Gräfin von Monte Christo* (1932) and the crime comedy *Der Mann der Sherlock Holmes war* (1937). As chief producer at Wien-Film during the 1938–45 period, Hartl's merit was the large number of typical 'Viennese films' he produced (directed for instance by Willi Forst*) in comparison to an unusually small number of propaganda films. During his management of Wien-Film, Hartl also wrote many scripts but directed only one film: *Wen die Götter lieben* (1942). After the war he continued to work as a producer, writer and director of light entertainment films. His most successful projects were *Der Engel mit der Posaune* (1948), *Weg in die Vergangenheit* (1954) and *Mozart* (1955). After 1963 Hartl worked as a film consultant. KU

Bib: Goswin Dörfler, 'An Austrian Director: Karl Hartl', *Focus on Film*, no. 29 (March 1978).

HARVEY, Lilian
Helene Lilian Pape; London 1906 – Juan-les-Pins, France 1968

British-born German actress, arguably the most popular musical star of the German cinema. She was contracted by Richard Eichberg*, who also hired Willy Fritsch* as her partner (*Die keusche Susanne*, 1926), creating the 'dream couple' of the German film. From 1928 she worked for Ufa*, advertised as 'the sweetest girl in the world', in such successes as *Hokuspokus, Die Drei von der Tankstelle* (both 1930), *Der Kongreß tanzt* (1931), *Zwei Herzen und ein Schlag, Ein blonder Traum* (both 1932) and *Ich und die Kaiserin* (1933). In 1932, she signed a contract with 20th Century-Fox, but none of her Hollywood films made much of an impact and she returned to Europe in 1935, to star in one of the most delightful but also most brazenly derivative Nazi comedies, *Glückskinder* (1936, dir. Paul Martin), a covert remake of *It Happened One Night*. More double acts with Fritsch followed (*Fanny Elßler*, 1937; *Capriccio*, 1938). After helping choreographer Jens Keith escape to Switzerland, she was questioned by the Gestapo and emigrated to France, then to the US, where she briefly made a living as a nurse and in radio and theatre. In 1946 Harvey returned to France, worked on the music-hall revue 'Paris s'amuse', toured the provinces and Belgium, and in 1957 retired to the Côte d'Azur. KP

Bib: Christiane Habich (ed.), *Lilian Harvey* (1990).

131

HASSE, O(tto) E(duard)

Obersitzko 1903 –
Berlin 1978

German actor, famous for characters in uniform with a strong personality and individualist code of honour. He began his career at Max Reinhardt's* acting school in Berlin and appeared as an extra in F. W. Murnau's* film *Der letzte Mann/The Last Laugh* (1924). Between 1930 and 1939 he worked in Munich (at the Münchner Kammerspiele), and collaborated on a film with Karl Valentin* (*Der verhexte Scheinwerfer*, 1934); during the war he featured in prestige productions like *Stukas* (1941) and *Rembrandt* (1942). Hasse found ready roles after 1945, in the *Trümmerfilme* 'ruin film' genre, for instance *Berliner Ballade* (1948) and *Epilog* (1950), while also playing Nazis and ex-Nazis in international productions such as Anatole Litvak's* *Decision Before Dawn* (1950, US) and Alfred Hitchcock's* *I Confess* (1952, US). His greatest acting triumphs in Germany are in two anti-war films: as Admiral Canaris (*Canaris,* 1954) and in *Der Arzt von Stalingrad* (1958). He also worked frequently in France, where Jean Renoir used him in *Le Caporal épinglé/The Vanishing Corporal* (1962), before settling for German television, where he was instantly recognised and much loved by millions. KP

Bib: Hans Knudsen, *O. E. Hasse* (1960).

Other Films Include: *Peter Voß, der Millionendieb* (1932); *Peer Gynt* (1934); *Der letzte Walzer* (1953); *Les Aventures d'Arsène Lupin* (1956, Fr.); *Les Espions* (1957, Fr.); *Der Maulkorb* (1958); *Die Ehe des Herrn Mississippi* (1961); *Le Vice et la vertu/Vice and Virtue* (1963, Fr.); *Trois chambres à Manhattan* (1965, Fr.); *Etat de siège/State of Siege* (Fr./It., 1973).

HATHEYER, Heidemarie

Villach 1918 – Zurich,
Switzerland 1990

Austrian actress. Hatheyer gained her first acting experience in Viennese cabaret before performing in theatres in Vienna and Munich; she enjoyed a successful stage career for the rest of her life. As Friedrich Luft put it, 'Hatheyer was not beautiful but she exuded life, never played sentimentally, always honestly'. In 1937 she was discovered by Luis Trenker*, who cast her in *Der Berg ruft/The Challenge* (1937) as the 'wild, young girl of the mountains', which she played also in *Die Geier-Wally* (1940, dir. Hans Steinhoff*), her greatest success, fixing her persona as a strong, charismatic woman. Throughout the Nazi period she appeared in leading roles in films such as *Ich klage an, Die Nacht in Venedig* (both 1941), *Der große Schatten* (1942) and *Man rede mir nicht von Liebe* (1943). In the postwar period

and until the end of the 1950s she continued acting on stage and starred in some of the more popular films of the time (*Mein Herz darfst Du nicht fragen*, 1952, *Pünktchen und Anton*, 1953, *Der Meineidbauer*, 1956, ... *und führe uns nicht in Versuchung*, 1957). She remained active on stage until 1983 but failed to attract film offers until the 1980s. Her last film dates from 1988 (*Martha Jellneck*, dir. Kai Wessel), where she was once more praised for her candour and strong personality. FM/KP

Bib: Cinzia Romani, *Tainted Goddesses: Female Film Stars of the Third Reich* (1992).

HEER, Johanna Vienna 19[?]

Austrian cinematographer. Heer began her career as a director of photography in the US, where she worked on, among other films, *Subway Riders* (1979–81). Her work is characterised by her use of colours and light, which she calls 'painterly camerawork', developed to its most elaborate degree in Percy Adlon's *Zuckerbaby* (1985, Ger.). Since 1991 she has directed documentaries together with Werner Schmiedel: *Der andere Blick* (1991), an essay on G. W. Pabst* and the responsibility of the artist during the Third Reich, and a tribute to Simon Wiesenthal, *Die Kunst des Erinnerns – Simon Wiesenthal* (1994). AL

HEIMAT FILM and MOUNTAIN FILMS

German genres. The *Heimatfilm* is unique to Germany. Several films produced during the Weimar Republic (such as *Die Geier-Wally*, 1921) and the Third Reich may be categorised as *Heimatfilme*, but the apogee of the genre comes in the 1950s. *Heimatfilme* depict a world in which traditional values prevail: love triumphs over social and economic barriers, and the story is usually set in an idyllic German countryside, highlighting maypoles and other folkloric traditions. Many *Heimatfilme* take their titles from folk songs, such as *Grün ist die Heide* (1951) and *Am Brunnen vor dem Tore* (1952). The genre produced its own directors (Hans Deppe*) and stars (Sonja Ziemann and Rudolf Prack, for instance). As the popularity of the *Heimatfilm* waned in the late 1950s, films appeared which cross-bred it with other generic conventions, such as the musical and sex comedies. *Heimatfilme* died out after the mid-1960s, just as a number of New German Cinema* films (*Jagdszenen in Niederbayern/Hunting Scenes from Bavaria*, 1969, *Jaider – der einsame Jäger*, 1971) began to be critical of their social message and covert xenophobia. When Edgar Reitz* made his epic *Heimat*, fully aware of the word's resonance, he was implicitly commenting on both the genre and the genre's critical ripostes, preferring

to refer to Carl Froelich*/Zarah Leander's* *Heimat* (1938) and the ecological movement's rediscovery of regionalism and agrarian roots. Other prominent *Heimatfilme* include: *Schwarzwaldmädel* (1950), *Wenn die Abendglocken läuten* (1951), *Ferien vom Ich* and *Tausend rote Rosen blühn* (both 1952), and *Die Trapp-Familie* (1956).

Mountain films (*Bergfilme*) designate a popular German genre of the 1920s and 1930s which should not be confused with the *Heimatfilm*, despite some superficial similarities. Mountain films used simple, melodramatic plots, spendidly highlighting the snow-covered mountains, and often involving accidents and dangerous last-minute rescues. Arnold Fanck* and Luis Trenker* set its formula; Fanck's films – *Im Kampf mit dem Berge* (1921), *Die weisse Hölle vom Piz Palü/The White Hell of Piz Palu* (1929) – presented the struggle between the (usually male) protagonist(s) and the mountains in powerfully elemental and pantheistic terms. Franck's cameramen used special lenses and camera speeds to capture natural phenomena (sudden weather changes, avalanches or rock-falls), celebrating film technology along with nature. Trenker's films tended to feature more heroic, patriotic individuals in spectacular adventures undergoing trials of strength and conviction, as in *Berge in Flammen* (1931) and *Der Rebell* (1932). JG/TE

Bib: Willi Höfig, *Der deutsche Heimatfilm 1947–1960* (1973); Eric Rentschler, 'Relocating the Bergfilm', *New German Critique*, no. 51 (1990).

In Austria, the 'New *Heimatfilm*' designates alternative, critical attempts to deal with life in the Austrian countryside, in films and television series of the late 1970s and early 1980s. The New *Heimatfilm* deals with the country's Nazi past, its rigid morality based on Catholicism, and the intellectual aridity of village life. Documentary style, sparing use of dialogue and the use of dialect characterise the Austrian New *Heimatfilm*, as do counter-touristic landscape shots which dispense with idyllic scenes and kitsch.

The Austrian Broadcasting Company, ORF, produced *Alpensaga*, a six-part series (1976–80) written by Wilhelm Pevny and Peter Turrini and directed by Dieter Berner, which focused on life in a small village between 1899 and 1945, providing an account of the 'forgotten' past – the decline of the empire, and the rise and fall of Nazism. Another series, *Das Dorf an der Grenze* (dir. Fritz Lehner; script by Thomas Pluch), centred on the controversial situation of a bilingual village on the Slovenian border from 1918 to the present day (three parts, 1979–83; part four directed by Peter Patzak*, 1992). Lehner was also responsible for the film adaptation of *Schöne Tage* (1981, based on Franz Innerhofer's novel), a quasi-documentary on rural traditions, rendered in impressive yet not romanticising or picturesque images. Apart from realistically showing the ordinary life of mountain farmers, *Schöne Tage* also points to the devastating effects of a strict (Catholic)

set of moral standards. Confrontations with these moral codes recur in other films, such as *Raffl* (1984; dir. Christian Berger) and *Heidenlöcher* (1985; dir. Wolfram Paulus*), which place such moral codes in a social and political context. Films associated with the New *Heimatfilm* (such as Angela Summereder's *Zechmeister*, 1981), often deal with film-makers' experiences or with historical events. However, as in Paulus' second feature, *Nachsaison* (1987), they can also simply record daily routines and the struggle for economic survival. A 'representation of one's own world' (Alexander Horwath), the New *Heimatfilm* can therefore introduce diversity and authenticity into images of Austria otherwise often subject to the demands of tourism and the heritage industry. IR/SS

HELM, Brigitte Berlin 1906

German actress, famous for her double role as Maria in her first film, Fritz Lang's *Metropolis* (1927). A ten-year contract with Ufa* secured her leading parts as the vamp in films by Karl Grune, Marcel L'Herbier (*L'Argent*, 1929) and G. W. Pabst*, usually as the icy queen of someone's heart; she was especially eerie as the usurer's blind daughter in Pabst's *Die Liebe der Jeanne Ney/The Loves of Jeanne Ney* (1927) and genuinely moving in *Die wunderbare Lüge der Nina Petrowna* (1929). Navigating the change to the talkies in *Die singende Stadt*, 1930, she also worked in France and Britain. Her contract with Ufa completed, she retired from film, apparently disgruntled by bad publicity, but possibly also because she herself recognised that, as Ephraim Katz puts it: 'Her acting range never matched her exceptional beauty, a fact that became more evident with sound.' TE

Bib: Peter Herzog/Gene Vazzana, *Brigitte Helm: From Metropolis to Gold. Portrait of a Goddess* (1994).

Other Films Include: *Alraune* (1929); *Manolescu, Der König der Hochstapler* (1929); *Die Herrin von Atlantis* (1933); *Gold* (1934).

HERZOG, Werner Werner Stipetic; Munich 1942

German director of international reputation and one of the figureheads of the New German Cinema*. Herzog made shorts and documentaries (*Herakles*, 1962; *Spiel im Sand*, 1964; *Die beispiellose Verteidigung der Festung Deutschkreutz*, 1966) before directing his award-winning script *Lebenszeichen/Signs of Life* (1968). An *auteur* with a strong personal signature even when doing remakes (*Nosferatu – Phantom der Nacht/Nosferatu the Vampyre*) and literary adaptations (*Woyzeck*, 1979), Herzog has a single subject, which he varies according to the central character's self-image as over-reacher and prophet

135

or underachiever and holy fool: the impossible self-determination of the male individual, best embodied by Klaus Kinski* (five films) and Bruno S (two films). Herzog's trademark is the search for extreme locations, outlandish situations and excessive characters, but often in order to let a strange and touching humanity emerge from impossible odds. Herzog's best-known films are the megalomaniac quests of *Aguirre, der Zorn Gottes/Aguirre, Wrath of God* (1972), *Fitzcarraldo* (1982) and *Cobra verde* (1987), all starring Kinski. TE

Bib: Timothy Corrigan (ed.), *The Films of Werner Herzog: Between Mirage and History* (1986).

Other Films Include: *Auch Zwerge haben klein angefangen/Even Dwarfs Started Small* (1970); *Fata Morgana, Land des Schweigens und der Dunkelheit/Land of Silence and Darkness* (1971); *Die große Ekstase des Bildschnitzers Steiner, Jeder für sich und Gott gegen alle/ Every Man for Himself and God Against All/The Enigma of Kasper Hauser* (1974); *Herz aus Glas/Heart of Glass* (1976); *Stroszek* (1977); *Wo die grünen Ameisen träumen* (1984); *Echos aus einem düsteren Reich/Bokassa Ier – Echos d'un sombre empire/Echoes from a Sombre Empire* (1990); *Schrei aus Stein/Scream of Stone* (1991); *Lektionen in Finsternis/Lessons in Darkness* (1992); *Bells from the Deep: Faith and Superstition in Russia* (1993); *The Transformation of the World Into Music* (TV, 1994); *Tod für fünf Stimmen/Death for Five Voices* (TV, 1995); *Little Dieter Needs to Fly* (1997); *Mexico* (1999).

HOCHBAUM, Werner Paul Adolph
Kiel 1899 – Potsdam 1946

German director, rediscovered after his film *Brüder* (1929) was found in the GDR film archive in 1974. Hochbaum entered film-making with political propaganda movies for the Social Democratic Party (SPD). *Brüder* was initiated by the leftist group *Volksverband für Filmkunst* and aimed at establishing a German socialist-revolutionary cinema that could derive political profit from the contemporary popularity of Soviet cinema. Developing a distinctly oppositional aesthetic programme, Hochbaum succeeded for a while even during the Nazi regime. Barred from film work in 1939, he spent the war years scripting an anti-fascist film which he planned to direct immediately after, but died before he could put it in production. KU

Other Films Include: *Vorwärts* (1929, short documentary); *Razzia in St. Pauli* (1932); *Morgen beginnt das Leben/Life Begins Tomorrow* (1933); *Die ewige Maske/The Eternal Mask* (1935); *Schatten der Vergangenheit/Shadows of the Past* (1936); *Ein Mädchen geht an Land* (1938).

HOFER, Franz Saarbrücken 1882 – Berlin 1945

German director. Recently rediscovered as a true *auteur* of early German cinema, Hofer's work is marked by stunning formal qualities and bizarre twists of plot. Hofer began as a theatre actor and playwright, before turning to film as a scriptwriter in 1910 (*Das Geheimnis der Toten*, starring Henny Porten*), directing his first film, *Des Alters erste Spuren*, in 1913. The years 1913–14 marked his most productive phase, when he worked in almost every genre, directing some of the most famous actors and actresses of the period in comedies such as *Hurrah! Einquartierung* (1913), detective dramas like *Der Steckbrief* (1913), and the *Sensationsfilm* (sensational film) *Die schwarze Natter* (1913). Among his surviving films of the middle and late 1910s the melodramatic *Heidenröschen* (1916) is the most remarkable, not only for its extravagant lighting and decors but also for its complex use of cinematic space, point-of-view editing and narrative structure. After the war Hofer temporarily ran his own company, Hofer-Film. He apparently slowed down in the 1920s, remaking one of his earliest films, *Das rosa Pantöffelchen*, in 1926. His last two films as director about which something is known are *Madame Lu, die Frau für diskrete Beratung/The Woman for Discreet Advice* (1929) and the populist sound film *Drei Kaiserjäger* (1933). MW

Bib: Heide Schlüpmann, 'The sinister gaze: Three films by Franz Hofer from 1913', in Paolo Cherchi Usai and Lorenzo Codelli (eds), *Before Caligari: German Cinema 1895–1920* (1990).

HOFFMANN, Carl Neisse an der Wobert 1881 – Berlin 1947

German cameraman and director, along with Karl Freund* and Fritz Arno Wagner* the most famous photographer of Weimar* cinema. In 1916 he became chief cameraman for Decla-Film, mainly working for director Otto Rippert (particularly on the six-part series *Homunculus*, 1916), where he experimented with trick photography. His close relation with Decla-Bioscop was sustained through his collaboration with Fritz Lang*. Hoffmann worked as photographer on several films by Joe May*, Paul Leni*, Richard Oswald*, F. W. Murnau*, Karlheinz Martin and Arthur Robison. His photography for *Der Kongress tanzt* (1931) offered an early example of mobile camera and sound film working well together. In 1927 he directed his first film, *Der Geheimnisvolle Spiegel* (1928), and from then on worked as director and camera operator on a dozen more films until his last pictures as director (*Ab Mitternacht*, 1938) and as cinematographer (*Via Mala*, 1945). His son Kurt Hoffmann* is a director. MW

HOFFMANN, Kurt
Freiburg i. Breisgau 1910

German director, son of Carl Hoffmann*. Beginning in 1939, with a series starring Heinz Rühmann*, he became one of Germany's most prolific directors of the postwar years. He directed almost forty films between 1948 and 1971, including remakes and a successful series with Liselotte Pulver*. Hoffmann was a conservative at heart though intellectually a radical, a surefooted professional with auteurist ambitions, torn between sentimentality and satire. His most ambitious films are *Ich denke oft an Piroschka* (1955), *Die Bekenntnisse des Hochstaplers Felix Krull/The Confessions of Felix Krull* (1957) and *Wir Wunderkinder* (1958). TE

Bib: Ingo Tornow, *Piroschka und Wunderkinder oder Von der Vereinbarkeit von Idylle und Satire: Der Regisseur Kurt Hoffmann* (1990).

HOPPE, Marianne
Rostock 1911

German actress. From 1928 Hoppe worked as an actress in Berlin theatres, making a star debut in the cinema with *Der Schimmelreiter* and *Jäger Johanna* (both 1934). She often played opposite Gustaf Gründgens*, to whom she was married from 1936 to 1945, and acted in several films of the Nazi period (*Crepuscule*, 1937, *Der Schritt vom Wege*, 1939, *Lumière dans la nuit*, 1943). After the war she returned to the theatre but also made appearances in the films of Helmut Käutner*, Wolfgang Staudte*, Hans Deppe* and Erich Engel*, and as Rüdiger Vogler's mother in the opening scenes of Wim Wenders'* *Falsche Bewegung/Wrong Movement* (1975). TE

HÖRBIGER, Paul
Budapest, Hungary 1894 –
Vienna 1981

Austro-Hungarian actor, who began his career as a stage actor in 1919 and pursued a successful theatre career throughout his life. During the silent era he acted for Fritz Lang* (*Spione/The Spy*, 1928), playing a servant or a chauffeur, and was praised for his 'Chaplinesque' body language. In sound cinema, he specialised in musical comedies and film operettas (*Zwei Herzen im 3/4 Takt*, 1930; *Die lustigen Weiber von Wien*, 1931; *Der Kongress tanzt*, 1931; *Operette*, 1940), coming across as funny but also sentimental: his rhythmic speech-song, particularly appropriate for operetta films, contrasted with his melancholy facial expression. He thus fitted the image of the tragic yet light-hearted Viennese and was an ideal partner for Hans Moser*, Maria Andergast and Luise Ullrich* in the typical 'Viennese films', as well as in Max

138

Ophuls' *Liebelei* (1933). In 1935 he founded Algefa-Film and went on personifying the Austrian *ancien régime* through his characterisations of waiters, servants, chauffeurs, porters, but also barons and dukes. His best-known postwar films are Carol Reed's* *The Third Man* (1949), where he plays an intimidated porter, *Das Tor zum Paradies* (1949), where he impersonates death, and *Mädchenjahre einer Königin* (1954, with Romy Schneider*). Later he became mostly known as a wine-loving singer in his own television shows. AL/MW

HORN, Camilla
Frankfurt 1903

German actress, who began her extraordinarily long life in film as an extra with Marlene Dietrich*, as well as substituting for Lil Dagover* in F. W. Murnau's* *Tartüff* (1926). After Lillian Gish withdrew from Murnau's *Faust* (1926), Horn had her breakthrough chance, playing next to Gösta Ekman (Sr) and Emil Jannings* and convincing as the naive but passionate Gretchen. She signed a contract with Ufa* for four years and starred in *Der fröhliche Weinberg* (1927), but left for Hollywood the same year, working for United Artists in *Tempest* (1928) and *Eternal Love* (1929). She returned to Berlin in 1929; in the 1930s her career took her to Paris and London as well as Germany (*Die Drei um Edith*, 1929; *Moral um Mitternacht*, 1930). Horn played opposite many of the leading men of the time, such as Gustav Diessl and Louis Graveure, Hans Albers* and Gustav Fröhlich, Ivan Petrovich and Albrecht Schoenhals. From the Gretchen type she graduated to the blonde vamp, playing models, countesses, dancers and ladies of the *demi-monde*. In 1941–42 she went to Italy. After the war she continued to make stage and television appearances, appearing once again in films in the 1980s: *Frankies Braut* (1982), *Der Unsichtbare* (1987), *Schloss Königswald* (1987). KP/TE

Bib: Camilla Horn, *Verliebt in die Liebe: Erinnerungen* (1985).

HORNEY, Brigitte
Berlin 1911 – Hamburg 1988

German actress, whose first film role was in Robert Siodmak's* *Abschied* (1930). *Ein Mann will nach Deutschland* (1934) and *Liebe, Tod und Teufel* (1934) marked the beginning of her ambivalent film career in Nazi Germany. Though Horney's expressive eyes, spare gestures, strong-willed and gamine charm did not fit the fascistic stereotyping of women, the Nazis made use of her skills and popularity as an 'anti-star' by channelling her image of inner strength into patriotic fighting films, skilfully deploying her unconventional beauty in erotic and exotic adventures (*Savoy-Hotel 217*, 1936). In 1936–37 she made two British films: *The House of the Spaniard* (1936) and *Secret Lives* (1937). She fled Germany in 1945 and lived in Switzerland and the US

thereafter. From the 1960s she frequently returned to Germany to work on her second, less spectacular career in German television series: among others, *Derrick* (1977–80), *Heidi* (1976–77), *Jakob und Adele* (1983–86) and *Das Erbe der Guldenburgs* (1986–88). KU

I

IRMEN-TSCHET, Konstantin
Moscow 1902 –
Munich 1977

German-Russian cinematographer of great versatility and range. After his arrival in Berlin in 1920, Tschet was hired as camera assistant by Ufa*, where in collaboration with Günther Rittau* (lasting until 1933) he became a key figure, helping to create Lang's *Metropolis* (1927, shots of the models) and *Die Frau im Mond* (1929, launch pad). In 1928 he was second cameraman (to Rittau) on Joe May's* *Heimkehr*. He shot films of all genres with directors Schwarz*, Siodmak*, Schünzel*, Hartl* and Paul Martin. *Hitlerjunge Quex* (1933) became the best-known of his films with Hans Steinhoff*. He specialised in trick shots and special effects, and was responsible for the camerawork on a number of multi-language entertainment films. The chief cameraman on Germany's first colour film *Frauen sind doch bessere Diplomaten* (1939–41) as well as the Ufa's anniversary film *Münchhausen* (1943), Irmen-Tschet continued working in Germany after the war, usually with directors he had known in the 1930s (von Baky*, Tourjansky, Jacoby*). TE

Other Films Include: *Liebeswalzer* (1930), *Liebling der Götter* (1930), *Der Mann, der seinen Mörder sucht* (1930), *Ein blonder Traum* (1932), *F.P.1 antwortet nicht* (1932), *Viktor und Viktoria* (1933), *Mazurka* (1935), *Königswalzer* (1935), *Glückskinder* (1936), *Fanny Elßler* (1937), *Gasparone* (1937), *Die Frau meiner Träume* (1944), *Die fidele Tankstelle* (1950), *Der träumende Mund* (1953), *Salto mortale* (1953).

J

JACOBY, Georg
Mainz 1882 – Munich 1964

German director, whose fifty-year career began in 1913 (*Buckelhannes*). In 1915 he signed a contract with PAGU*, directing propaganda films (*Durchhaltefilme*) such as *Die Entdeckung Deutschlands* (1917). After the war Jacoby developed a talent for social drama, melodrama and sex films; his adventure films (*Der Mann ohne Namen*, 1921), epics (*Quo Vadis*, 1923) and comedies* (*Der dumme August des Zirkus Romanelli*, 1926), blending action and social analysis with a sophisticated *mise-en-scène*, made him one of the German cinema's commercially most reliable professionals. Jacoby was a pillar of genre cinema during the Nazi period (*Heißes Blut*, 1936), in charge of Ufa's* hottest musical star Marika Rökk*. He directed *Eine Nacht im Mai* (1938), the first German musical modelled on the Hollywood 'production number' genre, as well as the first German (Agfa) colour film, *Frauen sind doch bessere Diplomaten* (1941). His career culminated with Germany's top-grossing musical ever, *Die Frau meiner Träume* (1944), again starring Rökk. In the 1950s, Jacoby mainly specialised in remakes. KU

Bib: Helga Belach (ed.): *Wir tanzen um die Welt: Deutsche Revuefilme 1933–1945* (1979).

Other Films Include: *Bogdan Stimoff* (1916); *The Fake* (1927, UK); *Die Lindenwirtin* (1930); *Die Csárdás-fürstin/Princesse Czardas* (1934); *Der Bettelstudent* (1936); *Gasparone* (1937); *Kora Terry* (1940); *Familie Schimek* (1957)

JACQUES, Norbert
Luxembourg-Eich 1880 – Koblenz 1954

German screenwriter and popular novelist, who started as a journalist in 1904 and had his first success with a novel in 1909 (*Funchtal*). His breakthrough came in 1921 when the *Berliner Illustrierte* serialised his novel of a tyrannical superman who used social upheaval in order to indulge his sadistic impulses. *Dr Mabuse, der Spieler*, was immediately adapted by Thea von Harbou* and made into a two-part film by Fritz Lang* (1921/22). After extensive travels through China, the South Sea Islands, Africa and Brazil, which he wrote about in numerous articles in subsequent years, Jacques specialised in sensational detective stories, two of which were filmed by Hans Steinhoff* (*Mensch gegen Mensch*, 1924; *Das Frauenhaus von Rio*, 1927). In the 1930s Jacques

tried once more to revive his Mabuse (*Dr Mabuses letztes Spiel*, 1932), which supplied a number of motifs for Lang and Harbou's *Das Testament des Dr Mabuse* (1932). The film was banned in 1933 and Jacques' novel remained unpublished until 1950. Attacked by the Nazis as decadent, he nonetheless remained in Germany, writing historical biographies, including one of the poet Schiller, made into a film, starring Horst Caspar (*Friedrich Schiller*, 1940). In 1942/43, his novel *Bayer 205* was the basis for the nationalist film *Germanin*. Though elected mayor of the (Luxemburg) city of Schlachters in June 1945, Jacques was charged with collaboration and expelled to Germany by the French occupation forces in the summer of 1948. He continued as a writer for radio, newspapers and magazines, and adapted another of his novels for the screen (*Export in Blond*, 1950). MW

Bib: Michael Farin/Günter Scholdt (eds), *Dr Mabuse: Medium des Bösen* (1994, 3 vols).

JANNINGS, Emil
Rorschach, Switzerland 1884 –
Strobl, Austria 1950

German actor. A theatre actor since 1900, Jannings worked with the Max Reinhardt* company in 1915–16. His first film role came in the war propaganda film *Im Schützengraben* (1914). From 1916 his film parts were more substantial, and as Louis XV in Ernst Lubitsch's* *Madame Dubarry* (1919) he became world-famous. After *Quo Vadis* (1924) he felt typecast in costume drama, and succeeded in new roles: *Der letzte Mann/The Last Laugh* (1924) and *Variété/Variety* (1925), both well-received in the US. A three-year contract with Paramount followed, and in 1928 Jannings received the very first Oscar ever, for *The Last Command* (1928; dir. Josef von Sternberg). A wealthy man, he returned to Germany in 1929, having persuaded Sternberg to direct him once more, as Professor Rath in *Der blaue Engel/The Blue Angel* (1930). Jannings resumed his career in the theatre, but also recaptured his earlier film stardom in such Nazi propaganda films as *Der alte und der junge König* (1935). In 1936 he joined the board of directors of Tobis and was involved in *Ohm Krüger* (1941), one of the most expensive anti-British propaganda productions of the Third Reich. In 1946 the US military officially 'denazified' him. TE/SG

Bib: Herbert Holba, *Emil Jannings* (1979).

Other Films Include: *Frau Eva* (1916); *Lulu* (1917); *Die Brüder Karamasoff* (1920); *Danton* (1921); *Das Wachsfigurenkabinett/ Waxworks* (1923); *Tartüff* (1925); *Faust* (1926); *The Street of Sin* (1927, US); *Der Herrscher, Der zerbrochene Krug* (1937); *Robert Koch, der Bekämpfer des Todes* (1939); *Altes Herz wird wieder jung* (1943).

JARY, Michael
Laurahütte, Austria 1906 –
Munich 1988

Austrian-born German composer with a classical training and a penchant for jazz and swing, who worked initially as a Berlin bar pianist. Jary's first operetta, *Der Vizeadmiral*, premiered in 1934, and was followed in 1936 by the musical *Das Notwendige und das Überflüssige*. Offers from Ufa* led to his first film score for *Die unerhörte Frau* (1936) whose jazzy foxtrot 'Heut' bin ich glücklicher als glücklich' became an immediate hit and made a name for Jary in the burgeoning record industry. Between 1937 and 1945 Jary worked as film composer for several companies, among them Terra-Filmkunst. There, he soon formed a highly successful composer-songwriter team with Bruno Balz. Among their most popular numbers were 'Das kann doch einen Seemann nicht erschüttern', 'Davon geht die Welt nicht unter' (both classics to this day), as well as a waltz tune, written especially for Zarah Leander*, which is still probably her best-remembered song: 'Ich weiß, es wird einmal ein Wunder geschehen'. Jary's hit songs gave a whole generation of female singers their break, including Rosita Serrano, Evelyn Künneke and Kary Barnet. In 1939 he embarked on a second career, as band-leader of a swing band, recording jazz titles for the Odeon record label up to 1943.

After the war Jary built up the Radio-Dance Orchestra Berlin, but soon tired of it and returned to composing. With his unerring ear for what was in the air, he picked up on the changes in popular music, extending his range to pop songs for the first German rock 'n' rollers in the 1950s, thus continuing his career as tunesmith extraordinary until the late 1950s. His last big hit, 'Wir wollen niemals auseinandergehen', was featured in a 1961 pop music film. TE/SG

Other Films Include: *Abenteuer in Warschau* (1937); *Der Florentiner Hut, Paradies der Junggesellen* (1939); *Wunschkonzert* (1940); *Die große Liebe* (1942); *Karneval der Liebe* (1943); *Die Dritte von rechts* (1950); *Die verschleierte Maya* (1951); *Die Zürcher Verlobung* (1957); *Bei Pichler stimmt die Kasse nicht* (1961).

JUGO, Jenny
Mürzzuschlag, Steiermark 1905

Austrian-born actress, who signed a three-year contract with Ufa* in 1924. From the very beginning she displayed a talent for self-irony (*Die Hose*, 1927). In the sound era a fruitful collaboration with Erich Engel*, the director of eleven of her films, made her a star. With her naturalistic performance style Jugo was able to highlight the grotesque in the quotidian (in so-called *Alltagskomödien* ['everyday life comedies'] such as *Pechmarie*, 1934) as well as in artificial worlds (as in the costume film *Die Nacht mit dem Kaiser*, 1936), which made her an

ideal medium for Engel's 'enlighted humour'. Her portrayal of Eliza in *Pygmalion* (Engel, 1935) marked the peak of her success as a comedienne. After Helmut Käutner's* *Königskinder* (1950) she retired from the cinema. KU

Other Films Include: *Die Puppe vom Lunapark* (1924); *Wer nimmt die Liebe ernst?* (1931); *Allotria* (1936); *Die Gattin* (1943).

JÜRGENS, Curd Munich 1915 – Vienna 1982

German actor and director. From the mid-1930s to the 1970s Jürgens enjoyed a parallel career in theatre and film. Willi Forst* gave him a first film role in *Königswalzer* (1935), establishing him as good-looking lover and carefree daredevil. With Helmut Käutner's* Zuckmayer adaption *Des Teufels General/The Devil's General* (1955) his persona acquired dimensions of psychological depth. In *Die Ratten* (1955) and *Les Héros sont fatigués/The Heroes Are Tired/Heroes and Sinners* (1955, Fr.), he continued to make his mark as a character actor, playing opposite Brigitte Bardot* in *Et Dieu ... créa la femme/And God Created Woman* (1956). In the 1960s he participated in a number of European and American film projects (often remakes of German pre-war films) as well as the German *St. Pauli* series. He also directed four films: *Prämien auf den Tod* (1949), *Die Gangsterpremiere* (1951), *Ohne Dich wird es Nacht* (1956), and *Bankraub in der Rue Latour* (1960). SG/TE

Bib: Gregor Ball, *Curd Jürgens* (1982).

JUTZI, Phil (Piel) Alt-Leiningen 1896 – Neustadt/Weinstrasse 1946

German director. One of the most influential film-makers of the late Weimar period, Jutzi was to become a reference point for socially committed directors from Slatan Dudow to Rainer Werner Fassbinder*. A former painter of working-class origins, he bought his first film camera in 1916, changing his name to Piel Jutzi in the early 1920s. In 1931, he was successfully sued by Harry Piel*, who wanted to protect his name. Receiving his first credit as an independent director with the detective film *Das blinkende Fenster* (1920), Jutzi came to the fore in the late silent period with three semi-documentary films* about working-class subjects [> ARBEITERFILME]: *Kindertragödie* (1928), *Ums tägliche Brot/ Our Daily Bread*, 1929) and *Mutter Krausens Fahrt ins Glück/Mother Krause's Journey to Happiness*, 1929). In 1931, he scored a nationwide success with a strong dramatic adaption of Döblin's novel, *Berlin Alexanderplatz* (starring Heinrich George* as Franz Biberkopf), which has remained his best-known film. Despite

constant difficulties with Nazi officials, Jutzi continued to direct innumerable shorts, chiefly comedies and crime stories, additionally serving as cinematographer in many of his own films as well as films by others until the early 1940s. MW

Bib: Hans-Michael Bock/Wolfgang Jacobsen (eds), *Phil Jutzi* (1993).

K

KAMMERSPIELFILM

German genre, designating films produced during the early 1920s which drew on the conventions of contemporary German theatre. *Kammerspielfilme* usually received critical acclaim but did not achieve commercial success. The scriptwriter Carl Mayer* created the genre's narrative model in his screenplays for *Scherben/Shattered* (1921), *Hintertreppe* (1921), *Sylvester – Tragödie einer Nacht* (1923) and *Der letzte Mann/The Last Laugh* (1924). Characteristically, the plot is a realist drama portraying servants or members of the lower middle class who meet with a tragic end through murder or suicide. Most *Kammerspielfilme* were set indoors and drew on innovative cinematic techniques, as exemplified in the minimal use of titles and expressive camera movements in *Scherben, Sylvester* and *Der letzte Mann*. The *Kammerspielfilm*'s central figure was often an anti-hero, typical of many German films of the post-World War I era, and anticipating the protagonists of American *film noir* and of the post-World War II German *Trümmerfilm* ('ruin film'). The leads went to well-known stage actors such as Werner Krauß*, Eugen Klöpfer* and Fritz Kortner*, ensuring that, despite minority appeal, the films were premiered in Ufa's* most prestigious Berlin first-run movie theatres. JG

Bib: Jo Leslie Collier, *From Wagner to Murnau: The Transposition of Romanticism from Stage to Screen* (1988).

KÄUTNER, Helmut
Düsseldorf 1908 – Castellina, Italy 1980

German director (and former actor), whose first film, the sophisticated comedy *Kitty und die Weltkonferenz/Kitty and the World Conference* (1939), was banned by Goebbels at the outbreak of World War II because of its sympathetic portrait of a British diplomat. Käutner con-

tinued to deviate from the official Nazi formula with the Gottfried Keller adaptation *Kleider machen Leute/Clothes Make the Man* (1940), starring Heinz Rühmann*. Equally remarkable was his subsequent psychological melodrama, *Romanze in Moll/Romance in a Minor Key* (1943). Disliked by the Nazi officials for what they regarded as its escapist mood, the film enjoyed far greater popularity than many propaganda features. Also banned, but successful abroad, was *Große Freiheit Nr. 7/Port of Freedom/La Paloma* (1944, with Hans Albers*), which became a major hit in Germany after the war. Except for the prize-winning anti-war film *Die letzte Brücke/The Last Bridge* (1954) and the successful Zuckmayer adaptations *Des Teufels General/The Devil's General* (1955), *Der Hauptmann von Köpenick/The Captain from Köpenick* (1956) and *Der Schinderhannes* (1958), Käutner's post-war films met with an increasingly negative reception. From the mid-1960s he concentrated mainly on the theatre, opera and television. In 1974 he was given a German award for his performance in the title role of Hans Jürgen Syberberg's* *Karl May* (1974). MW

Bib: Wolfgang Jacobsen and Hans Helmut Prinzler (eds), *Käutner* (1992).

Other Films Include: *Frau nach Maß* (1940); *Anuschka* (1942); *Unter den Brücken/Under the Bridges* (1946); *In Jenen Tagen/In Those Days* (1947); *Der Apfel ist ab* (1948); *Königskinder* (1950); *Käpt'n Bay-Bay* (1953); *Himmel ohne Sterne, Ludwig II: Glanz und Elend eines Königs* (1955); *Ein Mädchen aus Flandern* (1956); *Montpi* (1957); *Der Rest ist Schweigen/The Rest is Silence* (1959).

KETTELHUT, Erich Berlin 1893 – Hamburg 1979

Art director. After training as a stage painter and attending various arts and crafts schools, Kettelhut worked in various theatres before joining the Berlin design and furnishings company Martin Jacoby-Boy which did commissions for Joe-May*-Filmgesellschaft. In 1919 he was hired as assistant art director for May's eight part project *Die Herrin der Welt*. He built the models for Lang's *Das wandernde Bild* (1920). Erich Pommer* engaged him in 1920 for Decla-Bioscop, which became part of Ufa* in 1921. Together with Hunte and Vollbrecht he worked as 'studio architect' for *Dr Mabuse, der Spieler* (1922), *Die Nibelungen* (1922–24) and *Metropolis* (1926). After design work on *Berlin, die Sinfonie der Großstadt* (1927) and a short stint at Paramount in Hollywood, he was in charge of art direction for May's *Asphalt* (1929), where the studio sets posed special challenges because of complex camera movements. During the following years he worked exclusively for Pommer productions, building the spectacular aircraft launch pad for *F.P.1 antwortet nicht* (1932). In the 1930s he remained one of Ufa's top art directors, considered the antipode to Herlth and

146

Röhrig. Kettelhut, man of the theatre, was the specialist for static-monumental scene designs, coming into his own designing spectacular music and revuefilms for Georg Jacoby and Marika Rökk*. He continued his association with Jacoby and Pommer in the postwar period, designing his last film once again with Fritz Lang (*Die 1000 Augen des Dr Mabuse*, 1960). KP

Other Films Include: *Das indische Grabmal* (1921), *Dona Juana* (1927), *Liebling der Götter* (1930), *Bomben auf Monte Carlo* (1931), *Quick* (1932), *Ein blonder Traum* (1932), *Schwarze Rosen* (1935), *Schlußakkord* (1936), *Glückskinder* (1936), *Frauen sind doch bessere Diplomaten* (1939–41), *Sensation in San Remo* (1951), *Eine Liebesgeschichte* (1953/54), *Haie und kleine Fische* (1957), *U 47 – Kapitänleutnant Prien* (1958).

KINO REFORM MOVEMENT

German film movement. Cinema reform movements flourished in most European countries in the first decades of this century. In Germany one can distinguish two attempts by the cultural establishment (one around 1907, the other immediately after World War I, mainly represented by teachers and the clergy) to contain the nefarious influence of the new mass medium, seen to reside in its reliance on fiction and explicit body-language. However, the *Kinematographische Reformvereinigung*, founded in Berlin in 1907, had ultimately a rather ambivalent attitude towards the cinema: while it professed to protect women and children, whose exposure to narrative was regarded as a danger to public morality, the reformers were keen to enlist film as an educational tool in all manner of causes. In numerous pamphlets and articles (many published in the journal *Bild und Film*, 1912–15) leading reformers such as Herrmann Häfker (born in Bremen 1873, died at the Mauthausen concentration camp in 1939) and Konrad Lange (1855–1921) tried to steer a path between advocating prohibition (fearing the power of moving images to incite imitation) and preventive measures (trusting the soothing effects of nature films, documentaries and uplifting patriotic subjects). An ambitious eight-volume monograph series, *Lichtbühnen-Bibliothek* (1913–15), also put forward the case for nationalising the film industry. Although this advice remained unheeded, the movement's regional associations were strong enough to produce and exhibit suitably 'cultural' films [> DOCUMENTARY (GERMANY)], and to lobby successfully for censorship and the protection of minors. Politically, reformers saw in the cinema the product of 'international capital' threatening the traditional values of the nation. One strategy advocated was to preempt the 'smut-merchants' by adapting literary works and persuading reputable stage actors to get involved in making films, paralleling the more commercially minded motives of the so-called *Autorenfilm* to

widen audience appeal by addressing the middle-class viewer. The success of the *Autorenfilm* took the wind out of the reformers' sails, at least until the abolition of censorship in 1918 brought the first wave of sex films, when they were able to mount an effective parliamentary lobby, which led to the reintroduction of censorship in 1921. JG/MW/TE

Bib: Sabine Hake, *The Cinema's Third Machine: Writing on Film in Germany 1907–1933* (1993).

KINSKI, Klaus
Nikolaus Günther Nakszynski; Zoppot, East Prussia (now Poland) 1926 – Lagunitas 1991

German actor, whose expressive features, mannerisms and impossibly wide grin took him from subordinate parts in B-movies (such as the Edgar Wallace series), where he was typecast as a psychopathic eccentric, to art cinema stardom, via a stint as favourite villain in Italian Westerns. After more second-rate productions in Italy and France, he was cast as the mad Spanish conquistador in Werner Herzog's* *Aguirre, der Zorn Gottes/Aguirre, Wrath of God* (1972), which began a five-film collaboration that was to last until their parting quarrel in 1987 during the filming of *Cobra Verde* (1988). As the criminal, sex-mad director of a California health farm in Billy Wilder's *Buddy, Buddy* (1981), Kinski was able to combine the salient elements of all his acting careers. His daughter Nastassja Kinski (born 1961) has become an international film star, in such films as Roman Polanski's *Tess* (1979) and Wim Wenders'* *Paris, Texas* (1984). TE

Bib: Philippe Rege, *Klaus Kinski* (1987).

Other Films Include: *A Time to Love and a Time to Die* (1958, US); *Das Geheimnis der gelben Narzissen/The Devil's Daffodil* (1961); *Der schwarze Abt, Das indische Tuch* (1963); *Winnetou, II Teil* (1964); *Doctor Zhivago* [US], *Per qualche dollari in più/For a Few Dollars More* (1965, It./Sp./Ger.); *Il grande silenzio* (1968, It.); *L'Important c'est d'aimer* (1974, Fr.); *Un genio, due compari, un pollo* (1975, It.); *Kinski – Paganini* (1989).

KLEIN-ROGGE, Rudolf
Cologne 1888 – Graz, Austria 1955

German actor, originally from the stage, who obtained his first minor roles on screen in 1919. He appeared in a number of films by Weimar directors such as Franz Osten and Friedrich Zelnik, but is remembered for his impressively demonic villains in the title roles of Fritz

Lang's* *Dr Mabuse, der Spieler/Dr Mabuse, the Gambler* (1922) and *Das Testament des Dr Mabuse* (1933), as well as for characters in other Lang films: the cruel Chinese emperor of *Der müde Tod/Destiny* (1921), King Etzel in *Die Nibelungen* (1924), Rotwang in *Metropolis* (1927), and Haighi in *Spione* (1928). Increasingly relegated to supporting roles – for instance in the Emil Jannings* star vehicles *Der alte und der junge König* (1935), *Der Herrscher* (1937) and *Robert Koch, der Bekämpfer des Todes* (1939) – Klein-Rogge seemed unable to add new dimensions to the screen image created by Lang. MW

KLÖPFER, Eugen Rauhenstich-Talheim 1886 – Wiesbaden 1950

German actor who was an established theatre actor and member of the the Deutsche Theater when he started a second career in cinema which, despite considerable success, always remained of secondary importance to him. In Murnau's* *Der brennende Acker* (1922) and *Die Austreibung* (1923) he figured as a simple country bumpkin. Klöpfer was the startled petit-bourgeois, whose drab world has fallen to pieces in Karl Grune*'s *Die Strasse* (1923), and in the Zuckmayer adaptation *Katharina Knie* (1929) he played the aged acrobat Karl Knie, coming to a pitiable end. From the mid-1920s, Klöpfer was often cast in title roles, portraying historical German heroes such as Götz von Berlichingen (1925), Luther (1927), or Schiller (1940). Klöpfer's role as a stolid, homesick Teuton in *Flüchtlinge* (1933) began a series of fateful appearances which culminated in his playing the local government officer Sturm in *Jud Süss* (1940). Banned from making public appearances in 1945, he spent two months in prison. After legal proceedings exonerated him in 1948, he resumed acting for the stage. MW

Bib: Ulrich Scherzer, *Eugen Klöpfer: Sein Leben, sein Wirken* (1960).

Other Films Include: *Der Tänzer* (1919); *Die Arche* (1919); *Sehnsucht* (1920); *Maria Magdalene* (1920); *Die lebende Fackel* (1920); *Die Geier-Wally* (1921); *Das Geld auf der Straße* (1921); *Schlagende Wetter* (1923); *Sylvester* (1923); *1914, die letzten Tage vor dem Weltbrand* (1930); *Unheimliche Geschichten* (1932); *Die goldene Stadt* (1942); *Die Brüder Noltenius* (1945).

KLUGE, Alexander Halberstadt 1932

German director, who practised law before entering the cinema as assistant on Fritz Lang's* *Der Tiger von Eschnapur/The Tiger of Bengal* and *Das indische Grabmal/The Indian Tomb* (both 1959) and director of art documentaries. From 1962, when he helped to draft the 'Oberhausen Manifesto' [> NEW GERMAN CINEMA], Kluge

became the chief ideologue of the Young and New German Cinema* whose success is difficult to conceive without his manifold activities.

One of the first post-Oberhausen films to obtain state subsidy and international recognition was Kluge's *Abschied von gestern/Yesterday Girl* (1966). Like all his best-known films, from *Die Artisten in der Zirkuskuppel: ratlos/Artists at the Top of the Big Top: Disorientated* (1968) to *Der Angriff der Gegenwart auf die übrige Zeit/The Blind Director* (1985), *Abschied von gestern* reveals a complex principle of narrative construction that uses the frictions (*Reibungen*) and fractions (*Bruchstellen*) – two of Kluge's favourite metaphors – between fragments of verbal and (audio)visual speech (public records, news, quotations, found footage) to produce distancing effects. A constant reference point in Kluge's films is the need to 'work on our history', carried over into his collective projects: *Deutschland im Herbst/Germany in Autumn* (1978), *Der Kandidat/The Candidate* (1980), *Krieg und Frieden/War and Peace* (1983), and culminating in *Die Patriotin/The Patriot* (1979). Kluge's film work is part of a larger cultural project encompassing political activism, fiction writing and television programmes, not to mention comprehensive sociological research published in collaboration with Hellmut Becker and Oskar Negt between 1961 and 1992. MW

Bib: Peter C. Lutze, *Alexander Kluge: The Last Modernist* (1998).

Other Films Include: *Die unbezähmbare Leni Peickert/The Indomitable Leni Peickert* (1970); *Der große Verhau/The Big Dust-up* (1971); *Der starke Ferdinand/The Strong Ferdinand* (1976); *Die Macht der Gefühle/The Power of Emotion* (1983); *Vermischte Nachrichten* (1986).

KNEF, Hildegard [in US: NEFF, Hildegarde]
Ulm 1925

German actress whose adventurous life and career took her from Russia to Hollywood, and from draughtswoman for Ufa's* special effects department to Broadway. Her acting career began in earnest with Germany's first postwar film produced by DEFA*, *Die Mörder sind unter uns/The Murderers are Amongst Us* (1946). She created a sensation as a new type of *femme fatale*, more matter-of-fact and less sultry than Marlene Dietrich*, but also a complete break from the preferred erotic ideal of the Nazi entertainment film. After a (brief) nude appearance in *Die Sünderin/The Sinner* (1951) made her notorious, Fox brought her to Hollywood, with mixed results. Starring in German, French and British films, opposite Hans Albers,* Erich von Stroheim, Tyrone Power, Gregory Peck and others, she became one of the best-known European actresses of the 1950s and 1960s. Her film successes were complemented by stage appearances, for instance in the

Broadway musical *Silk Stockings* (based on Lubitsch's* *Ninotchka*), but Knef also shone as a cabaret singer and wrote a best-selling autobiography. TE/SG

Other Films Include: *Zwischen gestern und morgen* (1947); *Fahrt ins Glück* (1948); *Decision Before Dawn* (1950, US); *Nachts auf den Straßen, Diplomatic Courier* (US), *The Snows of Kilimanjaro* (US), *Alraune, La Fête à Henriette* (1952, Fr.); *The Man Between* (1953, UK); *Caterina di Russia* (1962, It.); *Landru* (1963, Fr.); *Jeder stirbt für sich allein* (1976); *Fedora* (1978, US); *Flügel und Fesseln/The Future of Emily* (1984, Ger./Fr.).

KOERFER, Thomas Berne 1944

German-Swiss director. A graduate in economics, Koerfer began his film career as a volunteer with Alexander Kluge* at the Ulm Film Institute and with Brunello Rondi in Rome. From camera operator and editor on television documentaries he advanced to contributor on a political television magazine before making his first feature film, the Brechtian parable *Der Tod des Flohzirkusdirektors oder Ottocaro Weiss reformiert seine Firma* (1973). The use of intertitles, rhetorical commentaries, medium and long shots by Renato Berta, interspersed with literary and philosophical disquisitions, made the film a textbook example of anti-illusionism. Thanks to a strong emphasis on performance, *Der Tod des Flohzirkusdirektors* established Koerfer as the most prolific intellectual talent among the young German-Swiss directors. He continued to pursue his complex and imaginative politics of form in variations on musical (*Konzert für Alice*, 1985) and literary themes from Robert Walser (*Der Gehülfe*, 1976), Rousseau, Voltaire (*Alzire oder der neue Kontinent*, 1978) and Gottfried Keller (*Der Grüne Heinrich/Green Henry*, 1994). While his films have been attacked as hermetic and cerebral, Koerfer has also tried his hand at more popular subjects in the big-budget family saga *Glut* (1983) and the road movie *Exit Genua* (1990). MW

Other Films Include: *Die Leidenschaftlichen* (1982); *All Out* (1990); *Die Liebe zum Tode* (1991).

KOHLHAASE, Wolfgang Berlin 1931

German screenwriter whose background in journalism launched his career as dramaturge at the DEFA*-studios in 1950 and subsequently played a prominent part in his becoming one of East German cinema's key writers. His reputation was consolidated with a series of so-called 'Berlin-Films' directed by Gerhard Klein, depicting in a neorealist, underplayed style the lives of young people in the divided city (*Eine*

Berliner Romanze, 1956, *Berlin – Ecke Schönhauser*, 1957). Their *Der Fall Gleiwitz* (1961, co-author Günther Rücker) uses a similarly semi-documentary manner to pinpoint the historical moment when the Nazis triggered World War II. Kohlhaase and Klein once more returned to the Berlin-Film genre with *Berlin um die Ecke* (1965). With *Ich war neunzehn* (1967) Kohlhaase began his collaboration with Konrad Wolf*, resulting in films like *Der nackte Mann auf dem Sportplatz* (1973), *Mama, Ich lebe* (1976) and *Solo Sunny* (also co-director, 1979). After Wolf's death Kohlhaase scripted two documentaries (*Konrad Wolf*, Gitta Nickel, 1977; *Die Zeit, die bleibt. Ein Film über Konrad Wolf*, Lew Hohmann, 1985) and worked with Frank Beyer* (*Der Aufenthalt*, 1982, *Der Bruch*, 1985). Belonging to the GDR elite, he frequently travelled to the West, and in 1984 adapted one of his own radio plays into the script for Bernhard Wicki's* *Die Grünstein-Variante*. MW

KORTNER, Fritz Vienna 1892 – Berlin 1970

Austrian-born German actor and director, who appeared in films from 1915 and became a star in F. W. Murnau's* *Satanas* (1920), Reinhold Schünzel's* *Katharina die Große/Catherine the Great* (1920), Carl Froehlich's* *Die Brüder Karamasoff/The Brothers Karamasov* (1920) and Paul Leni's* *Hintertreppe/Backstairs* (1921, co-dir. Leopold Jessner). His virtuoso acting and use of changing facial expressions were best demonstrated as Dr Schön in G. W. Pabst's* *Die Büchse der Pandora/Pandora's Box* (1929), which made him one of the foremost German screen personalities. With the coming of sound, Kortner impressed with his voice in E. A. Dupont's* *Atlantic/Atlantik* (1929) and *Menschen im Käfig/Cape Forlorn* (1930), both multi-language films shot in Britain. Attacked by the Nazi press for being Jewish, Kortner emigrated to London. In 1941 he settled in Hollywood as a scriptwriter and character actor in films mostly with anti-fascist subjects (*The Strange Death of Adolf Hitler*, 1943; *The Hitler Gang*, 1944; *Berlin Express*, 1948). A naturalised American citizen since 1947, Kortner returned to Germany the same year to appear in Josef von Baky's* *Der Ruf/The Last Illusion* (1949). He soon regained his prewar prestige as an actor and director for cinema, theatre and television. MW

Bib: Walter Kaul and Robert G. Scheuer (eds), *Fritz Kortner* (1970).

Other Films Include: *Manya, die Türkin, Im Banne der Vergangenheit* (1915); *Der Märtyrer seines Herzens* (1918); *Die Nacht der Königin Isabeau* (1920); *Beethoven, Maria Stuart* (1927, two parts); *Dreyfus* (1930); *Danton, Der Mörder Dimitri Karamasoff, Der brave Sünder* (1931); *Abdul the Damned* (1935, UK); *The Razor's Edge* (1946, US); *Sarajewo* (1955).

KRACAUER, Siegfried
Frankfurt 1889 –
New York 1966

German theorist, who published on a wide range of cultural phenomena. Between 1920 and 1933 Kracauer was also one of Weimar Germany's major film critics and cultural affairs editor of the renowned *Frankfurter Zeitung*. Kracauer was the first to analyse film from a sociological perspective, grounded on his extensive research in problems of epistemology (*Soziologie als Wissenschaft*, 1922) and class analysis (*Die Angestellten*, 1930). He left Germany for Paris in March 1933, and in 1941 fled occupied France to settle in the US. A commission to analyse Nazi film propaganda (*Propaganda and the Nazi War Film*, 1942) led to a comprehensive psychological history of German film, the influential *From Caligari to Hitler* (1947), which argues that changes in style and content of Weimar* cinema resulted from changes in the psychological disposition of the nation's key social formation, the middle-class male. Frequently criticised for rigidity of method and selectivity of evidence, *From Caligari to Hitler* has nonetheless remained the classic account of the relationship between film and society in general.

Kracauer's *Theory of Film: The Redemption of Physical Reality* (1960) may one day claim the same position in the development of film theory*, but his posthumously published book on photography and history (*History: Last Things Before the Last*, 1967) has also renewed interest in his work. TE/MW

Bib: Michael Kessler and Thomas Y. Levin (eds), *Siegfried Kracauer* (1992).

KRÄLY, Hanns [US: KRALY, Hans]
Hamburg 1895 –
Los Angeles, California 1950

German scriptwriter, who worked with Ernst Lubitsch* on all his German films and later followed him to Hollywood. His comic effects and brilliant dialogue full of Berlin humour contributed greatly to the erotic charm of Lubitsch's early Ossi Oswalda* and Pola Negri* pictures as well as to the sophisticated flair of Warner comedies such as *Three Women* (1924), *So This Is Paris* (1926) and *The Patriot* (1928). The collaboration with Lubitsch ended with *Eternal Love* (1929), and Kräly subsequently worked as the scenarist for Jacques Feyder's* *The Kiss* (1929) and co-wrote the story for Henry Koster's *It Started With Eve* (1941), before retiring in 1943. MW

KRAUSS, Werner
Gestungshausen 1884 –
Vienna 1959

German actor, who entered the film business early in 1916 and appeared in popular genres such as sex education films (*Aufklärungs-filme*), detective stories, and melodramas. Krauß' fame began with Robert Wiene's* *Das Cabinet des Dr Caligari/The Cabinet of Dr Caligari* (1920), where he played the (mad?) Dr Caligari. Although in many of his subsequent roles he continued to portray enigmatic and troubled figures (as in the Freudian melodrama *Geheimnisse einer Seele/Secrets of a Soul*, 1926), Krauß' various parts as the depressive gate-keeper in *Scherben/Shattered* (1921), Jack the Ripper in *Das Wachsfigurenkabinett/Waxworks* (1924), Scapinelli in *Der Student von Prag/The Student of Prague* (1926), and the lecherous butcher in *Die freudlose Gasse/Joyless Street* (1925) show a commendable range and resist typecasting. He also appeared as Count Muffat in Jean Renoir's *Nana* (1926). A favourite actor of G. W. Pabst* and one of the most typical faces of the Weimar* cinema, he remained prominent during the Nazi era, playing a leading role in the infamous *Jud Süss/Jew Süss* (1940, dir. Veit Harlan*). The three films he starred in after the war were unremarkable. MW

Bib: Wolfgang Goetz, *Werner Krauß* (1954).

KRUG, Manfred
Duisburg 1937

German actor. A steelworker from the Ruhr and talented jazz and cabaret singer who went to drama school in Berlin and belonged to Bert Brecht's Berliner Ensemble until 1957, he began his career in film with realistic interpretations of socially marginalised, often semi-criminal teenagers in the years of (East-)Germany's recovery. It was director Frank Beyer*, who freed him from this persona and entrusted Krug with the role of the quietly courageous Polish internationalist Oleg, who fights in the Spanish Civil War and serves the cause of international solidarity (*Fünf Patronenhülsen*, 1960).

His real breakthrough, as an anti-authoritarian ideal for younger people, came two years later with the satirical comedy *Auf der Sonnenseite* (1962), where he played the lead as a spirited and rebellious ex-steelworker, and for which he wrote the (largely autobiographical) script. In the following years, Krug built on his great popular success in several historical spectacles. Witty dialogues and numerous action sequences gave him the opportunity to show off his dark, smoky voice as well as his athletic abilities (*Mir nach Canaillen!*, 1964; *Die gestohlene Schlacht*, 1972). He continued to embody the non-conformist prole as the construction worker Balla in Beyer's *Spur der Steine* (1966), as a trucker in *Weite Straßen, Stille Liebe* (1969) and *Wie*

füttert man einen Esel? (1973). When in 1976 'the only world-class GDR-star', as he was called, protested against the expulsion of his friend, the poet Wolf Biermann, an adaption of Kleist's 'Michael Kohlhaas' in which he had the title role was withheld from exhibition, and he left the GDR for the West in June 1977, continuing his career as one of Germany's most successful television actors. First continuing his former screen image as a rebellious trucker in the TV series *Auf Achse/On the Road* (1977–79 and 1983), he has turned to socially more settled characters in *Detektivbüro Roth* (1983/84), *Tatort* (since 1984) culminating in his role as the lawyer Liebling in *Liebling Kreuzberg* (1985/86 and 1994). MW

Bib: Heiko R. Blum, *Manfred Krug: Seine Filme, sein Leben* (1993).

Other Films Include: *Mazurka der Liebe* (1957); *Vergeßt mir meine Traudel nicht* (1957); *Leute mit Flügeln* (1960); *Königskinder* (1962); *Beschreibung eines Sommers* (1962); *Wenn du groß bist, lieber Adam* (1965); *Abschied* (1968); *Das Versteck* (1977); *Der Blaue* (1994).

KRÜGER, Hardy Eberhard Krüger; Berlin 1928

German actor, with an international reputation. While still at school, Krüger was chosen to play in the propaganda film *Junge Adler* (1944). His first postwar film was *Diese Nacht vergeß' ich nie* (1949). Typecast as an easy-going teenager, he seemed unable to make his mark until *Solange du da bist* (1953). Dissatisfied with offers from German directors, he sought work abroad. His international career, unusually for a German actor, began in 1956 with the British war film *The One That Got Away* (1956). Under the direction of Joseph Losey, Howard Hawks, Robert Aldrich and Richard Attenborough*, he profiled himself as an experienced character actor, often portraying taciturn, strong-minded protagonists. From 1961 onwards, Krüger occasionally worked as producer and director of nature and wildlife documentary films, but seems to have kept aloof from the next generation, since he appeared only once in a film of the New German Cinema*. TE/SG

Other Films Include: *Blind Date/Chance Meeting* (1959, UK); *Hatari!* (1960, US); *Les Dimanches de Ville d'Avray* (1962, Fr.); *The Flight of the Phoenix* (1965, US); *Barry Lyndon* [UK], *Potato Fritz* (1975); *A Bridge Too Far, The Wild Geese* (1977, both UK); *Blue Fin* (1979, Australia).

KUBELKA, Peter Vienna 1934

Austrian director, who studied film at the *Akademie für Musik und darstellende Kunst* in Vienna and at the *Centro Sperimentale* in Rome.

155

Kubelka made his first film, *Mosaik im Vertrauen* (1955), in collaboration with Ferry Radax, before he developed in *Adebar* (1957), *Schwechater* (1958) and *Arnulf Rainer* (1958–60) what he called '*Metrischen Film*' ('metric film'), a radical technique that at times reduces the image to black and white abstract frames, anticipating later structuralist films. But his works are also very much *sound* films, and the soundtrack of *Arnulf Rainer* cannot be 'turned off' any more than its images, whose 'rhythm' is intended to penetrate even closed eyelids. The apparently more realistic *Unsere Afrikareise* (1961–66) is also built on a complex montage structure. Here, images record multiple 'systems' – white hunters, natives, animals, buildings – in a manner that preserves their individuality, but at the same time the editing of sound and image brings these systems into comparison and collision. In *Pause!* (1975–77), the artist Arnulf Rainer is once again the source of the film's imagery. Since the mid-1990s Kubelka has been working on *Denkmal für die alte Welt*. Kubelka's complete works, elaborated over twenty-five years, would not run for much longer than an hour. He was co-founder of the Austrian Film Museum in 1964 and assistant film librarian at the UN archive in New York. He is a member of the New York Film-makers Cooperative. MW

Bib: Christian Lebrat, *Peter Kubelka* (1990); Gabriele Jutz/Peter Tscherkassy (eds), *Peter Kubelka* (1995).

for DEFA

L

LAMPRECHT, Gerhard Berlin 1897–1974

German director, who in the 1920s and 1930s was one of the mainstays of middle-class, middle-brow commercial cinema. Lamprecht's debut as director with *Es bleibt in der Familie* (1920) already revealed the theme connecting his oeuvre across different genres and political eras: a feel for characters in their social environment. He came to prominence as the adapter of Thomas Mann's *Die Buddenbrooks* (1923), but broke new ground with a number of *Problemfilme* ('social problem films') set in Berlin, also known as '*Milljöh*' or '*Zille*' films. For the Nazi regime he directed melodramas (*Barcarole*, 1935; *Die Geliebte*, 1939) and a biopic (*Diesel*, 1942). But Lamprecht remained a liberal with socialist sympathies, and after World War II he worked for DEFA*, making one of the best-known *Trümmerfilme* 'ruin films' (*Irgendwo in Berlin/Somewhere in Berlin*, 1946). Intimate knowledge of Berlin is also the strength of his masterpiece, an adaptation of Erich

Kästner's famous childrens' book *Emil und die Detektive/Emil and the Detectives* (1931).

From 1955 onwards, Lamprecht concentrated on his second career as a film historian and archivist: between 1962 and 1966 he ran the Deutsche Kinemathek (later Stiftung Deutsche Kinemathek), and between 1967 and 1970 compiled a ten-volume catalogue of German silent films (1903–31) which has remained the standard reference work for the period. TE/KU

Other Films Include: *Frauenbeichte* (1921); *Menschen untereinander* (1926); *Der schwarze Husar* (1932); *Der Spieler* (1938); *Meines Vaters Pferde* (1954).

LANG, Fritz
Vienna 1890 – Beverly Hills, California 1976

German director, whose exceptional career in German and American cinema (with a short episode in France) spanned silent and sound film. Lang began as a scriptwriter for Joe May's* company, where he met his future wife and collaborator Thea von Harbou*. Joining Erich Pommer's* Decla in 1917 as a director, Lang applied a style at once austere and lyrical to romantic, sentimental, sensationalist and fantastic story material: *Der müde Tod/Destiny* (1921), *Die Nibelungen* (1924, two parts), *Metropolis* (1927), *Spione/The Spy* (1928). In his first German period (1919–33) he wrote most of his scripts, usually in collaboration with von Harbou. *Dr Mabuse, der Spieler/Dr Mabuse, the Gambler* (1922, two parts) is notable for its attempt to represent psychological processes filmically (in Mabuse's hypnotism of his victims); *Metropolis* (1927), the futuristic tale of a repressive technocratic society, is renowned for its special effects, its extravagant sets and even more extravagant budget, which caused financial difficulties for Ufa*, while *M – Eine Stadt sucht ihren Mörder/M* (1931) subverts the conventional detective thriller by developing a deep psychological portrait of a serial killer and child molester. *Das Testament des Dr Mabuse/The Testament of Dr Mabuse* (1933) was banned by the Nazis and Lang emigrated to France, where he directed *Liliom* (1934, starring Charles Boyer) before moving on to Hollywood.

Despite the success of his first American film, *Fury* (1936), Lang experienced some of the classic difficulties of European directors in Hollywood. Nevertheless he managed to build up a substantial career in America, working in different studios and genres, usually against established conventions. This is most noticeable in his Westerns: *The Return of Frank James* (1940), *Western Union* (1941) and especially *Rancho Notorious* (1952, with Marlene Dietrich*). He also contributed to the costume drama (*Moonfleet*, 1955) and the war film (*American Guerrilla in the Philippines*, 1950). His American career, however, is distinguished by his mastery of *film noir*, with films such as

Secret Beyond the Door... (1948; his most underrated American film), *The Blue Gardenia* (1953), *The Big Heat* (1953) and the astonishingly Pirandellian *Beyond a Reasonable Doubt* (1956).

In 1958 Arthur Brauner invited Lang back to Germany to direct *Der Tiger von Eschnapur/The Tiger of Bengal* and *Das indische Grabmal/The Indian Tomb* (1959). Lang accepted, not least because he and von Harbou had written the script in 1920 for Joe May, who, breaking their agreement, had directed it himself. Another return to his earlier work, *Die 1000 Augen des Dr Mabuse/The 1000 Eyes of Dr Mabuse* (1960), concluded his work, although his final film gesture was to appear, as himself, in Jean-Luc Godard's *Le Mépris/Contempt* (1963). WB

Bib: Stephen Jenkins (ed.), *Fritz Lang: The Image and the Look* (1981); Patrick McGilligan, *Fritz Lang – The Nature of the Beast: A Biography* (1997).

Other Films Include: *Die Spinnen/The Spiders* (two parts: 1919 and 1920); *Die Frau im Mond/Woman on the Moon* (1929). **In the US**: *You Only Live Once* (1937); *Man Hunt* (1941); *Hangmen Also Die!* (1943); *Ministry of Fear, The Woman in the Window* (1944); *Scarlet Street* (1945); *Clash By Night* (1952); *While the City Sleeps* (1956).

LEANDER, Zarah
Karlstadt, Sweden 1907 –
Stockholm 1981

Swedish-born German actress and singer, who, after the departure of Marlene Dietrich*, became the German cinema's most famous *femme fatale*. After *Premiere* (1937), her first German-language film, proved a popular success, Leander signed a long-term contract with Ufa*. Her persona was crucially shaped in the films directed by Detlef Sierck* [Douglas Sirk] (*La Habanera, Zu neuen Ufern/To New Shores*, both 1937), melodramas in which a woman is ready to sacrifice herself for either man or child. Leander became, during the Nazi era, a highly paid icon of dangerous allure and female sophistication. She was both a composite of Hollywood glamour queens and a curiously 'Mediterranean' screen goddess. Irked by official disapproval (Hitler twice vetoed her nomination as 'state actress'), she broke her Ufa contract and returned to Sweden in 1943. Unable to resume her film career in postwar Germany, Leander made a modest comeback on stage, performing songs from her old films. TE/SG

Bib: Cornelia Zumkeller, *Zarah Leander: Ihre Filme, ihr Leben* (1988).

Other Films Include: *Heimat, Der Blaufuchs* (1938); *Es war eine rauschende Ballnacht, Das Lied der Wüste* (1939); *Der Weg ins Freie*

(1941); *Die große Liebe* (1942); *Cuba Cabana* (1952); *Ave Maria* (1953); *Bei dir war es immer so schön* (1954).

LENI, Paul Stuttgart 1885 – Hollywood, California 1929

German director and set designer. A trained graphic artist and stage designer for Max Reinhardt*, Leni started his film career as a painter of film posters and then as set designer for Joe May*. Making his directorial debut with an impressive war melodrama (*Der Feldarzt/Das Tagebuch des Dr Hart*, 1918), Leni continued to design the sets for big-budget productions at Ufa*. He co-directed and designed the *Kammerspielfilm* *Hintertreppe/Backstairs* (1921, script Carl Mayer*, co-dir. Leopold Jessner), which owes much of its atmosphere and visual power to his sets. Always an experimenter, he also worked with Guido Seeber* on semi-abstract shorts in the mid-1920s.

Early in 1922 Leni founded his own production company whose first venture was the menacing horror film *Das Wachsfigurenkabinett/ Waxworks* (1924), which he directed himself, featuring Emil Jannings*, Conrad Veidt* and Werner Krauß*. A huge success and one of Weimar* cinema's enduring classics, *Das Wachsfigurenkabinett* earned Leni an invitation from Carl Laemmle to Hollywood, where he proved his visual flair for a new kind of horror film as the director of *The Cat and the Canary* (1927) and *The Man Who Laughs* (1928), before his career was abruptly cut short by a fatal case of blood poisoning. MW

Bib: Hans-Michael Bock (ed.), *Paul Leni: Grafik, Theater, Film* (1986).

Other Films Include: *Prima Vera, Dornröschen* (1917); *Die platonische Ehe, Prinz Kuckuck* (1919); *Die Verschwörung zu Genua* (1921); *The Last Warning* (1929, US).

LEUWERIK, Ruth Ruth Leeuwerik; Essen 1924

German actress, who embodied the maternal ideal of the 1950s. Leuwerik's film career began in 1950 with *13 unter einen Hut*, establishing her as the mature and sensible companion whose passions are kept well hidden. In a period of social reconstruction, in need of moral uplift, she became (together with Maria Schell*) the most popular female star of the next two decades. At first teamed with the discreet and straightforward Dieter Borsche in family dramas (*Vater braucht eine Frau*, 1952) and comedies of manners (*Königliche Hoheit*, 1953), she formed the ideal couple with O. W. Fischer (*Bildnis einer Unbekannten*, 1954). Her biggest international success came with *Die Trapp-Familie/The Trapp Family* (1956) and *Die Trapp-Familie in*

Amerika (1958), in which she convincingly moved from gracious nun to elegant aristocrat. The decline of the star system in the 1960s took Leuwerik 'down-market' (*Und Jimmy ging zum Regenbogen*, 1970) and into routine literary adaptations (*Unordnung und frühes Leid*, 1977, based on Thomas Mann). TE/KU

LIEBENEINER, Wolfgang Liebau, Schlesien 1905 – Vienna 1987

German actor, director and producer. From 1931, Liebeneiner played romantic screen lovers (in among other films, Ophuls'* *Liebelei*, 1933), and in 1937 he directed his first feature (*Versprich mir nichts!*). Although not a Party member, Liebeneiner held high office in the state bureaucracy and Nazi cultural life, becoming professor and director of the film academy as well as governor of the Reichs-filmkammer. His visual flair and professionalism served him on his propaganda assignments such as *Bismarck* (1940) and (as director and co-author) the notorious pro-euthanasia film *Ich klage an* (1941). Liebeneiner continued directing after the war, claiming he had used his position to protect opponents of the regime. As a key figure of Germany's postwar genre cinema (*Liebe 47*, 1949; *Die Trapp-Familie/ The Trapp Family*, 1956; *Schwejks Flegeljahre*, 1964), Liebeneiner personified the continuities between late Weimar*, Nazi and postwar German cinema in all their ambiguities. TE/KU

Other Films Include: *Der Florentinerhut* (1939); *Auf der Reeperbahn nachts um halb eins* (1954); *Eine Frau für's ganze Leben* (1960); *Götz von Berlichingen* (1979).

LIEBMANN, Robert Berlin 1890 – [?]

German scriptwriter. Before writing screenplays for Richard Oswald* in 1919, Liebmann worked with directors as different as Ludwig Berger*, Reinhold Schünzel*, Max Mack*, Georg Jacoby* and Harry Piel*. Liebmann became chief script adviser for Erich Pommer's* unit at Ufa* in April 1929. His first sound film, the Lilian Harvey*–Willy Fritsch* comedy *Liebeswalzer* (1930), was a huge national and international success, giving rise to a wave of film operettas. With Carl Zuckmayer and Carl Vollmöller, Liebmann wrote perhaps the most famous Weimar sound film, *Der blaue Engel/The Blue Angel* (Josef von Sternberg, 1930). Equally adept at turning out thrillers (Robert Siodmak's* *Voruntersuchung*, 1931) or historical dramas (*Yorck*, 1931) Liebmann was nevertheless sacked by Ufa in March 1933 for being Jewish. He emigrated to Paris, where he adapted a Molnar play for Fritz Lang* (*Liliom*, 1934) and wrote *Carrefour* (1938, dir. Kurt

Bernhardt*) and *Lumières de Paris* (1938, Richard Pottier). Little is known about his fate during or after the war. MW

LIEDTKE, Harry
Königsberg, 1882 –
Bad Saarow-Pieskow 1945

German actor of enormous popularity during the 1910s and 1920s. Like most German film actors, Liedtke's debut was on stage, switching to the cinema in 1912. Like his female partner Henny Porten*, Liedtke began, with *Die Rache ist mein*, at Oskar Messter's* studio. His well-mannered and elegant youthful lovers varied only little through the years and genres, perfectly fitting the image of the ideal husband and son-in-law. Liedtke's star vehicles nonetheless played on bourgeois fantasies of otherness, in order to celebrate conformity: a criminal that turns out not to be one (*Der Mann ohne Namen*, 1921) a soldier whose main weapon is charm (*Liebe und Trompetenblasen*, 1925), a bohemian who is not anti-social (*Robert und Bertram*, 1928) and an impecunious nobleman rich in social graces (*Die Zirkusprinzessin*, 1929). In contrast to the daredevil Harry Piel*, Liedtke is the embodiment of the conservative masking as happy-go-lucky adventurer. Ernst Lubitsch* took Liedtke's persona ad absurdum as early as 1919, as if Liedtke's Prinz Nucki in *Die Austernprinzessin* was already the parody of *Die Zirkusprinzessin*, made ten years later. At first, Liedtke did not seem to survive the transition to sound, either as youthful lover or as a voice audiences warmed to, but the 1940s saw him make a comeback as fatherly figure and greying-at-the-temples philandering dandy (*Sophienlund*, 1943). KU

Other Films Include: *Der Amateur* (1916); *Madame Dubarry* (1919); *Die Finanzen des Großherzogs* (1923); *Der Bettelstudent* (1927); *Delikatessen* (1930); *Nie wieder Liebe* (1931); *Die Stadt Anatol* (1936); *Das Konzert* (1944).

LINDTBERG, Leopold
Vienna 1902 – Sils Maria 1984

Austrian-born director and actor, who worked in both capacities in Germany under Wilhelm Dieterle*, Erwin Piscator and Leopold Jessner, but left for Zurich after the Nazis came to power in 1933. Alternately working for the stage, mainly at the Zurich Schauspielhaus, and for the cinema, he was associated for twenty years with the leading Swiss film producer of the time, Lazar Wechsler*. At Wechsler's Praesens-Film, Lindtberg became Switzerland's most prolific and popular director, with a number of dialect films and literary adaptations to his name. *Jä-soo!* (1935) is representative of the first category, with its fairly primitive *mise-en-scène* successfully put to the service of a cast of popular actors from the Zurich cabaret, Lindtberg

apparently wishing to do for Zurich what Marcel Pagnol was doing for Marseilles. Among his more ambitious, mostly literature-based films are *Füsilier Wipf* (1938), *Wachtmeister Studer* (1939), *Landammann Stauffacher* (1941), *Die mißbrauchten Liebesbriefe* (1942, awarded a prize at the Venice festival), *Der Schuß von der Kanzel* (1942), and *Matto regiert* (1947), which brought in remarkable box-office profits for Wechsler's company Praesens-Film and gave the Swiss film industry a hitherto unknown economic upswing. *Füsilier Wipf*, a national(ist) epic set during World War I but released in the threatening immediate pre-World War II years, was the greatest Swiss box-office hit ever (in Switzerland), and, in Hervé Dumont's words, 'a veritable catalogue of the ideas of the "spiritual defence of the nation"'. This notion, which would come into full force in 1939, was part of a federal government-sponsored cultural propaganda effort designed to promote a strong, unified sense of 'Swissness' in the face of the war threat, based on regionalism, on the literary heritage and on the army. At the end of the film, Wipf, turned into a man by the army, accepts his true place as the 'ideal Swiss' on a mountain farm, with his demure fiancée. *Die letzte Chance/The Last Chance* (1944–45, perhaps Lindtberg's most accomplished film) was a humanitarian story about a group of Jewish refugees seeking asylum in Switzerland, and a huge international success which shifted Praesens-Film towards an international strategy, to which also belong Lindtberg's less successful last three films, *Swiss Tour* (1949), *Die Vier im Jeep/Four in a Jeep* (1951) and *Unser Dorf/The Village* (1953). After leaving Praesens-Film in 1958, Lindtberg turned again to the stage and also made successful series for German, Austrian and Swiss television in the 1960s and 1970s. MW

Bib: Hervé Dumont, *Leopold Lindtberg et le cinéma suisse 1935–53* (1975).

LINGEN, Theo
Franz Theodor Schmiz;
Hanover, 1903 – Vienna, 1978

German actor and director, mainly known for his comic performances on stage and screen. After several years of theatre experience Lingen had his film debut in the musical comedy *Dolly macht Karriere* (1930). This booming genre of the early sound era gave him the opportunity to successfully create his own eccentric style of acting by combining the grotesque slapstick of the silent era with a distinct nasal voice and staccato delivery. With parodic distance and Prussian aloofness Lingen embodied tragi-comical dandies or petit-bourgeois pedants. One of his most notable creations was the valet *Johann* (1943), a typical example of the subordinate keeping his superior dignity through formal and stylised behaviour. From the 1950s onwards, Lingen appeared in less sympathetic or complex comic roles in a number of

remakes and serial films (*Der Mustergatte*, 1956; *Die Lümmel aus der ersten Bank*, 1968–71). As the director of *Till Eulenspiegel* (1936), he showed an underused talent for revues and musical numbers. KU

Bib: Willibald Eser, *Theo Lingen: Komiker aus Versehen* (1968).

Other Films Include: *Ein toller Einfall* (1932); *Ich kenn' Dich nicht und ich liebe Dich nicht* (1934), *Das Fräulein von Barnhelm* (1940); *Der Theodor im Fußballtor* (1950).

LIST, Niki Vienna 1956

Austrian director, who started with short films. His first feature, *Malaria* (1982), was a huge box-office success; it won the Max Ophuls Prize in 1983 and the Austrian Film Prize in 1984. This stylish '*Zeitgeist*' parody about a fashionable meeting place ('Café Malaria') and its eccentric customers was followed by *Mama lustig ... ?* (1984), a direct, sensitive documentary portraying a boy who suffers from Down's syndrome. In 1992 List continued this project with *Muß denken*. His *Müller's Büro* (1986), a *film noir*-comedy-musical, was again a box-office hit; it too received the Austrian Film Prize as well as the Golden Ticket (reward for commercial success) in 1986. List has also worked for television and as a press photographer. IR

Other Films Include: *Sternberg Shooting Star* (1988); *Werner Beinhart* (1990, Ger., co-dir.).

LITERATURVERFILMUNG

German generic term denoting literary adaptations. Although the first film adaptation of classical German literary material dates back to a treatment of Schiller's *Die Räuber* (February 1907), the term *Literaturverfilmung* emerged only with some delay after similar practices in France, Italy or the US, during the time of the *Autorenfilme**. In 1913 alone 21 adaptations of classics and another 37 films based on original scripts by well-known authors were produced, representing 17% of that year's total output. From the very beginning, these adaptations caused irritation by the clash between the perceived cultural superiority of literature and the cinema as a visual/techno-logical medium. Whichever way the opposition was argued, almost every new adaptation revived the same debate, showing that it was symptomatic of a wider struggle over the cultural value and social hiearchy among competing art forms and their institutional prestige. Originating in the years before World War I in the context of the Kino reform movement*, the controversy remained fixed around the high culture/low medium opposition well into the 1960s, a sign of the strong

163

continuity (i.e. sound financial basis and audience preference) of the genre through all periods of German cinema.

Showing comparable perseverance to its critics, the film industry countered public scepticism about literary adaptations and assured their box-office success, by pairing well-known literary source material with popular or prestigious actors, mostly drawn from the theatre (Paul Wegener*, Albert Bassermann, Asta Nielsen* in the 1910s, Fritz Kortner*, Emil Jannings*, Werner Krauss*, Rudolf Klein-Rogge*, Elizabeth Bergner* in the 1920s, Heinrich George*, Gustaf Gründgens*, Fritz Rasp*, Adele Sandrock*, Carl Raddatz*, Martin Hellberg in the 1930s and 40s, Ruth Leuwerik* in the 1950s, Bruno Ganz*, Klaus Maria Brandauer*, Barbara Sukowa*, Edith Clever in the 1970s and 1980s).

During the silent era, from 1912 to 1929, over 230 works of the German literary canon have been adapted for the cinema, including classics by Büchner (*Danton*, 1921), Eichendorff (*Der Taugenichts/ The Good-for-Nothing*, 1922); Goethe (*Erlkönig's Töchter*, 1914; *Faust*, 1926), E. T. A. Hoffmann (*Hoffmann's Erzählungen/Tales of Hoffmann*, 1916), Lessing (*Nathan, der Weise/Nathan the Wise*, 1923), Schiller (*Die Verschwörung zu Genua/The Genoa Conspiracy*, 1921; *Luise Millerin*, 1922), Storm (*Zur Chronik von Grieshuus/The Chronicle of the Grey House*, 1925) as well as from modern and contemporary writers such as Gerhart Hauptmann (*Rose Bernd*, 1919; *Hanneles Himmelfahrt/Hannele's Trip to Heaven*, 1922; *Phantom*, 1922; *Die Weber/The Weavers*, 1927), Arthur Schnitzler (*Fräulein Else*, 1929), Frank Wedekind (*Lulu*, 1917; *Erdgeist/Earth Spirit*, 1923; *Die Büchse der Pandora/Pandora's Box*, 1929), or Carl Zuckmayer (*Schinderhannes*, 1928; *Katharina Knie*, 1929). Notwithstanding the screen adaptations of foreign authors, (e.g. Dostoevsky – *Die Brüder Karamasoff/The Brothers Karamazov*, 1920; *Raskolnikow*, 1923), Mérimée (*Carmen*, 1918), Molière (*Tartüff*, 1925), Shakespeare (*Hamlet*, 1921; *Othello*, 1922; *Der Kaufmann von Venedig/The Merchant of Venice*, 1923; *Ein Sommernachtstraum/A Midsummer Night's Dream*, 1925), Stendhal (*Vanina*, 1922), R. L. Stevenson (*Der Januskopf/Janus Head*, 1920), Bram Stoker (*Nosferatu – Eine Symphonie des Grauens*, 1921), Strindberg (*Rausch/Intoxication*, 1919; *Fräulein Julie*, 1922), Tolstoy (*Anna Karenina*, 1920), *Literaturverfilmungen* fulfil one central task of a national cinema, namely the confirmation of normative values and a shared geographical-historical heritage across the inter-media exchange between two cultural institutions. That this goal, coupled with the profit motif, cares little about authorship, intentionality and aesthetic autonomy was notoriously documented in the case of Pabst's* adaptation of Brecht/Weill's *Die Dreigroschenoper/The Threepenny Opera* (1931).

While the transition to sound (and the new prominence of the spoken word) brought no substantial paradigmatical shift in the industry's basic strategy, choice of literary sources or to the critical protest around literary adaptations, it was nonetheless the case that after the

Nazis' rise to power in 1933, German literature displayed a penchant for 'nordic' authors, such as Henrik Ibsen (*Peer Gynt*, 1934; *Stützen der Gesellschaft/Pillars of Society*, 1935; *Ein Volksfeind/An Enemy of the People*, 1937; *Nora*, 1944), Knut Hamsun (*Viktoria*, 1935), Selma Lagerlöf (*Das Mädchen vom Moorhof/The Girl from the Marsh Croft*, 1935) or Hermann Sudermann (*Der Katzensteg/The Cat Walk*, 1937; *Heimat/Homeland*, 1938; *Die Reise nach Tilsit/The Journey to Tilsit*, 1939; *Johannisfeuer/St John's Fire*, 1939), as well as for regional writers or *Heimatdichter*, such as Ludwig Ganghofer (*Schloss Hubertus/Castle Hubertus*, 1934; *Der Edelweisskönig/The Edelweiss King*, 1938), Ludwig Anzengruber (*Doppelselbstmord/Double Suicide*, 1937), Ludwig Thoma (*Waldfrieden/Forest Quiet*, 1936) and Gottfried Keller (*Regine*, 1934; *Kleider machen Leute/Clothes Make the Man*, 1940). Oddly enough, an author like Oscar Wilde was also repeatedly adapted (*Ein idealer Gatte/An Ideal Husband*, 1935; *Lady Windermeres Fächer/Lady Windermere's Fan*, 1935; *Eine Frau ohne Bedeutung/A Woman of No Importance*, 1936), suggesting that the focus of most film historians may have been somewhat skewed, when they argue that literary adaptation in the Nazi years was mostly determined by the ideological appropriation of the national classics, from Lessing (*Das Fräulein von Barnhelm*, 1940) via Schiller (*Wilhelm Tell*, 1934; *Friedrich Schiller*, 1940) and Kleist (*Amphitryon*, 1935; *Der zerbrochene Krug/The Broken Jug*, 1937), to Storm (*Der Schimmelreiter/The Rider on the White Horse*, 1934; *Pole Poppenspäler*, 1935; *Immensee*, 1943), Fontane (*Ball im Metropol*, 1937; *Der Schritt vom Wege/Effi Briest*, 1939) and Hauptmann. Just as pronounced is the (ideologically pliable) transformation of motifs found in contemporary popular authors, e.g. Hanns Heinz Ewers* (*Hans Westmar*, 1933), Thea von Harbou* (*Das indische Grabmal* and *Der Tiger von Eschnapur/The Indian Tomb* and *The Tiger of Bengal*, 1938), Norbert Jacques* (*Die drei Smaragde/The Three Emeralds*, 1939; *Friedrich Schiller*, 1940), Walter von Molo (*Fridericus*, 1936; *Der unendliche Weg/The Neverending Road*, 1943), or Heinrich Spoerl (*So ein Flegel/Such a Lout*, 1934; *Wenn wir alle Engel wären/If We All Were Angels*, 1936; *Der Maulkorb/The Muzzle*, 1938; *Die Feuerzange-bowle*, 1944), all of which yielded profitable, popular comedies and melodramas. In 1935, for instance, c. 50% of German cinema relied on literary sources; after 1937 this number decreased dramatically, to an average of only 5% until 1945, suggesting the changing character of Nazi entertainment cinema as a propaganda tool in the run-up to and during the war.

From 1945 until the mid-1960s, in East and West Germany, the classics from Goethe to Fontane, and from Thomas Mann to Zuckmayer continued to be made into films, often for the third or fourth time in as many decades. More polemical writers such as Heinrich Mann remained the exceptions (*Der Untertan/The Subject*, W. Staudte*, 1951), with popular detective fiction or boys-own classics heading the list (cf. the hugely successful *Edgar Wallace* (1959–72) and *Karl May*

(1962–68) film series [> GERMAN CINEMA], followed by the hardy perennials of entertainment literature and romance, worked into rural comedies, *Heimatfilme** and costume dramas.

Around 1965, a major shift of accent can be made out within German literary adaptations, less in the choice of authors (the mix of classics, popular authors, and contemporary writers remaining broadly the same in every period, indicative of the different target audiences). What changed with the advent of the New German Cinema* was a new self-confidence of the director as author, claiming a certain independence vis à vis the literary source, and thus not afraid to give 'interpretations' of a literary text, without any pretence at rendering its essence in a more transparent or accessible medium. This is true of avant-garde directors like Jean-Marie Straub/Danièle Huillet (e.g. *Nicht versöhnt/Not Reconciled,* 1965 after Heinrich Böll; *Klassenverhältnisse/ Class Relations,* 1984, after Kafka) and Werner Nekes (*Uliisses*, 1983), writers like Kluge* and Herbert Achternbusch, filming their own work, and Fassbinder*, Herzog*, Reitz*, Sanders-Brahms*, Syberberg*, Rudolf Thome, Wenders*, all of whom have adapted literary works by imparting to them their own particular signature. If anything, the distanced, reflexive and historicising approach to literary texts was even stronger among GDR directors such as Wolf* (e.g. *Der geteilte Himmel,* 1964; *Goya,* 1971), Beyer* (e.g. *Spur der Steine,* 1966; *Jakob, der Lügner,* 1974), Egon Günther (e.g. *Lotte in Weimar,* 1975; *Die Leiden des jungen Werthers,* 1976), Ralf Kirsten (*Der verlorene Engel,* 1971; *Die Elixiere des Teufels,* 1973) or Hermann Zschoche (e.g. *Glück im Hinterhaus/Happiness in the Back,* 1980). A special case perhaps is Volker Schlöndorff*, whose entire oeuvre might be said to revolve around and redefine the relation of the contemporary film-maker to the literary author, having adapted among others Kleist, Musil, Proust, Brecht, Frisch, Miller, Tournier, and scoring his greatest success with an adaptation of Günter Grass (e.g. *Die Blechtrommel/The Tin Drum,* 1979).

The late 1980s and early 1990s, conscious of the intertextual spaces opened up by these directors, have produced literary adaptations such as Werner Schroeter's *Malina* (1991, after a novel by Ingeborg Bachmann), which go beyond either co-opting the literary heritage for market shares, or historically distancing and thus actualising an important classic, but draw inspiration from literature for formal challenges within the filmic medium itself. By contrast, the same period also saw a number of high-quality, often TV-financed adaptations, such as those of Franz Seitz (*Doktor Faustus,* 1982; *Erfolg,* 1992), whose purpose is precisely to get an easy ride on the back of an already assured literary reputation. In terms of box-office, however, the most successful adaptations are the ones based on contemporary bestsellers (e.g. *Momo,* 1986; *Der Name der Rose,* 1986; *Herbstmilch,* 1988; *Die unendliche Geschichte/The Neverending Story,* 1990; *Schlafes Bruder/Brother of Sleep,* 1995; *Campus,* 1997). MW

Bib: Eric Rentschler (ed.), *German Film and Literature: Adaptations and Transformations* (1986).

LORRE, Peter
Rosenberg, Austria-Hungary 1904 – Hollywood, California 1964

Hungarian-born German actor and director, originally a stage actor (including for Bertolt Brecht), whose performance as the child murderer in Fritz Lang's* *M – Eine Stadt sucht ihren Mörder/M* (1931) made him an international star. Lorre's eloquent, sad face and distinctive voice singled him out for being typecast, a fate aggravated by emigration, at first to France in 1933 (where he worked for G. W. Pabst*), then to Hollywood via Britain (where he worked for Alfred Hitchcock) in 1934. Lorre's Hollywood career began when Columbia offered him a contract in 1934 and he played a crazed scientist in *Mad Love* (Karl Freund*, 1935). Lorre's roles for the next decade alternated between psychopaths, Nazi spies, double agents and effete small-time crooks. At 20th Century-Fox, the Mr Moto series offered him a chance to give a comic inflection to his generally sinister persona. His second breakthrough came when he was partnered with Humphrey Bogart and Sydney Greenstreet in such classics as *The Maltese Falcon* (1941) and *Casablanca* (1942). Lorre returned to Germany to direct one of the great masterpieces of *film noir* (*Der Verlorene/The Lost One*, 1951). Disappointed by the lack of critical or commercial response to the film, he continued his acting career in Hollywood, mainly directed by Roger Corman in shock-horror spoofs, often opposite Vincent Price and Boris Karloff. TE/KU

Other Films Include: *Bomben auf Monte Carlo, Die Koffer des Herrn O. F.* (1931); *Du haut en bas* (1934, Fr.); *The Man Who Knew Too Much* (1934, UK); *Think Fast, Mr. Moto* (1937, US); *Arsenic and Old Lace, Passage to Marseille* (1944, both US); *Beat the Devil* (1953, US); *Tales of Terror* (1962, US); *The Raven, The Comedy of Terrors* (1964, both US).

LUBITSCH, Ernst
Berlin 1892 – Hollywood, California 1947

German director, actor and producer, and one of the great geniuses of comedy in the cinema. Joining Max Reinhardt's* ensemble in 1911, Lubitsch became successful as a film actor in 1913, creating the comic persona of the wily and lecherous shop assistant (for instance in *Die ideale Gattin* and *Die Firma heiratet*, both 1913), before also taking over direction (first film: *Fräulein Seifenschaum*, 1915). His international breakthrough came in 1919, with a string of hits: *Die*

Austernprinzessin/The Oyster Princess, Madame Dubarry/Passion, Die Puppe. On the strength of the American success of *Madame Dubarry*, Lubitsch left for Hollywood in 1921, to direct Mary Pickford, and then a series of social satires which inaugurated the new genre of the 'sophisticated comedy' – *The Marriage Circle* (1923); *Lady Windermere's Fan* (1925); *So This is Paris* (1926) – which was to make him world-famous. The coming of sound did not diminish Lubitsch's talent or acumen (*The Love Parade*, 1929, starring Maurice Chevalier; *Monte Carlo*, 1930), and in 1935 he became director of production at Paramount, and it was for them that he made the sparkling political comedy *Ninotchka* (1939), with Greta Garbo*.

The famous 'Lubitsch touch' was a combination of sharp socio-psychological analysis and indirect comment, leaving out what the spectators could easily supply by way of erotic play or sexual innuendo. *To Be or Not to Be* (1942) is probably the blackest example of Lubitsch's satirical humour, unmasking the cruelty and barbarity of the Nazi regime by focusing on stupidity, illogicality and pompous make-believe. TE/KU

Bib: Sabine Hake, *Passions and Deceptions: The Early Films of Ernst Lubitsch* (1992).

Other Films Include: *Schuhpalast Pinkus* (1916); *Ich möchte kein Mann sein, Carmen* (1918); *Anna Boleyn* (1920); *Die Flamme* (1922). **In the US**: *Forbidden Paradise* (1924); *The Student Prince in Old Heidelberg* (1927); *Design for Living* (1933); *Heaven Can Wait* (1943); *Cluny Brown* (1946).

M

MACK, Max Moritz Myrthenzweig;
Halberstadt 1884 – London 1973

German director, one of the most prolific and versatile film-makers of the German cinema in the 1910s and the early 1920s, widely acclaimed in his profession as well as by the broad public at the time, and since the late-1920s all but forgotten. Coming from the theatre in 1910, Mack started out in films as actor and screenwriter, but quickly made the transition to direction the following year. Late in 1912 he directed *Der Andere/The Other One*, the first so-called *Autorenfilm**, which brought onto the screen the famously camera-phobic Albert Bassermann, one of the most renowned stage actors of his day. The landmark

event so mesmerised generations of film historians that they have unfairly ignored a number of other Mack films, equally crucial to an understanding of the stylistic and cultural identity of Wilhelmine cinema*: this applies to recent rediscoveries such as the melodrama *Zweimal Gelebt/Lived Twice* (1912), remarkable for its unusual dramatisation of cinematic space, but above all, to a string of hugely successful urban comedies, centred on the attractions of modern technology, mobility, entertainment and consumerism (*Der stellungslose Photograph/The Unemployed Photographer*, 1912; *Wo ist Coletti?/ Where is Coletti?*, 1913; *Die blaue Maus/The Blue Mouse*, 1913; *Die Tangokönigin/The Tango Queen*, 1913; *Das Paradies der Damen/A Ladies' Paradise*, 1914). By the end of the 1910s, which were to remain his most productive and successful decade, Mack's filmography counted nearly a hundred films of almost every conceivable genre (including an early film with Ernst Lubitsch, *Robert und Bertram*, 1916). Until the mid-1920s, Mack still figured prominently as the routine craftsman of the popular mainstream, whose 'look' and style he had done so much to define, recycling many of his once original comic and dramatic formulas for action, romance and cloak and dagger films across the ever shifting contexts of operetta (*Die Fledermaus*, 1923, starring Harry Liedtke* and Lya de Putti*), tourism (*Die Fahrt ins Abenteuer/The Wooing of Eve* 1925) and backstage drama (*Das Mädchen mit der Protektion*, 1926, both starring Ossi Oswalda*). By the late 1920s, however, he had been pushed to the margins of the industry by a new generation of popular directors. Growing increasingly dissatisfied with the constraints of commercial film-making, he experimented with amateur youth actors in his last silent picture *Der Kampf der Tertia* (1928/29). This semi-voluntary retirement from feature films had earlier led to him once more becoming the pioneer, directing Germany's first short sound feature, the all-star comical sketch *Ein Tag Film* (1928). Because of his Jewish origins, he left Germany for Prague within months of the Nazi takeover, settling in London in 1934. Despite his continuous efforts to gain a foothold in the American and English film industries in the 1930s and 1940s, he only produced one more feature-length film, *Be Careful, Mr. Smith* (1935, UK). Mack, besides being a passionate practitioner, was also a talented writer on the cinema (cf. *Die zappelnde Leinwand*, 1916; *Wie komme ich zum Film*, 1919) and published his (discreetly disguised) memoirs in 1943 (*With a Sigh and a Smile: A Showman Looks Back*). The 'prototype of a life-long showman', as his long-time companion, the film critic Hans Feld, once described him, Mack remained the typical film director during his thirty-year retirement in oblivion and exile: 'Immaculate appearance, even in London when down to his last suit, always holding a cigar in his mouth whilst holding forth on future plans … Up to the last moment he was planning his comeback.' MW

Bib: Michael Wedel, *Max Mack: Showman im Glashaus* (1996).

MAETZIG, Kurt
Berlin 1911

German director, whose research in film technology and photo-chemistry protected him from deportation by the Nazis, who nevertheless banned him from film-making in 1937 because of his Jewish descent. In 1944 Maetzig joined the underground Communist Party (KPD) and after the war he became a main protagonist in East German film culture, not only through his work as a documentary and feature film director but also as co-founder of DEFA* and first head of the Deutsche Hochschule für Filmkunst (film school) in Potsdam.

Maetzig directed a great number of documentaries before making his first feature film, *Ehe im Schatten* (1947), a very successful *Trümmerfilm* ('ruin film'). After the programmatic change in GDR film-making around 1952–53, he directed the prototypical DEFA film, a two-part biopic of the socialist icon Ernst Thälmann: *Ernst Thälmann – Sohn seiner Klasse* (1954) and *Ernst Thälmann – Führer seiner Klasse* (1955). Trying to infuse East German film culture with new genres and topics, he made, with *Septemberliebe* (1960), one of the few DEFA productions touching on the division of Germany, a year before the Berlin wall went up. When his second so-called *Gegenwartsfilm* (*Das Kaninchen bin ich*, 1965) was withheld from exhibition, Maetzig returned to more conventional genres before retiring in the mid-1970s. TE/KU

Bib: Günter Agde (ed.), *Kurt Maetzig – Filmarbeit: Gespräche, Reden, Schriften* (1987).

Other Films Include: *Die Buntkarierten* (1949); *Der Rat der Götter* (1950); *Mann gegen Mann* (1976).

MARA, Lya
Alexandra Gudowitsch; Riga 1897 – ?

Latvian-born actress whose girlish sex-appeal became popular in Weimar Germany in numerous entertainment films produced and directed by her then husband Friedrich Zelnik (Czernowitz 1885 – London 1950). A trained ballet dancer in Riga and Warsaw with some acting experience already in Polish films, Mara was brought to Berlin by Zelnik in 1917 to become the leading actress at his Berlin company 'Film-Manufaktur' (renamed 'Zelnik-Mara-Film GmbH' in 1920). After first appearing in films by other directors but with Zelnik as her screen partner, she exclusively acted under the direction of her husband from 1921 onwards, in increasingly tailor-made roles that promoted her as an icon of innocence, whether as the elegant, unjustly suspected wife in *Die Ehe der Fürstin Demidoff* (1921) or as the virginal small-town girl who turns men's heads by the dozen in *Das Mädel von Piccadilly* (2 parts, 1921) or *Die Männer der Sybill* (1922). Her exceptional success reached its peak as the typical 'Wiener Mädel'

(Viennese girl) in the film operettas *An der schönen blauen Donau* (1926), *Das tanzende Wien* (1927) and *Heut' tanzt Mariett* (1928), earning her the rare honour of becoming the heroine of a series of 100 romance novels entitled *Lya: Der Herzensroman einer Kinokönigin* that swamped the German market in 1927/28. With only one musical comedy (*Jeder fragt nach Erika*, 1931) to her credit, it seems the coming of sound brought her career to an abrupt halt. In 1932, Mara and Zelnik emigrated to London where all trace of her has been lost. MW

MARISCHKA, Ernst
Vienna 1893 – Chur, Switzerland 1965

Austrian director, writer and actor. Marischka, who was to become one of the main purveyors of Austrian popular entertainment films, saw his first cinematic success as a director in 1912 with the full-length feature *Der Millionenonkel*. Subsequently he wrote numerous librettos and scripts for silent and sound films, such as *Wiener G'schichten* (1940, dir. Geza von Bolvary*), and directed successful films such as *Abenteuer im Grand-Hotel* (1943), with Hans Moser*, *Saison in Salzburg* (1952) and *Mädchenjahre einer Königin* (1954, with Romy Schneider*). His greatest fame, however, came from his *Sissi* trilogy (1955–57), one of the biggest successes in Austrian cinema. The three films – *Sissi* (1955), *Sissi – die junge Kaiserin* (1956) and *Sissi – Schicksalsjahre einer Kaiserin* (1957) – lavish sentimental costume dramas based on a romanticised portrait of Empress Elizabeth of Austria, turned Romy Schneider into a major international star. They also made an important contribution to the restoration of the Austrian concept of national identity, by recycling elements of the Habsburg myth; they are still popular hits both on television and video in Austria and in other continental European countries. Marischka's 1950s films stand out thanks to his masterful use of colour and flamboyant decor, as well as the great attention to detail that characterises their scripts. Marischka's brother Hubert Marischka (Vienna 1882–1959) had his roots as an actor in the theatre and operetta. He also worked as a scriptwriter and director of popular entertainment films, including *Wir bitten zum Tanz* (1941) with Paul Hörbiger* and Hans Moser, *Wiener melodien* (1947), *Du bist die Rose vom Wörther See* (1952, Ger.), and *Liebe, Sommer und Musik* (1956). FM/AL

MAY, Joe
Vienna 1880 – Hollywood, California 1954

Austrian-born German director, who began as a scriptwriter and director in 1912, founded May-Film (1915–32), turned his wife Mia May into a popular serial queen, rose to singular pre-eminence in Weimar* cinema, and tragically failed to find a foothold in Hollywood after

forced exile. In the 1910s and 1920s he directed and produced a number of very successful melodramas, detective thrillers and serials (four 'Stuart Webbs' and twenty-three 'Joe Deebs' detective films). His famous six-part epics (*Veritas Vincit*, 1919; *Die Herrin der Welt*, 1919; *Das indische Grabmal*, 1921) were indicative of his prescience about the future of the feature-length film for the world market. May liked to work with a permanent team (M. Faßbender, R. Kurtz, M. Jacoby-Boy) and saw himself as a promoter of new talent (Thea von Harbou*, Fritz Lang*, E. A. Dupont*). Working with Erich Pommer* on *Asphalt* (1929), May visited Hollywood in 1928 to gather information on the techniques of sound film and returned to make the comedy *Ihre Majestät die Liebe* (1931).

In 1934 he arrived in Hollywood (via London and Paris) with a Paramount contract. His first two Hollywood films, *Music in the Air* (1934, produced by Pommer and scripted by Billy Wilder* and Robert Liebmann*) and *Confession* (1937), were unsuccessful. From 1939 he began to make B-pictures in various genres, but by the mid-1940s found himself bankrupt, trying with his wife to run a restaurant, appropriately called 'The Blue Danube'. TE/SG

Bib: Hans-Michael Bock and Claudia Lenssen (eds), *Joe May: Regisseur und Produzent* (1991).

Other Films Include: *Vorgluten des Balkanbrandes* (1912); *Ein Ausgestoßener. 2 Teile, Entsagungen, Heimat und Fremde* (1913); *Die geheimnisvolle Villa* (1914); *Das Gesetz der Mine* (1915); *Tragödie der Liebe. 4 Teile* (1923); *Der Farmer aus Texas* (1925); *Dagfin* (1926); ... *und das ist die Hauptsache* (1931); *Paris – Méditerranée/Zwei in einem Auto* (1932); *Ein Lied für Dich* (1933). **In the US**: *The House of Fear* (1939); *The Invisible Man Returns* (1940); *The Strange Death of Adolf Hitler* (1943); *Johnny Doesn't Live Here Any More* (1944).

MAYER, Carl Graz, Austria 1894 – London 1944

Austrian-born German scriptwriter, who started his film career in 1919 with the scripts for the two archetypal Expressionist* films, *Das Cabinet des Dr Caligari/The Cabinet of Dr Caligari* (1920, co-author Hans Janowitz) and *Genuine* (1920), both directed by Robert Wiene*. After these successes, his name became more closely associated with psychological dramas such as *Hintertreppe/Backstairs* (1921), *Scherben/Shattered* (1921), and *Sylvester* (1923) which helped initiate the *Kammerspielfilm**. After collaborating with F. W. Murnau* on *Der letzte Mann/The Last Laugh* (1924), *Sunrise* (1927, US) and *Four Devils* (1929, US), Mayer returned to Europe, first to France, where he co-wrote Paul Czinner's* *Mélo* (1932), and later to Britain, where his consultancy on *Pygmalion* (1938), the documentary *The Fourth Estate* (1939) and *Major Barbara* (1941) was uncredited. Because he was

'writing films' rather than merely writing for film, Mayer is not adequately described as 'scriptwriter' and it seems clear that the extraordinarily detailed specifications he gave did guide the hands and eyes of directors, cameramen and set designers. TE/KU

Bib: Jürgen Kasten, *Carl Mayer: Filmpoet* (1994).

Other Films Include: *Brandherd* (1920); *Der Gang in die Nacht* (1920); *Die Straße* (1923); *Tartüff* (1926).

MEISEL, Edmund Vienna 1894 – Berlin 1930

Austrian-born composer. Trained as a violinist and conductor, Meisel was active in film from 1926, when Prometheus-Film commissioned him to compose music for the German release in 1930 of Eisenstein's *Bronenosets Potëmkin/The Battleship Potemkin* (1926). The premiere brought him unaccustomed recognition as a composer of avant-garde film and stage music. *Berlin, die Sinfonie der Großstadt/Berlin, Symphony of a City* (1927; dir. Walter Ruttmann*) gave him the opportunity to develop to the full his harsh rhythms and atonal sound sequences, his score contributing much to the international acclaim that the film received. Meisel subscribed to the then current idea that sound and image should be contrapuntal, and critics sometimes complained that his music was trying to compete with the film for the audience's attention. In fact, Meisel's music was rejected in Moscow, and in 1928 he broke with Eisenstein. The first sound film he worked on, *Deutscher Rundfunk* (1928), seems to have been lost. Little is known about his time in Britain between 1928 and 1930, but when he returned to Germany, his style had altered, in line with the new norms of sound cinema: his film music had become more conventionally tonal and melodic. He died tragically early, aged 36. TE/SG

MESSTER, Oskar Berlin 1866 – Tegernsee 1943

German film pioneer, inventor, technician, producer and entrepreneur, who went into business as a manufacturer of film equipment, producing his first film projectors in 1896 and a film camera series in 1900. He secured nearly seventy patents, including one for a special Maltese cross, an optical printer and the synchronisation of projector and gramophone. Messter bought his first film theatre in Berlin in 1896, but produced films mainly for buyers of his projectors, only gradually making them to show in his own theatres and for Berlin's many variety halls. By 1897, Messter had equipped his studio with artificial lighting, and his October sales catalogue of that year lists eighty-four films. Among these were street scenes such as *Am Brandenburger Tor* (1896), films of current events, especially public

appearances by Kaiser Wilhelm II (1897), and short narratives. Between 1903 and 1910 he produced 'Tonbilder' (sound pictures) with synchronised image and sound.

Messter founded Projektion and in 1913 Messters Projektion continued to manufacture film equipment while a new company, Messter Film, took over film production, acquiring a reputation in feature films and specialising in melodramas such as *Der Schatten des Meeres* (1912, with Henny Porten*) and *Die blaue Laterne* (1918). During World War I Messter worked on military applications of film technology (air reconnaissance, target practice, cameras for fighter planes). He established his own distribution company, Hansa Film-Verleih. The Messter business operated in a variety of areas, including newsreels (the 'Messter Woche' [> DOCUMENTARY]). Ufa* took over Messter's companies in 1917 and he became a member of the Ufa board of directors as well as their chief technical adviser. JG

MEYER, Rudi
Ludwig Wilhelm Rudolf Meyer;
Suhl, Germany 1901 – Amsterdam 1969

German-Dutch producer. Meyer began his career in 1919 at Decla in Berlin, the company of his famous uncle Erich Pommer*. When Decla merged with Ufa*, Meyer worked for Europe's largest studio in different capacities. On Pommer's departure for Hollywood in 1926, Meyer switched to a smaller studio, Aafa, and devoted his talents to production, publicity and international film distribution. When the Nazis came to power in 1933 he emigrated to the Netherlands. His arrival in Amsterdam had a strong impact on Dutch film culture, since Meyer brought expertise not only in distribution but also in production. The latter in particular was in great demand; Meyer introduced continuity and stability in Dutch film-making where *ad hoc* projects had been the rule. He also hired talented émigré directors to make quality pictures for a mass audience. In 1935 he presented his first production, *De kribbebijter/The Crosspatch*, directed by Herman Kosterlitz, who later made a Hollywood reputation as Henry Koster. Meyer also persuaded Ludwig Berger* to come to the Netherlands to direct *Pygmalion* (1937), a tremendous success. Friedrich Zelnik was imported to direct two further hits, *Vadertje Langbeen/Daddy Long-Legs* (1938) and *Morgen gaat het beter/Tomorrow is Another Day* (1939). Meyer made a star of Lily Bouwmeester, who featured in these last three pictures. He also cast her in the lead in Berger's *Ergens in Nederland/Somewhere in Holland* (1940). This touching film about marital relations during mobilisation was released shortly before the Germans occupied Holland, obliging Meyer to stop working. He was deported to Auschwitz but survived the camps, returning to Holland in 1947 and becoming a Dutch citizen. Postwar conditions in Holland were less favourable for film-making, however, and Meyer's network of émigrés had fallen apart. Even so, he produced the two most suc-

cessful Dutch films of the 1950s, *Sterren stralen overal/Stars Are Shining Everywhere* (1953, dir. Gerard Rutten) and *Fanfare* (1958, dir. Bert Haanstra). When he died, he was remembered as the producer who never failed to make a movie successful. KD

MOSER, Hans Johann Julier; Vienna 1880–1964

Austrian actor. After twenty-seven years of theatre and cabaret, Moser made his film debut in a supporting role in *Die Stadt ohne Juden* (1924); it took him nine more years and the coming of sound to find popularity as a folk comedian in Willi Forst's* 'Viennese films'. Moser created the character of the morose petit-bourgeois which was the foundation of his enormous popularity, setting the norm for the servants and bureaucrats typical of Austrian films until the 1950s. Always the underdog, he protested against his repressed social position with badly articulated recriminations in Viennese dialect. His chaotic and confusing manner (mumbling and flailing his arms, often to the point of near-hysteria) seldom solved his problems but made a sharp and funny counterpoint to the 'Prussian' Theo Lingen with whom he often played (for instance in *Ungeküßt soll man nicht schlafen gehen*, 1936). He also appeared in a few melodramas (*Maskerade/Masquerade in Vienna*, 1934), and his comic servants, always insisting on maintaining the order laid down by their masters, had a tragic quality. His appearances made even his most trivial films interesting. As Peter Handke said, 'You always wait impatiently until he appears'. Moser lost much of his poignancy in his postwar films, when he indulged in cosy Viennese charm (such as *Kaiserball*, 1956). KU/FM

Bib: Willibald Eser, *Hans Moser: 'Habe die Ehre'* (1981).

Other Films Include: *Der Dienstmann* (1928 and 1932); *Familie Schimek* (1935); *Einmal der liebe Herrgott sein* (1942); *Einen Jux will er sich machen* (1953); *Kaiser Joseph und die Bahnwärterstochter* (1962).

MUELLER-STAHL, Armin Tilsit 1930

German actor, with an increasingly international career. In the mid-1950s Mueller-Stahl transferred from stage to screen and got his breakthrough playing a legionnaire in a political thriller (*Flucht aus der Hölle*, 1962). He became one of DEFA's* most outstanding young actors and was offered many dramatic as well as comic roles. He worked for Frank Beyer*, and consolidated his popularity with frequent television appearances. In 1980 he fled to West Germany and quickly became internationally known after leading roles in, for instance, Rainer Werner Fassbinder's* *Lola* (1981) and George

Sluizer's* *Utz* (1992). For Jim Jarmusch's episode film *Night on Earth* (1992, US) he played an East German taxi-driver stranded in New York, and in 1989 he starred in Costa-Gavras'* psychodrama *Music Box*, also shot in the US. TE/SG

Bib: Armin Müller-Stahl, *Unterwegs nach Hause: Erinnerungen* (1997).

Other Films Include: *Der Kinoerzähler/The Film Narrator* (1993), *The House of the Spirits* (1993, Ger./US), *The Last Good Time* (1994, US), *Holy Matrimony* (1994, US), *Gespräch mit dem Biest/Conversation with the Beast* (1996, also dir.), *Shine* (1996, Aus), *Der Unhold/The Ogre* (1996, dir. Schlöndorff*), *The Game* (1997, US), *The Peacemaker* (1997, US), *The X-Files* (1997/98, US TV), *Jakob the Liar* (1999, US).

MÜLLER, Renate Munich 1906 – Berlin 1937

German actress, who emerged in *Peter der Matrose* (1929), the first of seven comedies she starred in, all directed by Reinhold Schünzel*. Her skills as a singer and knowledge of foreign languages made her the ideal actress for the musical comedies of the early 1930s, appearing under Wilhelm Thiele's* direction in the German and English versions of *Die Privatsekräterin/Sunshine Susie* (1931) and *Mädchen zum Heiraten/Marry Me* (1932), and for Schünzel in the French version of *Saison in Kairo, Idylle au Caire* in 1933. Her best-known Schünzel film is *Viktor und Viktoria/Victor and Victoria* (1933), a cross-dressing comedy, shot in several versions (though not with Müller in the lead in the non-German versions) and remade in 1982 with Julie Andrews.

After Hitler's rise to power she continued to play coquettish and self-confident females in several light-hearted comedies (*Die englische Hochzeit*, 1934), also acting in a blatant propaganda vehicle (*Togger*, 1937). Her premature death at the age of 31 was officially due to epilepsy, but rumour had it that Müller came into conflict with the Nazis about her relationship with a Jewish emigrant and committed suicide. TE/KU

Other Films Include: *Liebling der Götter* (1930; a film about her life was made in 1960 under the same title); *Walzerkrieg* (1933); *Allotria* (1936).

MÜLLER, Robby Willemstad, Curaçao 1940

Dutch-born cinematographer. After graduating from the Netherlands film academy, Müller followed the leading Dutch cinematographer Gerard Vandenberg to Germany, where he lit Hans W. Geissen-dör-fer's first TV feature, *Der Fall Lena Christ* (1968). He would sub-sequently work on six other Geissendörfer films. Müller is best known

for his camerawork on the films of Wim Wenders*, including *Summer in the City* (1970), *Alice in den Städten/Alice in the Cities* (1974), *Der Amerikanische Freund/The American Friend* (1977), *Paris, Texas* (1984), and *Bis ans Ende der Welt/Until the End of the World* (1991). Müller is highly esteemed by his peers, especially for his work in black and white. His eclectic career encompasses films by a large number of directors both in Europe and Hollywood, including Edgar Reitz* (*Die Reise nach Wien/Journey to Vienna*, 1973), Jim Jarmusch (*Down By Law*, 1986, *Mystery Train*, 1989), John Schlesinger (*The Believers*, 1987), and Andrzej Wajda* (*Korczak/Dr Korczak*, 1990). Müller has periodically returned to the Netherlands to shoot films directed by Paul de Lussanet (*Mysteries*, 1978), Erik van Zuylen (*Opname/In for Treatment*, 1978), and Frans Weisz (*Een zwoele zomeravond/A Hot Summer Night*, 1982 and *Hoogste Tijd/Last Call*, 1995), among others. HB

MURER, Fredi M. Beckenried 1940

Swiss director, who studied photography at the Zurich Kunstgewerbeschule. Seeing Robert Flaherty's poetic documentaries inspired him to become a film-maker. Among his early films, for the most part 'home movies', anarchic observations of his surroundings and of Zurich artists (for instance *Bernehard Luginbühl*, 1966), *Vision of a Blind Man* (1969) was the most radical break with conventional film aesthetics. Filming on the longest day of the year but with his eyes covered by opaque glasses, with *Vision of a Blind Man* Murer attempted a film based on sound perceptions rather than sight. Later in 1969, Murer's contribution to the omnibus film *Swissmade*, a dark science-fiction story entitled *2069*, signalled his turn to the socio-political concerns that were also to inform his ethnographic documentary *Wir Bergler in den Bergen sind eigentlich nicht schuld, dass wir da sind* (1974). After a fiction film, *Grauzone* (1979), an apocalyptic *noir* parable exploring the blackest depths beneath the surface of the Swiss idyll, Murer made *Höhenfeuer/Alpine Fire* (1985), a complex narrative of incestuous love within the stifled environment of mountain farmers. In its ethnographic though highly poetic look at 'Heimat' [> HEIMAT-FILM] and nature, at generational conflicts and Oedipal relationships, it constituted a high point of the 'new Swiss cinema', summarising its dominant themes and formal obsessions. MW

Bib: Otto Ceresa and Irène Lambelet, *Fredi M. Murer* (1981).

Other Films Include: *Marcel – Tag eines Elfjährigen* (1962); *Pazifik – oder die Zufriedenen* (1965); *Sad-is-Fiction* (1969); *Passagen* (1972); *Christopher und Alexander* (1973); *Der grüne Berg* (1990).

MURNAU, Friedrich Wilhelm
Friedrich Wilhelm Plumpe; Bielefeld 1888 – Santa Monica, California 1931

German director. With Fritz Lang* and G. W. Pabst*, Murnau is one of the three directors on whose work the fame of the German cinema of the 1920s rests. Murnau, who gave himself the name of a famous artists' colony, studied philology, art history and literature before becoming a pupil of Max Reinhardt*, mainly as assistant director. He joined the air force, spent most of the war in Switzerland and upon his return to Berlin directed *Der Knabe in Blau* (1919). Much influenced by the Danish cinema of the time, *Der Gang in die Nacht* (1921), his first success, was a poignantly lyrical treatment of a melodramatic love triangle involving a blind painter. Meeting the leading 'film author' Carl Mayer* proved decisive for both, with Murnau producing five films scripted by Mayer, including *Der Bucklige und die Tänzerin* (1920), *Schloß Vogelöd* (1921) and *Der letzte Mann/The Last Laugh* (1924). But Murnau also worked with Henrik Galeen (*Nosferatu – Eine Symphonie des Grauens/Nosferatu the Vampire*, 1922) and Thea von Harbou* (*Der brennende Acker*, 1922, *Die Finanzen des Großherzogs/The Grand Duke's Finances*, 1924), a variety indicative of his ability to mould a film subject to his style. His plots show a preference for archetypal triangular human entanglements in order to explode them from within, surrounding every relationship – of love or power – with radiant ambivalences.

Three Murnau films have entered the canon of world cinema, all for different reasons. *Nosferatu*, still the classic film version of Bram Stoker's *Dracula*, founded one of the few undying film genres and, in the eponymous Count, one of the half dozen universally recognised movie icons. *Der letzte Mann* is justly famous for its camerawork by Karl Freund* (his ingenious devices for making the camera mobile were dubbed '*entfesselt*' – unchained – a word connoting erotic licence at the time). But *Der letzte Mann* is also one of the most revealing parables of Weimar culture, with its fetishism of a uniform and Emil Jannings'* classic study of the self-tormented and yet monstrously autocratic male. Underrated in the Murnau canon are *Tartüff* (1926) and *Faust* (1926), again both with Jannings: one a *tour de force* of psychological perversity, the other a *tour de force* of spectacle and pyrotechnics, though neither was the commercial success Murnau and Erich Pommer* had expected (and needed).

By 1925 Murnau's reputation had reached Hollywood (thanks to Jannings' fame and the US distribution of *Der letzte Mann*), resulting in a four-year contract from William Fox. With a script by Mayer based on a Sudermann novel, Murnau embarked on what became his third acknowledged masterpiece: *Sunrise* (1927). Old-fashioned in its morality and sense of sin, but ultra-modern in its sensibility, it is one of the most cinematically sophisticated exercises ever about how to represent, precisely, the unrepresentable. What Lubitsch achieved in comedy, Murnau did for tragic subjects: thought and emotion,

178

cleansed of ambiguity and stripped of moody vagueness. A commercial failure, *Sunrise* led to leaner budgets on Murnau's other Fox assignments, *Four Devils* (1929) and *City Girl* (1930). He severed his contract and took a skeleton crew (and Robert Flaherty) to the South Seas, where he shot, under great difficulties, the independently produced *Tabu* (1931), a fairy tale of fate, eternal love and certain death in paradise. A week before its premiere, Murnau was killed in a car accident. TE

Bib: Lotte Eisner, *Murnau* (1972); Peter W. Jansen and Wolfram Schütte (eds), *Friedrich Wilhelm Murnau* (1990).

Other Films Include: *Satanas, Sehnsucht, Der Januskopf* (1920); *Marizza, genannt die Schmugglermadonna* (1921); *Phantom* (1922); *Die Austreibung/Driven from Home* (1923); *Komödie des Herzens* (1924, script).

N

NATIONAL SOCIALISM AND GERMAN CINEMA

Following the takeover by the National Socialist (Nazi) Party in January 1933, the Minister for Popular Enlightenment and Propaganda, Joseph Goebbels, exercised complete control over the film industry through: i) employment policy, ii) censorship, and iii) economic control mechanisms.

The *Reichsfilmkammer* (Reich Chamber of Film), dictated employment policy. With rare exceptions, only 'politically reliable' (and non-Jewish) members were admitted to the Chamber, and after 1938 the Nazis purged the few Jews who remained. Nazi employment policies caused an exodus of talent from the German film industry from 1933 onwards [> EMIGRATION AND EUROPEAN CINEMA].

To ensure that the films did not contradict film laws, pre-emptive censorship of screenplays by the *Reichsfilmdramaturg* became more important than censorship of the finished film, the standard practice since the Weimar Republic. After the first wave of purges, self-censorship became so effective that screenplays were, as a rule, only submitted for approval on a voluntary basis.

In 1934 the government introduced the categories of 'nationally and politically valuable' and 'nationally and politically especially valuable' films, which were exempt from tax. A financial incentive to tempt film companies into making films promoting Nazi ideology, it gave the gov-

ernment extra leverage without appearing to be interfering in the market. Additional economic control over the film industry was exercised by the state-run Filmkreditbank until 1937, when major portions of the industry were nationalised, such as Ufa*, and the distribution companies Terra and Tobis-Rota (amalgamated as Terra-Filmkunst). Independent film production was banned in June 1941, and the German film industry, consolidated into the giant Ufa Film, came under direct control of the Ministry of Propaganda. JG

Bib: Julian Petley, *Capital and Culture: German Cinema 1933–1945* (1979).

NEBENZAL [NEBENZAHL], Seymour New York 1897 – Munich 1961

American-born German producer, who began his career in Berlin as co-founder (with Richard Oswald*) of Nero-Film in 1924. With generous budgets and the guarantee of unrestricted artistic freedom, Nebenzal was able to woo G. W. Pabst*, Fritz Lang* and Paul Czinner* (*Ariane*, 1931). The collaboration with Pabst was the most fruitful; after *Die Büchse der Pandora/Pandora's Box* (1929), Nebenzal produced Pabst's first five sound films. With Lang, he made *M – Eine Stadt sucht ihren Mörder/M* (1931) and the last German Nero production, *Das Testament des Dr Mabuse/The Testament of Dr Mabuse* (1933), before going into exile in France, where he produced Anatole Litvak's *Mayerling* (1936) and Max Ophuls'* *Le Roman de Werther/Werther* (1938). In 1940 he left for the US and produced Douglas Sirk's (Detlef Sierck*) *Summer Storm* (1944) and Joseph Losey's* remake of Lang's *M* (1950). KU

NEGRI, Pola Pola Barbara Apollonia Chałupic; Lipno, Poland 1894 – San Antonio, Texas 1987

Polish-born actress. Emigrating from Poland during World War I, Negri advanced to stardom in Ernst Lubitsch's* films, personifying animal energy and cunning, and playing the man-crazy virgin as well as the man-eating vamp. In films such as *Carmen* (1918), *Die Augen der Mumie Mâ* (1918), *Madame Dubarry/Passion* (1919), *Sumurun* (1920) and *Die Bergkatze* (1921) she triggered murderous rivalries among her admirers. The first German actress to be offered a contract by Paramount (in 1922), she had her greatest American success with *Forbidden Paradise* (1924), directed by Lubitsch. Back in Europe by the late 1920s, Negri, despite her Polish accent, attempted a comeback in the German sound cinema (*Mazurka*, 1935), but in 1941 returned to the US, eventually reduced to parodying her silent screen image in *Hi*

180

Diddle Diddle (1943). Film projects in postwar Germany came to naught, and Negri's last appearance was a cameo in *The Moon-Spinners* (1964, US). TE

Other Films Include: *Nicht lange täuschte mich das Glück* (1917); *Bella Donna* (1923, US); *A Woman of the World* (1925, US); *Barbed Wire* (1927, US); *Moskau-Shanghai* (1936); *Tango Notturno* (1937).

NEW GERMAN CINEMA

German art film movement, *c.* 1965–82. Perhaps the only common characteristic of the New German Cinema was its rejection of German commercial cinema, first formulated in the 'Oberhausen Manifesto', drawn up and presented in 1962 at the Oberhausen festival of short films by young directors eager to make feature films. These directors identified the postwar commercial cinema with National Socialism, since many German directors of the 1950s had indeed begun their careers during the Third Reich. Refusing apprenticeship with such politically tainted directors and technicians, the Oberhausen generation either went abroad (Volker Schlöndorff*), taught themselves (Werner Herzog*), or, in a later phase, studied at film schools (Wim Wenders* and Helke Sander*). The only acceptable German cinema role models being directors who had died early (such as F. W. Murnau*) or had emigrated in 1933 (such as Fritz Lang*), it was German literature that provided subjects, from contemporary novels such as those of Peter Handke, Günter Grass and Heinrich Böll to the classically romantic works of Goethe, Kleist and Fontane. The directors' rejection of German commercial film was manifested in their refusal to follow established German film genre conventions and in their reluctance to hire well-known German stars or create their own. The (mediated) influence of American narrative conventions is more noticeable than any continuity with German cinema. Wim Wenders'* *Im Lauf der Zeit/Kings of the Road* (1976) and *Hammett* (1982, US) were clearly referring to the American road movie and *film noir* respectively, while the American melodramas of Douglas Sirk (Detlef Sierck*) became models for R. W. Fassbinder's* films: *Angst essen Seele auf/Fear Eats the Soul* (1974), *Die Ehe der Maria Braun/The Marriage of Maria Braun* (1979), *Lola* (1981), *Die Sehnsucht der Veronika Voss/Veronika Voss* (1982).

Although Alexander Kluge* (*Abschied von gestern/Yesterday Girl*, 1966) and Jean-Marie Straub and Danièle Huillet (*Nicht versöhnt, oder Es hilft nur Gewalt, wo Gewalt herrscht/Not Reconciled*, 1965) show more radical breaks with both German and American classical narrative cinema when compared to the narrative techniques of Wenders and Fassbinder, the films of the New German Cinema do share common themes. Many concentrate on disadvantaged social groups or outsiders, especially people from lower- and middle-class

181

backgrounds: a guest worker in Fassbinder's *Angst essen Seele auf,* a mentally ill woman in Helma Sanders-Brahms'* *Die Berührte/No Mercy, No Future* (1981), female alcoholics in Ulrike Ottinger's* *Bildnis einer Trinkerin/Ticket of No Return* (1979), social outcasts in Werner Herzog's* *Jeder für sich und Gott gegen alle/Every Man for Himself and God Against All/The Enigma of Kaspar Hauser* (1974), and a suicidal child therapist in Wenders' *Im Lauf der Zeit.* The New German directors' common stance outside Germany's commercial film industry gave rise to two trends. Firstly, the film-makers were constantly looking for new ways of financing their films. The Kuratorium Junger Deutscher Film was formed to fund the early productions of the New German Cinema, and directors hoped to take control of the distribution of their own films, through their *Filmverlag der Autoren*.* Secondly, the intransigent attitude to commercial film-making meant that New German directors (consciously drawing on literary precedents) considered themselves the film's sole authors and dispensed with professional producers or scriptwriters. Thus the films of the New German Cinema became identified with their directors, their names becoming the trademark of, and advertising for, the films, apart from promoting the label 'New German Cinema' at film festivals. Generally, New German Cinema films ran in art houses and were not commercially successful. New German Cinema was prized by critics for its cultural value and, for the first time since the 1920s, they argued that there existed German films which belonged to the realm of art.

Since the early 1980s the directors identified with the New German Cinema have gone in different directions: Kluge mainly produces short cultural reports for commercial broadcasting stations; Herzog has worked in other cultural areas (opera and television journalism); Wenders, Sanders-Brahms and Margarethe von Trotta* direct international film projects, and Fassbinder died in 1982. Other German film-makers such as Wolfgang Petersen*, Doris Dörrie* and Roland Emmerich* no longer share the blanket rejection of stars and genre films, but are involved in both German television and American film industry productions. JG/TE

Bib: Thomas Elsaesser, *New German Cinema: A History* (1989).

NIELSEN, Asta Copenhagen 1881–1972

Danish actress, who worked mainly in Germany. Nielsen was educated at the Royal Theatre school in Copenhagen. After her theatrical debut in 1902 and work in various Scandinavian theatres, she made her spectacular film debut in Urban Gad's *Afgrunden/The Abyss* (1910), an international success which aroused the attention of the German film industry. Nielsen was the earliest 'vamp' in world cinema, developing a strong, erotic persona which was central to the emerging genre of the Danish erotic melodrama. She was equally at ease with tragedy

and used the longer films pioneered in Denmark to develop a more naturalistic acting style. She made two more Danish films, *Den sorte Drøm/The Black Dream* and *Balletdanserinden/The Ballet Dancer* (both 1911), before leaving with Gad for Germany. There they made twenty-four films in three years, evolving into one of the director-star teams which would become familiar in European art cinema. *Nachtfalter* (1911), *Die arme Jenny* (1912), *Der Totentanz/The Death Dance* (1912) and *Jugend und Tollheit/Youth and Madness* (1913), among others, ensured her both critical and popular success around the world. In 1912 her film *Die Kinder des Generals/ Generalens Døtre/The General's Daughters* was chosen to inaugurate Copenhagen's giant 3,000-seater Paladsteatret cinema, the biggest in northern Europe.

Nielsen returned to Denmark during World War I and made *Mod Lyset/Towards the Light* (1918), but by then Danish cinema was on the decline and the film was a failure. The war over, she went back to Germany where she worked for the rest of the silent period, focusing on prestigious stage and literary adaptations with directors such as Ernst Lubitsch* and Carl Froelich*. Her own production company, Art-Film, produced *Hamlet* (1920), in which she played the prince, *Fräulein Julie/Miss Julie* (1921) and *Der Absturz* (1922). She made notable appearances in *Vanina/Vanina Vanini* (1922), *INRI* (1923), *Die freudlose Gasse/Joyless Street* (1925, dir. G. W. Pabst*) and *Dirnentragödie/The Tragedy of the Street* (1927). In 1932, she made her first sound film and last movie, *Unmögliche Liebe/Impossible Love* (1932). Rejecting Nazi overtures to stay, she returned to Denmark in 1937. Nielsen made over seventy films, about thirty of which are preserved. ME/MW

NOVOTNY, Franz
Vienna 1949

Austrian director. One of the exponents of the 'New Austrian Cinema', Novotny started with short films in the 1960s and trained at the Austrian state television broadcasting company as a reporter and director. His television film *Staatsoperette* (1977), a grotesque musical treatment of the Austrian First Republic, resulted in a condemnation by the Church, a scandal in Parliament and Novotny's dismissal from the television company. His cinema debut, *Exit – Nur keine Panik* (1980, Aust./Ger.), describes the excursions of an excessive male duo through the Viennese underworld, involving non-professional actors, slapstick action and 'local flavour'. Novotny's emphatically proletarian style, most obvious in his preference for vulgar language, made *Exit* a cult movie. His subsequent film, *Die Ausgesperrten/Locked Out* (1982), based on a script by Austrian writer Elfriede Jelinek, used a similar formula in its trenchant account of a juvenile who kills his family and the events leading up to the murders. The subversion of 'family values', as well as explicit sexuality and violence, made the film very

183

controversial. Novotny's forceful anti-establishment stance turned into farce in *Coconuts* (1985) and *Spitzen der Gesellschaft* (1990); in 1995 he made *Exit II – Verklärte Nacht*. He also writes and directs commercials. IR/AL

O

OPHULS, Max Max Oppenheimer; Saarbrucken 1902 – Hamburg 1957

German director (sometimes spelt Ophüls; in the US occasionally Opuls). After a ten-year career in the theatre and in radio Ophuls joined Ufa* in 1931. His breakthrough came with the international success of *Liebelei* (1933; also French version, *Liebelei une Histoire d'amour*), based on a play by Arthur Schnitzler. Identified with Viennese charm and bitter-sweet world-weariness, Ophuls tried to extend his range after emigrating to Paris in 1933. Proving extremely versatile in putting together unlikely projects, between 1934 and 1940 he directed French, Italian, Dutch and English-language films, most of them exquisite evocations of a world of lost illusions, such as *La signora di tutti* (1934, It.) and *La Tendre ennemie* (1936, Fr.). Ophuls became a French citizen in 1938; nevertheless, he fled to America in 1941, but was unable to realise a film project until 1947. His first Hollywood film starred Douglas Fairbanks Jr. (*The Exile*, 1947), but he has become especially known for his three classic 'women's pictures', *Letter from an Unknown Woman* (1948), *Caught* (1949) and *The Reckless Moment* (1949), produced respectively for Universal, MGM and Columbia.

At the end of the 1940s Ophuls returned to Paris where he enjoyed a *succès de scandale* with *La Ronde* (1950), his second Schnitzler adaptation. Following *Madame de ...*/*The Earrings of Madame de ...* (1953), featuring Danielle Darrieux, he was commissioned to direct the French-German co-production *Lola Montès* (1955, with Martine Carol), thought a failure at the time but now considered his masterpiece. Ophuls' stylistic trademarks are his intricate and extensive camera movements, functionally relating decor and music to the protagonists, and his films combine wit and an undaunted romanticism. His son Marcel Ophuls (born Frankfurt 1927) was his assistant on *Lola Montès* and himself became an international film-maker; he is especially noted for his remarkable *Le Chagrin et la pitié*/*The Sorrow and the Pity* (1971), a ground-breaking documentary on the complex, compromised and ambivalent attitudes of French people in a provin-

184

cial town during the German occupation. He pursued the German occupation theme in *Hôtel Terminus/The Life and Times of Klaus Barbie* (1988, Fr.), about the Nazi war criminal Klaus Barbie. TE/GV

Bib: Max Ophuls, *Spiel im Dasein* (1963); Paul Willemen (ed.), *Ophuls* (1978); Helmut G. Asper, *Max Ophüls: Eine Biographie* (1998).

Other Films Include: *Dann schon lieber Lebertran* (1931, Ger.); *Die verliebte Firma, Die verkaufte Braut/The Bartered Bride* (1932, Ger.); *Lachenden Erben* (1933, Ger.); *On a volé un homme* (1934, Fr.); *Divine* (1935, Fr.); *Komedie om geld/A Comedy About Money* (1936, Neth.); *Yoshiwara* (1937, Fr.); *Le Roman de Werther/Werther* (1938, Fr.); *Sans lendemain* (1940, Fr.); *De Mayerling à Sarajévo* (1940, Fr.); *Le Plaisir* (1952, Fr.).

OSWALD, Richard

Richard Ornstein; Vienna 1880 – Düsseldorf 1963

Austrian-born director, who made his first films in 1914 and founded his own company in 1916. In the post-World War I period Oswald took up current social debates around sexuality and crime to make a range of popular movies (such as the three-part *Es werde Licht!*, 1917–18; *Das Tagebuch einer Verlorenen*, 1918; *Anders als die Anderen/ Different from the Others*, 1919; *Feme*, 1927). Along the way he 'discovered' stars such as Conrad Veidt*, Werner Krauß*, Lya de Putti* and Wilhelm Dieterle*. A sought-after director in almost every popular genre at least since his expensive costume drama *Lady Hamilton* (1921), Oswald did well in the first years of sound cinema, excelling in operetta films like *Wien, du Stadt der Lieder* (1930) or the historical panorama *1914, die letzten Tage vor dem Weltbrand* (1931), and making one of the many versions of the romantic tale *Alraune* (1930). A few months after the Nazi takeover he emigrated to Britain, then France, and finally the US. He was the father of the director Gerd Oswald (1919–89). MW

Bib: Helga Belach and Wolfgang Jacobsen (eds), *Richard Oswald: Regisseur und Produzent* (1990).

Other Films Include: *Dida Ibsens Geschichte* (1918); *Die Reise um die Erde in 80 Tagen, Unheimliche Geschichten* (1919); *Nachtgestalten, Manolescus Memoiren* (1920); *Lucrezia Borgia* (1922); *Im weißen Rössl* (1926); *Frühlings Erwachen* (1929); *Dreyfus* (1930); *Der Hauptmann von Köpenick* (1931); *Unheimliche Geschichten* (1932).

OSWALDA, Ossi
Oswalda Stäglich; Berlin 1897 –
Prague 1948

German actress who was a chorus girl in Berlin when she was discovered by Hanns Kräly*, who drew Lubitsch's* attention to her. She became the star of the director's early comedies: the young apprentice in *Schuhpalast Pinkus* (1916), the Countess in *Prinz Sami* (1917), the film diva in *Meine Frau, die Filmschauspielerin* (1918). Soon labelled 'the Mary Pickford of Germany', Oswalda established her screen persona in a series of short comedies that were specially written for her (e.g. *Ossi's Tagebuch*, 1917). Whether one considers the excessive temperament and erotic aggression of her performance in *Die Austernprinzessin* (1919) or her artificially repressed sensuality in *Die Puppe* (1919) – Oswalda was soon typecast as the ultimate child-woman type, charming audiences by her unquestioning *joie de vivre* and an unusually uninhibited eroticism. After Lubitsch left for Hollywood, she worked with her former fellow actor Victor Janson on a series of comedies before she was contracted by Ufa* in 1925, subsequently turning Willy Fritsch's* head in the Max Mack*-comedies *Das Mädchen mit der Protektion* (1925) and *Die Fahrt ins Abenteuer* (1926) or toying around with her former Lubitsch-Partner Harry Liedtke* in *Das Mädel auf der Schaukel* (1926) and *Eine tolle Nacht* (Richard Oswald*, 1926). After the coming of sound, she only appeared in two more films, as the knife-thrower in Georg Jacoby's* *Der keusche Josef* (1930) and as a Variety dancer in *Der Stern von Valencia* (1933). In the early 1940s she moved to Prague where she spent her last years in reduced circumstances at the side of producer Julius Aussenberg. MW

Bib: Sabine Hake, *Passions and Deceptions: The Early Films of Ernst Lubitsch* (1992).

OTTINGER, Ulrike
Konstanz 1942

German director, whose training in fine art is reflected in her concern with the exploration of the image/sound relationship; her episodic narratives are conveyed through beautiful and stylised tableaux, underscored by a highly manipulated soundtrack. A major objective is to renegotiate visual pleasure for the female and lesbian spectator. Unlike many contemporary German feminist film-makers, though, Ottinger has rejected a realist treatment of women's issues, preferring exaggeration, artifice and parody. *Madame X – Eine absolute Herrscherin/Madame X – An Absolute Ruler* (1978), about a band of female pirates, though defended by Monika Treut*, provoked a hostile response from many feminists. In the context of postmodernist debates, however, Ottinger's aesthetics have become familiar enough, and are now better understood. *Bildnis einer Trinkerin/Ticket of No*

Return (1979), only ostensibly about a couple of female alcoholics, aims to represent female desire and parodies the conventions of woman as spectacle; it again provoked fierce debate among feminists. *Freak Orlando* (1981), based on Virginia Woolf's novel and featuring Magdalena Montezuma, relates the mythology of the social/sexual outcast through the ages. With her lengthy documentaries *China – Die Künste – Der Alltag/China – The Arts – The Everyday* (1985) and *Taiga* (1992) – respectively six and eight hours long – and the feature film *Johanna d'Arc of Mongolia* (1988), Ottinger's recurring theme of exoticism was extended to her fascination with Oriental cultures. Ottinger's insistence on mythologising and aestheticising women's experience has retrospectively been validated by many critics as a more fruitful approach than one which focuses on subject matter. US

P

PABST, Georg Wilhelm Raudnitz 1885 – Vienna 1967

Austrian director, who epitomised the psychosexual realism of Weimar* cinema and late 1920s 'new sobriety'. After studying engineering in Vienna, Pabst moved to Berlin in 1921 as an actor, assistant director, and scriptwriter for Carl Froelich*. His reputation was made with *Die freudlose Gasse/The Joyless Street* (1925), which drew a pessimistic picture of Germany's social and moral situation after World War I [> STRASSENFILME]. He directed Brigitte Helm* in *Die Liebe der Jeanne Ney/The Loves of Jeanne Ney* (1927), but his best-known films are *Die Büchse der Pandora/Pandora's Box* (1929) and *Das Tagebuch einer Verlorenen/Diary of a Lost Girl* (1929), both featuring the quintessentially modern eroticism of Hollywood actress Louise Brooks*.

Pabst's first talkie, *Westfront 1918/Comrades of 1918* (1930), was an uncompromisingly frank anti-war film. Though Pabst was a convinced left-of-centre liberal, his political instincts often deserted him. His 1931 adaptation of the Bertolt Brecht–Kurt Weill piece *Die Dreigroschenoper/The Threepenny Opera* led to a law suit which Weill won. Political controversy embroiled his Franco-German co-production *Kameradschaft* (1931), a plea for solidarity among the international working class. In the 1930s Pabst worked regularly in France, where, apart from scriptwriting and 'technical supervision' on a number of projects, he directed some French versions of his German films and completed four French films – *Don Quichotte/Don Quixote* (1933), *Mademoiselle Docteur* (1936), *Le Drame de Shanghai* (1938) and *Jeunes filles en détresse* (1939) – before moving to Hollywood.

After one unsuccessful picture and an aborted project, he returned to France and then to Austria at the outbreak of World War II. He spent the next six years in Germany, making three intriguing films under the Nazi regime (*Komödianten*, 1941; *Paracelsus*, 1943; *Der Fall Molander*, 1945), which severely damaged his international reputation. His first film after the war, however, was a denunciation of anti-semitism, and several of his subsequent melodramas probed the phenomenon of Nazi Germany (*Der letzte Akt/The Last Ten Days*, 1955; *Es geschah am 20. Juli/Jackboot Mutiny*, 1955). MW/TE

Bib: Eric Rentschler (ed.), *G. W. Pabst: An Extraterritorial Cinema* (1990).

PAGU (PROJECTIONS AG 'UNION')

German film company. Founded by Paul Davidson*, and the first fully integrated film company in Germany, PAGU started as a chain of cinemas all over Germany in 1906, and by 1911 had branched out into distribution, initially to secure the exclusive rights to Asta Nielsen's* films. In 1913 Davidson added a film studio near Berlin, specifically to produce the lucrative Nielsen films (directed by Urban Gad). Both Davidson's luxurious 'Union-Theaters' (UT) and his PAGU films, which relied heavily on subjects from literature, were designed to appeal to middle-class tastes. Attendance at UT movie theatres rose from 2.5 million to 6 million between 1911 and 1913 and the cinema chain was sold in 1917, later becoming part of Ufa*. His hands free, Davidson concentrated on production, picking a winner with Ernst Lubitsch*. In 1918, Ufa bought the majority of PAGU's shares but left Davidson to operate it as an independent company. Lubitsch and Davidson made lavish productions such as *Madame Dubarry/Passion* (1919) and *Anna Boleyn* (1920) under Ufa's auspices. Integrated into the Ufa empire in 1926, PAGU ceased to be registered as a separate company. JG/TE

PATZAK, Peter Vienna 1945

Austrian director, who has worked in film and television since the 1970s. His attempts to establish a political cinema in Austria connect him with the 'New Austrian Cinema' of Franz Novotny*, Wolfgang Glück* and Wolfram Paulus*. With writer Helmut Zenker, Patzak created the popular television detective series *Kottan ermittelt* (1976–84), built round a fictional Viennese police officer, Kottan, and his eccentric team. *Kottan* contains a great deal of slapstick, references to popular culture and anarchic parodies of Austrian clichés and genre conventions. Patzak has also made literary adaptations (*Die Försterbuben*, 1984), social dramas such as *Kassbach* (1979), the por-

trait of a petit-bourgeois and his latent fascism, and action thrillers (*Killing Blue*, 1988). He has worked with international stars such as Elliott Gould (*Strawanzer*, 1983, Aust./Ger.) and Eddie Constantine (*Tiger – Frühling in Wien*, 1984, Aust./Ger.). Fascist attitudes in every-day life, hatred of foreigners and political corruption are Patzak's sub-jects, while his use of dialect and lower-class heroes, as well as borrowings from classic cinematic genres, have attracted a wide audi-ence. He is one of the few recent Austrian directors to have produced films with regularity. IR/AL

Bib: AG Film (eds), *Peter Patzak, Filme* (1983).

Other Films Include: *Situation* (1973); *Phönix an der Ecke* (1982); *Der Joker* (1987); *Im Kreis der Iris* (1992).

PAULUS, Wolfram Grossarl, Salzburg 1957

Austrian director, scriptwriter and editor. An exponent of 'New Austrian Cinema', Paulus started by making short films. His first fea-ture, the black-and-white *Heidenlöcher* (1985), based on a true story from the Nazi period, was set in a mountain village in the Salzburg province. It uses local dialect and mainly amateur actors and was de-scribed as a 'New *Heimatfilm*' [> HEIMATFILM], winning many prizes. Paulus' work aims at a deromanticised (though poetic), culturally and sociologically based image of life in the countryside, with its routines and conflicts, in contrast to the glossy representations of the 1950s and 1960s. It deals with the devastating impact of tourism on rural com-munities and with conflicts related to Catholicism, as well as with ne-glected parts of Austrian history of the 1930s and 1940s, with its 'everyday' fascism. Paulus' second and third features, *Nachsaison/Off Season* (1987) and *Ministranten/The Altar Boys* (1990, the story of schoolboys in the 1960s who form a gang in a rural valley), continued in the same vein but in a less radical form. *Du bringst mich noch um/You're Driving Me Crazy* (1994) represents his attempt at a new orientation: it is a comedy with urban surroundings and professional actors, and more literary dialogue. SSc

PETERSEN, Wolfgang Emden 1941

German director. A graduate of the Deutsche Film und Fernse-hakademie Berlin, Petersen directed numerous television productions, notably thrillers for the popular crime series *Tatort*, before making his first feature film, *Einer von uns beiden* (1973), a solid, professionally crafted piece of story-telling. Hired by producer Günther Rohrbach, he turned the big-budget WDR/Bavaria production *Das Boot/The Boat* (1981) into one of the German cinema's rare international

box-office hits. Petersen's follow-up, the most expensive film ever made in Germany (*Die unendliche Geschichte/The Neverending Story*, 1984), was shot in English, becoming his passport to Hollywood, where Petersen seems set to remain a successful director of thrillers (*Shattered*, 1991; *In the Line of Fire*, 1993; *Outbreak*, 1994). MW

Bib: Wolfgang Petersen (with Ulrich Greiwe), *Ich liebe die großen Geschichten: Vom 'Tatort' bis nach Hollywood* (1997).

Other Films Include: *Air Force One* (1997, US), *The Perfect Storm* (1999, US).

PICK, Lupu Jassy, Romania 1886 – Berlin 1931

Romanian-born director and actor, who as an actor played in Richard Oswald* fantasy films, Henny Porten* comedies and the Joe Jenkins and Stuart Webb detective series. His last and best-known role was as the Japanese diplomat Massimoto in Lang's* *Spione/The Spy* (1928).

Pick's first directorial assignments were popular star vehicles, including a futuristic anticipation of television (*Der Weltspiegel/The Mirror of the World*, 1918). In the early 1920s he collaborated closely with writer Carl Mayer* on *Kammerspielfilme**, which they inaugurated with *Scherben/Shattered* (1921) and *Sylvester* (1923). The films' critical success and aesthetic influence on Weimar* cinema are traditionally attributed to Mayer, but it was as much due to Pick's distinctive use of camera movement, sparse decors, and the natural flow of *mise-en-scène* (with only one intertitle in *Scherben*) that the genre generated an atmospheric intensity around its sociological representation of the everyday. A trilogy was conceived that would have included *Der letzte Mann/The Last Laugh* (1924), but a disagreement between Pick and Mayer led Pick to leave the project and the assignment went to F. W. Murnau*. Thereafter, Pick made only a few films, some unjustly forgotten, like the intriguingly offbeat *Gassenhauer* (1931). MW/TE

Other Films Include: *Mr. Wu* (1918); *Herr über Leben und Tod* (1919); *Zum Paradies der Damen* (1922); *Eine Nacht in London/A Night in London* (1928); *Napoleon auf St. Helena* (1929).

PIEL, Harry Düsseldorf 1892 – Munich 1963

German actor and director. At first employed by Gaumont and working for Léonce Perret, Piel wrote and directed a number of increasingly successful action films and detective series, which not only earned him the label of 'dynamite director' but also allowed him to establish his own production company in 1915. With *Der große*

Unbekannte (1919), he created the adventure hero 'Harry Peel', played by himself, making him one of the most famous screen actors in Germany.

Benefiting from hyper-inflation, he produced big-budget films in Germany largely with hard currency: *Rivalen* (1923) for the British Apex Film, *Schneller als der Tod* (1925) for Gaumont. In the late 1920s he completed several films for German companies, among them *Sein größter Bluff* (1927), starring Marlene Dietrich*, and was able to re-establish his place within the industry through a number of box-office hits (*Menschen, Tiere, Sensationen*, 1938). During the war years he completed only one film, *Panik* (1943), which was banned because its war sequences were deemed too realistic. Piel re-established his Ariel-Film company in 1950, producing his own film, *Der Tiger Akbar* (1951). MW

Bib: Matias Bleckmann, *Harry Piel: Ein Kino-Mythos und seine Zeit* (1993).

PINSCHEWER, Julius
Hohensalza-Posen 1883 – Berne 1961

German-Swiss producer and director, who started in film in Berlin in 1910 and during the same year began producing short advertising films (for his company Pinschewer Film), convinced that promotional film-making should attain the same standards as narrative film. Diversifying into short commercial scenes, trick-movies (some photographed by Guido Seeber*) and slapstick comedies – with popular stars such as Otto Gebühr*, Curt Bois*, Alfred Braun and Asta Nielsen* – Pinschewer soon became one of Germany's leading producers. Making political propaganda on the same principles as commercial advertising, Pinschewer also gained an influential position in German propaganda during World War I, as head of his own distribution company, Vaterländischer Filmvertrieb. Increasingly specialising in industrial films and animated shorts after 1920, Pinschewer's studios collaborated with prominent artists such as Lotte Reiniger* and Walter Ruttmann* and animators such as Harry Jaeger, Hermann Abeking and Fischerkoesen. In 1925, the year in which his *Kipho* (co-dir. Guido Seeber*) was presented at the Kino- und Photoausstellung Berlin, Pinschewer held the monopoly for exhibiting advertising films in all German Ufa* cinemas as well as in other cinemas, variety halls, and operetta houses in over 450 cities

Increasingly ousted from the German market in the late 1920s by the newly founded Echo Reklame Gesellschaft, Pinschewer still pioneered the first sound commercial, the nine-minute *Die chinesische Nachtigall* (1929), before he took refuge from the Nazis in Berne in 1934. Back to square one, he soon managed to establish a new studio and produced animated advertising films for the Swiss and sometimes

the British market until the mid-1950s, in the process becoming the founder of the Swiss animation film tradition. Among the small number of his non-commercial productions are *Chad Gadjo* (1930), *Hatikwah* (1949), *Ein Schweizer Bauernkünstler. Jean-Jacques Hauswirth 1808–1871* (1952). MW

Bib: Roland Cosandey, *Julius Pinschewer: Cinquante ans de cinéma d'animation* (1989).

POMMER, Erich
<div align="right">Hildesheim 1889 –
Los Angeles, California 1966</div>

German producer, both driving force and *éminence grise* of fifty years of German cinema history. A former employee of Gaumont and Eclair, Pommer founded Decla (Deutsche Eclair) in 1915, which later merged with Bioskop (Decla-Bioskop) and in 1923 was absorbed by Ufa*, where he became a key member of the directorial board. A European by temperament and conviction [> FILM EUROPE], Pommer produced many of the most artistically and commercially successful German films of the Weimar* cinema. After a brief stint in Hollywood (1926–27), he returned to Germany, on loan from his American employers. The Nazi takeover forced Pommer to resume his globetrotting, which took him to Paris (1933), Hollywood (1934), London – where he founded Mayflower Pictures with Charles Laughton in 1937 – and again Hollywood (1940). He returned to Germany as an officer in the US Army in 1946, supervising the first licensing of production companies in the post-Nazi film industry. He returned to Hollywood in 1956. TE/MW

Bib: Wolfgang Jacobsen, *Erich Pommer: Ein Produzent macht Filmgeschichte* (1989); Ursula Hardt, *From Caligari to Casablanca: Erich Pommer's Life in the International Film Wars* (1996).

PORTEN, Henny
<div align="right">Frida Ulricke Porten;
Magdeburg 1890 – Berlin 1960</div>

German actress. Daughter of the cameraman and director Franz Porten, Henny Porten began assisting her father at an early age and soon became the star attraction of the Messter* Projektion company, having her own series by 1913. During her career of almost fifty years, Porten played under the direction of reliable entertainment directors such as Adolf Gärtner, Curt A. Stark, Rudolf Biebach and Carl Froelich* (*Mutter und Kind*, 1924), as well as with more ambitious directors like Ernst Lubitsch* (*Kohlhiesels Töchter, Anna Boleyn*, both 1920), Robert Wiene* (*I.N.R.I. Ein Film der Menschlichkeit*, 1923),

E. A. Dupont* (*Die Geier-Wally*, 1921), Paul Leni* (*Hintertreppe/Backstairs*, 1921, co-dir. Leopold Jessner) and G. W. Pabst* (*Skandal um Eva*, 1930, her first sound movie). Also a producer, she was the star embodiment of the typical German 'wife and mother'. In the 1930s, her career was uneven, despite remakes of her silent successes. The target of accusations from the political left as well as the right, after World War II Porten found it difficult to continue, opting for minor roles in two DEFA* films (*Carola Lamberti – Eine vom Zirkus*, 1954; *Das Fräulein von Scuderi*, 1955), before retiring from filming. TE/KU

Bib: Helga Belach, *Henny Porten: Der erste deutsche Filmstar 1890–1960* (1986).

Other Films Include: *Schatten des Meeres* (1912); *Die blaue Laterne* (1918); *Das alte Gesetz* (1923); *Violantha/Die Königin der Berge* (1927); *Alle machen mit* (1933); *Wenn der junge Wein blüht* (1943).

PRAUNHEIM, Rosa von
Holger Mischwitzky;
Riga, Latvia 1942

German director and radical militant gay activist. He started out in the underground cinema and then made hilarious genre parodies – many for television – such as *Die Bettwurst/The Bedroll* (1970). Praunheim became internationally famous with the provocative *Nicht der Homosexuelle ist pervers, sondern die Situation, in der er lebt* (1971). This television film was highly controversial because it used negative stereotyping of gay men in order to politicise them, and indeed the film helped bring about the gay liberation struggle in West Germany. Praunheim made a musical about AIDS, *Ein Virus kennt keine Moral/A Virus Knows no Morality* (1986), and an AIDS trilogy: *Positiv/Positive* (1989), *Schweigen = Tod/Silence = Death* (1989), *Feuer unterm Arsch/Asses on Fire* (1990). Many of his films, whether fiction or documentary, are about social outsiders: *Tally Brown in New York* (1979) is about an ageing female performer; *Stadt der verlorenen Seelen – Berlin Blues/City of Lost Souls* (1983) brings together black transsexuals and transvestites, a Jewish trapeze artist and other performers; and *Ich bin meine eigene Frau/I Am My Own Woman* (1992) is not only a funny and compassionate biopic of the witty transvestite Charlotte von Mahlsdorf but also a political reflection on life in the former East Germany. Praunheim's aim is to change attitudes towards minorities, not just gays. His work is usually humorous, though always confrontational in its attacks on dominant notions of good taste and decency. US

Bib: Richard Dyer, *Now You See It: Studies on Lesbian and Gay Film* (1990); Rosa von Praunheim, *Fünfzig Jahre pervers* (1993).

PRODUCTION

Producers. Individuals such as Max Skladanowsky* and Guido See-ber* controlled all aspects of film-making at the turn of the century. They directed the films as well as overseeing their editing, camera-work, exhibition and financing. As film production transformed itself into an important branch of the economy around 1910, the role of film producer/manager became a distinct profession within the industry.

Because of their complexity and expense, longer films required a more specific division of labour. As a result, the creative and the financial aspects of film production were gradually separated from each other. The producer became responsible for managing finances, leaving artistic control largely to the director. Oskar Messter* began to commission directors to produce particular genres in 1896 (for example, Franz Porten who specialised in 'Tonbilder' (sound pictures) [> WILHELMINE CINEMA]. Messter himself was not active in directing. Paul Davidson*, general director of Projektions AG 'Union' (PAGU*) from 1909 onwards, organised film production by building up teams of company employees who fulfilled different functions (di-rector, screenwriter, cameraman, set designer, actors). For example, Ernst Lubitsch* was in charge of the artistic direction of a team that included screenwriter Hanns Kräly*, cameraman Theodor Sparkuhl, set designers Kurt Richter and Ernst Stern and actors Erich Schönfelder, Harry Liedtke*, Victor Janson, Margarete Kupfer, Ossi Oswalda*. Division of labour was not, however, strictly observed even at PAGU: Lubitsch and Kräly also acted, and Davidson's world-class star, Asta Nielsen*, collaborated on her films' screenplays.

Companies such as Decla and Ufa* divided the tasks of financial manager and producer beginning in the late 1910s, with the central producer under management's control. Erich Pommer*, Ufa's central producer between February 1923 and January 1926, gave his directors a free hand to work without fixed budgets, release dates or production plans. As a member of the Ufa board of management, Pommer tried to represent the director's interests to the board, which was respon-sible for financial decisions.

Ufa* was reorganised in 1927 under a new general manager, Ludwig Klitzsch*. The areas of financing and production became strictly div-ided from each other and the producer-unit system was introduced. Within this system, five producers worked under a central producer, chosen by the board of directors. The five producers, called 'heads of production team' ('Herstellungsgruppenleiter'), specialised in organis-ing productions of particular film genres. Erich Pommer, who special-ised in producing high class films, represents one example of this system.

The producer-unit system was introduced at Ufa* at about the same time it became the norm in the US. While Hollywood's seven major producing studios made it into a standard procedure for film productions during the 1930s and 1940s, the producer-unit system in

194

Germany remained the exception. Throughout its history, Germany's film industry was made up of too many small production firms, so that only in the period under the Nazis, during which Germany's film industry was nationalised, did the Ufa model prevail. Normally, the producer/manager of the smaller film companies was dependent on the distribution firm that had helped finance the film, and often had a decisive voice, especially in casting decisions [> DISTRIBUTION].

That small German production companies were at the mercy of large distributors continued to be the case until the 1970s. Distributors such as Herzog, Schorcht, Gloria* and Constantin* controlled production decisions of Berolina-Film*, Junge Film-Union, CCC, Arca and Rialto. For example, Kurt Ulrich, producer of Berolina-Film, had to negotiate distribution guarantees and casting decisions with Ilse Kubaschewski, head of Gloria*. Walfried Barthel, head of the distributor Constantin* arranged with Horst Wendlandt's Rialto and Wolf C. Hartwig's Rapid to be the exclusive distributor of their films in order to secure a competitive edge.

As the commercial success of American films in Germany grew during the 70s, German distributors (such as Constantin*) along with their suppliers, the small film production companies, went bankrupt. In an effort to regain control of the market, the distributor 'Neue Constantin' began to produce its own commercial films [> CONSTANTIN]. Under the new general director Bernd Eichinger* the jobs of financial manager, head of distribution and producer were merged, rather like it had been during the 1910s.

The introduction of film funding* for art cinema during the 1960s and 1970s meant that many films were subsidised to such a degree that they no longer needed to make profits at the box-office. Financing was arranged by the director who applied for grants from the funding institutions: the director becoming also the producer of his film. For this reason, directors of the New German Cinema* such as Alexander Kluge*, Werner Herzog* and Wim Wenders* were neither directors nor producers but 'film-makers'. The film-makers also had the final say on creative decisions affecting the film (camerawork, set design, music, editing and casting) although the jobs associated with these areas of production and post-production continued to be carried out by others. JG

Production Companies. The demands and tastes of movie audiences were not of primary concern to German film producers until roughly 1910. Oskar Messter* and the film companies Deutsche Mutoskop- und Biograph GmbH and Alfred Duskes made films in order to market film projectors and other technical equipment. As film production developed into an autonomous section of the film industry, audience demands increasingly determined what kind of films were made. The Brothers Skladanowsky*, Heinrich Bolten-Baeckers and Paul Davidson* were the key figures in films becoming exclusively a commodity produced for a paying public. This principle remained in place

195

until the early 1970s, despite Erich Pommer's* policy at Ufa* during the 20s (see above). Even the rise of propaganda films during the Third Reich did not fundamentally alter the supply and demand system which dominated the German film industry [> NATIONAL SOCIALISM AND GERMAN CINEMA].

The economic structure of the German film industry has remained by and large de-centralised since its beginnings in the 1910s. On average, only one film company out of three produced a film annually in 1930 (i.e. 405 firms produced 146 films); by 1960 however, each film company was producing an average of just over two films (i.e. 37 firms produced 94 films). A state-organised monopoly of Germany's film industry existed only between 1942–45 and between 1946–90 in East Germany [> DEFA].

The creation of large film companies in the 1920s also did not affect the industry's de-centralised structure in any fundamental way. PAGU* was the first fully integrated company in the German film industry. Ufa* adopted this model in 1917 and became the richest film company in Germany by taking over the companies Nordisk, Messter* and PAGU. Nonetheless, Ufa* produced only 6% of all German feature films between 1926 and 1928. The companies owned by Ufa* lost their legal independence after Ludwig Klitzsch's* reorganisation of the firm. Another push for integration of the German film industry took place in the 1930s. The percentage of films produced by larger film companies such as Ufa*, Bavaria and Tobis increased during this time, whilst film production by smaller firms fell: Ufa* produced 25% of all German films from 1935 to 1936 and Bavaria and Tobis made a combined total of 12% of all films. Germany's thirty-nine smaller film companies altogether produced 63% of all German films.

The real power of the large film companies lay not in production but in distribution*. Germany's 16 major distributors (Ufa*, National, Südfilm, Bayerische, among others) distributed 65% of all films exhibited in Germany to movie theaters from 1926 to 1928, Ufa* alone being responsible for 19.6%. The shift in power-relations became stronger during the 1930s, with up to 90% of production costs of a film being raised by the distributors by 1936.

The Nazi government systematically bought out German film companies starting in 1937, and by 1942 all the companies had been absorbed into one large company, the Ufa-Film GmbH ('Ufi'). In practice, the industry was run by a state-sponsored cartel which eliminated any competition, dependent on a state-funded subsidy system. Gradually the industry consolidated its finances, largely due to three factors: administrative cost-cutting after nationalisation, expansion of domestic markets through Nazi occupation of neighbouring countries and an increased audience demand for films during the war years.

Although in West Germany after 1945, distributors continued to finance the films of small production companies, just as they had during the 1920s and 1930s, the nature of film production changed in the late 1950s, as film companies co-produced more and more films with

196

other European companies. The drop in cinema attendance in France, Italy and Germany after 1956 encouraged German producers to follow this trend, since co-productions allowed film companies to share the burden of high production costs in the face of sinking box-office returns [> FILM EUROPE, EXPORT]. The rise of Neue Constantin as a producer reflects this trend, with films no longer made primarily for a German public. Bernd Eichinger*'s European blockbusters (*Das Boot*, 1981, *The Name of the Rose*, 1986, *House of Spirits*, 1993) are targeted for release on the international market. German financial, managerial and creative imput in other international, Hollywood-produced films often goes unnoticed. For instance, it is not widely known that the Cine Vox films *The Neverending Story II* (1990) and *Shattered* (1991), or Regency Enterprises productions such as *JFK* (1991), *Sommersby* (1992) and *Falling Down* (1993) were co-produced with German companies. Audiences (as opposed to critics) also remain largely indifferent to the fact that German cinematographers* such as Michael Ballhaus* (*Bram Stoker's Dracula*, 1993) and directors such as Carl Schenkel (*Knight Moves*, 1991), Wolfgang Petersen* (*Outbreak, Airforce One*), Roland Emmerich* (*Universal Soldier,* 1992, *Independence Day*) and Uli Edel (*Body of Evidence*, 1993) have in practice become Hollywood directors. JG

Bib: Claudia Dillmann-Kühn, *Artur Brauner und die CCC: Filmgeschäft, Produktionsalltag, Studiogeschichte 1946–1990* (1990); Wolfgang Jacobsen, *Erich Pommer: Ein Produzent macht Filmgeschichte* (1989); Michael Esser (ed.), *Berlin und das Kino. In Berlin produziert: 24 Firmengeschichten* (1987).

PULVER, Liselotte Berne 1929

Swiss-born actress, who worked originally on the stage, and became much loved for her blonde vivaciousness, pert personality and high-spirited laughter. She first appeared in Leopold Lindtberg's* *Swiss Tour* (1949), and Kurt Hoffmann* first directed her in a detective comedy (*Klettermaxe*, 1952), one of ten films they made together. Her breakthrough came with *Ich denke oft an Piroschka/Piroschka* (1955), after which she received international offers from, among others, Jacques Becker in France (*Les Aventures d'Arsène Lupin*, 1956) and Douglas Sirk (Detlef Sierck*) in the US (*A Time to Love and a Time to Die*, 1958). In her German productions she cultivated a comic, often capricious and obstinate persona and she became one of the most popular young actresses of German film, performing in numerous box-office hits such as *Das Wirtshaus im Spessart* (1957), *Kohlhiesels Töchter* (1962), *Die Bekenntnisse des Hochstaplers Felix Krull/The Confessions of Felix Krull* (1957) and *Buddenbrooks* (1959). She became one of the 'European' stars of the 1950s and 1960s; apart from Becker and Sirk, Billy Wilder directed her as James Cagney's provoca-

tive secretary in *One, Two, Three* (1961), and she worked in Spain, the US and France, where she appeared both in popular cinema, with stars such as Jean Gabin (*Monsieur*, 1964), and in *auteur* films, notably Jacques Rivette's *Suzanne Simonin, la religieuse de Diderot/La Religieuse/The Nun* (1965–67). MW/GV

PUTTI, Lya de Vesce 1897 – New York 1931

Hungarian-born actress, best remembered as the seductive Bertha-Marie in E. A. Dupont's* *Varieté/Variety* (1925). She began her career in a string of supporting roles, as in Richard Oswald's* *Die Liebschaften des Hektor Dalmore* (1921) and *Othello* (1922) with Emil Jannings*. In 1922 she appeared in two films by F. W. Murnau*, *Der brennende Acker* and *Phantom*. By the mid-1920s, de Putti starred in Lothar Mendes' *S.O.S. Die Insel der Tränen* (1923, opposite Paul Wegener*) and in Karl Grune's* *Eifersucht* (1925, opposite Werner Krauß*). After the success of *Varieté*, Adolph Zukor invited her to Hollywood in 1926, where she was typecast as the exotic, European *femme fatale* in five films, including D. W. Griffith's *Sorrows of Satan* (1926) and as a Russian revolutionary in *The Scarlet Lady* (1928). MW

Bib: Johannes Zeilinger, *Lya de Putti: Ein vergessenes Leben* (1991).

Q

QUALTINGER, Helmut Vienna 1928–86

Austrian actor, who became famous in the 1950s, primarily as a cabaret artist. Qualtinger created the characters of Travnicek and Herr Karl, malicious representations of 'true Viennese' figures whose easy-going nature and charm cover up stupidity, xenophobia and ignorance. In his first films, the oversize actor appeared in supporting roles based mainly on his corpulence. Later, in movies such as *Kurzer Prozess* (1967, dir. Michael Kehlmann), he was able to display his dramatic talent as the cranky police superintendent Pokorny. His parts became increasingly challenging in the 1970s, for example in *Das Schloß/The Castle* (1971, based on Kafka), in *Das falsche ewicht* (1971), and in *Grandison* (1979), where he impersonates a judge who 'crushes' the wife of a thief both physically and psychologically. One of his internationally famous films is Jean-Jacques Annaud's film ver-

sion of Umberto Eco's *Le Nom de la Rose/Der Name der Rose/The Name of the Rose* (1986). FM

Bib: Michael Horowitz, *Helmut Qualtinger* (1987).

R

RABENALT, Arthur Maria Vienna 1905

Austrian director, who stage-managed his first opera at the age of sixteen and for the next twelve years worked at several opera houses and theatres as a director, but was banned from stage management in 1933 because of his avant-gardist style. He trained with G. W. Pabst* and Alexander Korda and turned to writing and directing entertainment films such as *Was bin ich ohne Dich* (1934). From 1935 to 1938 he worked in Austria, Italy and France (working on the dialogue of *Die klugen Frauen*, the German-language version of Jacques Feyder's *La Kermesse héroique/Carnival in Flanders*, 1935). After 1938 he directed a series of light-hearted musical (for instance *Leichte Muse*, 1941) and circus (*Zirkus Renz*, 1943) films in Germany, but he is equally known for his propagandist film ... *reitet für Deutschland* (1941). After the war he continued stage work (founding the cabaret group *Schaubude*, directing musicals and dramas, managing theatres), published on theatre and film history, and stayed active as a film and, since 1959, television director. KU

Bib: Arthur Maria Rabenalt, *Der Film im Zwielicht* (1958).

Other Films Include: *Weißer Flieder* (1940); *Das Mädchen Christine* (1948); *Glücksritter* (1957); *Ein Haus voll Musik* (1965).

RADDATZ, Carl Werner Fritz; Mannheim 1912

German actor, specialising in 'officer and gentleman' roles, whose debut was in *Urlaub auf Ehrenwort* (1937, dir. Karl Ritter*), a nationalist army drama. Typecast as the aloof but acceptable face of the military in air force films about World War I (such as *Stukas*, 1941), Raddatz managed to infuse his performances in melodramas and women's films with an ambivalent sex appeal, lending credibility to roles as either hero or villain (*Verklungene Melodie*, 1938; *Immensee*, 1943). He worked for directors as different as Veit Harlan*

199

(*Opfergang*, 1944) and Helmut Käutner* (*Unter den Brücken*, 1945), and his charm remained in demand after the war. In the early 1960s Raddatz retired from cinema, concentrating instead on theatre and television work. TE/KU

Other Films Include: *Wunschkonzert* (1940); *In jenen Tagen* (1947); *Das Mädchen Rosemarie* (1958); *Jons und Erdme* (1959).

RASP, Fritz Bayreuth 1891 – Gäfelfing 1976

German actor, who played chillingly impressive villains for more than five decades. After supporting roles in Fritz Lang's* films, Rasp took leads in G. W. Pabst's* *Die Liebe der Jeanne Ney/The Loves of Jeanne Ney* (1927), *Das Tagebuch einer Verlorenen/The Diary of a Lost Girl* (1929) and *Die Dreigroschenoper/The Threepenny Opera* (1931). His refusal to feature in Ufa* propaganda films obliged him to work with smaller companies in the 1930s and 1940s, where one of his most memorable parts was as the visionary scholar in Pabst's *Paracelsus* (1943). Rasp's comeback in the late 1950s centred on the renewed popularity of the Edgar Wallace crime series, with his acting in *Froen med Masken* (1959, Den.), *Die Bande des Schreckens* (1960) and *Der Zinker* (1963) a mock-ironic version of the evil malevolence Rasp himself had so decisively fashioned in the 1920s. MW

Other Films Include: *Schuhpalast Pinkus* (1916); *Schatten/Warning Shadows* (1923); *Das Haus der Lüge* (1926); *Dreyfus* (1930); *Emil und die Detektive/Emil and the Detectives* (1931); *Nanu, Sie kennen Korff noch nicht!* (1938); *Es war eine rauschende Ballnacht* (1939); *Irgendwo in Berlin* (1946); *Magic Fire* (1955, US); *Dr. med. Hiob Praetorius* (1964); *Lina Braake – oder: Die Interessen der Bank können nicht die Interessen sein, die Lina Braake hat* (1975).

REINECKER, Herbert Hagen 1914

German scriptwriter, notable for the length of his career in both film and television. Reinecker's first treatment for a feature film was *Der Fall Rainer* (1942), after which he co-scripted with A. Weidemann the propaganda film *Junge Adler* (1944). Because of his association with ideologically dubious projects, his postwar return to cinema was slow, but after his screenplay for *Canaris* (1954) won the Deutscher Filmpreis he was once more much in demand. In the 1960s, Reinecker specialised in adventure and crime stories. With television producer Helmut Ringelmann he pioneered the first, long-running German television detective series at ZDF, *Der Kommissar*, scripting ninety-seven episodes. Since 1973 Reinecker has been chief writer on the nationally and internationally successful German television crime series, *Derrick*. JG

Bib: Ricarda Strobel, *Herbert Reinecker* (1992).

Other Films Include: *Kinder, Mütter und ein General* (1955); *Spion für Deutschland, Der Stern von Afrika* (1956); *Der Fuchs von Paris* (1957); *Taiga, Die Trapp-Familie in Amerika* (1958); *Bumerang* (1959); *Schachnovelle* (1960); *Der Hexer, Die Goldsucher von Arkansas* (1964); *Rheinsberg* (1967); *Der Tod im roten Jaguar, Winnetou und Shatterhand im Tal der Toten* (1968).

REINERT, Charles Basle 1899 – Fribourg 1963

Swiss film publicist. A Jesuit priest, Reinert founded the Zurich *Filmbüro des schweizerischen katholischen Volksvereins* and its periodical *Der Filmberater* in 1941, thereby establishing the long and still continuing history of denominational involvement in the Swiss film scene. Through the institution and the periodical he tried to exert moral influence on the Swiss film industry, during and after World War II. In addition, Reinert edited probably the first comprehensive encyclopedia of all aspects of world cinema (*Kleines Filmlexikon*, 1946, Italian version by Pasinetti, 1948), which, supplemented by a handbook in 1960 (*Wir vom Film*), was to remain for some three decades one of the primary sources of information on film for the German-speaking public. MW

REINHARDT, Max Maximilian Goldmann; Baden, near Vienna 1873 – New York 1943

Austrian-born director, who, through his theatre work, was the single most important stylistic influence on Expressionist film* and *Kammerspielfilm**. As the director and later owner of the Deutsche Theater Berlin (1905–20 and 1924–33), Reinhardt redefined stagecraft in Germany and dominated the bourgeois theatre. Between 1909 and 1914 he directed four films, including *Sumurun* (1909), *Insel der Seligen* (1913), based on motifs from Shakespeare, and *Eine venezianische Nacht* (1914), but he was particularly crucial in training the elite of German actors who were to move between the theatre and the cinema during the 1910s and 1920s. His staging of crowds found echoes in the films of Fritz Lang* and F. W. Murnau*, and he decisively shaped the atmospheric lighting style and *mise-en-scène* of German art cinema up to 1924, in contrast to Erwin Piscator's constructivist theatre, which influenced Brecht and proletarian cinema [> ARBEITERFILME]. As the Nazis expropriated his theatres, Reinhardt toured Europe. In 1934 he emigrated to the US, where he directed *A Midsummer Night's Dream* (1935, co-dir. Wilhelm Dieterle*), for Warner Bros, before concentrating on his acting school in New York. One of his sons, Gottfried Reinhardt, became a Hollywood producer. TE/KU

Bib: Lotte Eisner, *The Haunted Screen: Expressionism in the German Cinema and the Influence of Max Reinhardt* (1969).

REINIGER, Lotte Berlin 1899 – Dettenhausen 1981

German film animator, famous for her silhouette films, created from back-lit paper cut-outs. After designing film titles, Reiniger made her first animation film in 1919 and between 1920 and 1924 perfected her style in advertising films for Julius Pinschewer*. Reiniger animated a dream sequence (the famous falcon dream) for Fritz Lang's* *Die Nibelungen* (1924), which, although removed from the finished film, was widely screened. The banker Louis Hagen funded Reiniger's master-piece, a feature-length silhouette film (*Die Abenteuer des Prinzen Achmed/The Adventures of Prince Achmed*, 1926; credited by some as the first feature-length animation film) for which she created 250,000 single images and had a 'multiplane' camera specially designed and built.

From the late 1920s to the mid-1930s, Reiniger worked within the Berlin avant-garde milieu, making experimental shorts while continuing with silhouette films, for instance *Doktor Dolittle und seine Tiere* (1928). She also contributed silhouette sequences to live-action films, notably G. W. Pabst's* *Don Quichotte/Don Quixote* (1933) and Jean Renoir's *La Marseillaise* (1937). From 1936 she lived in Britain and worked for the Crown Film Unit and the General Post Office Film Unit, making some short films. In 1953–55 she received commissions from British and Canadian television, and in the 1960s shifted her work to the theatre, opera and book illustrations. MW

Bib: Christel Strobel and Hans Strobel, *Lotte Reiniger* (1993).

REINL, Harald Bad Ischl, Austria 1908 – Puerto de la Cruz, Tenerife 1986

add to DEFA

Austrian-born director. Reinl was Leni Riefenstahl*'s stunt double in *Stürme über dem Montblanc* (1930), and her assistant director on *Tiefland/Lowlands* (1940–44, released 1954), and in 1948–49 directed his first feature film, *Bergkristall* (1949). Reinl's service to German popular cinema was his re-crafting of traditional genres for postwar consumption. His knack of adapting popular Edgar Wallace crime novels (*Der Frosch mit der Maske*, 1959) and Karl May adventure stories (*Der Schatz im Silbersee/The Treasure of Silver Lake*, 1962; *Winnetou I, II, III*, 1963–65; *Winnetou und Shatterhand im Tal der Toten*, 1968) made him one of the most bankable but also most critically scorned directors of the 1960s. TE/KU

202

REITZ, Edgar

REITZ, Edgar Morbach 1932

German director. Reitz shared directing and scripting credits for a number of films with Alexander Kluge*, for whom he was cameraman on *Abschied von gestern/Yesterday Girl* (1966). A co-signatory of the 'Oberhausen Manifesto' (1962), Reitz co-founded the Ulm Film Academy (Institut für Filmgestaltung Ulm), where he taught until 1968.

Reitz's early feature films, from *Mahlzeiten/Mealtimes* (1967) to *Stunde Null/Zero Hour* (1977), and including *Geschichten vom Kübelkind* (1963–70) and *Das goldene Ding* (1971), both co-directed by Ula Stöckl, established his place in the New German Cinema*, a fact only fully appreciated when *Heimat* (1984) became a worldwide success, both with audiences and critics, and Reitz's previous work was reassessed. By homing in on an ideologically loaded term, Reitz prompted much public soul-searching in Germany, while ostensibly responding to the controversy caused by the US television series *Holocaust*. *Heimat* examined German history from 1919 to 1982 as seen by the inhabitants of a small village. Its sequel, *Die zweite Heimat. Chronik einer Jugend* (1993), which concentrated on a shorter period (the late 1960s) and a different social environment (students in Munich), did not evoke the same public response. *Heimat* and its sequel were made for both theatrical and television release. MW/TE

Bib: Reinhold Rauh, *Edgar Reitz: Film als Heimat* (1993).

REMAKES

Generic term/production strategy. The recurring commercial success in Germany of remakes of popular domestic films until the mid-1960s points to the existence of specific national film conventions. These conventions, established by the domestic film industry, drew on German (literary) culture to create paradigms with which national audiences could identify. Films which had been successful in the past were replaced by remakes once star images, cinematic form or technique had undergone a break, such as the switch to sound, colour or widescreen.

Many German films made in the 1910s were remade in the 1920s (e.g. *Der Student von Prag*, 1913, remade 1926; *Die blaue Maus*, 1913, remade 1928), and many successful silent films came out in sound versions in the early 1930s, such as *Der Andere* (1913, remade 1930), *Die vom Niederrhein* (1925, remade 1933) or *Die elf Schillschen Offiziere* (1926, remade 1932). Many film hits of the Weimar years were remade in the 1950s and the first half of the 1960s. At least 20% of the top ten films in Germany during the 1950s were new (usually colour) versions of pre-war German black-and-white films, such as *Schwarzwaldmädel* (1950, prior version 1933). Some of the films were once again remade in the first half of the 1960s, usually as wide-screen films, on the

strength of the popularity of the 1950s remake. One example of this phenomenon is *Charleys Tante* which had two successful remakes in 1955 and in 1963). Some stories were remade repeatedly until 1971, after which time the popularity of Hollywood films made the classics of the German cinema fade from cultural memory [> AMERICAN FILMS IN GERMANY]. For example, the operetta *Die Försterchristl* was made into a film four times between 1926 and 1962 [> GERMAN CINEMA: MUSICALS].

Foreign film companies also remade German films for their own markets (an English version of the German film *Der Tunnel*, 1933, was released in England as *The Tunnel* in 1935). Such remakes of successful German films were considered necessary in the 1930s, partly for language reasons, partly to counter negative prejudices encountered by the German original. The preference of national audiences for domestic stars throughout Europe [> STAR SYSTEM] led producers to substitute nationally known stars in such remakes.

Whilst the practice of remakes for a particular European audience was abandoned in the 1960s, American remakes of popular European, particularly French films, are common. This is allegedly because the American mainstream public does not like subtitled films or finds European narrative conventions confusing, in contrast to European audiences who became used to American film conventions very early on [> AMERICAN FILMS IN GERMANY]. Films such as *Trois hommes et un enfant* (1985), *Nikita* (1989) or *Spoorlos* (1989) were remade, transplanted to an American cultural context (*Three Men and a Baby*, 1987, *La Femme Nikita*, 1993 and *The Vanishing*, 1993) in order to guarantee a popular reception in the US. Among German films, only Wim Wenders'* *Der Himmel über Berlin/Wings of Desire* (1987) was remade in 1997 as *City of Angels* although *Männer* (1985, dir. Doris Dörrie*) and *Bandits* (1997, dir. Katja von Garnier) have been under consideration. JG/MW

RIEFENSTAHL, Leni Berlin 1902

German director. Trained as a dancer, Riefenstahl started her film career as an actress in Arnold Fanck's* 'mountain films' (*Der heilige Berg/The Holy Mountain*, 1926, among others). With her first film as a director, *Das blaue Licht/The Blue Light* (1932), Riefenstahl not only gained critical and commercial success, but also won Hitler's personal approval, leading to a commission to film the Nuremberg Party Convention in 1934. *Triumph des Willens/Triumph of the Will* (1935), with its careful orchestration of narrative structure and spectacle, remains the best-known film of Nazi cinema, retaining its ambivalent power of propaganda and visual pleasure. Riefenstahl thought of herself as an independent film artist but claimed that it was her close personal relationship with the Führer which led to her second feature-length documentary, the two-part *Olympia* (1938), a record of the

1936 Olympic Games. Detained in Allied prison camps for almost four years on charges of pro-Nazi activity, she found herself economically as well as socially isolated after the war. After numerous attempts to restart a career in film, she turned successfully to photography, attracting fiercely loyal admirers but also implacable and unforgiving critics. MW

Bib: Leni Riefenstahl, *The Sieve of Time* (1992).

Other Films as Director: *Der Sieg des Glaubens/Victory of Faith* (1933, short); *Tag der Freiheit: Unsere Wehrmacht/Day of Freedom: Our Armed Forces* (1935); *Tiefland/Lowlands* (1940–54).

RIEMANN, Katja Kirchweyhe 1963

German actress who studied dancing in Hamburg and, considering the profession too demanding for a lucrative career, switched to acting in Hanover where she was discovered by theatre and TV director Peter Beauvais, who, shortly before his death, cast her for the six-part TV series *Sommer in Lesmona* (1986) and recommended her to the Munich Kammerspiele, where she worked until her TV career took off with a role in the crime series *Tatort* at the side of Götz George* in 1989 (*Katjas Schweigen/Katja's Silence*). After a brief stint at the Berlin Schiller-Theater under Alexander Lang during the 1990/91 season, a number of further TV productions (*Regina auf den Stufen,* 1989/90; *Von Gewalt keine Rede,* 1992; *Andere Umstände – Drei Männer und ein Baby,* 1993), and two film roles, she had her breakthrough to stardom in Sönke Wortmann's* romantic comedy *Der bewegte Mann/Maybe ... Maybe Not* (1994), making her the leading German film actress of the 1990s, a position she has successfully defended ever since. Stereotypically, a blonde beauty with a steely gaze and a laconic smile, she has become synonymous with the new audience appeal of 1990s German cinema, mostly in sophisticated comedies (*Nur über meine Leiche/Over My Dead Body,* 1994; *Stadtgespräch/Talk Of The Town,* 1995; *Die Apothekerin/The Pharmacist,* 1997) and musicals (*Bandits,* 1997; *Comedian Harmonists,* 1998), with only occasional forays into thriller (*Nur aus Liebe,* 1996) and drama (*The Long Hello and Short Goodbye,* 1998), genres she has so far kept very much reserved for her stage and TV roles. MW

Bib: Katharina Blum, *Katja Riemann: Mit Charme und Power* (1998).

RITTER, Karl Würzburg 1888 – Argentina 1977

German director, producer and screenwriter. After training as a professional soldier and seeing action in World War I, Ritter studied

architecture, worked as an illustrator and entered the film business in 1925 as producer and screenwriter. Resentful of the Versailles Treaty and frustrated by the Weimar Republic (later reflected in his *Pour le mérite*), Ritter joined the Nazi Party out of conviction. By the time Hitler came to power, Ritter had consolidated his position in the film industry: since 1932 he was chief producer at the 'Reichsliga', a right wing media lobby, and in 1933 Ufa* hired him as producer. His first Ufa production was the propagandist *Hitlerjunge Quex* (1933, directed by Hans Steinhoff*, who had already directed a number of Ritter scripts). Ritter was in charge of almost all subsequent Nazi propaganda films, besides sitting on the board of Ufa. Ritter's films extol sacrifice of the individual for the sake of the nation, often harking back to his World War I experience, as in *Unternehmen Michael*, 1937; *Pour le mérite*, 1938; *Stukas*, 1941, giving the genre of the 'soldier's film' a certain emotional force. His attempts at comedy (*Capriccio*, 1938; *Bal Paré*, 1940) were less convincing, even though his first short had been a comedy with Karl Valentin* (*Im Photoatelier*, 1932). In 1949 Ritter emigrated to Argentina, where his effort to establish a film company failed, as did an attempted comeback in Germany. KU

Bib: John Altmann, 'The Technique and Content of Hitler's War Propaganda Films: Karl Ritter and His Early Films'/'Karl Ritter's Soldier Films', *Hollywood Quarterly* (Summer/Fall 1950).

Other Films Include: *Urlaub auf Ehrenwort* (1937); *G.P.U.* (1942); *Ball der Nationen* (1956).

RÖHRIG, Walter Berlin 1897 – Potsdam 1945

German set designer, associated with the Expressionist Berlin Sturm group and a key figure of German art direction. A stage designer in the 1910s, he came to attention, along with Walter Reimann and Hermann Warm*, as the creator of the highly inventive sets for Robert Wiene's* classic *Das Cabinet des Dr Caligari* (1919). Collaborating for the first time on Paul Wegener's* *Der Golem, wie er in die Welt kam* (1920), Röhrig worked regularly with Robert Herlth (until 1936), on such key films as Murnau's* *Der letzte Mann* (1924), *Tartüff* (1925), and *Faust* (1926), but also for other leading directors of the Weimar cinema*: designing the prologue and epilogue of *Der müde Tod* (1921, dir. Fritz Lang*), *Der Schatz* (1923, dir. G. W. Pabst*), *Looping the Loop* (1926, dir. Arthur Robison), *Asphalt* (1929, dir. Joe May*), *Das Flötenkonzert von Sanssouci* (1930, dir. Gustav Ucicky*), and *Der Kongress tanzt* (1931, dir. Eric Charell*). During the Third Reich, Röhrig remained active, responsible among others for the sets of Schünzel's* *Amphitryon* (1935), one of the most stylistically daring films of the 1930s. MW

RÖKK, Marika

RÖKK, Marika Cairo 1913

German actress and leading revue-film star. Her film debut was in two British comedies (*Kiss Me, Sergeant, Why Sailors Leave Home*, both 1930), followed by two Hungarian films, before an Ufa* contract led to *Leichte Kavallerie* (dir. Werner Hochbaum*, 1935). But it was Georg Jacoby* (married to Rökk since 1940) who directed her star vehicles with rare continuity until 1959 (*Der Bettelstudent*, 1936; *Kora Terry*, 1940; *Die Frau meiner Träume*, 1944; *Kind der Donau*, 1950; *Bühne frei für Marika*, 1958). An exceptionally attractive and talented dancer, Rökk could carry off the cliché romance plot-lines, lavish settings and glamour costumes. More than any other film star of the Nazi period, she benefited from Ufa's enormous efforts to copy American musicals with the coming of sound and colour. MW

Bib: Helga Belach (ed.), *Wir tanzen um die Welt: Deutsche Revuefilme 1933–1945* (1979).

Other Films Include: *Hallo Janine!* (1939); *Frauen sind doch bessere Diplomaten* (1941); *Maske in Blau* (1953); *Die Fledermaus* (1962); *Schloß Königswald* (1987, TV).

ROMMER, Claire Berlin 1904

German actress, whose brief but phenomenal success lasted from 1922 to 1926 and is indicative of a largely forgotten popular film culture. Unlike many other German film stars, Rommer's fame was based less on the films she appeared in than on her fans' perception of her star image, cultivated via publicity material in fashion magazines and photographs on postcards and cigarette cards. Her first screen hit was *Wem nie durch Liebe Leid geschah!* in 1922, but she was equally known as a stage actress in light comedies (*Foppke, der Egoist* [Berliner Residenztheater, 1926]) and in soubrette roles from operettas and variety theatres (such as the Berlin Scala). Rommer emigrated when the Nazis came to power and was quickly forgotten in Germany. Because she is not associated with any of the 'classics' of Weimar* cinema, she has continued to be ignored by film historians. JG

RÜHMANN, Heinz Essen 1902 – Berlin 1994

German actor, director and producer. For over fifty years Rühmann typified the 'good German': an apolitical, reliable, shy Everyman who, while recognising official authorities, maintained his independence which he expressed through impudence and wiliness. Rühmann made nearly a hundred films, in practically all of which the plot revolves

207

around the conflict between the hero's middle-class ideals and the real-life circumstances which thwart him (*Wenn wir alle Engel wären*, 1936; *Der Mustergatte*, 1937).

In 1948, Rühmann attempted to change his image by co-founding the film company Comedia, which went bankrupt in 1952, proof that its star's image was fixed in the German audience's imagination and could not be changed at will. From the 1920s Rühmann also acted on stage, and he appeared frequently on television after 1968. As one of the most enduring of the nation's idealised self-images, he received many film awards for his contribution to the German entertainment industry. He also directed: *Lauter Lügen* (1938); *Lauter Liebe* (1940); *Sophienlund* (1943); *Der Engel mit dem Saitenspiel* (1944); *Die kupferne Hochzeit* (1948); *Briefträger Müller* (1953). JG

Bib: Hans Hellmut Kirst and Mathias Forster, *Das große Heinz Rühmann Buch* (1990).

RUTTMANN, Walter Frankfurt 1887 – Berlin 1941

German director. After studying painting and architecture, Ruttmann began working on a series of non-figurative shorts (*Lichtspiel Opus I–IV*, 1921) which brought him a considerable reputation in film circles and finally the assignment of the falcon dream sequence in Fritz Lang's* *Die Nibelungen* (1924) on which Lotte Reiniger* also worked, along with a commission to do commercials for Julius Pinschewer*. With *Berlin, die Sinfonie der Großstadt/Berlin, Symphony of a City* (1927), Ruttmann turned a quota production for Fox Europe into the one film that assures his place in film history. Applying graphic principles of his abstract geometrics to realistic photographs from the city of Berlin, Ruttmann achieved a perfection of rhythmic montage, enhanced by Edmund Meisel's* score and cinematography by Karl Freund*, which not only impressed S. M. Eisenstein, but has affected generations of avant-garde and documentary film-makers since [> DOCUMENTARY (GERMANY)]. His most radical project, *Wochenende/Weekend* (1931), was a film without images, recorded with a sound-on-film camera. Ruttmann became a Nazi, wrote an anti-semitic prologue (which was not used) to Leni Riefenstahl's* 1935 *Triumph des Willens/Triumph of the Will* and did supervisory editing on Riefenstahl's *Olympia* (1938). He was fatally wounded on the Eastern front while shooting newsreel footage in 1941. MW

Bib: Jeanpaul Goergen (ed.), *Walter Ruttmann: Eine Dokumentation* (1989).

Other Films Include: *Melodie der Welt/World Melody* (1929); *Feind im Blut* (1931); *Metall des Himmels* (1935); *Mannesmann* (1937); *Aberglaube* (1940).

208

RYE, Stellan
Ränders 1880 – Western Front 1914

Danish-born director. Rye began his career as an officer in the Danish army and made his debut as a playwright at the Dagmar Theatre in Copenhagen in 1906, writing several plays over the next few years. He worked as a stage director from 1910 and in 1911 wrote his first film script. The same year he was arrested and sentenced for homosexuality. He left for Berlin in 1912, where he worked again in theatre and film. In 1913 he directed *Der Student von Prag/The Student of Prague*, a macabre fantastic film, generally considered a key early example of German Expressionism*. This was followed by half a dozen films, including *Evinrude, die Geschichte eines Abenteurers/Evinrude, Die Augen des Ole Brandis/The Eyes of Ole Brandis*, and *Das Haus ohne Tür/The House Without a Door* (all 1914). Rye joined the German army in 1914 and died on the Western front later the same year. ME

S

SAGAN, Leontine
Leontine Schlesinger; Vienna 1899 – Pretoria, South Africa 1974

Austrian director. Sagan's main career was as a theatre director and stage actress (she studied with Max Reinhardt*), but she became famous with her first feature film, *Mädchen in Uniform/Maidens in Uniform* (1931), set in a girls' boarding school. On release it created a scandal, more for its criticism of the Prussian authoritarian education system than for its depiction of homoerotic desire. Feminist and gay film scholars reclaimed Sagan in the 1970s as one of the few female directors of the Weimar* period, and hailed her film as a milestone in lesbian film-making. She emigrated to Britain, where she made one more film, *Men of Tomorrow* (1932) for Alexander Korda, and later went to South Africa. US

SANDER, Helke
Berlin 1937

German director, and activist in the German women's movement. After working for television in Finland, Sanders attended the Berlin Deutsche Film- und Fernsehakademie (DFFB) and was the founder of *Frauen und Film*, which she edited from 1974 to 1983. Her semi-autobiographical fiction films (*Die allseitig reduzierte Persönlichkeit REDUPERS/The All-round Reduced Personality*, 1977; *Der subjective*

Faktor/The Subjective Factor, 1981; *Der Beginn aller Schrecken ist Liebe/Love is the Beginning of all Terrors*, 1984, in two of which she played the lead), comprised a sort of trilogy of different stages of women's self-realisation. Since 1980 she has held a post as professor of film at the Hochschule für Bildene Künste Hamburg, and has published short stories and novels. TE/KU

Other Films Include: *Viimeinen yö* (1964, TV, Fin.); *Brecht die Macht der Manipulateure* (1968, doc.); *Kindergärtnerin, was nun?/What Now, Nursery Workers?*, *Kinder sind keine Rinder/Children are not Cattle* (1969); *Eine Prämie für Irene/A Bonus for Irene* (1971); *Macht die Pille frei?* (1972, TV doc.); *Die Erfahrungsschere* (1985, TV); *Felix* (1987, co-dir.); *Die Deutschen und ihre Männer/The Germans and their Men* (1990); *Befreier und Befreite/Liberators Take Liberties* (1992, two parts).

SANDERS-BRAHMS, Helma Emden 1940

German director. A television presenter before making documentary portraits and a number of features dealing with working-class issues in didactic political film essays, Sanders-Brahms turned to the then much discussed 'foreign worker problem' for her first international success, *Shirins Hochzeit/Shirin's Wedding* (1976). Although she won the main federal prize for her next project, a Kleist adaptation (*Heinrich*, 1977), she was singled out by critics as the main offender in the general uproar about the abuse of literary adaptations.

From 1974 onwards she produced or co-produced most of her own films and altered their style, discarding political didacticism for radical subjectivism. These films visualised German history as female *Trauerarbeit* (mourning work), usually by trying to exorcise Oedipal mother-daughter relationships, a subject that had emerged with force in German women's cinema [> FRAUENFILM]. Her best-known film in this genre is *Deutschland, bleiche Mutter/Germany, Pale Mother* (1980), though her (generally ignored) follow-up, *Die Berührte/No Mercy No Future* (1981), is in many ways a cinematically tighter, visually more harrowing and emotionally more impressive achievement. Her work has since evolved in the direction of the 'European' art cinema*, as in *Flügel und Fesseln/The Future of Emily* (1984, Ger./Fr.) and *Laputa* (1986). She was one of the co-directors of the women's portmanteau film *Felix* (1987). Despite her manifold efforts in the early 1990s to preserve the DEFA* studios as a site of film production, Sanders-Brahms is one of the least-loved directors in Germany, a fact she has commented upon in numerous articles and polemics since the 1980s. TE/MW

Bib: Brigitte Tast (ed.), *Helma Sanders-Brahms* (1980).

SANDROCK, Adele Rotterdam 1863 – Berlin 1937

Dutch-born actress, who had her breakthrough in 1919 when, playing an old matron, she created a persona that she was to repeat with slight variations in most of the hundred-odd films she appeared in up to 1936. Sandrock often achieved comedy effect by exaggerating and parodying her own persona, especially when underscoring it with imperious gestures or when dressed in lavish, heavy costumes. Perfectly suited to represent old-fashioned battle-axes, she often played noblewomen, as in *Der Kongreß tanzt* (1931), although her best-remembered role is as the goddess Juno in Reinhold Schünzel's* *Amphitryon* (1935). Some of her other notable films include *Marissa, genannt die Schmugglermadonna* (1921), *Das Mädchen mit der Protektion* (1925), *Die Durchgängerin* (1928), *Die Förstelchristel* (1931), *Alles hört auf mein Kommando* (1934), and *Die Puppenfee* (1936). KU

Bib: Adele Sandrock, *Mein Leben* (1940).

SCHACHT, Roland Reichenberg 1888 – Berlin 1961

German critic and screenwriter who was, next to Willy Haas*, Kurt Pinthus and Herbert Jhering, one of the most productive film critics of the Weimar Republic. After publishing articles on literary topics, from 1919 he began to write film criticism for the theatre journal *Freie Deutsche Bühne*. His reviews subsequently appeared in a wide range of newspapers, such as *Der Kunstwart, B.Z. am Mittag, Berliner Börsen-Courier, Neue Berliner Zeitung, Deutsche Allgemeine Zeitung, Die Weltbühne, Die Hilfe, Der Bildwart*, and *Hannover Kurier*. His range of topics was equally impressive. Apart from reviewing films, Schacht wrote about production, distribution and cinema politics, film genres and other film specific questions, such as 'American films on the German market'. He considered film to be an autonomous, contemporary entertainment medium, equal to literature and theatre. Audience popularity seemed to him a more adequate criterion for judging films than one deriving from aesthetic and artistic concerns. An outsider among his *feuilleton* colleagues, Schacht often aligned himself with the trade perspectives of the film industry, even taking a pro-Hollywood stance, deriving the American film industry's superiority from its closer ties with audiences as well as the optimistic tone of its products. From the late 1920s he applied himself to other projects, including screenwriting (*Spiel mit dem Feuer,* 1934, *Die blonde Carmen,* 1935, *Frühlingsluft,* 1938, *Zwei Frauen,* 1938, *Verdacht auf Ursula,* 1939, and *Em Windstoß,* 1942). JG

SCHEIN, Harry
Vienna 1924

Austrian-born Swedish film critic and official. Initially an engineer, Schein came to Sweden in 1939. During the 1950s he was one of the most distinguished film critics in Sweden. He was also responsible for outlining the important reform of film policy in Sweden which led to the creation of the Swedish Film Institute in 1963, of which he was made managing director. Throughout the 1960s Schein was an advocate of the Social Democrat government and its cultural policy. Together with his powerful position, this made him a controversial head of the Institute; however, he worked there until 1978, when he came into conflict with the new conservative government. He has since worked as chairman of the Swedish broadcasting corporation (Sveriges Radio) and the national investment bank. He is also a novelist and columnist. LGA/BF

SCHELL, Maria
Margarethe Schell; Vienna 1926

Austrian-born actress, who made her debut at sixteen in the Swiss films *Steinbruch* and *Maturareise* (both 1942). Her first German film after World War II, *Der Engel mit der Posaune/The Angel with the Trumpet* (1948), brought her international fame and offers from the German film industry. Postwar German audiences warmed to Schell's overtly emotional acting as a vulnerable young woman, though critics were derisive. In the early 1950s she appeared with Dieter Borsche (*Dr Holl*, 1951) and O. W. Fischer (*Solange Du da bist*, 1953) in melodramas and love stories. Her subsequent success in artistically more ambitious films like *Die letzte Brücke/The Last Bridge* (1954), René Clément's *Gervaise* (1956, Fr.) and Alexandre Astruc's *Une Vie* (1958, Fr.) gave her an international career. She played in Luchino Visconti's *Le notti bianche/Nuits blanches/White Nights* (1957, It./Fr.) and in *The Brothers Karamazov* (1958, US) by Richard Brooks. Unlike German critics, Americans valued Schell's acting for its European sophistication. She continues to work in German-speaking film, theatre and television. TE/KU

Other Films Include: *The Magic Box* (1951, UK); *Die Ratten* (1955); *Rose Berndt* (1956); *Ich bin auch nur eine Frau/Only a Woman* (1961); *Folies bourgeoises/Die verrückten Reichen* (1976); *Der Besuch der alten Dame* (1982, TV, Switz.).

SCHLINGENSIEF, Christoph
Oberhausen 1960

German director, interventionist *enfant terrible* of the German cultural scene and one-man *Gesamtkunstwerk* who works in a variety of media (theatre, TV, art happening, web art) and under a variety of dis-

212

guises (sometimes credited as 'Thekla von Mülheim'). An autodidact twice refused admission by the Munich film school, his provocative, radically unconventional and highly self-reflexive low-budget work for the cinema since the mid-1980s has served to polarise German critics and audiences alike. A cultural shaman erratically hitting the traumatic spots of contemporary society, his obsession with *Vergangenheitsbewältigung* (coming to terms with the past, i.e. the Nazi period, as in *100 Jahre Adolf Hitler*, set in the *Führerbunker* during the last hour of World War II), with national identity and generational conflict has led critics to baptise him 'the last German Heimatfilmer' (Georg Seeßlen), but it also makes Schlingensief an awkward heir of R. W. Fassbinder's* generation, as whose undertaker he advertised himself in *Die 120 Tage von Bottrop* (1996), subtitled 'The Last New German Film'. One of his most popular films, and surely one of the most notorious and least characteristic contributions to the cinematic landscape of reunified Germany, was the cannibalistic *Das deutsche Kettensägenmassaker/The German Chainsaw Massacre* (1990), a political satire about the first days of reunification: a splatter movie in which the flood of Eastern refugees serves a butcher's family – tellingly named the 'Bürgers' – as the raw material for lunch. MW

Bib: Jutta Lochte/Wilfried Schulz (eds), *Schlingensief! Notruf für Deutschland: Über die Mission, das Theater und die Welt des Christoph Schlingensief* (1998).

Other Films Include: *Tunguska – Die Kisten sind da* (1984); *Die Schlacht der Idioten* (1986); *Menu total* (1986); *Egomania – Insel ohne Hoffnung* (1986); *Mutters Maske* (1988); *Terror 2000 – Intensivstation Deutschland* (1992); *United Trash* (1996).

SCHLÖNDORFF, Volker Wiesbaden 1939

German director, whose debut film was *Der junge Törless/Young Törless* (1966), the first international success of the Young German Cinema [> NEW GERMAN CINEMA]. In 1969 he founded (with Peter Fleischmann) the Munich-based production company Bioskop-Film, which has produced all his films since 1974. Schlöndorff's speciality became literary adaptations, and his film based on a novella by Heinrich Böll, *Die verlorene Ehre der Katharina Blum/The Lost Honour of Katharina Blum* (1975, co-directed by Schlöndorff's wife Margarethe von Trotta*), caught well the mood of latent hysteria in the years of left extremism and conservative witch-hunts. Schlöndorff also participated in topical collaborative projects, such as *Deutschland im Herbst/Germany in Autumn* (1978). Since winning an Oscar for the Günter Grass adaptation *Die Blechtrommel/The Tin Drum* (1979), Schlöndorff has preferred to work with large budgets and international stars in Europe and the US, directing films such as *Swann in*

213

Love/Un amour de Swann (1984, Fr./UK) with Jeremy Irons, Ornella Muti and Alain Delon, *Death of a Salesman* (1985, US) with Dustin Hoffman and John Malkovich, and *Homo Faber/The Voyager* (1991) with Sam Shepard. TE/SG

Bib: Rainer Lewandowski, *Die Filme von Volker Schlöndorff* (1981); Thilo Wydra, *Volker Schlöndorff und seine Filme* (1998).

Other Films Include: *Mord und Totschlag/A Degree of Murder* (1967); *Michael Kohlhaas Der Rebell* (1969); *Der plötzliche Reichtum der armen Leute von Kombach* (1971); *Strohfeuer/Summer Lightning* (1972); *Der Fangschuß* (1976); *Die Fälschung* (1981); *A Gathering of Old Men* (1987); *The Handmaid's Tale* (1990); *Der Unhold/The Ogre* (1996); *Palmetto* (1998).

SCHMID, Daniel

Flims 1941

Swiss director, who studied history, political science, advertising and art history in Berlin, Mexico and Berkeley before enrolling at the Film Academy in Berlin and assisting Peter Lilienthal between 1966 and 1970. Schmid's own films, beginning with his fictional documentary about the last servants' school in Europe (*Thut alles im Finstern, Eurem Herrn das Licht zu ersparen*, 1971), and an account of an annual banqueting ritual during which traditional master and servant roles are reversed (*Heute nacht oder nie*, 1972), are part of a baroque, romantic and theatrical tradition. This situates him closer to the work of German directors such as R. W. Fassbinder*, Hans Jürgen Syberberg* and Werner Schroeter* (on whose films Schmid repeatedly collaborated as actor or assistant director) than to the more realistic aesthetics of the 'new Swiss cinema' developed in French-speaking Switzerland at the time. Equally 'German' preoccupations are in evidence in the morbid melodrama *La Paloma* (1974) and in his first international production *Violanta* (1977, starring Lucia Bosé, Anne-Marie Blanc and Gérard Depardieu), as well as in *Hécate* (1982), but above all in the controversial *Schatten der Engel/Shadows of Angels* (1975), an adaptation of R. W. Fassbinder's* provocative play *Die Stadt, der Müll und der Tod*, co-written by and co-starring Fassbinder himself. A bewildering amalgam of occultism, psychiatry, drugs and politics in *Der Tee der drei alten Damen* (1990), and the visual conjuring of memories in *Hors saison* (1992), are also more on the margins of Swiss national cinema. Schmid's dreamlike reflections on excess, artifice and cinematic representation have nevertheless secured him a place as the 'magician' among the directors of his generation. MW

Bib: Patrizia Landgraf (ed.), *Daniel Schmid* (1988).

Other Films Include: *Notre Dame de la Croisette* (1981); *Mirage de la vie* (1983, a portrait of Douglas Sirk); *Il bacio di Tosca* (1984); *Jenatsch* (1987); *Les Amateurs/The Amateurs* (1990), *Zwischensaison/Off Season* (1992), *Das Geschriebene Gesicht/The Written Face* (1995).

SCHMITZ, Sybille
Maria Christine Schmitz;
Düren 1909 – Munich 1955

German actress who started her career on stage, and entered cinema in 1928 with *Freie Fahrt*, a propaganda film for the Social Democratic Party (SPD). Three years later she established her reputation as the mysterious beauty in Carl Theodor Dreyer's* *Vampyr* (1932). Audiences were fascinated by her exotic and emancipated eroticism, which combined pure sensuality (*Die Unbekannte*, 1936) with strength of character (e.g. as George Sand in *Abschiedswalzer*, 1934). From 1938 she appeared in several more or less overtly tendentious Nazi propaganda films (*Wetterleuchten um Barbara*, 1941). Her highly strung spirituality did not accommodate itself well to the mores of postwar German cinema, and as her fame declined, her personal life suffered, ending in suicide in 1955. Fassbinder's* *Veronika Voss* is said to be based on Sybille Schmitz' final years. KU

Other Films Include: *F.P.1 antwortet nicht* (1932); *Ein idealer Gatte* (1935); *Die Umwege des schönen Karl* (1937); *Trenck, der Pandur* (1940); *Das Leben ruft* (1944); *Zwischen gestern und morgen* (1947); *Das Haus an der Küste* (1953).

SCHNEIDER, Romy
Rosemarie Albach-Retty; Vienna
1938 – Paris 1982

Austrian-born actress. The daughter of actors Wolf Albach-Retty and Magda Schneider, the beautiful Romy Schneider played her first role as her real mother's daughter in *Wenn der weiße Flieder wieder blüht* (1953, Ger.), the duo becoming the most popular film couple of 1950s German-speaking cinema. Schneider also enjoyed popular success as Queen Victoria in *Mädchenjahre einer Königin* (1954), but Ernst Marischka's* 'Sissi' trilogy – *Sissi* (1955), *Sissi – die junge Kaiserin* (1956) and *Sissi –Schicksalsjahre einer Kaiserin* (1957) – in which she played the romanticised Empress Elizabeth of Austria, turned her into a mass icon. Disparaged by critics, the movies enjoyed huge popular acclaim throughout Europe, and helped consolidate a particular Austrian image by quoting the country's myths (the scenery, the Habsburg dynasty, Viennese waltzes ...). After appearing in two successful remakes – *Mädchen in Uniform* and *Christine* – in 1958, she moved to France. Against the wishes of producers and audiences, she

distanced herself from the Sissi image and embarked on a career as a serious character actress (successfully, except in Germany). In the 1960s and 1970s she worked in international art cinema, with Luchino Visconti, Orson Welles (*Le Procès/The Trial*, 1962), Joseph Losey (*L'Assassinat de Trotsky/The Assassination of Trotsky*, 1972), but especially in France, mostly with Claude Sautet. In Sautet's *Les Choses de la vie/The Things of Life* (1970), *César et Rosalie* (1972) and *Mado* (1976) among other films, she portrayed, alongside actors like Michel Piccoli and Yves Montand, 'modern' women, though her characters' emancipation was limited to sexuality and usually ended in compromise. She reached the height of her international career in Visconti's *Ludwig* (1972), portraying a mature, hard Elizabeth who had nothing in common with the Sissi of the earlier films. Her relationship with her native country and its history was ambivalent and she appeared in several films critical of fascism, including *La Passante du Sans-Souci/Die Spaziergängerin von Sans-Souci* (1982, Fr./Ger.), her last film. Schneider was for long an object of gossip press speculation, especially at the time of her liaison with Alain Delon (with whom she appeared in, among other films, *La Piscine/The Swimming Pool*, 1968), but she became a much-liked actress in France, eliciting popular sympathy especially for the tragic death of her son. SG/AL/GV

Bib: Michael Jürgs, *Der Fall Romy Schneider: Eine Biographie* (1991).

Other Films Include: *Robinson soll nicht sterben* (1957); *Katia* (1959); *The Cardinal* (1963, US); *What's New Pussycat* (1965); *Le Train* (1973, Fr./It.); *Le Trio infernal* [Fr./It./Ger.], *L'Important c'est d'aimer* (1974, Fr.); *Le Vieux fusil* (1975, Fr.); *Gruppenbild mit Dame* (1977, Ger.); *La Mort en direct/Deathwatch* (1979, Fr.); *La Banquière* (1980, Fr.).

SCHNYDER, Franz Burgdorf 1910–1993

Swiss director, who began as actor and director in Swiss and German theatre before making his film debut in 1941 with a contribution to the nationalistic cinema of the 'spiritual defence of the nation', *Gilberte de Courgenay*, the sentimental portait (set during during World War I) of an inn-keeper's daughter (Anne-Marie Blanc) who becomes the guardian angel of a group of mobilised Swiss soldiers. More ambitious in form and content, *Wilder Urlaub* (1943), a critical, class-conscious account of contemporary Swiss democracy, was such a box-office failure for Lazar Wechsler's* Praesens-Film that Schnyder had to make short industrial and documentary films for eleven years before he could return to feature films. He then made a number of dialect films (*Heidi und Peter*, 1955, *Zwischen uns die Berge*, 1956) and literary adaptations of works by Jeremias Gotthelf (*Uli der Knecht*, 1954, *Uli der Pächter*, 1955, *Die Käserei in der Vehfreude*, 1958, *Anne Bäbi Jowäger*, two parts, 1960–61, *Geld und Geist*, 1964), which established

him as one of the most prolific Swiss directors of the 1950s and early 1960s. To the younger generation of the 'new Swiss cinema' film-makers Schnyder was the exemplary representative of 'daddy's cinema'. The reality was less simple and Schnyder remained a highly contradictory and temperamental personality. No sooner had he taken over Neue Film (Zurich) in 1957 than he denounced the heroic-idealistic clichés about Swiss national identity prevailing in films about World War II, a tradition to which he had himself significantly contributed, for instance with his reconstruction of the conflicting national reactions to the 1940 invasion of Belgium and the Netherlands by Nazi Germany (*Der 10. Mai*, 1957). MW

Other Films Include: *Der Souverän* (1947); *Der Sittlichkeitsverbrecher* (1963); *Die sechs Kummerbuben* (1968).

SCHROETER, Werner Georgenthal, Thuringia 1945

German director. A seminal figure of the New German Cinema* who has gained an international cult following for his cinema of camp excess and artifice. Schroeter's films occupy a transitional space between avant-garde and art cinema, neither quite narrative nor quite abstract. His emotionally charged, performance-inspired cinema draws on, and radically reinterprets, opera, oscillating between parody and celebration. For Schroeter, a gay director, the central figure is always the outsider, and his major theme is the yearning for self-realisation, through passionate love and artistic creativity.

Eika Katappa (1969), a camp appropriation of nineteenth-century opera, provided Schroeter with an international breakthrough. As a consequence he was taken up by television. *Der Tod der Maria Malibran/The Death of Maria Malibran* (1972), sublime and bizarre, and considered by many (including Michel Foucault and Schroeter himself) as one of his best films, is also his most difficult. With *Regno di Napoli/ Kingdom of Naples* (1978), Schroeter shifted towards art cinema; it became his first commercial release. *Der Rosenkönig/The Rose King* (1986), dedicated to the actress Magdalena Montezuma, is an excessive and entrancing hallucinatory fable of Oedipal and homosexual passion, and his most explicitly gay film. Schroeter continues to break with received aesthetics by aestheticising the model of the 'social problem film'. Many who regard him as a film-maker of fantastic fables were surprised at his politically hard-hitting documentaries: *Der lachende Stern/ The Laughing Star* (1983) and *De l'Argentine/To the Example of Argentine* (1985). Working since the 1980s mainly as a theatre and opera director, Schroeter had a brief comeback as a film-maker with a big-budget production, *Malina* (1991), starring Isabelle Huppert. US

Bib: Peter W. Jansen and Wolfram Schütte (eds), *Werner Schroeter* (1980).

SCHÜFFTAN, Eugen Breslau 1893 – New York 1977

German cinematographer of genius who developed a complex optical matte, the 'Schüfftan process', which combined miniature sets and full-size action in a single shot with the aid of mirrors. Schüfftan used his technique most memorably in Fritz Lang's* *Metropolis* (1927), on which he supervised all the special effects. A brief sojourn in Hollywood followed. Back in Germany by the early 1930s, Schüfftan photographed Robert Siodmak's* *Abschied* (1930) and G. W. Pabst's* *Die Herrin von Atlantis* (1932). In the wake of the Nazi takeover he emigrated to France, where he was cinematographer on Marcel Carné and Jacques Prévert's *Drôle de drame* (1937) and *Quai des brumes* (1938), as well as several Max Ophuls* films. The German invasion in 1939 forced him into a second exile in the US. He was initially barred from working, but fellow émigrés such as Douglas Sirk (Sierck*), Edgar G. Ulmer and Siodmak made it possible for him to earn a living, and he left his mark on the *film noir* lighting style of the 1940s. A US citizen since 1947, he moved back and forth between Europe and Hollywood, his career culminating in an Academy Award for the photography of *The Hustler* (1961, US). TE/MW

Other Films Include: *Eifersucht* (1925); *Madame Pompadour, Love Me and the World is Mine* (1927); *Menschen am Sonntag/People on Sunday* (1930); *Das Ekel* (1931, also directed); *Der Läufer von Marathon* (1933); *La Tendre Ennemie* (1936, Fr.); *Yoshiwara* (1937, Fr.); *Le Roman de Werther/Werther* (1938, Fr.); *Sans lendemain* (1940, Fr.); *Hitler's Madman* (1943, US); *Summer Storm* (1944, US); *The Dark Mirror* (1946, US); *Ulisse/Ulysses* (1954, It.); *La Tête contre les murs* (1959, Fr.); *Lilith* (1964, US).

SCHÜNZEL, Reinhold Hamburg 1888 – Munich 1954

German director, producer and actor. Schünzel started his career as a director in 1918 with short comedy films, and soon became one of the most prolific directors of the Weimar* popular cinema, equally at home with proletarian subjects (*Das Mädchen aus der Ackerstrasse*, 1920), big-budget historical drama (*Katharina die Große*, 1920) and comedy (*Hallo Caesar*, 1927). He was extremely popular as an actor (often starring in his own films); his comic persona ranged from foppish aristocrats to street-wise Berlin good-for-nothings, combining both in the character of Tiger Brown in G. W. Pabst's* *Die Dreigroschenoper/The Threepenny Opera* (1931).

Outside Germany, Schünzel the director did not become known until the sound era, when he directed, with *Viktor und Viktoria* (1933), *Die englische Heirat/The English Marriage* (1934) and *Amphitryon* (1935), three of the most popular sophisticated comedies of the time. Though he was Jewish on his mother's side, his films were such big

box-office that the Nazis were anxious to keep him on. In 1937, how-
ever, Schünzel left Germany for the US, but his directorial career
foundered. As actor, Schünzel played Germans in anti-Nazi films such
as Fritz Lang's* *Hangmen Also Die!* (1943), Dorothy Arzner's *First
Comes Courage* (1943) and Alfred Hitchcock's *Notorious* (1946).
Schünzel went back to Germany in 1949 to return to the stage and only
occasionally appeared on screen. TE/MW

Bib: Jörg Schöning (ed.), *Reinhold Schünzel: Schauspieler und
Regisseur* (1989).

SCHWARZ, Hanns Ignatz Schwartz; Vienna 1890[2?] – USA 1945

Austrian director. A student of interior design and painting, Schwarz
was asked to make a documentary film for the Bulgarian government.
He then worked as an independent director in Berlin from 1923. After
1925 he was, along with Joe May*, the most successful director of
Erich Pommer's* production group at Ufa*, where, with a first-class
team at his disposal, his comedies and silent operetta films combined
popular entertainment formulas with high technical and artistic qual-
ity (for instance *Das Fräulein vom Amt*, 1925). The exceptional success
of *Ungarische Rhapsodie* (1928) and *Die wunderbare Lüge der Nina
Petrowna* (1929) led Pommer to commission Schwarz to make Ufa's
first feature-length sound film, *Melodie des Herzens* (1929), which was
followed by many internationally popular Pommer/Schwarz sound op-
erettas in the early 1930s (*Einbrecher*, 1930; *Bomben auf Monte Carlo*,
1931, among others) that are said to have considerably influenced the
development of the genre in Germany and the US. In 1933 Schwarz
emigrated first to Britain, where he directed *The Return of the Scarlet
Pimpernel* (1937), and later to the US, though he did not work in film
there. KU

Other Films Include: *Liebling der Götter* (1930); *Zigeuner der Nacht*
(1932).

SCHWARZENBERGER, Xaver Vienna 1946

Austrian cinematographer and director. After apprenticeship in
Britain, Schwarzenberger worked primarily in television, including
five films for Axel Corti* and four episodes of *Alpensaga* (1976–80)
[> HEIMATFILM]. His work in Germany with R. W. Fassbinder* began
in 1978 and lasted until the latter's death in 1982. In their collabor-
ations, they succeeded in finding a visual concept to suit each story.
Their thirteen-part television film, *Berlin Alexanderplatz* (1980), was
inspired by Josef von Sternberg's lighting; in *Lili Marleen* (1980),

Schwarzenberger quoted the extreme lighting of the old Ufa* films; the symbolic colours in *Lola* (1981) recalled the Hollywood melodramas of the 1950s. Schwarzenberger's debut as a director in 1984 (*Donauwalzer,* which he saw as a tribute to Willi Forst*) received much attention. His subsequent work, however, appears more conventional. AL

SCHWEIGER, Til
Freiburg 1963

German actor spearheading, along with Katja Riemann* and Joachim Król, the new generation of star actors mainly responsible for the box-office revival of German cinema in the 1990s. After studying acting in Cologne (1986–89), Schweiger began as a member of the Contra-Kreis-Theatre in Bonn, but made his first impression on a wider German audience when he briefly appeared in Hans W. Geissendörfer's TV-soap *Lindenstrasse* in 1991. From his first role on the big screen in the youth comedy *Manta, Manta* (1992) he steadily honed his persona, the well-built macho with the soft core, reminscent of such 1950s juvenile heart-throbs as Horst Buchholz* (whose part he played in the 1996 TV remake of Georg Tressler's* 1959 film *Die Halbstarken*) and Hardy Krüger*. His dry charm and boyish grin, behind which often lurks a sense of irony and pastiche, proved equally convincing as involuntarily comic shamblers (*Manta, Manta*; *Der bewegte Mann/Maybe ... Maybe Not*, 1994), soft-boiled criminals (*Männerpension*, 1995; *Knockin' on Heaven's Door*, 1997) and nostalgic tough-guys (as in his critically acclaimed boxer and pop fan Rudy in *Ebbies Bluff*, 1992 and the award-winning title role in the French-Polish co-production *Bandyta/Brute*, 1996). Schweiger has also used his status as Germany's No 1 screen star to promote personal projects, combining acting with securing finance as a producer, for the road movie *Knockin' on Heaven's Door*, which became *the* surprise-hit at the German box-office of the 1997 season. Thanks to Schweiger (and his good relations with transatlantic producer Bernd Eichinger*) the film was the first German motion picture to be co-produced by and pre-sold for distribution to Buena Vista, the outcome of a deal which also included three supporting roles for Schweiger in Hollywood B-thrillers the same year (*Judas Kiss, S.L.C. Punks*, and *The Replacement Killers*). Living half of the year in Malibu and spending the other half in Berlin, he made his directorial debut in 1998 with *Der Eisbär/The Polarbear*, casting himself in the lead as a conscience-troubled contract killer for his German fans, while keeping a steady eye on possible offers from Hollywood as the next Rutger Hauer. MW

Bib: Katharina Blum, *Til Schweiger* (1997).

Other Films Include: *Bunte Hunde* (1994), *Lemgo* (TV, 1994), *Das Superweib* (1995), *Adrenalin* (TV, 1996), *Das Mädchen Rosemarie* (TV, 1996), *Der große Baragozy* (1999).

220

SCHYGULLA, Hanna Katowice, Poland 1943

Polish-born German actress, closely associated with the work of R. W. Fassbinder*, who created her early star image. She copied gestures and appearance from Hollywood screen goddesses and gave them a self-mocking inflection. Until 1972 she had parts in nearly all of Fassbinder's films, enjoying her greatest public success in Germany as the eponymous heroine of *Fontane Effi Briest/Effi Briest* (1974). However, it was her lead in *Die Ehe der Maria Braun/The Marriage of Maria Braun* (1979) which brought her international fame, while the big-budget production *Lili Marleen* (1981) confirmed her reputation as Europe's most vulnerable *femme fatale*. After Fassbinder's death, Schygulla successfully continued her work with leading European directors such as Jean-Luc Godard, Carlos Saura, Marco Ferreri, Andrzej Wajda, Volker Schlöndorff* and Margarethe von Trotta* Critics abroad acclaimed her, but in Germany she failed to retain a following. TE/SG

Other Films Include: *Jagdszenen in Niederbayern/Hunting Scenes from Lower Bavaria* (1969); *Liebe ist kälter als der Tod/Love is Colder than Death, Katzelmacher* (1969); *Götter der Pest/Gods of the Plague* (1970); *Warnung vor einer heiligen Nutte/Beware of a Holy Whore* (1971); *Der Händler der vier Jahreszeiten/The Merchant of Four Seasons* (1972); *Wildwechsel/Jailbait* (1972); *Falsche Bewegung/Wrong Movement* (1975); *Ansichten eines Clowns* (1976); *Die dritte Generation/The Third Generation* (1979); *Die Fälschung* (1981); *Il mondo nuovo* (1982); *Passion* [Fr.], *Antonieta, Heller Wahn* (1983); *Storia di Piera, Eine Liebe in Deutschland* (1983).

SCREENWRITERS

The first screenwriters in Germany around 1910 were poorly paid freelancers who made film outlines in the form of captions describing a dramatic situation. Surprisingly many of them were women, including Rosa Porten, who had written 25 scripts by 1927 or Luise del Zopp who wrote 35 scripts between 1911 and 1915. As the cinema became a more prestigious institution [> WILHELMINE CINEMA], novelists also turned to screenwriting (e.g. Paul Lindau [*Der Andere*, 1913], Hanns Heinz Ewers [*Der Student von Prag*, 1913]).

With longer and more costly films, screenwriting grew to be an independent profession, with the screenplay a vital component of the film production process, since it facilitated control over the complex logistics of the shooting schedule and location work. Given the many literary adaptations, the screenwriter also often played mediator between the novelist and his work when filmed (an early example was Luise Heilborn-Körbitz who adapted Thomas Mann's *Buddenbrooks,* 1923 and Hermann Sudermann's *Der Katzensteg,* 1927). In some cases

directors or even stars wrote their own screenplays (e.g. Urban Gad, Richard Oswald*, Joe May*, Hella Moja, Fern Andra, Henny Porten*).

The fact that screenwriting was well-established by 1914 can be gauged by the numerous handbooks claiming to explain how to write a successful script: Peter Paul's *Filmbuch*, 1914; Wilhelm Adler's *Wie schreibe ich einen Film?*, 1917; E. A. Dupont's* *Wie ein Film geschrieben wird und wie man ihn verwertet*, 1919 (revised 1925). The profession's self-confidence also led to the formation of a trade union organisation, the *Verband deutscher Filmautoren*, founded in 1919 but dissolved in 1933 by the Nazis; it was not re-established until 1986, as the *Arbeitgemeinschaft der Drehbuchautoren*.

The first generation of screenwriters came from very diverse backgrounds. Some, like Thea von Harbou* (*Das indische Grabmal* [1921], *Die Nibelungen* [1924], *Metropolis* [1927], *Die Frau im Mond* [1929]), Ruth Goetz, Fanny Carlsen and Jane Beß* were novelists of commercial literary genres (*Heimatromane*, romance or sentimental fiction) whilst others were literary critics or reviewers (Willy Haas*, a former critic for the trade journal *Film-Kurier*; Fred Hildenbrandt, a former editor-in-chief for the *Berliner Tageblatt*; and Robert Liebmann*, writer for *BZ am Mittag* and probably, along with Jane Beß*, the most productive author during the 1920s). Other screenwriters, such as Henrik Galeen (*Der Golem,* 1914 and 1920, *Nosferatu,* 1921), Karl Heinz Martin, Ludwig Berger* and Carl Mayer* were professional playwrights.

As German directors enjoyed greater autonomy than their US counterparts, screenplays in the early 1920s were not considered inviolable. Once the producer-unit system was introduced at Ufa*, however, the function of the screenplay changed, with the shooting script, as in Hollywood, acting as the blueprint for the production. As the script changed function, so did the status of the screenwriter: 'author' of the film until the beginning of the 1920s, this role passed to the director, who nonetheless preferred to work with the same writer on a regular basis (Paul Wegener* with Hanns Heinz Ewers*; Ernst Lubitsch* with Hanns Kräly*; Fritz Lang* with Thea von Harbou*; Friedrich Wilhelm Murnau* with Carl Mayer*; Gustav von Ucicky* with Gerhard Menzel; Karl Ritter* with Felix Lützkendorf; Willy Forst* with Walter Reisch).

National Socialism did not change the basic status and function of screenwriters, although the fact that many of them were Jewish and had to emigrate severely depleted the talent pool. Carl Mayer*, Willi Haas*, Robert Liebmann*, Walter Reisch and many others left in 1933 [> EMIGRATION*]. Among the prominent ones who stayed, several wrote screenplays for notorious propaganda films, such as Bobby E. Lüthge (*Hitlerjunge Quex,* 1933), Hanns Heinz Ewers (*Hans Westmar,* 1933) and Felix Lützkendorf (*Wunschkonzert,* 1940). What is more, the writers who worked under the Nazis continued to work after 1945. 90% of all films produced in West Germany in 1948 and a

staggering 47% of all films produced in 1960 were written by screenwriters already active during the Third Reich. Prolific newcomers included Herbert Reinecker* (West Germany) and Wolfgang Kohlhaase* (East Germany).

The film-makers of the New German Cinema* promoted the image of the director/producer/writer who combines all the creative functions in one person. Yet in several cases, the writer continued to play a vital role. The collaboration of Peter Handke and Wim Wenders*, Peter Märthesheimer and R. W. Fassbinder*, Peter Steinbach and Edgar Reitz* seemed in this respect to continue the tradition of the Weimar cinema, while a general dearth of professionally trained screenwriters is an often voiced complaint when the German cinema is compared to that of France and Britain. JG/TE

Bib: Jürgen Kasten, *Film schreiben: Eine Geschichte des Drehbuchs* (1990); Alexander Schwarz (ed.), *Das Drehbuch: Geschichte, Theorie, Praxis* (1992).

SEEBER, Guido Chemnitz 1879 – Berlin 1940

German cameraman. The leading pioneer of lighting and trick photography during the first three decades of German cinema, Seeber was in charge of the construction of the first large film studios in Babelsberg in 1911–12. Subsequently he gained his reputation as 'the grand master of trick film' (S. M. Eisenstein) with his work on films such as *Der Student von Prag/The Student of Prague* (Stellan Rye*, 1913), Paul Wegener* and Henrik Galeen's *Der Golem* (1914) and Lupu Pick's *Sylvester* (1924). In 1925 he created his own 'absolute' film in the form of the intriguingly titled *Kipho-films*, which were at one and the same time promotion films (for the installation of a permanent museum of the cinema's beginnings), avant-garde films and films about film. He remained active as head of the special effects department at Ufa* until his death. MW

Bib: Norbert Jochum (ed.), *Das wandernde Bild: Der Filmpionier Guido Seeber* (1979).

Other Films Include: *Weihnachtsglück* (1909); *Die geheimnisvolle Streichholzdose* (1910); *Der fremde Vogel* (1911); *Das wandernde Bild* (1920); *Lebende Buddhas* (1925); *Geheimnisse einer Seele/Secrets of a Soul* (1926); *Die Zirkusprinzessin* (1929); *Ein Mädchen mit Prokura* (1934); *Ewiger Wald* (1936).

SIERCK, Detlef [US: SIRK, Douglas] Hans Detlef
Sierck; Hamburg 1900 – Lugano, Switzerland 1987

German director. Sierck was a successful stage producer and director in the years before 1933. Of the political left, he transferred to the cinema, less strictly censored in the mid-1930s than the theatre because of its international market. He turned to features in 1935, soon gaining a reputation for the visual quality of his films and his talent for directing women. He was employed by Ufa*, and his first international success was the musical melodrama *Schlußakkord/Final Chord* (1936). The peak of his German career, however, were two Zarah Leander* melodramas, *Zu neuen Ufern/To New Shores* (1937) and *La Habanera* (1937). In autumn 1937, Sierck emigrated to the US, where he changed his name to Douglas Sirk and had to rebuild his reputation. After several false starts, he succeeded with a number of Technicolor melodramas, characterised by baroque *mise-en-scène* and powerful emotional appeal, most notably *All That Heaven Allows* (1956), *Written on the Wind* (1957) and *Interlude* (1957, partly shot in Europe). After a production completed in West Germany (*A Time to Love and a Time to Die*, 1958), Sirk made his last American film for Universal with *Imitation of Life* (1959), before retiring to Switzerland.

Once thought of as mere soap opera tear-jerkers, Sirk's American melodramas were rediscovered in the 1970s by critics who appreciated their 'distancing' excess (and feminists who noted their powerful female characters). Sirk was emulated by Rainer Werner Fassbinder*, who saw in him not only a kindred spirit but living proof of a continuity with German film culture which could encompass popular genres as well as intelligent art cinema. TE/MW

Bib: Michael Stern, *Douglas Sirk* (1979).

Other Films Include: *April, April* (1935); *Das Mädchen vom Moorhof* (1935); *Stützen der Gesellschaft* (1935); *Das Hofkonzert* (1936; also Fr. version, *La Chanson du souvenir*, 1936). **In the US**: *Hitler's Madman* (1943); *Lured* (1947); *All I Desire* (1953); *Magnificent Obsession* (1954); *There's Always Tomorrow* (1955); *Battle Hymn* (1956); *The Tarnished Angels* (1958).

SIODMAK, Robert Dresden 1900 – Locarno, Switzerland 1973

German director, who first made his mark as co-director of the feature documentary *Menschen am Sonntag/People on Sunday* (1930) with Edgar G. Ulmer. Siodmak went on to direct feature films at Ufa*, among them one of the earliest German sound films, *Abschied* (1930). After the completion of *Brennendes Geheimnis/The Burning Secret*

(1933), adapted from a novella by Stefan Zweig, Siodmak was forced into exile, first to France, where he had the most prolific career of all the German émigrés, making a number of seminal *noir* movies, especially *Le Chemin de Rio* (1937), *Mollenard* (1938) and *Pièges* (1939), as well as outstanding musicals like *La Crise est finie* (1934) and *La Vie parisienne* (1935).

Late in 1938, Siodmak moved to Hollywood, and directed a succession of B-pictures and atmospherically charged psychological thrillers for Universal, which count among the key examples of American *film noir*: *Phantom Lady* (1944), *The Spiral Staircase* (1945), *The Killers* (1946). Siodmak returned to Europe, directing various and variable films in France, Britain and, from 1954, Germany, but in 1957 he once more conjured up, with *Nachts, wenn der Teufel kam/The Devil Strikes at Night*, about a mentally disturbed mass-murderer, his skill as the 'master of *film noir*'. TE/MW

Bib: Hervé Dumont, *Robert Siodmak: Le Maître du film noir* (1981).

Other Films Include: *Der Kampf mit dem Drachen oder: Die Tragödie des Untermieters* (1930); *Der Mann, der seinen Mörder sucht* (1931); *Voruntersuchung* (1931); *Stürme der Leidenschaft/The Tempest* (1932); *Quick, König der Clowns* (1932); *West Point Widow* (1941, US); *Son of Dracula* (1943, US); *The Suspect* (1944, US); *The Dark Mirror* (1946, US); *Time out of Mind* (1947, US); *Cry of the City* (1948, US); *Criss Cross, The Great Sinner* (1949, both US); *Die Ratten* (1955).

SKLADANOWSKY, Max Berlin 1863–1939

German film pioneer. From 1892, in collaboration with his brother Emil (Berlin 1859–1945), Skladanowsky constructed a double projection apparatus which was patented in 1895 under the name of the 'Bioskop' (Bioscope). The Bioskop made possible the first public presentation of moving pictures in Germany at the Berlin Wintergarten on 1 November of the same year, six weeks ahead of the Lumière brothers' first screening. Apart from this opening programme, which consisted of nine short sketches, Skladanowsky put together a second series of Berlin city views for touring through Germany in 1896–97 (*Berlin Alexanderplatz*). However, the Bioskop proved uncompetitive against both domestic (Messter*) and French (Lumière*) machines. Skladanowsky attempted to find other ways of commercially exploiting his invention and had a modest success with photograph flip books. MW

Bib: Barbara Cantow (ed.), *Max Skladanowsky und die Erfindung des Kinos* (1993); Joachim Castan, *Max Skladanowsky* (1995).

SÖDERBAUM, Kristina Stockholm 1909

Swedish-born actress. On account of her marriage to Veit Harlan* and her Nordic, childlike features, Söderbaum became famous for leading parts in Nazi melodramas and propaganda films: *Jud Süss* (1940), *Immensee* (1943), *Die goldene Stadt* (1942), in which Harlan's *mise-en-scène* made her into the foremost symbol of the fascist obsession with racial purity (*Reinheitsfanatismus*), riding, virtually naked and on a white stallion, into the sea to sacrifice herself in *Opfergang* (1944). From 1951 (*Unsterbliche Geliebte*) to 1958 (*Ich werde Dich auf Händen tragen*) she starred in seven more films, showing a hitherto unplumbed depth in her acting, which, together with her historic associations, made her an impressive apparition when in Hans Jürgen Syberberg's* *Karl May* (1974) she once more stepped in front of the camera. KU

Bib: Kristina Söderbaum, *Nichts bleibt immer so: Rückblenden auf ein Leben vor und hinter der Kamera* (1983).

SPIO (Spitzenorganisation der deutschen Filmindustrie/-wirtschaft)

German motion picture association. The 'Chief Organisation of the German Film Industry' was founded in 1923 as an umbrella for the film business's largest professional organisations, to act as a pressure group and crafts guild in relations with the government. It had two weaknesses: it tried to bring together too many incompatible constituents (for instance, distributors and exhibitors), and it was from the very beginning strongly dominated by Ufa* interests. The highly influential 'SPIO Plan' of Autumn 1932 featured the centralisation of the industry and its demands were met by the Propaganda Ministry and the big financial institutions when they established the Filmkreditbank in May 1933. In June 1933, SPIO was integrated in the Reichsfilmkammer, which was answerable only to Goebbels [> NATIONAL SOCIALISM AND GERMAN CINEMA]. In 1959, SPIO was revived and given added responsibilities for copyrights, patents and the commercial exploitation of films on television. SPIO is also in charge of selecting the German entries at national and international film festivals, and publishes a statistical yearbook. TE/MW

STAR SYSTEM

Despite its reputation as an art cinema, the German cinema has, for most of its existence, been a stars-and-genre cinema. From the 1910s onwards, the industry established a nationally successful star system,

structured around film series devoted to a single actor or actress, which capitalised on new distribution* strategies (the 'monopoly film system') and aggressive advertisement campaigns in the trade press. Whereas male stars often built their screen fame on their established reputation as stage performers (Albert Bassermann, Paul Wegener*, Alexander Moissi), female stars (Henny Porten*, Asta Nielsen*, or Hanni Weisse) were to a large extent the product of the cinema itself. Top stars of the 1920s were, among others, Porten, Harry Piel*, Otto Gebühr* and Claire Rommer* (see TOP TEN STARS 1923–1926, below). In the 1930s and 1940s, Hans Albers*, Heinrich George*, Paula Wessely* and Jenny Jugo* were the most popular, and in the 1950s Ruth Leuwerik*, O. W. Fischer*, Romy Schneider* and Liselotte Pulver* enjoyed star billing. In the 1910s and 1920s, the German film industry produced a number of internationally successful stars, such as Asta Nielsen*, Emil Jannings*, Pola Negri*. As the German film industry became more nationalised throughout the 1930s, few German stars were popular beyond national boundaries (a top star like Heinz Rühmann*, for instance, was entirely unknown in either France or Italy). Some German émigrés to the US, however, achieved star status, such as Marlene Dietrich* and Peter Lorre*.

The star discourse was promoted in several widely read fan magazines (*Die Filmwoche*, 1923–43, *Filmwelt*, 1929–43, *Film-Revue*, 1947–63, *Star/Star-Revue*, 1948–61), polls regularly tested the popularity of stars (top ten lists), star photographs (on postcards, cigarette images, posters) widely circulated, serialised stories appeared in the *Illustrierter Film-Kurier* (1919–44) and *Illustrierte Film-Bühne* (1948–69), with film posters and monographs feeding the public's appetite. Unlike America's star system, Germany's star discourse at first focused less on the actors' private lives (with the exception perhaps of Kaiser Wilhehm II, who thanks to his frequent appearances in actualities, is often called 'Germany's first film star'). After World War II, gossip magazines increasingly targeted film stars as well, and by the mid-1950s several of the traditional fan magazines (and a newcomer, *Sterne/Filmjournal* [1951–60]), devoted much space to the private lives of actors and actresses, copying American journals such as *Photoplay*, a trend that may explain why, for the first time since 1925, American stars became popular with the German public [> AMERICAN FILMS IN GERMANY], with names like Ingrid Bergman, Audrey Hepburn, Rock Hudson, Tony Curtis appearing in the German Top Ten. Where American stars resembled contemporary German film stars (Ingrid Bergman's star image was similar to that of Maria Schell and Ruth Leuwerik), they did well, but such uniquely American stars as John Wayne, Henry Fonda or even Marilyn Monroe did not become popular in Germany during the 1950s and 1960s.

In the 1970s and 1980s, when production of popular German feature films dropped dramatically, few German film stars were left. Increasingly, actors became popular through television – as in the case of Götz George*, Loriot and Otto. The stars of New German Cinema*

were its directors (with the possible exception of Klaus Kinski* and Hanna Schygulla*). Only in the 1990s, the renewed popularity of star-driven genres such as comedies, musicals, and fantasy films has brought to the fore a generation of actors and actresses primarily associated by the broad public with the big screen, even if they started on television: Katja Riemann*, Maria Schrader, Heike Makatsch, Til Schweiger*, Joachim Król, Jürgen Vogel and Peter Lohmeyer. JG/MW

Top ten stars, 1923–1926. Opinion polls were published in the fan magazines *Neue Illustrierte Filmwoche* (No. 23, 1924) and the *Deutsche Filmwoche* (No. 19, 1925; No. 19, 1926; No. 11, 1927) from 1923 to 1926 in which as many as 15,000 readers were asked to name their favourite male and female film star of the previous year. Below is the percentage of votes which the top ten most popular film stars received during the years 1923–26 according to the annual lists of the trade journals, where the ten most popular stars collected more than 80% of all the votes cast. For instance, Claire Rommer* received 11.2% of all votes cast for female stars during the years 1923–26 and thus ranked second in the list of most popular female stars. Charles Willi Kayser received 8.2% of all votes for male stars, making him the fifth most popular male star. Both have vanished entirely from film history, as have Lee Parry, Alphons Fryland and Ernst Hofman.
Top Ten Female Stars: 1. Henny Porten* (13.7%); 2. Claire Rommer (11.2%); 3. Lil Dagover* (9.7%); 4. Lya Mara* (8.9%); 5. Lya de Putti* (8.2%); 6. Lee Parry (7.8%); 7. Lilian Harvey* (7.2%); 8. Mady Christians (5.3%); 9. Xenia Desni (5.1%); 10. Dary Holm (3.5%). Total: 80.6%.
Top Ten Male Stars: 1. Harry Piel* (12.4%); 2. Otto Gebühr* (11.3%); 3. Harry Liedtke* (11.0%); 4. Conrad Veidt* (8.8%); 5. Charles Willi Kayser (8.2%); 6. Willi Fritsch* (8.2%); 7. Alphons Fryland (7.5%); 8. Ernst Hofman (6.6%); 9. Paul Richter (4.6%); 10. Emil Jannings* (3.7%). Total: 82.3%. JG

STAUDTE, Wolfgang　　Saarbrücken 1906 – Zigarski, Slovenia 1984

German director, who emerged as a talent during the war (*Akrobat schööön*, 1943; *Ich hab' von Dir geträumt*, 1944). Working at DEFA* after 1945, he became widely known with the very first German post-war feature film, *Die Mörder sind unter uns/The Murderers are Amongst Us* (1946) and subsequently continued, first with *Rotation* (1949) and then with the Heinrich Mann adaptation *Der Untertan/The Underdog* (1951), to lead East German cinema's own dissection of the country's recent history. Staudte's decision in 1955 to continue his work in the West forced him to compromise with commercial demands. In *Rosen für den Staatsanwalt/Roses for the Prosecutor* (1959)

and *Herrenpartie/Stag Party* (1964) Staudte returned to his critical stance, connecting the fascist past with West Germany's present. The public outcry that ensued virtually silenced one of Germany's most gifted and intelligent directors. TE/KU

Bib: Eva Orbanz and Hans Helmut Prinzler (eds), *Staudte* (1991).

Other Films Include: *Die Geschichte vom kleinen Muck* (1953); *Madeleine und der Legionär* (1958); *Der Maulkorb* (1958); *Die Herren mit der weißen Weste* (1970); *Zwischengleis* (1978).

STEINHOFF, Hans
Marienberg 1882 –
Luckenwalde 1945

German director, who made his name with one of his first films, *Kleider machen Leute* (1922). During the following twelve years he became an experienced director and screenplay writer of witty entertainment movies shown all over Europe. An early Nazi sympathiser, Steinhoff was an exemplary director for promoting cleverly packaged Nazi ideology. Together with producer Karl Ritter he served the regime with powerful films of unambiguously propagandistic intent, backed by enormous budgets and top crews: *Hitlerjunge Quex* (1933), *Ohm Krüger* (1941), *Der alte und der junge König* (1935), *Rembrandt* (1942). He died in a plane crash while attempting to escape from the Red Army advancing on Prague in 1945. TE/KU

Bib: Pierre Cadars and Francis Courtade, 'Hans Steinhoff', *L'Avant-scène du cinéma*, no. 87 (March 1976).

Other Films Include: *Der Mann, der sich verkaufte, Gräfin Mariza* (1925); *Angst* (1928); *Nachtgestalten/The Alley Cat* (1929); *Die Pranke/L'Uomo dall'artiglio* (1931); *Kopfüber ins Glück* (1931; also Fr. version, *Chacun sa chance*); *Robert Koch, der Bekämpfer des Todes* (1939); *Die Geier-Wally* (1940); *Gabriele Dambrone* (1943).

STEINWENDNER, Kurt
Curt Stenvert; Vienna 1920

Austrian director. Steinwendner studied painting and sculpture at the Vienna Art Academy. In the 1950s he started working in Austrian cinema as a set decorator, later writing scripts and becoming a director of experimental shorts, documentaries and feature films. His films, in particular *Wienerinnen – Schrei nach Liebe* (1952) and *Flucht ins Schilf* (1953), belong on the margins of Austrian film history. They differ notably from the nostalgic 'Viennese films' of their time, and the harsh image of Vienna they give has been compared to that of Carol Reed's

The Third Man (1949) and to Italian neo-realism. Steinwendner later continued to make documentaries. IR

STRASSENFILME

German film genre (the term, meaning 'street film', was coined by film critic Siegfried Kracauer*) describing a particular form of German (Weimar*) urban melodrama made between 1923 and 1930, in which a middle-class (generally male) protagonist strays onto 'the street' seeking relief from both the *ennui* and the moral confinement of bourgeois existence, while a lower-class (generally female) protagonist tries to escape the underworld milieu.

Typically, the protagonists are chastised or destroyed by the experience of the city's darker or licentious side (personified in the figure of the prostitute). While testifying to the iniquities of modern urban life and the repressions of the Wilhelmine past, the classic *Straßenfilme* – Karl Grune's *Die Straße/The Street* (1923), G. W. Pabst's* *Die freudlose Gasse/The Joyless Street* (1925), Bruno Rahn's *Dirnentragödie/Tragedy of the Street* (1927), and Josef von Sternberg's *Der blaue Engel/The Blue Angel* (1930) – tended to end up deterministically reaffirming existing class divisions and the primacy of middle-class values. Films which attempted a less melodramatic, quasi-documentary treatment of city life, like *Menschen am Sonntag/People on Sunday* (1930), were rare. Even *Mutter Krausens Fahrt ins Glück/Mother Krause's Journey to Happiness* (1929), the most famous 'alternative' street film made by the Marxist film collective Prometheus, deployed the melodramatic devices of its rivals. Directed by Piel Jutzi, it purported to be the first real 'Zille-film' (the *Straßenfilme* being influenced by the proletarian milieu depictions of Berlin artist Heinrich Zille) and was hailed as the 'first German Proletarian-Revolutionary film' by the Communist press. As in many other *Straßenfilme*, the main female protagonist perishes as a victim of her milieu. This film rejects, however, the typical determinism of its mainstream kin, ending instead with the next 'class-conscious' generation taking to the street in protest as part of an organised Communist demonstration [> ARBEITERFILME].

Beyond its role in the debate about Weimar cinema's ideological responsibilities, the *Straßenfilm* genre was significant in terms of gender politics. As a vehicle in which actresses such as Greta Garbo, Asta Nielsen* and Marlene Dietrich* starred as prototypical *femmes fatales*, it offered audiences models of 'new women' capable of threatening the patriarchal order. JM

Bib: Patrice Petro, *Joyless Streets: Women and Melodramatic Representation in Weimar Germany* (1989).

STUDIOS

Given its reputation for studio-bound pictures, it is worth recalling that German films were predominantly set in exterior locations until the 1920s. Only from the mid-1920s onwards (until the mid-1950s) was the German film industry synonymous with a cinema of mostly interior locations. Apart from reasons of climate, the close ties to the theatre and a (neo-)romantic pictorial tradition, this tendency is a tribute to the high standards of studio-building in Germany since the 1910s. The first studios, which emerged at the same time as fixed-site cinemas around 1905, combined artificial and natural light, the so-called glass-house studios (although as early as 1896 Oskar Messter ran a studio which if required, could be operated exclusively with artificial light). The conversion to artificial-light-only studios was completed in the mid-1920s and followed the American lead. Production of German films was concentrated in relatively few studios, and by 1927 the Ufa* studios in Neubabelsberg (*Die Nibelungen* [1922], *Der letzte Mann* [1924] and *Metropolis* [1925]) along with the Emelka-Filmwerkstatten in Geiselgasteig near Munich headed the list of large capacity studios. In 1930, for instance, some 42 pictures were shot in Neubabelsberg alone, having forced smaller studios (such as Staaken-Werke, Ifa-Atelier, Mayfilm AG) into liquidation the previous year. In 1936 the two largest studios, Ufa and Tobis studios, together controlled 73.3% of the total German studio space.

After World War II the Babelsberg studios of Ufa came into the possession of the state-run film company of East-Germany, DEFA*, depriving the West German firms of crucial capacity. New studios sprang up even in smaller cities, such as the Göttingen studios. Bavaria Filmkunst GmbH in Munich-Geistelgasteig kept its preeminence (30/35 films in 1956/57), followed by CCC-Filmateliers in Berlin-Spandau (24 films in 1956/57). In the 1950s and 1960s the trend was to-wards fewer studios making fewer films (in 1966 Bavaria produced 4 films to CCC's 11), with the consequence that it became once more fi-nancially feasible to use exterior locations (Berolina* for instance, favoured location shooting for its Heimat films, while the Karl May cycle of the 1960s was shot mostly in Yugoslavia). New German Cinema* productions also became associated with exterior locations (Werner Herzog*, Wim Wenders*, the major exception being R. W. Fassbinder* who hated outdoor shooting).

In the 1960s existing studio capacity was increasingly rented out to television productions. But as the networks built up their own studio capacity (WDR in Cologne, NDR in Hamburg, ZDF in Mainz), fur-ther studio closures became inevitable (Artur Brauner finally closed the CCC Spandau studios in 1970) and only Bavaria Studios in Munich kept going, thanks to international and even US productions (directed by among others, Ingmar Bergman, Sam Peckinpah, R. W. Fassbinder). With the revival of commercial film-making in the 1980s, even the Spandau studios reopened (for Otto Waalkes' *Otto* films) and

231

ambitious productions like *Das Boot* (1981) and *Die unendliche Geschichte* (1984) revitalised the technical infrastructure of Bavaria, making its studios attractive to international productions (among others, Columbia made *Moscow on the Hudson,* 1983 in Munich, and Warner Bros *The Little Drummer Girl,* 1985). After the collapse of East Germany, the old Ufa* Neubabelsberg studios were extensively refurbished, in the expectation of once more becoming the leading Studio for national and international productions. JG/TE

Bib: Wolfgang Jacobsen (ed.), *Babelsberg: Ein Filmstudio, 1912–1992* (1992).

SUKOWA, Barbara
Bremen 1950

German actress, remarkable for her strong facial features and her ability to put across fiercely independent personalities. Working for theatre and television since 1971, she was 'discovered' by Rainer Werner Fassbinder*, who cast her in his television productions *Frauen in New York* (1977) and *Berlin Alexanderplatz* (1980), where she played the child-whore Mietze, brutally murdered in the woods. In 1981, Sukowa rose to wider recognition in Fassbinder's *Lola* and as the 'terrorist' Marianne in Margarethe von Trotta's* *Die bleierne Zeit/The German Sisters* (1981). In subsequent women's films [> FRAUENFILM], such as von Trotta's *Rosa Luxemburg* (1986) and Jeanine Meerapfel's *Die Verliebten/The Lovers* (1987), Sukowa played the intellectual consumed by an inner fire. On the strength of her roles in Fassbinder and von Trotta films, she had her 'international' debut in Lars von Trier's postwar, postmodern thriller *Europa/Zentropa* (1991). TE/MW

SYBERBERG, Hans Jürgen
Nossendorf, Pomerania 1935

German director. Syberberg began in German television, producing hundreds of current affairs and documentary shorts and programming features between 1963 and 1966, before turning to longer documentaries on theatrical subjects. His first fiction film was the Tolstoy adaptation *Scarabea – Wieviel Erde braucht der Mensch?* (1969), followed by the Kleist-based *San Domingo* (1970). His most famous films, the so-called 'German trilogy', began with *Ludwig – Ein Requiem für einen jungfräulichen König/Ludwig – Requiem for a Virgin King* in 1972, followed by *Karl May* (1974), and *Hitler – Ein Film aus Deutschland/Our Hitler/Hitler – A Film from Germany* (1977), to which must be added two 'by-products', *Theodor Hirneis oder: Wie man ehem. Hofkoch wird* (1973) and *Winifred Wagner und die Geschichte des Hauses Wahnfried 1914–1975* (1975). Syberberg uses intricate stylistic strategies of distanciation, thematic clashes and inter-

232

textual echoes in order to give body to complex but also often confused thoughts on history, culture and politics. Regarded in France and the US as a serious spokesman for the New Germany, he found himself at home an outcast, variously accused of incompetence, plagiarism, arrogance and proto-fascism, charges to which he has responded pedantically in numerous books, essays and newspaper articles. MW

Bib: Thomas Elsaesser, 'Myth as the Phantasmagoria of History: H. J. Syberberg, Cinema and Representation', *New German Critique*, nos 24–25 (1981–82).

Other Films Include: *Parsifal* (1982); *Die Nacht* (1985); *Edith Clever liest James Joyce* (1985); *Fräulein Else, Penthesilea* (1987); *Die Marquise von O* (1989).

T

THIELE, Rolf Redlice, Czechoslovakia 1918

German producer, scriptwriter and director, co-founder of one of the many small companies the Allies licensed after World War II, in order to decentralise the post-Ufa* German film industry. Filmaufbau Göttingen, set up in 1946, did better than most, with Thiele the producer responsible for some of the biggest box-office hits of the 1950s, such as *Nachtwache* (1949), *Königliche Hoheit* (1953) and *Die Buddenbrooks* (1959, two parts). The company had its first major success with a *Trümmerfilm* ('ruin film'), *Liebe 47* (1949).

As a director, Thiele seemed to have two passions. One was Thomas Mann adaptations (including *Tonio Kröger*, 1964); the other, double standards in matters of sexuality (*Primanerinnen*, 1951; *Sie*, 1954). The film for which he is remembered is *Das Mädchen Rosemarie* (1958), with Nadja Tiller* as the high-class prostitute in a satirical account of an infamous Frankfurt society scandal involving patricians, new money and politicians: just the sort of tale of hypocrisy and lust to fire Thiele's imagination. In the late 1960s, when hypocrisy was no longer an issue, Thiele concentrated on lust and made sex films. TE

Bib: Rolf Aurich (ed.), *Filmaufbau GmbH Göttingen* (1993).

THIELE, Wilhelm

Wilhelm Isersohn; Vienna 1890 –
Los Angeles, California 1975

Austrian director and scriptwriter, who studied music and worked as a
stage actor and director in Austria. Influenced by Erik Charell's stage
operettas, he went to Germany as a stage director, was hired as a film
actor (1920–22; his first film was *Orchideen*), then as a scriptwriter (for
instance *Die kleine vom Varieté*, 1926; dir. Hanns Schwarz*) and di-
rector (from 1922). Although relatively successful as a writer and di-
rector of silent film operettas (his first film as director was *Carl
Michael Ziehrer, der letzte Walzerkönig*, 1922) and comedies (*Adieu
Mascotte*, 1929), Thiele became famous for his innovative use of sound
in *Liebeswalzer/The Love Waltz* (1929, Ger./UK) and *Die Drei von der
Tankstelle/Le Chemin du paradis* (1930, Ger./Fr.), which made him the
father of the German *Tonfilmoperette* (sound film operetta). He made
French and English versions of his German-speaking films. His use of
sound and image for comic effects and integration of singing and danc-
ing in the plot foreshadowed the 'integrated' Hollywood musical.
Thiele emigrated in 1933 and found work in Britain, Austria and New
York before going to Hollywood, where he made his first film in 1935
(*Lottery Lover*), followed by more or less successful B-movies (such as
Tarzan Triumphs, 1943) and series (such as *The Cavalcade of America,*
1952–56), but no musicals. He also made documentaries and pro-
motional films and worked in television from 1951. In 1960 Thiele di-
rected two comedies in Germany – *Der letzte Fußgänger* and *Sabine
und die 100 Männer* – before going back to Hollywood. KU

TILLER, Nadja

Maria Tiller; Vienna 1929

Austrian actress. Though she trained as an actress and dancer at Max
Reinhardt's* school, Tiller initially mainly played characters of little
depth, and after being elected 'Miss Austria' she mostly embodied
beautiful young women in such films as *Märchen vom Glück/Traum
vom Glück* (1949) until her mentor, Rolf Thiele*, provided a new de-
parture for her. In Thiele's *Die Barrings* (1955) and Harald Braun's
Die Botschafterin (1960), and in Gilles Grangier's *Le Désordre et la
nuit* (1958, with Jean Gabin), she embodied sexy but stronger
women; in Thiele's scandalous and very successful *Das Mädchen
Rosemarie/The Girl Rosemarie* (1958) she was a high-class prostitute,
and she finally 'became' the ultimate *femme fatale* in *Lulu* (1962).
Tiller subsequently mainly worked in French and Italian film, and for
German television and theatre. KU

234

TRENKER, Luis St. Ulrich, Italy 1892 – Bozen 1990

Italian-born Austrian actor and director, who was working as a mountain guide in the Alps when he was hired in 1921 to guide Arnold Fanck's* production unit for *Das Wunder des Schneeschuhs*. A robust, handsome athlete, he found himself playing the lead part in several Fanck 'Mountain films'*, usually as the partner of Leni Riefenstahl* (*Der Berg des Schicksals/Peak of Fate*, 1924; *Der heilige Berg/Peaks of Destiny*, 1927; *Der Kampf ums Matterhorn/The Fight for the Matterhorn*, 1928). From the early 1930s he himself also wrote and (co-)directed mountain films (*Der Berg ruft/The Challenge*, 1937), often with elements of the war film (*Berge in Flammen/The Doomed Battalion*, co-dir. Karl Hartl*, 1931; *Der Rebell/The Rebel*, co-dir. Kurt Bernhardt*, 1932), historical films (*Condottieri/Giovanni di Medici*, 1937), and comedies (*Liebesbriefe aus dem Engadin*, 1938). Living in Venice and Rome after the war, Trenker continued to make features and, increasingly, documentaries about mountains for Italian, Austrian and German companies, but without achieving the visual power and authenticity of his earlier features. However, he sustained his popularity in Austria and Germany as the author of successful books and narrator of multi-part series for German and Austrian television on mountains and mountaineering. MW

Bib: Piero Zanotto (ed.), *Luis Trenker: Lo schermo verticale* (1982).

Other Films as Director Include: *Der verlorene Sohn* (1934, also actor); *Der König der Berge* (1938, short); *Der Feuerteufel* (1940, also actor); *Im Banne des Monte Miracolo* (1943–48, also actor); *Il prigioniero della montagna/Flucht in die Dolomiten* (1955, also actor); *Von der Liebe besiegt* (1956, also actor); *Wetterleuchten um Maria* (1957); *Sein bester Freund* (1962).

TRESSLER, Georg Vienna 1917

Austrian-born director, who began as a caricaturist before working as an actor and assistant director to Geza von Bolvary* and Arthur Maria Rabenalt* in Austria between 1935 and 1939. Tressler made his directorial debut with a short fiction film, *Urlaub im Schnee* (1947). Unable to direct a full-length feature film in Austria, he moved to Germany, where he rose to prominence with two films modelled on Hollywood juvenile delinquency dramas, *Die Halbstarken* (1956) and *Endstation Liebe* (1957). A result of his collaboration with scriptwriter Will Tremper, the detailed observation of urban teenagers in both films prepared the way for the 'Young German cinema' [> NEW GERMAN CINEMA] and brought Horst Buchholz*, the leading man in both films as well as in Tressler's subsequent *Das Totenschiff* (1959),

to international attention. After directing Liechtenstein's first feature film in 1958 (*Ein wunderbarer Sommer*), Tressler was assigned to Walt Disney's biopic of Beethoven, *The Magnificent Rebel* (1961), a financial and critical failure which ended his international career as soon as it had begun. Tressler was, however, one of German television's most prolific directors. MW

Other Films Include: *Spielereien* (1949); *Unter achtzehn* (1957); *Geständnis einer Sechzehnjährigen* (1961).

TREUT, Monika Mönchen-Gladbach 1954

German film-maker, whose controversial films feature porn star Annie Sprinkle, safe-sex educator Susie Bright and gender-bending performance artist Shelly Mars. *Bondage* (1983) explored S & M before it was fashionable, and Treut's first feature film, directed with Elfi Mikesch, *Verführung: Die grausame Frau/Seduction: The Cruel Woman* (1985), had its government grant withdrawn. *Jungfrauenmashine/Virgin Machine* (1988), a lesbian coming-out story, is refreshingly anti-moralistic, provocative and formally inventive. Although Treut won The Jack Babuscio Award for her contribution to Lesbian and Gay Cinema in 1993, her films have frequently angered the lesbian community. Rejecting the exclusiveness of lesbian politics, its political correctness and its promotion of 'positive images', she prefers to make films that through humour are accessible and pleasurable to all. *Female Misbehaviour* (1992), a collection of documentaries, includes a portrait of Camille Paglia. She also directed *Erotique* in 1994. US

Bib: Julia Knight, 'The Meaning of Treut?', in Pam Cook and Philip Dodd (eds), *Women and Film* (1993).

TROTTA, Margarethe von Berlin 1942

German director. Starting with *Das zweite Erwachen der Christa Klages/The Second Awakening of Christa Klages* (1978), von Trotta's films stand out from the semi-documentary and autobiographical works of German woman film-makers such as Jutta Brückner* and Helke Sander* through their storytelling gusto and closely scripted narratives. Nonetheless, her theme is a feminist one: the impossible quest for female identity, both barred by and founded on the emotional interdependence of two women. Sisters either by blood (*Schwestern oder die Balance des Glücks/Sisters or the Balance of Happiness*, 1979, *Die bleierne Zeit/The German Sisters*, 1981) or by affinity (*Christa Klages, Heller Wahn*, 1983), her heroines are always political creatures, most apparent in her overtly political psychothriller *Die bleierne Zeit*, based on the life of the terrorist Gudrun

Ensslin, and *Rosa Luxemburg* (1986), both starring Barbara Sukowa*. Von Trotta has not always pleased her critics: feminists object to her conventional (melo)dramatic narration, and men find her male characters pale and perfunctory. Yet her early films especially – including the underrated *Der Fangschuß/Coup de Grâce* (1976), co-scripted and co-directed by her – are enduring landmarks of the New German Cinema*. TE

Other Films Include: *Eva* (1988); *Felix* (1987, co-dir.); *Paura e amore/Fürchten und Lieben/Three Sisters* (1988); *L'Africana/Die Rückkehr* (1990); *Zeit des Zorns* (1994).

TSCHECHOWA, Olga Alexandropol, Russia 1897 – Obermenzing 1980

Russian-born German actress and director, whose first film role as the sensual Countess in F. W. Murnau's* *Schloß Vogelöd* (1921) set the pattern for her subsequent career. Appearing in over forty films in less than ten years, often as a highly strung or erotically overcharged aristocrat, she was also much in demand elsewhere, filming in Paris, London and Hollywood. In 1929 she directed *Der Narr seiner Liebe*. The coming of sound proved no obstacle. Her Slav vowels made her the perfect Austrian sophisticate, and Max Ophuls* cast her in just such a role in his Schnitzler adaptation *Liebelei* (1933). A top star thereafter, vying with Zarah Leander* for the title of the National Socialist cinema's leading lady, Tschechowa – no differently from her frequent partner Willi Forst* – benefited in 1945 from the 'Austria bonus' and preserved her political innocence. *Mit meinen Augen, for instance,* shot in the last weeks of the war, was released in 1948, smoothing the transition to such aptly named comedies as *Kein Engel so rein/No Angel so Pure* (1950). In the 1970s, she came out of retirement to play the grandmother in *Die Zwillinge vom Immenhof* (1973) and *Frühling auf Immenhof* (1974). TE

Bib: Renate Helker and Claudia Lenssen (eds), *Olga Tschechowa* (1992).

Other Films Include: *Nora* (1923); *Mädels von heute, Die Stadt der Versuchung* (1925); *Brennende Grenze* (1927); *Moulin Rouge* (1928), *Der Choral von Leuthen* (1933); *Peer Gynt* (1934); *Burgtheater* (1935); *Liebe geht seltsame Wege, Unter Ausschluß der Öffentlichkeit, Gewitterflug zu Claudia* (1937); *Rote Orchideen, Verliebtes Abenteuer* (1938); *Bel Ami, Befreite Hände* (1939); *Angelika* (1940); *Menschen im Sturm/Men in the Storm* (1941); *Gefährlicher Frühling* (1943).

TYKWER, Tom

German director and scriptwriter whose films from the mid-1990s are hailed as much for their *Zeitgeist* flavour and popular potential as for a recognisable *auteur* signature, a mixture *Variety* felt to be 'as exciting and complex as the work of a David Lynch or the Coen brothers'. Tykwer began with short and experimental films, before coming to international attention with his first feature, the family thriller *Die tödliche Maria/Deadly Maria* (1993) whose darkly atmospheric photography and stark psychological contrasts reminded critics of the age of German Expressionism*. *Winterschläfer/Wintersleepers* (1997), the no less ghostly erotic melo-thriller about two couples tied to each other in the blinding white landscape of the Bavarian Alps after a car accident, impressed critics with its nervously restless mobile camera, but is even more notable for an obliquely ironic undercurrent beneath the emotionally intense overtone.

In 1994 Tykwer became the co-founder, with Dani Levy and Wolfgang Becker (for whose *Das Leben ist eine Baustelle/Life is All You Get*, 1997, he also wrote the script) of the independent production company X-Filme Creative Pool which in 1998 produced *Lola rennt/Run Lola Run*. It drew over a quarter million Germans to the cinema on its opening weekend and has subsequently enjoyed large scale international distribution. Innovative in its temporal and narrative structure, a kinetic *tour de force* through Berlin, full of unexpected twists, combining still photography, video technology and animation sequences, and driven by a heart-stopping techno beat, *Lola rennt* has been called 'the first German cyberdrama', and Tykwer is set to become the cult genius of the younger generation of German filmmakers who also cater for a broad audience. MW

Bib: Michael Töteberg (ed.), *Tom Tykwer: Lola rennt* (1998).

U

UCICKY, Gustav

Austrian director. Ucicky's ability, as cameraman and director, to create pictures of intense atmosphere and appealing beauty put him at the core of German entertainment film-making at Ufa* from 1929 to 1936, successfully exploiting every popular genre from the musical (*Der unsterbliche Lump*, 1929) and comedy (*Hokuspokus*, 1930) to

historical film (*Yorck*, 1931, *Mensch ohne Namen*, 1932, and *Morgenrot*, 1933). The unveiled nationalism of his early films, including his best-known 'Fridericus Rex' film *Das Flötenkonzert von Sanssouci* (1930), made him a welcome collaborator on propaganda films after 1933. His successful treatment of a Gerhard Menzel script in *Morgenrot* founded his cooperation with the fascist author for the next few years (*Flüchtlinge/Refugees*, 1933; *Das Mädchen Johanna*, 1935; *Savoy Hotel 217*, 1936; *Heimkehr*, 1941). Having 'fulfilled his duty', Ucicky was released from the Ufa headquarters to Vienna and to less offensive melodramas in 1942 (*Späte Liebe*, 1943; *Am Ende der Welt*, 1943; banned, released 1947). Regularly employed by the German and Austrian film industries after 1945, he specialised in literary adaptations of Carl Zuckmayer (*Nach dem Sturm*, 1948), Ludwig Ganghofer (*Der Jäger von Fall*, 1957), Selma Lagerlöf (*Das Mädchen vom Moorhof*, 1958) and Trygve Gulbranssen (*Das Erbe von Björndal*, 1960), before he died during the preparation of *Das letzte Kapitel* in 1961. KU/MW

Other Films Include: *Der zerbrochene Krug/The Broken Jug* (1937); *Der Postmeister* (1940); *Das Herz muß schweigen* (1944).

UFA

German film company. Eventually becoming the most vertically and horizontally integrated German film conglomerate, Ufa was created in 1917 as a result of a government-sponsored merger of Nordisk's*, Messter's* and Union's German branches. While Ufa took the leading position among German film companies, it did not hold a monopoly. Unlike the American majors, Ufa had to face competition – in 1922 there were 380 distributors and 360 production firms in Germany. In contrast to the American film industry, where distribution policies usually determined production plans, at Ufa the production team was in charge of output. The result was a permanent overproduction of films and often poor exploitation in the cinemas. Between February 1923 and January 1926, Erich Pommer* acted as central producer, introducing a novel policy: directors were encouraged to work as creative teams, paying less attention to budgets or shooting schedules. Free to experiment, directors created films informed by established art forms (Expressionism*, romanticism, lighting styles inspired by Rembrandt and Max Reinhardt*) as well as stylistic-technical innovations such as the 'Schüfftan* process' – for example in *Die Nibelungen* (1924) and *Metropolis* (1927), and Karl Freund's* 'unchained camera' in *Der letzte Mann/The Last Laugh* (1924).

In 1924, Ufa experienced an economic crisis because of its organisational structure and, under the managerial iron fist of Ludwig Klitzsch, the restructuring of the company proceeded apace. Independent production and distribution firms were integrated into

Ufa to neutralise competition, while finances and production were strictly separated. Changing Ufa's structure according to principles of market economy also affected film style. Experimentation was relegated to the margins (documentary, animation), and innovations such as sound no longer belonged to the artists' domain but were implemented according to industry standards and demands. The Nazi Party took over Ufa's shares on 18 March 1937, and in January 1942 Ufa was subsumed under the conglomerate into which the entire industry had been organised [> NATIONAL SOCIALISM AND GERMAN CINEMA]. At the end of World War II, Ufa expired as a legal entity, but its various businesses were to keep both the government and the courts busy for decades. DEFA*, the GDR's nationalised film company, took over the Ufa studios in Babelsberg. JG/TE

Bib: Hans-Michael Bock and Michael Töteberg (eds), *Das Ufa-Buch* (1992); Klaus Kreimeier, *Die Ufa Story* (1992).

ULLRICH, Luise Vienna 1911 – Munich, Germany 1985

Austrian-born actress. Her very first screen appearance in Luis Trenker's* *Der Rebell/The Rebel* (1932, co-dir. Kurt Bernhardt*) typecast her as the domestic and sacrificing woman, a role she played throughout the next forty years. Especially during the Nazi regime, Ullrich was ideally suited for the brave wife and mother (for instance in Josef von Baky's* *Annelie: Geschichte eines Lebens*, 1941). One of the few films to provide a challenge for her was the early Mizzi Schlager part in Max Ophuls'* *Liebelei* (1933), which remained her best-known role, along with her portrayal of an impudent grandmother in R. W. Fassbinder's* five-part television series, *Acht Stunden sind kein Tag/Eight Hours Are Not a Day* (1973). KU.

Bib: Luise Ullrich, *Komm auf die Schaukel, Luise: Balance eines Lebens* (1973).

Other Films Include: *Regine* (1934); *Versprich mir nichts!* (1937); *Nora* (1944).

VALENTIN, Karl
Valentin Ludwig Fey;
Au, Bavaria 1882 – Planegg 1948

German actor and writer, the most popular stage comedian in Germany from the 1910s to the 1940s. A Munich folk-hero, with a background in variety theatre and music hall, Valentin was encouraged by the success of his visual gags and verbal routines to record, from 1912 onwards, some of his stage acts on film. His part in the surrealist goings-on of *Die Mysterien eines Frisiersalons* (Erich Engel*/ Bertolt Brecht, 1923) makes one wish for more, and in Max Ophuls'* *Die verkaufte Braut/The Bartered Bride* (1932) he almost runs away with the film: brief highlights in a film career that never quite did justice to Valentin's unique talent. His distinctive face and impossibly gaunt body were important props for his comic gags (*Der neue Schreibtisch*, 1914), but the grotesque verbal exchanges (often with his partner Lisl Karlstadt, and documented in more than 400 written sketches) did not come across on the silent screen and later suffered from (self?) censorship in, for instance, *Die Erbschaft/The Heritage* (1936). His films lay forgotten until the interest in early cinema, and the efforts of the Munich Film Museum, restored his reputation as one of the German cinema's great comic geniuses. TE/MW

Bib: Wolfgang Till (ed.), *Karl Valentin: Volkssänger? Dadaist?* (1982).

Other Films Include: *Der 'entflohene' Hauptdarsteller* (1921); *Der Sonderling* (1929); *Im Photoatelier* (1932); *Der Theaterbesuch, Der Firmling* (1934); *Der Antennendraht* (1938); *Der Tobis-Trichter. Volkshumor aus deutschen Gauen* (1941).

VEIDT, Conrad
Berlin 1893 – Hollywood, California 1943

German actor. After he had appeared in a number of sex education films, Veidt's pale face and deep-set eyes predestined him for phantasmagoric parts in films of the uncanny, starting with his best-known role as the somnambulist Cesare in *Das Cabinet des Dr Caligari/The Cabinet of Dr Caligari* (1920). By the time he played the lead in *Der Student von Prag/The Student of Prague* (1926), Veidt had become the quintessential icon of Expressionist* film, having embodied Ivan the Terrible, Cagliostro, Jekyll and Hyde, Richard III and scores of similar monsters. Enticed to Hollywood, Veidt starred in historical costume dramas (*The Beloved Rogue*, 1927) and Victor Hugo *grand guignol* (*The Man Who Laughs*, 1928, dir. Paul Leni*), but he returned

to Germany with the coming of sound in 1929. For E. A. Dupont's*
multi-language productions he went to Britain, then to Germany (*Der
Kongreß tanzt*, 1931), and back to Britain. During a visit to Berlin he
was briefly put under house arrest by the Nazis for acting in the
English adaptation of Feuchtwanger's *Jew Süss* (dir. Lothar Mendes,
1934; not to be confused with Veit Harlan's* anti-semitic 1940 ver-
sion), and left Germany for good. Although he was never out of work
(he also made films in France), his roles tended to be in underfunded
émigré projects, until necessity became a virtue and Veidt lent his fea-
tures to a number of memorable screen Nazis, most famously in
Michael Powell and Emeric Pressburger's U-boat drama *The Spy in
Black* (1939), and as Major Strasser in Michael Curtiz's classic
Casablanca (1942). TE/MW

Bib: Jerry C. Allen, *Conrad Veidt: From Caligari to Casablanca* (1987,
2nd ed. 1993).

Other Films Include: *Der Weg des Todes* (1917); *Das Tagebuch einer
Verlorenen/The Diary of a Lost Girl* (1918); *Anders als die Anderen/
Different from the Others, Wahnsinn Unheimliche Geschichten,
Satanas* (1919); *Das indische Grabmal* (1921); *Lucrezia Borgia* (1922);
Das Wachsfigurenkabinett/Waxworks (1924); *Der Kongreß tanzt*
(1931); *Der schwarze Husar* (1932); *Wilhelm Tell* (1934); *The Passing
of the Third Floor Back* (1935, UK); *King of the Damned* (1935, UK);
A Woman's Face (1941, US); *Nazi Agent* (1942, US); *Above Suspicion*
(1943, US).

VILSMAIER, Joseph Munich 1939

German director, cinematographer and screenwriter who, after an
apprenticeship at Arnold & Richter (ARRI) and a degree in music
from the Munich Conservatoire between 1953 and 1961, became
camera assistant and, from 1972, director of photography at Bavaria
Studios [> STUDIOS]. In 1988 he founded his own production company
(Perathon Film), making a relatively late directorial debut with
Herbstmilch/Autumn Milk (1988). This adaptation of the best-selling
biography of the Bavarian farmer's wife Anna Wimschneider became
a surprise hit nationally as well as internationally. It established
Vilsmaier as an able craftsman with a sure touch for historical accu-
racy and emotional effectivity. He stayed in the Bavarian idiom with
the melancholic Trümmerfilm* *Rama dama* (1990), as he generally
prefers rural settings and characters from the lower strata of society as
his witnesses of history, also evident in *Charlie and Louise*, his 1993
adaptation of Erich Kästner's children's classic *Das doppelte Lottchen*,
or in *Schlafes Bruder/Brother of Sound* (1995), the adaptation of
another best-selling novel, notable for its combination of character
psychology with an unusually sophisticated sound track. In *Stalingrad*

(1992), his two-and-a-half-hour retelling of the brutal 1942–43 battle launched by Hitler and his generals, Vilsmaier commanded a DM 40 million budget that allowed him a lavishly detailed re-creation of psychologically complex and pyrotechnically chaotic war scenes, which, however, failed to catch a mass audience. With *Comedian Harmonists* (1998), a musical period-film about the famous German acappella group disbanded by the Nazis because several members were Jewish, he returned to form, surpassing his earlier successes, by giving a twist to (but also cashing in on) the wave of nostalgia for 1920s and 1930s popular culture. Vilsmaier is married to actress Dana Vávrová who appears in most of his films. MW

VOHRER, Alfred Stuttgart 1918 – Munich 1986

German director and one of the most influential figures of German film and television entertainment from the 1960s to the 1980s. After training and first roles as an actor and singer, Vohrer's early career came to an abrupt halt with World War II when he lost one of his arms. Continuing work by directing radio plays, he made his debut as a film director in 1958 with *Schmutziger Engel*. His first five films from the late 1950s and early 1960s, mine the then popular genre of the 'youth problem film'. In 1961 he changed to thrillers with his first Edgar Wallace film (*Die toten Augen von London*), followed by other popular fiction adaptations, such as a Karl May film (*Unter Geiern/La dove scende il sole/Parmi les vautours/Mehjujastrebovima*, 1964) a Johannes M. Simmel film (*Gott schütze die Liebenden*, 1973) and a Heinz G. Konsalik adaptation. Vohrer upgraded the sought-after genre and series films of the 1960s and 1970s with professional action sequences and a tongue-in-cheek approach to formula and stereotype. From the mid-1970s he proved his talent for popular entertainment by directing some of the most successful German television series: *Derrick* (1976/86), *Das Traumschiff* (1982/83), *Die Schwarzwaldklinik* (1984/85). KU

Bib: Georg Seeßlen, 'Alfred Vohrer', *epd Kirche und Film* 4 (1986).

Other Films Include: *Verbrechen nach Schulschluß* (1959); *Ein Alibi zerbricht* (1963); *Der Mönch mit der Peitsche* (1967); *Wer stirbt schon gern unter Palmen* (1974).

W

WAGNER, Fritz Arno
Schmiedefeld 1889 –
Göttingen 1958

German cinematographer, one of Germany's most productive and well-known cameramen, enjoying a 40-year career during which he was in charge of more than 120 films. From 1910 he worked for Pathé frères, doing various jobs in different European countries. Joining PAGU* in 1919, and employed as photographer and second assistant on *Madame Dubarry* (1919), he became chief cinematographer in the 1920s for Lubitsch* *(Sumurun)*, Wiene* *(Das Spiel mit dem Feuer)*, Murnau* *(Schloß Vogelöd, Nosferatu, Der brennende Acker)*, Grune* *(Am Rande der Welt, Waterloo)*, Lang* *(Der müde Tod, Spione)*, Gliese* *(Der Galeerensträfling, Die Jagd nach dem Glück)* and Robison *(Zwischen Abend und Morgen, Schatten)*. In the early 1930s he reached the zenith of his career, as preferred cameraman of Pabst* and Lang*. His style was characterised by realistic lighting and fluid camera movements. Between 1937–45 he was under contract with Tobis, filming a number of Nazi bio-pics *(Robert Koch, der Bekämpfer des Todes,* 1939) and large-scale propaganda films (e.g. *Ohm Krüger,* 1941). After the war Wagner continued to work, both on prestige projects and routine entertainment films. KP

Other Films Include: *Westfront 1918* (1930), *Die Dreigroschenoper* (1931), *M* (1931), *Kameradschaft* (1931), *Das Testament des Dr Mabuse* (1933), *Flüchtlinge* (1933), *Amphitryon* (1935), *Schwarze Rosen* (1935), *Der zerbrochene Krug* (1937), *Die Brücke* (1949), *Hotel Adlon* (1955), *Hochzeit auf Immenhof* (1956), *Ohne Mutter geht es nicht* (1958).

WARM, Hermann
Berlin 1889 – 1976

German art director, responsible, together with Walter Reimann and Walter Röhrig, for the painted decor of *Das Cabinet des Dr Caligari/The Cabinet of Dr Caligari* (1920; dir. Robert Wiene*). No overnight wonder, Warm had been a 'film architect' since 1912, working for PAGU* and Greenbaum before transferring to Erich Pommer's* Decla, where he also did the sets for Fritz Lang's* *Die Spinnen* (two parts: 1919 and 1920) and supervised art direction on *Der müde Tod/Destiny* (1921). At Ufa* he was in charge of F. W. Murnau's* *Schloß Vogelöd* (1921) and *Phantom* (1922), but also of *Der Student von Prag/The Student of Prague* (Henrik Galeen, 1926) and G. W. Pabst's* *Die Liebe der Jeanne Ney/The Loves of Jeanne Ney*

(1927). In the late 1920s he worked in France for Carl Theodor Dreyer*, designing an entire walled city for *La Passion de Jeanne d'Arc/The Passion of Joan of Arc* (1927) and creating the eerie mill in *Vampyr/The Vampire* (1932). After spending World War II in Switzerland, he continued in the German cinema until 1960 and his last film was Harald Braun's* *Die Botschafterin*. TE/MW

WECHSLER, Lazar
Petrikau, Poland 1896 – Zurich 1981

Polish-born Swiss producer, who moved to Switzerland in 1914 as an engineering student, and ten years later founded the country's first major production company, Praesens-Film in Zurich, which was to remain Switzerland's most profitable film company well into the 1950s.

Wechsler began producing documentaries in collaboration with aviator, camera operator and later shareholder Werner Mittelholzer (1894–1937); his interest in current affairs and his idealistic commitment persuaded S. M. Eisenstein to shoot the material for a documentary about abortion during a short visit to Switzerland in 1930 (*Frauennot – Frauenglück*). During World War II, Wechsler's exceptional acumen led him to spearhead the 'spiritual defence of the nation' [> LINDTBERG] at Praesens-Film, with a number of feature films distilling a strong sense of Swiss national identity, mediated through the representation of the army, the literary heritage and the regions. These films were made in close collaboration with his personnel, including directors Leopold Lindtberg*, Hermann Haller and Franz Schnyder*, cinematographer Emil Berna*, scriptwriter Richard Schweizer, composer Robert Blum, and actors Heinrich Gretler* and Anne-Marie Blanc. Notable titles include *Füsilier Wipf* (1938), *Wachtmeister Studer* (1939), *Die mißbrauchten Liebesbriefe* (1940), *Der Schuß von der Kanzel* (1942), *Marie-Louise* (1944) and *Die letzte Chance/The Last Chance* (1944–45), all hugely successful at home and abroad, putting Switzerland for the first time on the world cinema map. Encouraged by this outcome, Wechsler turned to a more expensive though ultimately less successful (co-)production policy, aiming at the international market, the most memorable results being Fred Zinnemann's *The Search/Die Gezeichneten* (1947) and Lindtberg's *Die Vier im Jeep/Four in a Jeep* (1950). Despite occasional popular success at home (*Heidi*, 1952; *Heidi und Peter*, 1954) or cultural prestige (*Es geschah am hellichten Tag*, 1958), Wechsler's star waned perceptibly through the 1950s and 1960s, and with it Praesens' national pre-eminence. MW

Bib: Walter Boveri *et al.*, *Morgarten kann nicht stattfinden: Lazar Wechsler und der Schweizer Film* (1966).

WEGENER, Paul
Jerrentowitz/Arnoldsdorf 1874 – Berlin 1948

German director and actor. Already one of the leading character actors from the Max Reinhardt* theatre, Wegener gained wider fame with his screen debut as the student Balduin in the first *Der Student von Prag/The Student of Prague* (1913). As producer, co-director and leading actor in *Der Golem* (1915), Wegener clearly felt close to this theme, since he made two other versions, *Der Golem und die Tänzerin* (1917) and *Der Golem, wie er in die Welt kam/The Golem* (1920). But Wegener the producer-director, in contrast to the actor, has been underrated as a key intellectual force behind the stylistic and thematic development of Wilhelmine cinema. His 1916 lecture, 'The Artistic Possibilities of Film', is one index of his interest in the cinema as an autonomous medium, but his selection of fantastic, gothic and fairy-tale motifs for his films, along with his choice of Guido Seeber* as cinematographer and technical adviser, is proof that Wegener sought to shape a 'national' cinema by combining German romanticism with technological excellence. It is thus not altogether surprising that this far-sighted artist, with his distinctive broad face and massive body, often described as 'Asian', should – after star parts in the films of Ernst Lubitsch*, Richard Oswald* and Joe May* – not hesitate in 1933 to continue acting in nationalist productions such as *Ein Mann will nach Deutschland* (1934) and *August der Starke* (1936), and even support outright propaganda efforts such as Veit Harlan's* *Der große König* (1942) and *Kolberg* (1945). TE/MW

Bib: Kai Möller (ed.), *Paul Wegener: Sein Leben und seine Rollen* (1954).

Other Films Include: *Der Verführte* (1913); *Sumurun* (1920); *Das Weib des Pharao/The Loves of Pharaoh* (1921); *Lukrezia Borgia* (1922); *The Magician* (1926, US); *Die Weber* (1927); *Alraune/Unholy Love* (1928); *Das unsterbliche Herz* (1939); *Hochzeit auf Bärenhof* (1942); *Der große Mandarin* (1948).

WEIDENMANN, Alfred
Stuttgart 1918

German director who studied fine arts, worked as a journalist, wrote youth novels, and made educational youth films for the National Socialist Party. He completed three films during the war, the best known of them being *Junge Adler* (1944), starring the young Hardy Krüger* and *the* charmer of the period, Willy Fritsch*. His professional eye for (and extravagant taste in) clean-cut faces, decor and movements gave his youth films high technical but also ideological polish, which he continued to cultivate in numerous productions until

246

the 1970s and beyond, eventually for television. His postwar films range from ambitious problem films (*Verdammt zur Sünde*, 1964) through literary adaptations (*Die Buddenbrooks*, part 2, 1959) to suspense thrillers (*Alibi*, 1955), comedies (*Julia, Du bist zauberhaft/ Adorable Julia*, 1961) and heroic drama (*Der Stern von Afrika*, 1956, co-dir.). KU

Other Films Include: *Soldaten von morgen* (1941); *Illustrierte* (1951, doc.); *Canaris* (1954); *Kitty und die große Welt* (1956); *Solange das Herz schlägt* (1958); *Ich suche einen Mann* (1965); *Der Schimmelreiter* (1978).

WEIMAR CINEMA

Historical period of German cinema. The first German republic, known as the Weimar Republic, lasted from 1918 to 1933. The economic might of Ufa* ensured that the Weimar cinema created the first mass audience for film. The number of movie theatres in Germany grew from roughly 2,000 in 1918 to 5,000 at the beginning of the 1930s; 300 films were produced annually at the beginning of the 1920s as inflation hit Germany, and even at the end of the Weimar period more than a hundred films were still being produced every year. A growing number of (small) film companies ensured diversity of production, and a proliferation of trade journals indicates how highly developed the commercial film industry was at this time. Although German films were popular in countries outside Germany, Weimar cinema remained primarily a national cinema built on domestic genres and stars. Some of the most popular Weimar genres included sex films, costume films, 'Prussian' films, comedies and musicals, and most of the popular stars were German: Henny Porten*, Claire Rommer* and Conrad Veidt*, among others.

The image of Weimar cinema has largely been formed by two film historians, themselves film critics during the Weimar period in Germany. Their books, both written in exile, explained Weimar cinema retrospectively in the light of their experience of the Holocaust. In *From Caligari to Hitler* (1947), Siegfried Kracauer* demonstrates how collective psychic dispositions led to acquiescence in the Third Reich, while Lotte Eisner*, in *L'Ecran démoniaque* (1952, published in English as *The Haunted Screen* in 1973), often basing herself on the same films as Kracauer, tries to show how the Weimar cinema reanimated German romanticism, later perverted by the Nazis. Many Weimar films were considered art cinema at the time, since some directors deliberately tried to create a stylistic link between their films and more traditional, prestigious areas of high culture. The celebrated Expressionist* films were aimed at an elite section of the middle class whose approval helped establish the films', but also the cinema's, general cultural value. Accordingly, the Weimar cinema was a cinema of

247

directors whose development and dynamics were determined by cineastes and not by mass audiences. In fact, though, many of the films of directors such as Fritz Lang*, Friedrich Wilhelm Murnau* and G. W. Pabst*, who received their first training in fine arts, were also extremely popular, especially when they followed or reshaped genre conventions. Lang's most popular films were thrillers (*Dr Mabuse, der Spieler/Dr Mabuse, the Gambler*, 1922; two parts), *Spione/The Spy*, 1928), historical spectaculars (*Die Nibelungen*, 1924), and science-fiction films (*Metropolis*, 1927, *Die Frau im Mond/Woman in the Moon*, 1929). It is true, on the other hand, that the production system of the 1920s allowed those with creative talent a larger measure of freedom to experiment with techniques specific to film than in the American film industry [> ERICH POMMER; UFA]. Films made under these conditions received international critical acclaim – *Der letzte Mann/The Last Laugh* (1924), *Varieté/Variety* (1925), Faust (1926) – and the American film industry wooed German film personalities (Murnau, E. A. Dupont*, Karl Freund* and Emil Jannings*, for example) in order to produce European-type films in America which would be more popular in Germany than pure American-style films. After the reorganisation of Ufa in 1927, the possibility for personal innovation within the German film industry also changed.

Because the Weimar cinema is tied to the Weimar Republic in name, 1933 traditionally marks a sharp break in the history of German film, with the coming to power of the Nazis and the systematic persecution of Jews in the German film industry. However, the types of film produced at this time did not undergo any fundamental change. Traditional German genres, such as operetta films and mountain films*, continued to be produced after 1933 and stars such as Jannings, Paul Wegener*, Olga Tschechowa*, Lilian Harvey* and Heinz Rühmann* continued to have successful careers, illustrating the problem of using the political history of Germany for the periodisation of its film history. JG/TE

Bib: Lotte Eisner, *The Haunted Screen: Expressionism in the German Cinema and the Influence of Max Reinhardt* (1973); Siegfried Kracauer, *From Caligari to Hitler: A Psychological History of German Film* (1947)

WENDERS, Wim Düsseldorf 1945

German director, one of the few internationally known directors of the German cinema to graduate from a film school where, still a student, he made his first full-length feature film, *Summer in the City* (1971). Also active as a critic, producer and co-founder of the *Filmverlag der Autoren**, he possesses an extensive film culture and is highly aware of the many threads that link him to German film history, both the 1920s and the Paris–Hollywood axis of the 1930s.

Falsche Bewegung/Wrong Movement (1975) and *Im Lauf der Zeit/ Kings of the Road* (1976) brought Wenders critical, commercial and popular success, and with it bigger budgets: *Der amerikanische Freund/The American Friend* (1977) led to a US contract with Francis Ford Coppola to direct *Hammett* (1982). A sobering experience, it was reflected in a number of subsequent Wenders films: *Lightning Over Water* (1980), on and with his friend the director Nicholas Ray; *The State of Things* (1982) featuring another Hollywood director, Sam Fuller; and *Paris, Texas* (1984), shot in the US, though a Franco-German production. Refocused on Germany since his *Der Himmel über Berlin/Wings of Desire* (1987), a poetic meditation on the impossibility of coming home, Wenders has made the German past (*Alice in den Städten/Alice in the Cities*, 1974) a continuing theme in both *Bis ans Ende der Welt/Until the End of the World* (1991) and *In weiter Ferne, so nah!/Far Away, So Close* (1993). The latter film looks at a post-unification Berlin, caught between a still murky past and ever more nomadic existences. Perhaps too readily seen as the reinventor of the American road movie, Wenders shares his detached observational stance (which covers deep narcissistic wounds) with the Austrian writer Peter Handke, who has written three scripts for him. A director with an unmistakable visual style and rhythm, and winner of many prizes at festivals, he often works with the same team, including cameraman Robby Müller*, editor Peter Przygodda and the actors Rüdiger Vogler, Bruno Ganz* and Hanns Zischler. TE

Bib: Robert Philipp Kolker and Peter Beik, *The Films of Wim Wenders: Cinema as Vision and Desire* (1993); Roger F. Cook/Gerd Gemünden (eds), *The Cinema of Wim Wenders: Image, Narrative, and the Postmodern Condition* (1997).

Other Films Include: *Schauplätze* (1967); *Same Player Shoots Again* (1968); *Silver City* (1969); *Alabama: 2000 Light Years* (1969); *Die Angst des Tormanns beim Elfmeter/The Goalkeeper's Fear of the Penalty* (1972); *Chambre 666* (1982); *Tokyo-Ga* (1985); *Notebook of Cities and Clothes* (1989); *Lisbon Story* (1994); *Lumière et compagnie/ Lumière and Company* (1995); *Die Gebrüder Skladanowsky/Brothers Skladanowsky* (1995); *Par-delà les nuages/Beyond the Clouds* (1995); *The End of Violence* (1997, US).

WERNER, Oskar
Oskar Josef Bschließmayer; Vienna 1922 – Marburg an der Lahn 1984

Austrian-born actor. Originally a stage actor, Werner played the Nazi Hermann Alt in Karl Hartl's* *Der Engel mit der Posaune* (1948), which initiated his international film career. Werner's sensitive acting and the fine, melodic beauty of his speech were the foundation of his

success. His characters were intellectual, often overly sensitive heroes, many of whom 'failed' as a result of their resistance to conformism. His film work includes barely twenty-five films, among them François Truffaut's* *Jules et Jim* (1962, Fr.) and *Fahrenheit 451* (1966, UK), and Max Ophuls'* *Lola Montès* (1955, Fr./Ger.), and, in the US, Stanley Kramer's *Ship of Fools* (1965); in the UK he appeared notably in *The Spy Who Came in from the Cold* (1965) and *Voyage of the Damned* (1976). FM

WESSELY, Paula Vienna 1908

Austrian actress, who mainly performed on stage but in 1934 accepted an offer from Willy Forst* to play the female lead in *Maskerade/ Masquerade in Vienna*, a role that suited her Viennese temperament and dialect. The film brought her to the attention of Joseph Goebbels, who subsequently built her up as the star who represented his ideal of the 'wholesome' German woman, conceived as an alternative to the unbridled eroticism of emigrant Marlene Dietrich*. Wessely reliably delivered this image in a string of propaganda melodramas directed by some of Ufa's* most experienced hands, such as Geza von Bolvary* (*Spiegel des Lebens*, 1938) and Gustav Ucicky* (*Heimkehr*, 1941). In the postwar period, despite appearing in few films, Wessely not only successfully resumed her stage career, but transformed her past film successes into an enduring myth, making her the *grande dame* of Austrian film culture and popular entertainment. KU

Bib: Cinzia Romani, *Tainted Goddesses: Female Film Stars of the Third Reich* (1992).

Other Films Include: *Episode* (1935); *Die ganz großen Torheiten* (1937); *Maria Illona* (1939); *Das Herz muß schweigen* (1944).

WICKI, Bernhard St. Pölten 1919

Austrian actor and director. Wicki's first success as an actor was in the war film *Die letzte Brücke/The Last Bridge* (1953), and, as director, six years later in another war film, *Die Brücke/The Bridge* (1959), considered among the best German productions of the 1950s. Awarded best director prize at the Berlin film festival for his next picture, *Das Wunder des Malachias* (1961), Wicki was assigned to prestigious international projects (*Der Besuch/The Visit*, 1964; *Morituri/The Saboteur Code Name – 'Morituri'*, 1965, US), which formed the basis of his reputation outside Germany. From the 1970s, he specialised in literary adaptations commissioned by West German television (*Das falsche Gewicht*, 1970; *Die Eroberung der Zitadelle*, 1977), some of which were co-produced by the East German DEFA*: *Die Grünstein – Variante*

250

(1984), *Sansibar oder der letzte Grund* (1987). From 1977 he worked on *Das Spinnennetz* (based on Joseph Roth), which grew to be his late *magnum opus*, and premiered at Cannes in 1989, though to a reserved critical reception. MW

Bib: Robert Fischer, *Sanftmut und Gewalt: Der Regisseur und Schauspieler Bernhard Wicki* (1991).

WIENE, Robert Breslau 1881 – Paris 1938

German director. Wiene is mostly remembered as the director of the legendary *Das Cabinet des Dr Caligari/The Cabinet of Dr Caligari* (1920), but had by then already directed dozens of films. A rather conventional director, he tried to repeat the success of *Caligari*, using similarly abstract settings and fantastic subjects in *Genuine* (1920) and *Raskolnikov* (1923). Having moved to Vienna in 1924, Wiene once more picked a fantastic subject in *Orlacs Hände/The Hands of Orlac* (1924), about a pianist (Conrad Veidt*) who, after a train accident, is given the hands of an executed murderer. Wiene also turned a script by Hugo von Hofmannsthal into the filmed opera *Der Rosenkavalier* (1926). In exile in Paris, he directed *Ultimatum* (1938, starring Erich von Stroheim), but died only days before the shooting was completed (by Robert Siodmak*). MW

Bib: Uli Jung and Walter Schatzberg, *Robert Wiene* (1992)

Other Films Include: *Die Königin vom Moulin Rouge* (1926); *Die Geliebte* (1927); *Die berühmte Frau* (1927), *Die Frau auf der Folter*, *Die große Abenteuerin* (1928); *Der Andere* (1930); *Taifun* (1933).

WILHELMINE CINEMA

Germany's first public film show took place in the Berliner Variety Wintergarten on 1 November, 1895. The brothers Emil and Max Skladanowsky* presented a 15 minute programme of filmed variety numbers. Early German cinema (or Wilhelmine Cinema) is a 'cinema of attractions' (T. Gunning), deriving from entertainment forms popular in variety theatres, fairgrounds and operetta houses: playlets, sketches, acrobatics, dance and sports numbers, nature scenes and (between 1903 and 1910) Oskar Messter's* *Tonbilder* (mimed highlights from opera, operettas, accompanied by sound-on-discs).

The shift from single-reel to multi-reel films took place in Germany around 1910/11. These longer films developed a wide range of genres, among which comedies, social problem films, melodramas, *Heimatfilme*, and detective films predominated. Actualities and newsreels were also popular, as were nature films and instructional films

(*Kulturfilme*). However, up to 1916, only 10% of all films shown in Germany were produced in Germany, film exchanges and distributors depending heavily on imports from Denmark, France, the US (via Britain), and Italy.

The boom years of the Wilhelmine era were those between 1911 and 1916. In 1905, only 40 cinemas existed, whereas in 1912 the number had risen to about 3,200, with up to 2 million spectators per day, indicating that the emergence of the cinema as a mass medium coincided with World War I, which both boosted national production and consolidated its audiences. Made up primarily of the urban population, audiences were mixed, with children and housewives, male adolescents, unemployed men and women forming the majority.

The industry was undercapitalised, and the combination of large (cheap) imports together with quick turnover of film programmes in theatres made German film production ruinously uncompetitive. In 1910, Ludwig Gottschalk introduced the Monopolfilm: following Pathé in France, films were no longer sold and exchanged, but rented out via a distributor who bought the monopoly right to exploitation, thus creating an artificial scarcity which translated into higher prices and profits.

The shift of the balance of power to distribution also altered production practice. While until the early 1910s films were a producer-driven commodity (Messter*, for instance, made films in order to sell his equipment), the boost in profitability for distributors and exhibitors allowed demand to determine supply, which spawned a new generation of distributor-producers, chief among them Paul Davidson*.

Another consequence of the Monopolfilm was the 'branding' of films, either via a star actor or actress (e.g. Asta Nielsen) or by advertising cultural capital (e.g. literary adaptations). In 1913, the so-called *Autorenfilme* (*Der Andere,* 1913, *Der Student von Prag,* 1913 and *Atlantis,* 1913) tried to exploit the cultural currency which their literary authors commanded, while well-known stage actors were engaged to further highlight artistic value, also reflected in the newly-built luxury theatres. Berlin's cinemas, in particular, such as the U.T. am Berliner Alexanderplatz, the Mozartsaal am Nollendorfplatz and the Marmorhaus were imposing buildings with more than 1,000 seats, whose exteriors and interiors emulated the architectural styles, glamorous furnishings and atmospheric flair of opera houses and stage theatres.

Concern about cultural value also came from another source. A powerful and well-organised Kino reform movement* sought to influence public opinion adversely, by militating against the longer feature film. By mimicking the entertainment habits of the Wilhelmine cultural elite in cinema architecture and film content, the industry also wanted to neutralise its critics. Only when these different social and economic determinants are factored in can one begin to comprehend the diversity of the films produced in Germany in the 1910s. For too

252

long pre-1918 film production has either been regarded as worthless or seen exclusively in terms of the *Autorenfilme*. The Wilhelmine cinema has an identity of its own, amounting to more than a mere prelude to the Expressionist cinema of the 1920s. JG/TE

Bib: Paolo Charchi Usai/Lorenzo Codelli, *Before Caligari: German Cinema 1895–1920* (1990); Heide Schlüpmann, *Unheimlichkeit des Blicks* (1990); Thomas Elsaesser (ed.), *A Second Life: German Cinema's First Decades* (1996).

WOHLBRÜCK, Adolf [WALBROOK, Anton]
Vienna 1896 – Garatshausen 1967

Austrian-born actor. After occasional roles in silent films, Wohlbrück embarked on a regular film career in 1931, playing in, among other films, *Viktor und Viktoria* (1933). In 1934, he succeeded in consolidating his image in Willi Forst's* *Maskerade/Masquerade in Vienna* as the painter Heideneck. Wohlbrück's elegant men-of-the-world were rooted in an acting style typical of the 'Viennese films' of the 1920s and 1930s. Restrained speech and abbreviated gestures seem to elevate this elegant *bon vivant* above the mediocrity surrounding him. Wohlbrück emigrated to Britain in 1936. He continued his career under the name Anton Walbrook, starring in *Gaslight* (1940) and working with such directors as Michael Powell and Emeric Pressburger in Britain (*The Life and Death of Colonel Blimp*, 1943; *The Red Shoes*, 1948; *Oh . . . Rosalinda!!*, 1955) and with Max Ophuls* in France in *La Ronde* (1950) and *Lola Montès* (1955). FM

WOLF, Konrad
Hechingen, 1925 – Berlin, 1982

German director. The son of the writer Friedrich Wolf, he emigrated with his parents and brother Markus across France and Switzerland to the Soviet Union after the Nazi takeover of 1933. A soldier in the Red Army at the age of 17, he returned to Germany as a USSR officer in 1945. After his release from the military, he studied film-making in Moscow at the VGIK under Sergej Gerasimov and Grigori Alexandrow from 1949–54, and whilst studying became assistant to Joris Ivens and Kurt Maetzig*. He then settled in East Germany in 1954, working as a journalist and cultural officer in the Soviet military administration. Wolf graduated from VGIK with the DEFA*-film *Einmal ist Keinmal* (1955). As a director in the feature film division of DEFA, he became the GDR cinema's perhaps most distinguished director. His best-known films *Sterne/Stars* (1958), *Professor Mamlock* (1961) and the semi-autobiographical *Ich war neunzehn* (1967) approach the near Nazi-past from a decisively humanistic point of view through the use of subtly-placed symbolism, enthusiastically received

at international festivals. With his return to contemporary issues in the Christa Wolf adaptation *Der geteilte Himmel* (1964), as well as with the later *Solo Sunny* (1979), he chose a more historically detailed neo-realist idiom in his depiction of his protagonists' daily lives and their thoughts about taboo themes like social protest or the illegal crossing of the border. Accorded numerous national and international awards, Wolf was the president of the Academy of Arts of the GDR from 1965 until his death in 1982. In 1985 the Academy of Film and Television in Potsdam-Babelsberg was renamed after him. MW

Bib: Konrad Wolf, *Direkt in Kopf und Herz: Aufzeichnungen, Reden, Interviews* (1989); Peter Hoff (ed.), *Konrad Wolf: Neue Sichten auf seine Filme* (1990).

Other Films Include: *Genesung* (1955); *Lissy* (1957); *Sonnensucher* (1958); *Leute mit Flügeln* (1960); *Der kleine Prinz* (1966); *Goya* (1971); *Der nackte Mann auf dem Sportplatz* (1973); *Mama, ich lebe* (1976); *Busch singt: Sechs Filme über die erste Hälfte des 20. Jahrhunderts* (1981–82).

WORTMANN, Sönke Marl 1959

German director of highly popular society and gender comedies, who along with Detiev Buck*, is the most prominent representative of the new generation of film-school graduates, whose genre films have reclaimed a place for German cinema in domestic first-run theatres. Wortmann attended Munich's Academy for Television & Film (HFF), where his first assignment, *Nachtfahrer*, earned him an invitation to London's Royal College of Art, and his graduation film, *Drei D*, was nominated for a student oscar in 1990. He then started working for television. There, his made-for-tv movies *Eine Wahnsinnsehe* (1990) and *Allein unter Frauen/Alone Among Women* (1991) already set the tone and established the thematics of his later films – the intricacies, double-binds and ironies typical of (hetero)sexual relationships of all kinds. Whereas in his first two films for the cinema, *Kleine Haie/Acting Out* (1992), *Mr. Bluesman* (1993), and the internationally successful comic-strip adaptation *Der bewegte Mann/Maybe ... Maybe Not* (1994) the emotional gaps opened up by social and sexual differences provide points of acute observation and profound irritation, his subsequent formula hits tended to gravitate towards the flatulence of talk show topicality and sight-gag culture, whether his target was the contemporary media world, as in *Das Superweib/The Super-Wife* (1995), or the everyday chaos and corruption of German mass universities, as in *Campus* (1997). The mordant satirical potential of such subjects, so elegantly brought to the fore in *Der bewegte Mann*, points towards Wortmann's commercial instinct, but his failure to live up to them also towards his limits as a director. In this respect his strength lies in his

handling of actors, which is why he has been a major force behind re-building a star system* for the cinema, fostering the careers of, amongst others, Til Schweiger*, Katja Riemann*, Jürgen Vogel, Veronika Ferres, and Joachim Król. MW

WYSBAR, Frank Tilsit 1899 – Mainz 1967

German director. After pursuing a twelve-year military career (which lasted until 1927) and co-editing the magazine *Theater und Kunst* with Georg H. Will, Wysbar entered film as assistant and production manager of Carl Boese* and Carl Froelich*. In 1931 he worked as the production manager on Leontine Sagan's *Mädchen in Uniform*. He later cast its two leading actresses, Hertha Thiele and Dorothea Wieck, for his second film as director, *Anna und Elisabeth* (1933), a drama about an alleged female faith-healer which was rejected by Nazi-critics as 'decadent'. His most famous film of that period, *Fährmann Maria* (1935, starring Sybille Schmitz* in the title role) is also dominated by mystical elements and the use of unconventional visual compositions.

When banned from working because of his Jewish wife, Wysbar left Germany late in 1938 for the US with only a tourist visa. After some years working on a temporary basis in different jobs, he directed his first American film in 1945, *Strangler of the Swamp*, a remake of his earlier *Fährmann Maria* marred by cheap horror effects. He became an American citizen around 1947, changing his name to 'Wisbar'. From 1948 he worked for television, running his own production company, Wisbar Productions Inc., and active as director, producer and author on over 300 programmes of the series *Fireside Theatre* (1949–55). In 1956 he returned to Germany and started to thematise the fall of the Third Reich in several starkly realistic films: submarine warfare in *Haie und kleine Fische* (1957), Stalingrad in *Hunde, wollt ihr ewig leben* (1959) and the sinking of a boat full of refugees in *Nacht fiel über Gotenhafen* (1960). MW

Other Films Include: *Im Bann des Eulenspiegels* (1932); *Rivalen der Luft* (1933); *Die Unbekannte* (1936); *Petermann ist dagegen* (1937); *Devil Bat's Daughter* (1946); *Lighthouse* (1946); *The Prairie* (1947); *Nasser Asphalt* (1958); *Fabrik der Offiziere* (1960); *Barbara* (1961); *Durchbruch Lok 234* (1963).

Z

ZIEGLER, Regina

Quedlinburg 1944

German producer, who, together with Clara Burckner's Basis Verlag, reflects the presence of women in all aspects of the New German Cinema*. Ziegler produced her first film in 1973 (*Ich dachte, ich wäre tot*), the debut film of director Wolf Gremm, with whom she has worked regularly since. Within a few years she became one of the most active producers, working with Ulrich Schamoni (*Chapeau Claque*, 1974), Marianne Lüdcke and Ingo Kratisch (*Familienglück*, 1975), Helma Sanders-Brahms* (*Heinrich*, 1977) and Peter Stein (*Klassen-Feind*, 1983). Her biggest commercial success was an adaptation of the novel by Erich Kästner, *Fabian* (1980). Also involved in international productions and co-productions, she has completed projects in Poland (Andrzej Wajda*'s *Korczak/Dr Korczak*, 1990), France and Italy. TE/KU

ZIEMANN, Sonja

Alice Toni Selma; Eichenwalde 1926

German actress. A dancer in operettas and musicals in Berlin from the age of 15, she appeared for the first time on screen in *Der Windstoß* (1942) and subsequently acted in supporting roles as chorus girl, before rising to fame with her performance in *Schwarzwaldmädel* (1950).

Along with her film partner Rudoph Prack (also in *Grün ist die Heide*, 1951) Ziemann became the most important female icon of the *Heimatfilm** of the 1950s, the nation's collective erotic fantasy in an otherwise rather homely and wholesome genre. From the late 1950s onwards, Ziemann began to modify her screen image, giving her bright surface some psychological depth, which assured her of assignments in international productions (*Journey into Nowhere*, 1962), and more dramatically challenging roles on German TV (*Das Messer*, 1971) alongside a theatre career that lasted well into the 1970s. KU

Other Films Include: *Die Jungfern vom Bischofsberg* (1943); *Liebe nach Noten* (1945); *Die Freunde meiner Frau* (1949); *Made in Heaven* (1952); *Die Privatsekretärin* (1953); *Kaiserball* (1956); *Gli italiani sono matti* (1958); *Nacht fiel über Gotenhafen* (1960); *Axel Munthe, der Arzt von San Michele/La Storia di San Michele/Le livre de San Michele* (1962); *De Sade/Das ausschweifende Leben des Marquis de Sade* (US/FRG, 1969); *Intimitäten* (1979, TV).

BIBLIOGRAPHY

Germany

Heike Amend and Michael Butow (eds), *Der Bewegte Film: Aufbruch zu neuen deutschen Erfolgen* (Berlin: Vistas, 1997).

Hans-Michael Bock (ed.), *CineGraph: Lexikon zum deutschsprachigen Film* (Munich: Edition Text and Kritik, 1984ff.).

Hans-Michael Bock and Michael Töteberg (eds), *Das Ufa-Buch* (Frankfurt am Main: Zweitausendeins, 1992).

Paolo Cherchi Usai and Lorenzo Codelli (eds), *Prima di Caligari: Cinema tedesco, 1895–1920/Before Caligari: German Cinema, 1895–1920* (Pordenone: Edizioni Biblioteca dell'Immagine, 1990).

Lotte H. Eisner, *The Haunted Screen: Expressionism in the German Cinema and the Influence of Max Reinhardt* (London: Thames and Hudson, 1969).

Thomas Elsaesser, *New German Cinema: A History* (London: BFI/Macmillan, 1989).

Thomas Elsaesser (ed.), *A Second Life: German Cinema's First Decades* (Amsterdam: Amsterdam University Press, 1996).

Terri Ginsberg and Kirsten Moana Thompson (eds), *Perspectives on German Cinema* (New York: G.K. Hall, 1996).

Wolfgang Jacobsen, Anton Kaes and Hans Helmut Prinzler (eds), *Geschichte des deutschen Films* (Stuttgart/Weimar: Metzler, 1993).

Uli Jung (ed.), *Der deutsche Film: Aspekte seiner Geschichte von den Anfängen bis zur Gegenwart* (Trier: Wissenschaftlicher Verlag, 1993).

Siegfried Kracauer, *From Caligari to Hitler: A Psychological History of the German Film* (Princeton, NJ: Princeton University Press, 1947).

Klaus Kreimeier, *Die Ufa-Story. Geschichte eines Filmkonzerns* (Munich: Hanser, 1992).

Stephen Lowry, *Pathos und Politik: Ideologie in Spielfilmen des Nationalsozialismus* (Tübingen: Niemeyer Verlag, 1991).

Paul Monaco, *Cinema and Society: France and Germany during the Twenties* (New York: Elsevier, 1976).

Corinna Müller, *Frühe deutsche Kinematographie: Formale, wirtschaftliche und kulturelle Entwicklungen* (Stuttgart/Weimar: Metzler, 1994).

Bruce Murray and Christopher Wickham (eds), *Framing the Past: The Historiography of German Cinema and Television* (Carbondale/Edwardsville: Southern Illinois University Press, 1992).

Julian Petley, *Capital and Culture: German Cinema 1933–1945* (London: BFI, 1979).

Patrice Petro, *Joyless Streets: Women and Melodramatic Representation in Weimar Germany* (Princeton, NJ: Princeton University Press, 1989).

Hans Günther Pflaum and Hans Helmut Prinzler, *Film in der Bundesrepublik Deutschland* (Munich: Carl Hanser Verlag, 1979. Revised and enlarged edition, 1994).

Thomas G. Plummer, et al. (eds), *Film and Politics in the Weimar Republic* (Minneapolis, MN: University of Minnesota, Dept. of German, 1982).

Eric Rentschler, *The Ministry of Illusion: Nazi Cinema and its Afterlife* (Cambridge, MA.: Harvard University Press, 1996).

Eric Rentschler (ed.), *German Film and Literature: Adaptations and Transformations* (New York and London: Methuen, 1986).

Eric Rentschler, *West German Film in the Course of Time: Reflections on the Twenty Years since Oberhausen* (Bedford Hills, NY: Redgrave Publishing, 1984).

Ralf Schenk (ed.), *Das Zweite Leben der Filmstadt Babelsberg: DEFA-Spielfilme 1946–1992* (Potsdam: Fimmuseum, 1994).

Heide Schlüpmann, *Unheimlichkeit des Blicks: Das Drama des frühen deutschen Kinos* (Frankfurt am Main: Stroemfeld/Roter Stern, 1990).

Marc Silberman, *German Cinema: Texts in Context* (Detroit, IL: Wayne State University Press, 1995).

Switzerland

Giovanni Barblan and Giovanni M. Rossi (eds), *Il volo della chimera: Profilo del Cinema svizzero 1905–1981* (Florence: La Casa Usher, 1981).

Freddy Buache, *Le cinéma suisse* (Lausanne: Editions L'Age d'Homme, 1978).

Freddy Buache, *Le cinéma suisse francophone, 1976–1985* (Brussels: APEC, 1985).

André Chaperon, Roland Cosandey and François Langer (eds), *Histoire(s) des cinéma(s)* (Lausanne: Equinoxe no. 7, 1992).

Hervé Dumont, *Histoire du cinéma suisse: films de fiction 1896–1965* (Lausanne: Cinémathèque suisse, 1987).

Michael Günther, *Filmschaffende, Film produktion und Filmwirtschaft in der Schweiz* (Zurich: Philosophischen Fakultät 1 der Universität Zurich, 1987).

Elaine Mancini, 'Switzerland', in William Luhr (ed.), *World Cinema since 1945* (New York: Ungar, 1987), pp. 542–9.

Rémy Pithon, 'Essai d'historiographie du cinéma suisse (1945–1991)', *Revue suisse d'histoire* (Basle), vol. 41 (1991).

Stephan Portmann, *Der Neue Schweizerfilm 1965–1985: Ein Studien-bericht zur Analyse ausgewählter Spiel- und Dokumentarfilme* (Freiburg: Universitätsverlag, 1992).

Martin Schaub, *The New Swiss Cinema, 1963–1974* (Zurich: Pro Helvetia, 1975).

Martin Schlappner and Martin Schaub, *Vergangenheit und Gegenwart des Schweizer Films 1896–1987: Eine kritische Wertung* (Zurich: Schweizerisches Filmzentrum, 1987).

Austria

Ruth Beckermann/Christa Blümlinger (eds): *Ohne Untertitel. Frag-*

258

mente zu einer Geschichte des österreichischen Kinos (Vienna: Sonderzahl, 1996).

Francesco Bono (ed.), *Austria (in) felix. Zum österreichischen Film der 80er Jahre* (Rome: Graz, 1992).

Elisabeth Büttner/Christian Dewald, *Anschluss an Morgen: Eine Geschichte des österreichischen Films von 1945 bis zur Gegenwart* (Salzburg: Residenz Verlag, 1997).

Walter Fritz, *Kino in Österreich 1896–1930: Der Stummfilm* (Vienna: Bundesverlag, 1981).

Walter Fritz, *Kino in Österreich 1929–1945: Der Tonfilm* (Vienna: Bundesverlag, 1991).

Walter Fritz, *Kino in Österreich 1945–1983: Film zwischen Kommerz und Avant-garde* (Vienna: Bundesverlag, 1984).

Gottfried Schlemmer (ed.), *Der neue österreichische Film* (Vienna: Synema, 1996).